LIMESTONE INDUSTRIES
of the
YORKSHIRE DALES
SECOND EDITION

DAVID JOHNSON

AMBERLEY

For my parents, who made it all possible.

First edition published 2002 by Tempus

Amberley Publishing
Cirencester Road, Chalford,
Stroud, Gloucestershire GL6 8PE

www.amberleybooks.com

British Library Cataloguing in Publication Data.
A catalogue record for this book is available from the British Library.

ISBN 978-1-4456-0060-4

Typeset in 10.5pt on 13pt Sabon.
Typesetting and Origination byAmberley Publishing.
Printed in the UK.

Contents

Acknowledgements

I should like to express my appreciation to all those who have willingly given up their time to answer my questions and to sift their memory bank concerning events from their past. Archives, record offices, and patent collections across the country have been of enormous help and I must single out the staff of the North Yorkshire Library Service and the North Yorkshire County Record Office for being patient with my seemingly endless requests for arcane books and papers. Managers and quarrymen, past and present, from across the Dales have without exception shown a willingness to share their memories with me: regrettably, there are simply too many to name individually but all are mentioned in Notes and References.

I also acknowledge with grateful thanks those who have given permission to reproduce copyright material, as acknowledged in the text. Every effort has been made to trace copyright holders, and an apology is extended to anyone who may have been left out. Illustrations not acknowledged in the text were taken by me, or are from my collection, except for plates 59, 88 and 120, and colour plate 30, whose ownership I have failed to trace.

I wish to thank William Stockdale, who very generously agreed to undertake the task of reading the original manuscript of the first edition. I should add, though, that any errors and omissions are entirely my own. Ken Hill worked wonders with often faded and age-worn photographs, and Trevor Croucher most ably turned my sketches into final artwork. The book is all the better for their work.

I must also record my gratitude for the ways in which Ian Spensley and Leslie Tyson have shared their extensive knowledge with me. The numerous landowners and quarry managers who have given their time freely and allowed me to access sites are also warmly thanked.

Preface to the First Edition

A few quotations from previous writers may help to provide the rationale for the writing of this book. In 1960 Arthur Raistrick, the pioneer of archaeology in the Yorkshire Dales, was able to remember when as a boy he was sent to the local lime kiln to buy a 'twopenny lump of fresh lime' for whitewashing the walls of the family house as part of the annual spring cleaning ritual.[1] Even in the interwar period lime still had a role to play in everyday life in the Dales. Twenty years later Boynton regarded limestone as one of the six 'essential building blocks' of industry and commerce, limestone having displaced coal from the prime position in terms of volume of output of raw material.[2] This observation, too, emphasises the role that limestone has had. The point here is that it was limestone not lime that he was referring to. Lime (quicklime, lump lime, cob lime – call it what you will) was rapidly becoming extinct as a major industrial product whereas limestone remains important today.

Already, by 1967, Wright was commenting about lime kilns that 'remarkably little information about them seems to exist'[3] and just a few years later Cossons was suggesting that lime kilns were among the 'least studied of industrial archaeological sites' despite the enormous number of defunct kilns that are to be found in many parts of the British Isles.[4] Again, at a conference in Exeter in 1984, the fact that the lime industry had been 'neglected locally and nationally' was lamented.[5] Cleasby, in 1995, expressed his surprise that so little was known about lime kilns and that there appeared to be 'no folk memories' of them in use.[6] The lime industry had slumped in less than two generations from an inescapable fact of life to obscurity.

In my opinion the lime industry, and the quarrying of stone that feeds it, have been the Cinderella of industrial archaeology until very recently. Compared with coal, iron, steel, lead mining, and textiles, relatively little desk or field research has been conducted into lime and limestone. A perusal of the references to the early chapters of this book will show that dedicated individuals have indeed researched their local scene, particularly regarding field kilns, but regional analyses are few

and far between. In this respect, perhaps, Isham's book on Cornwall is to be welcomed.[7]

The present book provides the first account of the lime burning and limestone quarrying industries in and around the Yorkshire Dales National Park. For a century or so this area ranked among Britain's most productive limestone-producing localities but the exploitation of lime here stretches back many centuries. The region has given us a number of important and far-seeking entrepreneurs, and limestone quarries – many now defunct – are an integral part of the Dales landscape. Cursed by some, quietly accepted by others, and enthusiastically appreciated by yet others, they have an important story to tell, not least of the generations of men who toiled in often dangerous and unpleasant conditions to help weave the very fabric of our economy. Even today you cannot go far in life without coming across processed limestone in one form or another.

It is not the intention to restrict coverage to the National Park. That would be to impose artificial bounds. Production of lime and limestone products occurred throughout the limestone belt that occupies much of the southern Dales but this extends beyond the park to the east and the south. For the purposes of this book, the whole area will be treated as one.

NOTE ON ADMINISTRATIVE BOUNDARIES

Before the reorganisation of county boundaries in 1974, much of the study area, now falling within North Yorkshire, was part of the old West Riding or North Riding counties. Use of these terms in the text refers to the pre-1974 situation.

Preface to the Second Edition

Since the book was first published, knowledge of the industry within the Pennines has grown incrementally, partly through further documentary research, but also by extensive field surveying of lime kiln sites and by archaeological excavation of early modern lime kilns. The new material has been reflected in this revised edition and the opportunity has been taken to include photographs not previously available, and to draw the reader's attention to recent work.

Except when citing primary sources, the units of mass and length used in the book are metric approximations, made for the sake of consistency. For most of the history of lime usage, the metric system would not have been recognised; systems of measurement differed according to region.

Introduction –
The Beginnings of Lime Usage

It is necessary to go back a long way to establish when limestone was first burnt for the benefit of mankind. How man made that technological leap, how he discovered that limestone would burn and that the lime so produced could be utilised, is a mystery. It may have been pure accident; it may have been the result of years of trial and error – having a niggling problem and seeking to overcome it. Neither history nor archaeology can supply the answers, but they can guide us so that we might pinpoint in time and space the origins of lime usage.

There is precise archaeological evidence that lime plaster was in use in Anatolia from before 7000 BC and elsewhere in the Middle East from 6000 BC.[1] Excavations have uncovered extensive use of lime as plaster in walls and on floors and the sheer quantity unearthed led the archaeologists concerned to accept that an 'organized community effort involving simple kilns or enclosed fires' existed in Anatolia in the Neolithic period, even before that society had evolved the techniques of making and firing pottery. According to Oates, however, the earliest excavated kiln dates from 2450 BC, in Mesopotamia,[2] but this seems to contradict the conclusions from Anatolia.

Gypsum had been in use throughout the Middle East as the main base material for plaster but lime had the advantage of being more durable and less soluble in water: lime plaster was a superior product. Different societies may have evolved aspects of technology in isolation, or may have adopted and adapted new ideas filtering through from elsewhere. Certainly Egypt was still using gypsum plaster for thousands of years later than in Anatolia. Archaeological work in the Giza area of Egypt has identified lime plaster from as late as the second millennium BC,[3] and from around 1500 BC at Knossos in Crete. As the eastern Mediterranean began to be dominated by the Greek empire, the use of lime in plaster became ever more widespread.

The use of lime as a mortar takes us back to prehistory in the Middle East. The ancient Mesopotamian civilisations that flourished in the Fertile Crescent between the Tigris and Euphrates rivers (modern Iraq) – the Assyrians and the Babylonians – were making extensive use of lime mortar in their cities.[4]

If we jump ahead to the Greek and Roman periods there is, predictably, more documentary evidence to give added weight to archaeological findings and deductions. The Athenian Xenophon (430-355 BC) recorded the sinking of a ship that was carrying linen as well as lime 'for its bleaching',[5] giving us a clear indication that lime was already recognised as a multi-use resource. In the second century BC Cato wrote, in his *De Agri Cultura*, of the benefits of lime as part of 'good husbandry' and he also detailed the preferred method of constructing a lime kiln.[6] He gave precise dimensions and stressed the need for keeping the 'fire continually going, beware of neglecting this at night or at any other time'.[7] From Cato's description there seems to have been a remarkable similarity between Roman lime kilns and those still in use in Britain in the early modern period.

In the following century Vitruvius Pollio, architect, engineer and inventor of the very first hydraulic cement (known as *pozzolana*, made up of a mixture of lime and volcanic ashes that helped the mortar to set), was able to discourse on the methods of slaking lime for building purposes.[8] In the first century AD Pliny the Younger – who has given us such an insight into the Roman world of his time – exhorted builders only to use lime which had been slaked for 'at least three years' while extolling the virtues of slaked lime in corn fields, orchards and olive groves in what are now Italy, France and Germany.[9]

Lime kilns from the Roman period have been excavated in Britain and on the continent. The description of such kilns given by Dix suggests that they were technologically more advanced than many that were in use in Britain many centuries later.[10] Roman kilns in Britain were circular or oval, either dug as a pit or set into a hillside. Stone and fuel were stacked in the kilns from the open top, they were fired and allowed to burn through and cool slowly over a period of weeks, and then the kilns were emptied from the top to minimise contamination with fire ash and to avoid any possibility of the kiln structure collapsing in on itself. The bowl was then cleaned out and the process repeated.

Purer lime was used in leather tanning and in the production of medicines; slaked lime was extensively used for mortar, plaster and stucco work; while lime from the bottom of the kiln that had been in contact with ashes was used on the land as a soil improver.

One particular Roman lime kiln was the subject of detailed investigation some years ago.[11] Landscaping in a quarry near Knottingley, in the far south of North Yorkshire, revealed a kiln similar in plan to those described by Dix. It was oval in form, only 150 mm in depth, and cut into native rock. The oval was 1.15 m on the long axis and slightly less on the other. It is likely that stone and wood were stacked within the oval and covered with turves or soil, much like a charcoal clamp, allowed to burn through and cool, and then dismantled. The Roman kiln in question remains undated but it seems to have been linked to a nearby agricultural site dated to the third or fourth century AD.

As with so much else in Britain, the collapse of Roman control and the subsequent slide into relative political and economic obscurity for these islands almost certainly led to a halt in technological development. Quarrying died down

as an activity, the relatively few stone-built structures of this era having a ready supply of cut stone in redundant Roman buildings. Agriculture was probably also frozen in time and the Romano-British estates, which had the wherewithal and the motivation to manufacture quicklime, disappeared. Widespread lime burning, as with quarrying, had to await the building boom that followed the Norman Conquest,[12] though every Anglo-Saxon church or high-status building required lime mortar for its construction.

From the twelfth to the fifteenth century the country oscillated between bouts of war and periods of peace but the underlying political instability of the Middle Ages was a direct cause of the building of royal and baronial castles, offensive or defensive in nature. Castles needed vast quantities of mortar and limewash. It is likely that every castle had its own kiln and in some cases they are documented.[13] A beehive-shaped kiln was built at Bedford Castle for the latter's reconstruction between 1216 and 1224,[14] and there is a similar kiln at Cilgerran Castle near Cardigan and an impressive one at Carreg Cennen Castle near Llandeilo. Bolton Castle, in Wensleydale, was constructed or at least substantially remodelled in 1378 and the legally binding agreement between Sir Richard le Scrope and John Lewyn, master mason, written in Norman French, has survived.[15] Among other requirements it was Lewyn's responsibility to find lime for the work. In the following year Sir Richard was granted *letters patent*, to strengthen and crenellate the castle 'with walls of stone and lime' (1).

Huge quantities of lime mortar were also required for the building and maintenance of monasteries and fortifications around medieval boroughs. Norwich, for example, employed its own limeburner at the turn of the fourteenth century: Michael Lymbrennere was paid the sum of *4d* a day while, in 1399, William Blakehommore was contracted to supply the burghers with the lime needed to construct a tower in the city walls.[16] In those troubled times lime was not just used for building. It is well known, for instance, that quicklime proved a very effective weapon in medieval warfare: Pythonesque perhaps, but true.

So much lime was being produced, for one reason or another, that concerns were raised as early as the thirteenth century.[17] For most of the medieval period wood remained the dominant fuel and lime burning consumed enormous amounts of wood. The concerns are less likely to have been environmental than pragmatic, as wood was the basic resource for building, ship construction, and domestic fuel. Lime burning was yet another competitor for a rapidly diminishing resource.

Various records exist to confirm that lime burning was continued during the medieval period in Yorkshire.[18] Lime kilns were in use in the twelfth century in Barwick in Elmet, north-east of Leeds; a lime kiln was constructed at Kildwick Bridge, to the south of Skipton, in 1309/10 (2); Lymkilnbanks was recorded as a place name in Otley around the same time. Catterick church, near Richmond, was rebuilt in 1412 and a nearby kiln was brought back into use specifically for that purpose.[19] In the reign of Edward III, in 1342 to be precise, lime kilns in the administrative unit of Richmondshire were contributing *40s* each year to official tax coffers.[20]

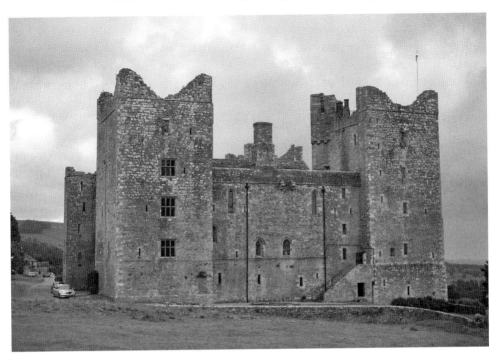

1. Bolton Castle in Wensleydale, crenellated in 1379 'with walls of stone and lime'.

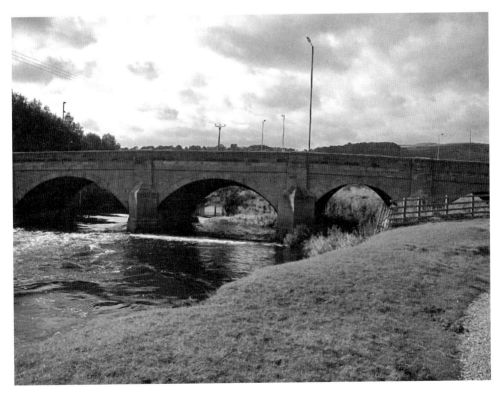

2. Kildwick Bridge near Skipton, where a lime kiln was built in 1309/10.

Perhaps rather more exciting than written records are physical remains that can be dated by archaeological means. A moated site within Gargrave was the subject of a dig in 1997 prior to the site's redevelopment. A circular structure was unearthed and stratified deposits of lime and ash within it verified that it was a lime kiln. There was no absolute dating evidence inside the structure but, by association with dated pottery nearby, the kiln may well have been in use no later than the twelfth or thirteenth centuries.[21] Whether it had been erected to provide mortar for the site's buildings or for agricultural use was not ascertained.

Excavation in 2009 of a farm-based lime kiln in the Forest of Bowland, just south of the Yorkshire Dales, proved by dating evidence of charcoal found within the kiln that it had been in operation during the thirteenth century.[22] At that time the land thereabouts had belonged to Kirkstall Abbey in Leeds and it is known that monasteries were instrumental in improving their estates by the use of soil additives such as lime as well as using it for building purposes. The thirteenth century was an era when farming methods and productivity made great advances. It was the end of the Medieval Warm Period – when climatic conditions were much better around the North Atlantic than in our day – and has been termed a time of 'high farming'.

From the scant remains found within North Yorkshire, and by extrapolating from what was known to be happening elsewhere, we can safely assume that lime burning was practised within the Dales in the medieval period. The castles at Middleham, Richmond, Castle Bolton and Skipton and on the western fringe of the Park in Mallerstang, the monastic houses near Richmond, at Bolton Abbey and Coverham, and the scatter of great houses all needed lime for mortar and limewash and must have had a lime kiln each. The physical proof on the ground has yet to be recorded, but the evidence from documentary sources is compelling.

It was during the sixteenth century when the first indisputable signs of agricultural lime usage in England begin to appear, largely through the writings of Fitzherbert, who first published his *Book of Husbandry* and *Book of Surveying* in the 1520s:

> Another manner of mending of arable land is to muck, marl, or dung it ... And in many countries where plenty of lime stone is the husbands do burn the lime stone with wood, and do set it upon their lands ... the which they call much better than dung, for lime is hot of himself ... He that hath lime stone may burn It with coal and wood, and make lime, wherewith he may lime his ground and that will bring good corn, or he may sell his lime at his pleasure. As to improving barren clay lands gather such lime stone together, and make a kiln in the most convenient place you have ... and having burned your lime (the manner whereof is so generally well known throughout the kingdom that in this place it needeth little or no repetition) you shall then on every acre so ploughed ... bestow at least forty or fifty bushels of lime ... spreading and mixing it exceedingly well with the other sand and earth; and the stronger and sharper the lime is, the better the earth will be made thereby, and the greater the

increase and profit will issue from the same ... It is the strength and goodness of the lime ... which bring forth the profits.[23]

Fitzherbert made it singularly clear that the properties of lime were well understood in his time, and his aside in brackets demonstrates that kiln technology was widely appreciated. Writing so soon into his century in the way that he did must surely be taken as circumstantial evidence that lime continued to be used without interruption from the medieval to the early modern period. It also puts into perspective the comments and claims of some of the agricultural improvers visited in the first chapter.

I

Early Days – The Sixteenth to Mid-Nineteenth Centuries

Organised attempts to raise farm productivity, both arable and pastoral, gathered pace as the country began to settle down after the upheavals of the later medieval period. Greater political stability brought about renewed hope and, in turn, led to the beginnings of a more organised economy. Those fortunate enough to own or to tenant land sought ways of boosting output and financial return and ever so slowly these ways filtered down to the lesser farmers who would have observed or heard about the achievements of others. The methods used to achieve improved results depended on what was locally available, and on trial and error. Thrifty farmers improvised with all sorts: rotted-down rags, shavings from ground-down cattle horns and bones, and the residue from malting all found their way into the soil.[1] Others resorted to what may now appear bizarre measures. Pigeons were not only a valued source of protein but also provided guano, cows and oxen past their prime provided blood to mix into the soil, and even human waste found its way onto the land of those desperate enough. In some coastal areas seaweed was harvested, allowed to decompose, and then applied as manure directly to the land.[2] Sea sand – sands containing a high proportion of shell fragments – was spread over the land in parts of western Scotland and Wales, the calcareous nature of the sand acting as a neutralising agent in the soil in much the same way as lime.

In wider usage, however, was a substance whose benefits had been known from at least the late fourteenth century. Marl is a friable amalgam of sand and clay, often rich in calcium. Mixed with dung or soil it slowly breaks down, releasing calcium into the soil, thus improving soil texture and the soil's water-retaining capacity. Elsewhere in the country, where marl and sea sand were not to be found, farmyard dung was the prime soil improver, as important then as it is in the Dales today.

As far as we can tell from the written record, agricultural lime seems to have come back into widespread usage in the sixteenth century. There is evidence from such diverse regions as South Wales,[3] Pembrokeshire[4] and Cumbria.[5] At this distance we cannot be sure whether lime was indeed coming back into use after a

break of several centuries, or whether it had continued to be applied to the land without any commentator before Fitzherbert perceiving it to be worthy of note. Arable yields did undoubtedly improve towards the end of the sixteenth century and lime kilns were becoming a more common sight in the landscape, perhaps lending credence to the argument that lime had largely gone out of use on the land prior to that. Moore-Colyer quoted Thomas Churchyard's *Worthiness of Wales*, written in 1587:

> They have begun of late to lime their land
> And plowe the ground where sturdie
> Okes did stand. [6]

George Owen, writing in 1603, regarded lime as the 'chiefest thereof' among all 'natural helps' available, with the corollary that lime was not as efficacious as marl, though cheaper to obtain.[7] He also felt that lime had been used more within the previous forty years than at earlier times, again supporting the view that lime was indeed seeing a resurgence of use. Owen quoted an old country saying that puts lime into perspective in his time as a soil improver: 'A man doth sand for himself, lime for his son and marl for his grandchild.' Clearly marl was seen to have a longer-term effect than lime,[8] but this could be a reflection of how early agriculturists mistakenly perceived lime to be a fertiliser in its own right rather than as an aid to manures. Many farmers tended to apply too much lime, with correspondingly less manure, thinking they both had the same effect. The result is quite predictable with our benefit of hindsight: the soil was gradually 'burned' and lost its productive capacity, and lime *per se* was seen as the culprit. As will be seen, it took many years to dispel this misconception.

A remarkable book was published in 1649, and again in 1652 in revised form, by a former Roundhead captain, Walter Blith.[9] Dedicated to Oliver Cromwell, but careful to address everyone from the nobility to the humble (and probably illiterate) cottagers, Blith discoursed on the merits of various soil inputs, like pigeon dung, farmyard dung, wood ashes, soot, human urine, marl and lime. On heathland, heather moorland, and lowland downs, he wrote, lime is of especial benefit. He himself transported lime 32 km to his farm to 'great advance'.[10] He rebuffed the common notion that lime burnt and therefore harmed the soil and he recommended mixing lime in with soil and manure for maximum effect.

We begin to see direct evidence of agricultural liming in the West Riding in the late sixteenth century,[11] and in 1602 a Giggleswick by-law decreed that 'none of the towne of Giggleswicke after the xxth of May next shall build any lime kilne within the same towne nor in the gardens or crofts adjoyneing', a definite reference to lime being produced for the land, and there is an even earlier reference in the by-laws, from 1564, to a kiln in the township. In 1617 William Foster of Arncliffe in Littondale, a yeoman farmer, entered into a legally binding agreement with William Burton of Litton for a house, buildings and lands, including 'meadow or pasture grounds in the myres called Lymekiln Croft' (3).[12] Whether the kiln was

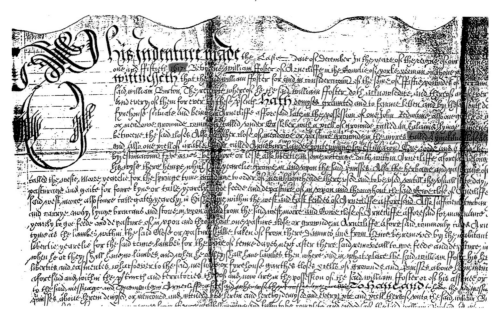

3. Indenture of 1617 between William Foster of Arncliffe and William Burton for Lymekiln Croft in Arncliffe, Littondale. (*WYAS Wakefield, Hammond Papers, uncatalogued*)

still in use in 1617 is immaterial: for the croft to have had that name meant that a lime kiln had been there for a considerable time.

Some three years later a similar indenture was agreed between Sir Peter Middleton of Ilkley, lord of the manor, and William Watson, who was a yeoman farmer in the same parish.[13] Watson was duly granted the right to extract all the 'lyme stones, lyinge, beinge … under the river browe of Wharfe … *where the river did run* [author's italics]' at Wheatley Holme near Denton. Watson had thus been given clearance to take and use, as he wished, all limestone boulders lying in the former bed of the river. Why did he want these rocks? It is inconceivable that he simply intended to sell them on, and the very fact that he was a yeoman farmer might indicate he wanted to turn the stones into lime for use on his lands. We can probably safely assume from these indentures that lime was a valuable product hereabouts, in areas which lacked naturally outcropping beds of limestone.

High on Ilkley Moor, on a low ridge of glacial deposits called Lanshaw Delves (SE 128 454), limestone boulders were extracted from glacial clays in shallow workings to feed primitive kilns just below the ridge. The evidence here is not from documentary sources: the kiln remains are still visible, as are the workings, and there is a scattering of limestone boulders on what is otherwise all glacial till. It would be interesting to know if this ridge was leased out in the same way as the former bed of the Wharfe. 'Probably' is the answer. Similar workings, then known as limestone boulder pits, were in use across the moors on the West Riding-Lancashire border.[14]

In 1621 Henry Holmes of Hebden Bridge, east of Grassington, left 'one lyme kilne and turves' to the value of 12*s* in his will. As the seventeenth century

4. Barren and acidic pastures above Foxup in Littondale which were limed, with varying degrees of success, in an attempt to reclaim them in the early nineteenth century.

progresses, more evidence of lime usage becomes available. In 1678 John Middleton, Sir Peter's descendant, entered into an indenture agreement with Richard Banks of Ilkley, gent, and three local yeomen for a piece of land in Middleton, near Ilkley, which included 'stonary' and lime kilns. The agreement was to run for twenty-one years and included the proviso that they must use the lime on the land in question for 'manuring and husbandry thereof'.[15] Enlightened and progressive landowners such as the Middletons were responding to the writings of learned men who were beginning to systematically set forth their ideas, often gained from pragmatic experience, on husbandry. The motive was usually to enable landowners to increase their income from the land, but tenant farmers also enjoyed the benefits. One of the earliest such writers was Worlidge, who published a detailed treatise on agriculture in which he extolled the benefits of improving soil to boost farm productivity. 'Lime, Chalk, Marle ... are an extraordinary Improvement,' he wrote in 1675,[16] adding that limestone 'after it is burned into *Lime* becomes a very excellent Improver of Lands' while '*Liming* of land is of most excellent use, many barren parts ... being thereby reduced into so fertile a condition' for agriculture.[17]

In parts of the country lime was being transported by the wagon load for up to 32 km, such was its perceived value, and was moved for much longer distances by packhorse.

In 1736 the Society of Gentlemen, in a rather ponderous and weighty tome, also encouraged the use of lime, especially in 'improving barren ground'.[18] Whereas Worlidge had doubted the value of lime in reclaiming acidic clay soils, the Society took a rather different view (4). Twenty years later, Thomas Hale's writings were

advising every husbandman to burn his own lime.[19] He wrote in great detail on every aspect of lime production and usage, from quarrying the stone to applying burnt lime to the land, and he noted the dramatic increase in lime usage in recent years, despite the still considerable cost of buying in burnt lime, describing it as 'the most useful change' in agricultural practices. Like Worlidge, Hale doubted the value of liming heavy clay soils, though he did give space to the contrary views of a Mr Ellis that 'lime agrees best of all with the cold wet clays'.[20] After as little as three years of applying lime to sour or soupy grassland, it could be sweetened sufficiently to produce a good sward of grass, as long as the lime was applied little and often rather than in infrequent large doses.

Though Hale's book was published posthumously, it proved to be very influential, as we shall see later, in the sea change that occurred in agriculture in the first half of the nineteenth century. A contemporary of Hale's, Robert Maxwell, made mention of one estate near Edinburgh where the application of lime had increased the aggregate value of the estate fourfold.[21] New land had been brought into production and existing land was improved, with the capital costs of liming being recovered within only one year. Maxwell was himself a landowner, from Cliftonhall near Edinburgh, and he has been described as the 'most remarkable' of a group of gentry in that area who espoused the new ideas of agricultural reform.[22] He was, in fact, Secretary of the Society of Improvers in Edinburgh.

Finally in this brief survey of eighteenth-century proponents is a work first published in Scotland in 1776 and later in England. Compiled by Lord Kames, it drew the same broad conclusions as the others. Lime usage was on the increase, its benefits visible even for doubting Thomases, but misuse or overuse of lime could have negative effects, rendering the soil 'so hard as to be unfit for vegetation'.[23] Lord Kames' treatise was probably the first to make reference to the use of ground, rather than burnt, limestone in Britain, though widespread use of ground limestone really only began in the twentieth century and it is unusual to read of its application so early. Where there was no fuel available to burn the stone, 'limestone beat small makes an excellent manure,' he said. Three bushels, he maintained, of ground limestone contained as much 'calcareous earth' as six of powdered lime.[24]

It is clear that change in husbandry – not just in the use of lime – came slowly over a period of at least 100 years.[25] The old concept of an Agricultural Revolution, as a process with a quantifiable timespan that saw massive change in land management, is no longer tenable. Change came imperceptibly as new ideas and approaches were discussed, adapted and implemented in various parts of the country. Change in agriculture must be seen as evolution rather than revolution, and it was a process that began in the sixteenth century, progressed piecemeal through the seventeenth, and gathered pace with the dissemination of ideas by eighteenth-century writers and landowners. In the closing years of that latter century, however, a number of loosely related and broadly contemporary circumstances conspired to effect major change in agriculture across the board, which, in turn, had far-reaching consequences for lime burning and usage.

THE BOARD OF AGRICULTURE

One of the first such happenings was the foundation of the Board of Agriculture in 1793. This was the direct and natural progeny of those landowners who had experimented on their estates and put their findings into print for the greater good: the Hales, Kames and Maxwells of the time. The board was created to perform two main functions. It was to act as a forum for the exchange, evaluation and implementation of new ideas, and it was to undertake a comprehensive survey of all aspects of agriculture across the entire country. By the time it was disbanded, in 1822, a complete series of county reports had been compiled, based on field surveys largely undertaken between 1793 and 1795. Though each county was allocated to a qualified surveyor, the quality of the reports varies quite markedly. It is fortunate that the reports for the North Riding (surveyed by Tuke in February 1794) and the West Riding (surveyed by Brown in 1793) are useful and comprehensive.

In the North Riding lime was in 'general use' mainly for reclaiming land from the waste rather than for improving existing land. If used on pasture, it was normal practice to mix it with dung.[26] The recommendation for reclaiming moorland was to pare off and burn the coarse grasses and heather or rush, then to apply lime in 'large' quantities, having first mixed the lime with ash from the burning of the vegetation. If burning and ploughing were completed in the first summer, then cross-ploughed in the autumn and limed the following spring and ploughed in, the new land would be fit for planting in the second summer.[27] This was the fundamental purpose of the board – determine methods already in use, establish best practice, and recommend improvements.

In the West Riding, William Marshall, who had spent six months in 1782 and nine in 1787 surveying Yorkshire's farming scene, found that lime had been in general usage on the land since the 1740s, though 'more practised some time past than at present'.[28] As in the North Riding, lime was mainly being applied to new lands. Where it was in use, Marshall felt that it was applied in such small quantities that it could hardly have made much difference to the quality of the soil. Brown concluded from his West Riding surveys that the whole of the Yorkshire Dales within the West Riding, which could be perceived as productive land, was 'kept under the grazing system, and seldom or never ploughed'.[29] On the fells and moors of the Dales, however, there were 'immense tracts of waste … pastured by them with cattle and sheep' but the 'stock upon them starved', such was the low quality of the pasture. He proposed enclosing and allocating the common pastures so as to improve the productivity of the grasslands and to do away with 'their pining inhabitants, which you scarcely *guess* to be *sheep*, but for the bits of ragged wool they carry on their backs'.[30] We can assume he was not impressed by what he saw.

Brown was scathing about husbandry in some parts of the Dales, but complimentary about other parts. In the Settle area, he wrote, 'lime produces great advantages upon the moors' despite its being 'very sparingly applied', as was also

the case in Chapel le Dale. In Dentdale, he observed, 'lime is applied to the pasture grass: and mixed with earth and dung'.

One interesting fact, among many, emerges from Marshall's work. He observed 'numerous' limestone mines (presumably quarries) across the county, though he gave no indication of the size or scale of the operations.[31]

NAPOLEONIC WARS

On a broader canvas, political events at the turn of the century played a major part in bringing about change in land management, and it could be argued that these events kick the rather more academic work of the Board of Agriculture into touch.

In 1803 England again declared war against France and the two countries were to be embroiled in conflict until 1815. Both countries utilised economic warfare in their armoury, particularly after 1806/07, when Napoleon issued decrees aimed at stopping all trade between Britain and mainland Europe. Necessity being the mother of invention, Britain was forced to rely more on its own resources and food production reached new heights, as did food prices. The Napoleonic blockade of Britain provided a new impetus to the development of new techniques, and encouraged landowners and tenant farmers alike to develop hitherto waste or underproductive land. Misfortune always seems to benefit someone: in these wars it was the landed gentry and aristocracy who enjoyed an economic boom. A few basic statistics illustrate this point well. Between 1795 and 1815 the quantity of food consumed and produced within Britain grew by 50 per cent, while the price of grain increased threefold from 1792 to 1812. In response, in parts of the Dales, pasture was ploughed up for crop growing.

PROTECTIONISM

Nothing lasts forever, and once the wars were over the bumper harvests and record profits that were being achieved by then led to a slump in market prices, and thus to agricultural depression.[32] It was now a buyer's market. The opening up of trade also brought about increased imports of grain into Britain which prompted landowners and farmers to call for protection. These demands were met by the passing of the new Corn Laws in 1815 (not to be confused with the protectionist Corn Laws in force from 1689 to 1756). Stiff tariffs made imports into the country uneconomic and provided a further boost for British farmers until they were finally repealed in 1846. This again left farmers unprotected against cheaper imports from abroad, but they did not face disaster: a doubling of the British population between 1801 and 1851, and an increased drift of people from the land to the growing urban centres, coupled with markedly improved transport systems, guaranteed farmers a market for their produce.

It does not take much to appreciate the significance of these political and demographic changes in lime production and lime-burning technology. There was an almost symbiotic relationship between the two. As we move from the eighteenth to the nineteenth century, the use of lime takes off like never before, and there is a mushrooming in the number of kilns in the landscape. In 1849, for example, Wilson noted that the 'progress of liming during the last fifty or sixty years has been both greater and more successful than during the preceding two and a half centuries'.[33]

ENCLOSURE MOVEMENT

The final set of circumstances under review was what we know as the Enclosure Movement. The open fields and common meadows and stinted cow pastures that surrounded the villages of lowland and upland Britain disappeared piecemeal over several centuries as land was taken into individual, private ownership and demarcated with hedges or walls. This enclosing of open, lower-lying valley land was largely complete by the end of the seventeenth century, particularly in upland areas such as the Dales. Vast tracts of moorland, mountain and rough lowland pastures remained in common usage for much of the following century and, in some cases, until the mid-nineteenth century.

It is the carving up of these tracts to which the enclosure movement is relevant. Between 1750 and 1850 around 4,000 individual Acts of Parliament were passed, each one limited to a localised area such as one common pasture ground or one particular stretch of moorland. Within that 100-year period two peaks stand out, between them accounting for at least half of all parliamentary enclosures: 1760 to 1780 and 1793 to 1815 (the latter from the foundation of the Board of Agriculture to the end of the Napoleonic wars). In addition to legally binding acts, many areas were allotted and demarcated by local agreements.

Several million hectares of 'waste' (that is, open land not used for cultivation or stock rearing) were enclosed during the movement, with the greatest proportion being in the midland and northern counties, including Yorkshire (5). Perusal of individual acts makes it clear that enclosure was not designed to improve the lot of the small farmer. Allocation of land was to those with the means to manage it purposefully and with the influence to make their wishes felt. Enclosure had a number of interrelated objectives, namely to expand the area under production by bringing into use moorland and mountain, thereby increasing agricultural output. Equally, output could be improved by making more efficient use of existing land. The thinking was that one farmer would be more motivated to maximise production from a given piece of land than a host of common users. Certainly, economies of scale would favour individual ownership. More efficient use of existing land also encompassed adopting modern methods of soil, crop and animal husbandry: individual ownership of land, privatisation in fact, made this more feasible. In addition, and perhaps rather cynically, landowners could

5. Upland enclosures in Arkengarthdale.

6. Enclosures associated with Pen-y-ghent House Farm, between Silverdale and Littondale.

maximise their own income by parcelling up and tenanting out their land. These tenants could be charged higher rents.

Enclosure dramatically changed the upland scene and largely gave us the landscape we see today. As far as the Dales are concerned, enclosure bequeathed the thousands of kilometres of dry-stone walls, the field barns and hogg houses dotted about the lower fells, and the walled green lanes that conform to a broadly common pattern. It also gave us a good proportion of the lime kilns that pepper the dales and lower fells today. Liming was an integral and fundamental element in the whole enclosure process. An indication of the scale at which lime was being applied to newly enclosed lands comes from the Pennigent Estate between Silverdale and Littondale. In 1811 Robert Preston paid James Ayrton 9s 'for spreading 316 loads of lime' on a neighbour's field, namely Mr Carr's (6), and Howarth Preston of Mearbeck, near Settle, purchased 265 loads from Joseph Bell between May 1772 and April 1773 at 7d a load, all of which was applied in Farnley Park, an as-yet-unidentified location, with a further 163 loads thereon in October 1773.[34]

An essay written in 1853 concerning an area just outside the Dales recorded that lime was in great demand during the 'period of forty years or more, over which the enclosures of the commons extended'.[35] It was during that half century that the English and lowland Scottish and Welsh landscapes became the artificial creation that we now regard as quintessentially British. By the 1850s the country was the most enclosed and partitioned of any part of Europe. This was the time during which the landowning and yeoman communities prospered more than ever before, and during which arose the 'professional tenant farmer'.[36]

It was also the period that witnessed the development of scientific farming methods, fostered by an increasing number of local societies focussed on agricultural improvement, and the founding in 1838 of the English (later Royal) Agricultural Society. Scientists became involved in agriculture, notably Sir Humphry Davy, who delivered a series of seminal lectures to the Board of Agriculture in 1812.[37] Davy was really the first to publicise exactly how lime worked in the soil. With probably only one exception, those who had written before him about the value of liming knew that it did work, but they did not understand the chemical reactions that took place nor what happens to lime when added to the soil. The single exception was Joseph Black (1728-99), who was the very first to identify the fundamental chemistry of lime production and usage. It was he who worked out that the carbonic acid in the chemical equation gave lime its soil-improving qualities, rather than the heat given off in the process, as had hitherto been thought.[38] Davy, however, recognised that the chemical reaction resulting from mixing lime with dung was quite different compared with mixing lime with vegetative matter. He was not totally correct in his assumptions but he did sow the seeds of a scientific approach to the use of lime on the land.[39]

PEACE AND PROSPERITY

Leaving agriculture aside, it is possible to identify other reasons why lime usage expanded from the late seventeenth century. Increasing levels of prosperity among yeoman families and those engaged in commerce and manufacturing followed on from the upheavals of the Cromwellian era. Peace and prosperity – the 'feel good' factor – initiated a huge rebuilding of houses in stone or brick. Vernacular building in the late seventeenth and early eighteenth centuries created a massive demand for lime mortar. The maintenance and annual spring cleaning-cum-disinfecting of those buildings created a parallel demand for limewash. A burgeoning, if still nascent, manufacturing sector in the British economy provided other outlets for lime producers. The influence of the Royal Society, founded in 1660, cannot be underplayed either. The society fostered improvement across the board and it became almost a moral imperative for landowners to develop their estates both economically and aesthetically.

WITHIN THE DALES

Of the hundreds of field kilns that lie largely forgotten across the Dales, we have documentary evidence for a mere handful, and hard evidence of limeburners is equally scant. The ancient parish of Thornton in Lonsdale had a large number of field kilns across its limestone pastures, yet we have but one reference to a limeburner: in September 1757 Thomas Moorby of Burton was married in the parish church.[40] Many other parishes do not even have one record. The majority of kilns were built at the behest of the local landowner, with the tenant farmers often being obliged to burn lime for the land. The landowner generally owned and paid for the kilns, the tenant worked them and possibly paid rent on them. In Austwick, for example, in 1780, John Chester paid an ancient rent of 1s for a 'parcel of land with a lime kiln thereon'.[41] Ancient rents were established after the dissolution of the monasteries and survived for longer in Craven than in most parts of the country.

At one time a lime kiln stood on the lower part of Castlebergh Hill in Settle, with stone being quarried from the hill itself. In the late eighteenth century the limeburner there was brought before the manor court, accused of jeopardising the safety of Upper Settle.[42] Local inhabitants had petitioned to have his workings closed down as they feared the hill might topple one day and cause damage to their houses. The jury found in the limeburner's favour on the grounds that, even if the hill did collapse, 'it would tumble not towards the town, but the direct or contrary way'. Perhaps the complainants had a point, though, as in 1883 two massive rocks did fall from Castlebergh: one damaged the Congregational church and the other came to rest in the school yard.

Another local limeburner, Edmund Brown, was hauled up before York assizes on 2 July 1805.[43] He operated lime kilns on Buck Haw Brow in Giggleswick parish and he had the gall to use the turnpike road as a storage area for stone for

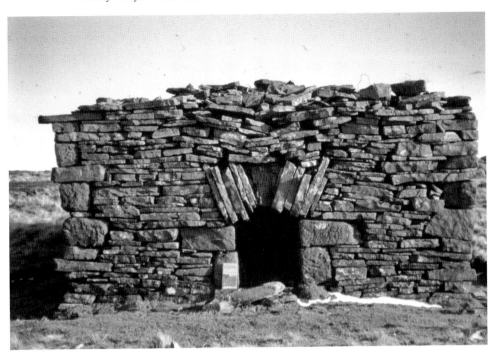

7. Coke oven on top of Fountains Fell, photographed in 1992.

his newest kiln. A number of independently run kilns worked the scar here, selling to farmers from across the whole area. They used coal or coke from Fountains Fell (7) as their prime source of fuel, and possibly coppiced wood from the scar, but the coal was regarded as particularly noxious by those living downwind of the kilns. Brown's transgression was perhaps seen by local people as a way of striking back. The upshot of the case was that he had to demolish his kiln and site it further away from the road and construct a retaining wall.

The spring assizes for 1823 considered a case of trespass on the road from Nether Hesleden to Pen-y-ghent House above Littondale.[44] A limeburner, Edward Brown, operated two kilns in Halton Gill on contract, one in Low Bark Pasture and one in Head's Pasture. A witness, Edward Wilson, testified that he had been employed by Brown for sixteen weeks in the summer of 1806 to cart burnt lime from the Low Bark kiln (8) and to spread it across the field, and in 1813 he was employed to cart lime from Head's kiln. That was not the problem, but Thomas Crabtree had also been engaged to cart coal to both kilns from Fountains Fell. The road in the valley bottom, through Helks, which he should have used, was impassable, but Brown was obliged by the contract to repair it. Rather than go to that expense, it seems he ordered Crabtree to use the Turf Road higher up. The outcome of this case is not known.

In 1806 John Peart, a Settle man of substance, took out a one-year lease on lands above Grassington that included Wisphill lime kiln, giving us a rare opportunity to identify ownership of a lime kiln.[45]

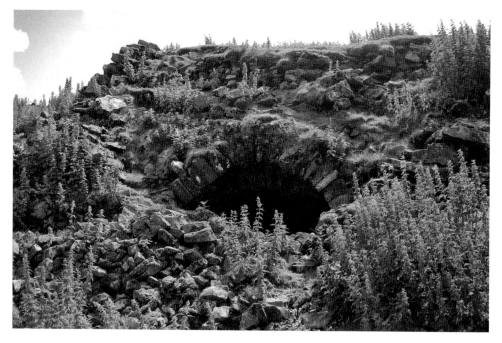

8. Ruins of the lime kiln in Low Bark Pasture above Foxup in Littondale, the centre of a court case in 1823.

Exactly thirty years later James Willis, a farmer at Yorescott just north of Bainbridge, paid John Atkinson 10s towards the building of a new kiln in Grange Gill as well as 8s for burning a predetermined quantity of lime.[46] This may have been a kiln near Spen House (SD 9304 9145) or one in Grange Gill Wood (SD 9285 9130). A site near Ingleton can also be tied in to a kiln operator in 1844, when Abraham Wild was working Twistleton Quarry on Twistleton End.

A very detailed legal document from 1857 describes an agreement between Elizabeth Routh of Gayle, near Hawes, and John Moore of Fossdale Farm above Hardraw, and it is of value to quote it in full:

> Elizabeth Routh agrees to allow the sum of five pounds to the said John Moore for his building a new Lime-kiln in Green Bank Pasture; and the said Elizabeth Routh further agrees to allow the said John Moore at the end of his first year of tenancy the sum of twenty pounds, the said John Moore having previously laid out that amount in well draining and liming at reasonable prices certain portions of the lands hereby agreed to be rented; and the said Elizabeth Routh further agrees after the year 1860 to allow the said John Moore ten pounds yearly towards draining and liming for a period not exceeding ten years from that date. [47]

By agreeing to drain and lime the land he was tenanting, Moore added to the value of the pasture and it was worthwhile from Routh's point of view to pay him – or presumably deduct from his rent – for improving the land.

It was unusual for field kilns to have been built so late, particularly as many are often said to have gone out of use during the latter decades of that century owing to serious recession within farming. Green Bank kiln cannot have had a long life and evidence from elsewhere in the north dates the latest closure of many field kilns to around 1900.[48] Many, however, continued in use well into the following century.

2

The Uses of Lime

We saw earlier that the discovery of lime's potential was most probably an accident, the result of someone idly observing how limestone reacted when innocently placed on a fire. Equally fateful may have been someone's reaction at seeing this burnt stone expand and turn to powder after being wetted. The role of lime as a soil improver undoubtedly arose from casual observation rather than from empirical experimentation. Intelligent and curious farmers no doubt drew the right conclusions from seeing how well grass and other plants grew on limestone-based soils rather than on other types of bedrock, or indeed how lush plant growth was where limestone rock had been temporarily stacked. Indeed, a French scientist called Duhamel observed how luxuriant the grass that grew on a spot outside his house was, where builders had recently stored their limestone blocks. He put two and two together in a most perceptive way. However the link between the raw material and its potential uses was first made, mankind's ingenuity and inventive nature soon found a multitude of uses for raw and processed limestone. Stowell listed over seventy uses of lime and limestone in the 1960s.[1] Some thirty years earlier, Searle had named about thirty broad types of use.[2] A list drawn up ten years before that itemised no less than ninety-one prominent uses for lime.[3]

What we are mainly concerned with in this chapter are the uses of lime before the massive expansion of the industry in the nineteenth century. For ease of discussion, such uses can be considered as non-agricultural and agricultural.

LIME IN BUILDING

Lime mortar was essential in the construction of any permanent stone building. A field boundary wall will stay upright for centuries without recourse to mortaring but no house, barn or byre, with their heavy flagstone roofs, could survive without mortar to bind their courses together. For thousands of years, until the patenting of Portland cement in 1824 by Joseph Aspdin of Leeds, there was no viable

alternative to mortar, a mixture of lime hydrate and sand.[4] Mixed with water it sets as a form of artificial limestone – not so strong, some would say, as Portland, which sets quickly, whereas lime mortar needs several days to really go off. This could be construed as a disadvantage, though anyone who has worked with lime mortar will know that its flexibility and plasticity make it a joy to use. Lime mortar has the added benefit of being able to breathe, unlike cement. Building with lime mortar takes much longer than with cement, though, thus increasing construction costs.

Documentary evidence for the use of lime mortar within the Dales emphasises how important it was. The household accounts of the Clifford earls of Cumberland (of Skipton Castle) contain a very detailed record of expenditure incurred in the building of 'my lord's new chapel' at Barden Tower in Wharfedale in 1515/16.[5] Payments were made to the 'steyn gedders' who quarried the limestone, to the 'staynbrekers' who broke it to the size required for firing in the on-site lime kiln, and to others whose job it was to lead stone from quarry to kiln. There was also the cost of tools and of running repairs to the kiln. In addition, there are a number of entries recording payment to the 'cowchers' or 'chowchers at lyme keilne'. This is a somewhat perplexing term. According to the Oxford English Dictionary the word is connected with 'layer', or 'bed'. Given that clamp kilns – and this would have been a clamp kiln at that early date – were filled with alternate layers of stone and fuel, perhaps they were the men who packed the kilns ready for firing. Unfortunately the accounts do not state the number of days' work for which payments were made, so it is not possible to determine where in the hierarchy of trades the chowcher fitted. Other men were paid to 'watch' the kiln, and other jobs have been listed above, so perhaps this is the most logical explanation for the term.

Even earlier than the Barden accounts, on 18 April 1412 a contract was signed for the rebuilding of Catterick church in lower Swaledale.[6] Dame Kathryn Burgh and her son, William, agreed with the mason, Richard of Cracall (now Crakehall), that they would 'finde lyme and sande' for the task that Richard was to complete within three years at a cost of 'eght [sic] score of marks' (one mark equalled 13s 4d). Just eight years later William was one of a number of local dignitaries who arranged for the building of a new stone bridge over the Swale at Catterick: in this instance the masons were given the right to 'get lymstone and burne itte, and care itte, and make yair lymkilns of your own cost'.[7]

Almost exactly two centuries later, in August 1613, Sir William Gascoigne's estate accounts itemised payments for repairs to his Green Mill near Richmond Castle.[8] Among the payments was £6 10s, out of a grand total of £125, for 131 quarters of lime purchased at 1s per quarter.

If we move into the eighteenth century, we see attempts being made to improve the quality of lime mortar. Early in that century a new type of cement came into use. Neve provided precise instructions for the preparation of this so-called cold cement:

Take half a pound of old Cheshire cheese, minus the rhind. Grate it and put in a pot. Add a pint of milk and let it stand overnight. Get half a pound of 'best unslaked or Quick-lime' and beat it to a powder with a pestle and mortar. Seive [*sic*] this into a bowl, add the cheese and milk mixture, and stir. Add the whites of 12 to 14 eggs, and temper the whole mixture. [9]

To make stone buildings weatherproof, the outer stonework was normally coated with render, or harl, again made from lime. The current fashion is to remove the render and expose the stonework, making the buildings look more appealing to the modern eye, but not returning them to their original state. Internal walls were plastered also and, in the majority of vernacular buildings, whitewash was applied over the internal plaster. Before the advent of stone-built houses, wattle and daub walls were coated with limewash or an amalgam of lime and cow dung, for the same reasons. Annual coatings of whitewash or limewash in spring helped to clean the walls after the long and smoke-filled winter months and helped to rid the house of unwelcome ants, slugs, snails, bugs and bacteria. Bugs in the walls tended to be a major problem, given the fact that until the late nineteenth century, ox, cow and occasionally goat hair were used to bind the plaster together.

Estate accounts for John Hutton of Marske, in Swaledale, are illuminating in this respect. [10] Through the latter half of 1690 payments were made to a bricklayer he had engaged, a Mr Yeoman, for lime mortar and 'lyme white' (whitewash), with many of the items including the cost of hair. For example, a bill for *6s* was settled in respect of 'course lyme and haire'. Horsehair was mixed in with the mortar as a binding agent and to give it greater powers of cohesion. Extensive building alterations were being undertaken by the Norton family around the same time at Worton Hall, near Bainbridge, and the accounts have survived. [11] One item in the list of disbursements for 1694 was payment to John Apray for 'plaistering in the chamber & hair & lime' at a cost of *2s*, so here, too, lime plaster was first mixed with hair to give it extra strength and to prevent it from cracking.

A similar, but much later, purchase was made by Reverend John Swale of Langcliffe. In 1870 he paid Matthew Jackman *14s 6d* for 'lime and hair'. [12]

SOAP, PAPER AND TANNING

Until the age of mass consumption began to dawn, village folk had to rely on their own resources and they had to improvise. One product in constant demand, though not necessarily for personal hygiene, was soap. Until cheap imports of Canadian potash began in the 1820s, soap was made by those who needed it. Many villages across the Dales, including my own, had a thriving textile industry with a dye house, tenter frames (for stretching linen cloth) and a fulling house (for cleansing and scouring the cloth). [13] All of these processes required copious amounts of soap. Retting, or softening, of hemp was such a widespread practice in earlier times that it had to be tightly controlled through the manor court

system and it is very common to see pronouncements made in local court sittings against retting hemp with lime in water courses, and inhabitants being fined for transgressions, because of the pollution caused. The inhabitants of Ellington, near Masham, seem to have been particularly uncooperative: rulings against 'rating hemp and lime contrary to the statute' were lodged in 1600, 1602 and 1604, but their transgressions clearly did not cease as the court sitting for October 1683 hauled up eleven villagers for the same offence.[14]

Two age-old methods of making soap are known to have been used. One method, described in *Hippocrates Chimicus*, a domestic manual produced in 1668, began with the placing of two parts of ash (derived from burning bracken in some upland areas) and one part of quicklime in a vessel. Added to this were one full pot of strained suet, obtained from the village tallow chandler, and eight pots of chamber lye. This was human urine collected particularly from ordinary people whose waste was not likely to have been sullied with alcoholic spirits. The whole concoction was agitated and heated, left to mature for a week or so, and occasionally stirred, until it began to thicken. Thankfully, perhaps, water of rose was added to domestic soap towards the end of the manufacturing process, but not to textile soap. Another method, to make what was called ball soap, was described by John Lucas in the mid-eighteenth century.[15] This used a mixture of salts derived from bracken ash, quicklime and tallow.

The finished soaps obviously performed a useful purpose but nasal sensitivities must have been sorely offended in the journey towards the end product.

Equally offensive, in an olfactory way, were the activities of tanneries. As with pre-modern textile manufacturing, it is amazing how many villages had tan pits. To use my home area in Ribblesdale as a micro-example, Settle was renowned as a centre for tanning. Where Langcliffe church now stands there were tan pits and for many years the Twistleton family of Sherwood House in Stainforth parish supplemented their farm and cattle dealing income with tallow and candle manufacture and tanning.

Tanning must have been one of the most repulsive of village activities in the medieval period, particularly on hot, sultry days, not least because it too used chamber lye or a concoction of either bird droppings and cold water or dog waste and hot water to soften the hides. To help remove the hairs, the hides were soaked for a minimum of eighteen hours in a solution of hydrated lime, after which the hair could be scraped off.

Paper making was another important local industry. The census for 1841, for example, records no less than fourteen paper makers resident in Stainforth. Lime was used to help reduce the acidity of the raw material as well as to break it up. Rags were the raw material – hence the close ties between the textile and paper trades – and these had to be reduced by being boiled in vats, or kiers, in a mixture of lime and water, before being beaten to pulp.

There is no direct evidence to link particular kilns to tanneries, soap makers or textile manufacturers in the Dales, but there is circumstantial evidence. The coal pits on top of Fountains Fell were supplying thousands of packhorse loads of coal

each year to lime kilns in the area around Settle, Langcliffe and Stainforth, as well as to Malham. Much of the lime being produced in those kilns had to be destined for these local village manufacturing processes rather than the land.

DEW PONDS

One feature of limestone pastures, where surface water is scarce, is the dew pond, a shallow, saucer-shaped depression created to hold rain water for stock that had no access to water courses or natural ponds (9). Many dew ponds were constructed as part of the enclosure process and Marshall gave us an account of how they were traditionally constructed in Yorkshire, though when dew ponds were first used has not been determined.[16] The depression must first be dug out to the requisite size and depth, and should then be lined with a layer of quicklime 120 mm thick, followed by a layer of clay, topped with a layer of stones. These prevented damage by the trampling of livestock, the clay provided an impermeable surface, while the lime discouraged earthworm activity. Lime was also to be spread around the rim of the dew pond, again to prevent earthworms from opening up a series of conduits for water to percolate downwards. To build a dew pond with a diameter of 12 m, he said, needed 650 kg of lime. Marshall also described a new method of constructing dew ponds in the Lockton area north of Pickering. Here lime mortar lined the depression, rather than quicklime, laid 25 mm thick. Doing this required 3,240 kg of lime.

Interestingly, a dew pond on Malham Moor was excavated by archaeologists from Bradford University in 1996 and what they found more or less confirmed Marshall's specifications.[17]

Some evidence of a layer of quicklime was found here, though years of root penetration and weathering had disturbed or destroyed much of it. This dew pond seems to have had limestone burnt in situ, as evidenced by fragments of coal

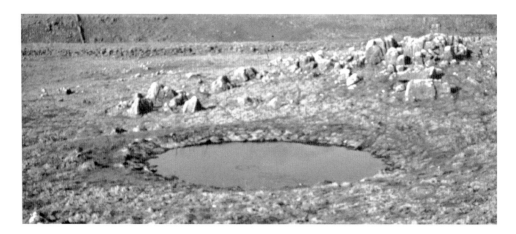

9. A dew pond on Malham Moor restored by the National Trust.

clinker. Its builders presumably found it easier to burn the stone there, thus giving the depression a fused and watertight seal, rather than bringing in burnt lime and trying to tamp it down on site. Providing this fused layer not only rendered the dew pond worm-proof but also prevented root penetration into the sub-soil. This is a useful little example of effective but simple technology being applied to solve a particular problem.

EXOTIC USES

In a somewhat gruesome vein, quicklime was widely used in the past for covering the dead when they needed to be disposed of rapidly, either during plagues or outbreaks of cattle murrain, known to us as foot and mouth disease. In the dreadful outbreak of foot and mouth that swept large parts of the Dales in 2001, farm buildings that had housed infected stock were cleansed using quicklime.

There was a now largely forgotten practice common to the western Dales and to Cumbria, known as 'need-fire', which was used to deal with foot and mouth epidemics. It was undertaken with a good deal of ceremony and according to strict rules. The fire had to be lit using dry sticks that had never been kept under cover and the fire had to have a 'greet reek' – a lot of smoke – so bracken or old roofing thatch were often added to the fire to stop it flaring. In addition, lime and whatever herbs were locally available were sprinkled on the fire to increase its effectiveness in purging 'all infections in the air'. When the fire was deemed to be ready, all the farm stock were driven through the smoke to drive out the infection. This may seem odd to us but such diseases were perceived to be the work of evil spirits and demons and, by driving the stock through the smoke, the animals were granted protection against malevolent spells.[18] It was surely better than burning carcasses on the massive piles we saw in 2001.

On a similar tack, lime has been utilised for centuries as a treatment – curative and preventative – for hypomagnesaemia, or staggers, in cattle. This common and often fatal disease is common at two points in the pastoral year. In late autumn, when the weather is often depressingly cool, wet and windy, cattle are especially susceptible if shelter is not at hand and if supplementary feed is not provided. Magnesium levels in the blood drop to critical levels. In spring, when stock are turned out to lush pastures after months indoors, excessive levels of potash or nitrogen in the soil can have a similar effect. The treatment now is a daily dose of magnesium salts, but in the past lime was seen as a preventative measure (top-dressing pastures with calcined magnesitic limestone) and as both preventative and curative (using a solution of calcium and magnesium salts, or calcium salts alone).

A rather bizarre image is conjured up when we recall the use of quicklime as a weapon of war. Historical chronicles relate the hurling of quicklime against the French in a battle in 1217 and one can well imagine a similar use being found for it in the constant battles and skirmishes that must have made peasant life intolerable at times in the Middle Ages.

Limestone, rather than burnt lime, was in use as roadstone from at least the eighteenth century. In the Skipton area, for example, a number of new roads were built between 1788 and 1793, 'the materials chiefly lime-stone, broken to about the size of an egg'.[19]

Perhaps we can draw this section to a close on a lighter note. Lime kilns are known to have been a place for young men and girls to gather and socialise on a cold evening, the heat given off from the kiln no doubt helping to make the event more pleasurable. They were also winter homes to gentlemen of the road. I have vivid memories from early childhood of being scared witless every time one tramp's hairy and wizened face appeared at our cottage window begging for food. It never occurred to me at the time, of course, but he was probably spending the night huddled inside the large Hoffmann kiln just across the field.

An interesting story was told to me by a former employee at Dowlow Lime Works near Buxton.[20] He first started work there on a cold and wet October morning and went inside the Hoffmann kiln there. To his amazement there were a dozen or so naked men laid out. He thought they were all dead but it turned out that the manager allowed them – tramps to a man – to sleep there as long as they cleared out first thing in the morning.

Let us finish with another recipe, this one for making paint for outdoor work. Thomas Brown, of Grassington, wrote it out in detail in his account book on 1 March 1798. He listed the ingredients and their cost:

Skimmed milk	2 quarts	3*d*
Fresh slacked lime	8 ounces	½*d*
Lineseed	6 ounces	3*d*
White burgundy pitch	2 ounces	2*d*
Spanish white	3 pounds	1*d*[21]

AGRICULTURAL LIME

As we saw in Chapter 1, by the late eighteenth century lime was being used in increasing amounts as an additive to soil, encouraged by the Board of Agriculture and those individuals bent on agricultural improvement. On some estates the application of lime was not just encouraged, it was mandatory, and the most common way of ensuring liming was practised was to enshrine the requirement within farm leases, either at renewal or when a lease was being offered to a new tenant.[22] At Flasby, in Malhamdale, for example, a lease from 1763 required each tenant to apply to all ploughed land '40 customary horse loads of unslecked (unslaked) lime upon an acre',[23] while the Westmorland estates of the Earl of Thanet inserted similar clauses into leases from at least 1767 to 1815.[24] Similar wording could be quoted from estates across the Dales during this long period.

Arthur Young, one of the most active and vociferous proponents of agricultural improvement, and soon to become Secretary to the Board of Agriculture, bought

or leased 2,220 ha of gritstone moorland between Greenhow and the Skipton-Harrogate road. This was – indeed still is – as bleak and inhospitable a tract of moorland as one could wish to find. But Young aimed to practise what he preached. One of his reasons for selecting this particular stretch of moor was the existence of a lime kiln and cheap limestone in a nearby quarry.[25] Unfortunately for his grand vision, he was soon called away to take up his duties in London and put the property back on the market.

Two decades earlier Young had undertaken an extended tour through the north country specifically to observe and record the state of agriculture. His grand journey took him from Sheffield all over the northern counties, visiting Swaledale and Wensleydale en route. He wrote in the account of his travels that in the north of England 'the dependence on lime is everywhere too great'[26] – too great in the sense of being very widespread rather than overdone. Lime was applied in particular to 'black moory soils' – peat – and 'lime, throughout most parts of the North, is what they principally depend on; the benefit they urge to be very great; and, considering they use only *stone* lime, it doubtless is so'.[27]

Marshall had a similar mission in life and he devoted six months in 1782 and nine in 1787 to surveying agriculture in the North Riding. He spent much of his time in the Vale of Pickering but he did visit Craven (Col. Pl. 1), which he found to be generally 'well cultivated and rich in soil, but not uniformly so: its surface being broken'.[28] Clearly it was the Craven Basin that was well cultivated and the Craven uplands – now the southern part of the Yorkshire Dales National Park – that were not. Like Young, he concluded that lime was extensively used in the North Riding: 'almost every principal farmer … burne his own lime'.[29] Note the use of the word 'principal': presumably small yeoman and tenant farmers used lime to a lesser extent. In his estimation, lime was being used to good effect, and on a variety of soil types.

It is strange that, twenty years later, Marshall was stating for the West Riding that 'lime husbandry was more practised some time past than at present'.[30] He was, however, quoting an informant here, so perhaps that information was not universally true across the county.

In 1799 Brown gave his opinions on the state of agriculture in the West Riding, which partly confirmed and partly contradicted those of Young and Marshall.[31] Lime was being applied to 'the greatest part of the land in cultivation' but 'the quantity laid on at any one time, is so inconsiderable, that … it can never produce the intended effect … We cannot refrain from expressing our dissatisfaction, both with the quantity applied, and the frequent repetition of this article'. He informed the reader that even small farmers were using lime but, because they had no notion of how lime worked in the soil, the rates of application were too small to be of any value, and the time between applications too short. He also felt too much lime was being ineffectively spread on fallow land and on land long in continuous cultivation, instead of being applied to pastures and to land being newly claimed from the waste. 'Could do better' would perhaps sum up his feelings about lime usage in the West Riding.

Brown provided us with some very detailed and useful information about the state of the land and the use of agricultural lime in the Dales.[32] As part of his survey, he journeyed from Grassington through Settle to Ingleton and then back through Skipton to Otley. Between Grassington and Settle most of the land was still 'uncultivated moors' but around Settle he came upon 'the finest grass' he had ever seen (10). Much of the higher land was still held in common and was thus unimproved. He observed that 'lime produces great advantages upon the moors' around Settle even though it was 'very sparingly applied'. On the way to Ingleton all the land was by then enclosed and parcelled up into fields of pasture 'of the richest character'. Judging by this he can only have travelled via Austwick, Clapham and Newby, an area that today consists of productive improved pasture and meadow. Brown then paid a visit to Masongill, west of Ingleton, to a farm run by Bryan Waller, who had 'lime applied to the pasture grass, and mixed with earth and cow dung'. This contrasts with a farm in Chapel le Dale, occupied by a Mr Ellershaw, because 'there is not much land limed in the neighbourhood, and what is done, is applied very sparingly' (11). I suppose we must conclude from this that Waller had been more receptive to, or aware of, new thinking in respect of lime usage. Around Skipton, Brown visited the estates of the Earl of Thanet, of Skipton Castle, who covenanted his tenants to 'fallow, lime, and manage in a husbandlike manner' the fields in their care. Finally, in Otley, he found a similar situation to Chapel le Dale with only 'some lime' being used.

Whether or not tenants willingly went to the expense of purchasing lime is a moot point. It may not have made any sense in tenants' pockets, especially if the cost of transporting lime from the nearest kiln could almost equal the purchase cost of the lime itself. If they could foresee no payback in terms of increased yields, why should they lime – unless their lease told them to? If they were required to build a kiln from scratch, how long did they expect the kiln to last, and how soon did they expect payback for this? It is apparent that in places tenants were so unconvinced of the benefits of liming that landowners used the threat of rent increases as a weapon to induce their tenants to lime the land.[33]

Further evidence of lime usage in Craven is provided by other contemporary travellers and surveyors. Reverend John Hutton travelled in the Settle and Ingleton area, mainly to view subterranean curiosities, but he did allude to lime usage in passing.[34] He wrote that 'many of the smaller farmers … earn their bread with carrying coals, during most part of the year from the pits at *Ingleton, Black Burton* … for fewel, and burning lime in order to manure their land'.[35] Whereas Brown had concentrated on landowning gentry and large yeoman farmers, Hutton gave us a keener insight into the smaller, near-subsistence farmers in the Dales. The fact that they were applying lime to their pastures as early as the 1770s might suggest that they did not need to be convinced of its value by people such as Brown, Young and Marshall. Whether they knew how lime worked is another matter altogether, though.

Speaking about the distant past, Riley remarked that in much of North Craven the burning of lime was a joint undertaking between landlord and tenant[36] – an issue we shall return to later.

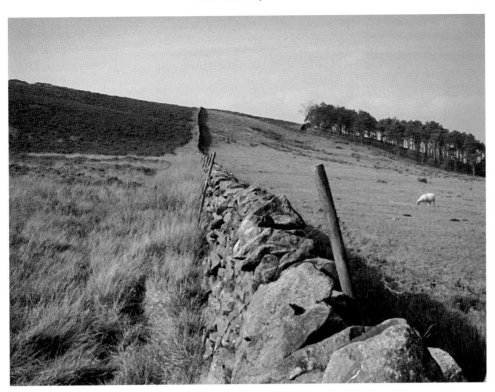

10. Above Settle: unimproved moorland adjacent to improved enclosures, with the 'finest grass' to be seen in the area.

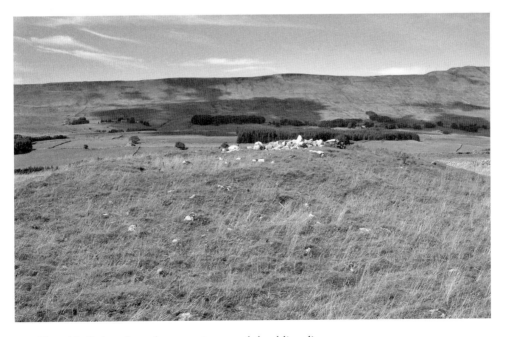

11. Chapel le Dale, where there was 'not much land limed'.

Anyone who has explored the Dales cannot fail to have noticed the often stark contrasts between land that has been improved at some point in the past and that which has had no treatment or which has been allowd to revert to its more natural state. The former is uniformly green or consists of flower-rich hay meadows enclosed within a network of dry stone walls and peppered with field barns (Col. Pl. 2); the latter has an unkempt air, with soft rush and coarse grasses dominating the sward (Col. Pl. 3).

LIME AND THE SOIL

Why, then, did agricultural reformers believe that lime can improve soils? What does lime actually do to the soil? The first point to stress is that lime in itself is not a fertiliser. It helps the soil in a number of ways, but it does not directly add fertility. What lime does do is act as a catalyst in making fertilisers more effective. If, for example, nitrogen-based fertilisers are regularly added to a soil, there is the possibility that acidity levels will rise and soil structure break down. By liming such a soil pH is raised again, thus reversing the negative effects of the nitrogen, and enabling the farmer to apply more nitrates than would otherwise be possible. Similarly, spreading large volumes of liquid slurry on grassland can lead to its becoming 'sewage sick', with the optimal rate of liming needing to be exactly doubled. The very fact of lime's ability to reduce acidity levels means that a given piece of land can support crops, including grass, better, and can boost yields by up to 30 per cent. It is this antidote function, this neutralising of acids and the consequent 'sweetening' of sour or 'hungry' soils, that farmers would emphasise most, if asked to list the benefits of liming. Even if the soils are not naturally clay-based – and many soils in the Dales are derived from acidic glacial deposits – the cool and moist climate and low evapotranspiration rates make many soils acidic: gleyed soils, acidic brown earths, and podsolised soils are all too common. Obviously most of the land in the Dales is under grass: if not treated with lime periodically, acidic soils will not bear nutrient-rich grass.

Lime achieves all this in clay soils by a process called flocculation. In heavy soils individual clay particles clump together, impeding the infiltration of water down through the soil to the bedrock below, and limiting the volume of oxygen that can penetrate the soil. This leaves the soil cold, damp and relatively lifeless. Flocculation breaks up the clumps, leaving more air pores within the soil, allowing water to freely drain and allowing warmth and oxygen in. Apart from making the soil more workable, if it needs to be ploughed and re-seeded, this also permits more bacterial and minibeast activity within the soil, and thus more recycling of nutrients within the soil, as well as easier root penetration through the soil. The end result is increased quality of plant growth and better quality of stock. In addition to all these benefits, lime is a direct source of nutrients for plant growth and in this sense it comes nearest to being a fertiliser. Plant growth draws calcium out of the soil, the rate of uptake depending on what is being grown. Calcium is

one of the elements vital to successful growth, so the net loss from uptake must be replenished by adding calcium to the soil, in other words by liming. Equally important is the propensity of lime to fix ammonia in the soil, and to help control the supply of potash and soda to the soil.

Our farming ancestors may not have understood all this. Indeed, according to Searle, many farmers even in the 1930s failed to appreciate the real purpose of liming, but its value really does go far beyond merely sweetening soupy soils.[37]

Let us now consider, for the Dales and adjacent areas, the methods of application proposed by the various improvers. They tended not to agree. We have seen already that Davy was of the firm opinion that lime should never be mixed with animal manure but J. M. Wilson strongly disagreed, asserting that Davy had been proved wrong in the intervening years.[38] Presumably the old saying 'lime on land without manure, will keep both land and farmer poor' may date from the early nineteenth century and it makes a lot more sense than the much older maxim 'lime enriches the fathers but impoverishes the sons', a belief derived from the one-time misconception that lime was a stand-alone fertiliser. Mind you, a contemporary of Wilson, a dictionary compiler named Morton, hung on to the view that lime should not be mixed with animal dung.[39] Vegetable compost and lime make a sound match, he wrote, 'lime (being) a very popular ingredient of compost heaps', but do not add it to animal manure, he warned. In fact he went as far as saying the value of such manure would be reduced were lime to be mixed in with it, because lime promotes decomposition which would lead to the 'destruction and loss of fertilising power' of the manure.

Nevertheless, certain landowners who in their own time were deemed to be progressive improvers did favour the mixing of lime with manure or compost. One such was George Crowe, of Kiplin Hall near Richmond, who stipulated that his tenants should 'lead lay and spread upon every acre … one and a half chaldrons of well burnt sod lime' along with compost and manure on 'new laid or meadow land'.[40] He went as far as to lay down detailed cropping and husbandry plans field by field for all farms on his extensive estate.

Yet, writing in 1926, F. E. Corrie was emphatic in his belief that lime should 'never be used with farmyard manure' because its valuable nitrogen content would be lost.[41]

There seems to have been a more general consensus that lime worked best on clay ground and moorland, on land being brought into cultivation for the first time, rather than on existing pastures. Let Lord Kames be the main spokesman: the effects of liming were most pronounced on what he called 'fresh soils', those previously unused.[42] On the other hand, he added that 'lime will never restore poor land; it will only make it still poorer', reinforcing the view that liming alone cannot rejuvenate overworked and exhausted soils. Brown considered that the expense of liming old soils and the labour involved 'may be considered as in a great measure lost'.[43] However, liming virgin soils could add to the value of such soils. As an example from the mid-nineteenth century in Weardale, one pasture increased in value more than fivefold after having been drained and limed,[44] and estate records throughout the Dales relate a similar story (12).

That really is the crux of the matter. To lime any land – old or new – in isolation was an utter waste of time and money. Liming was but one process of several and, even if proper procedures were followed, success depended on matching lime input to need. Lime requirement, the amount of lime needed to return a soil to optimum productivity, varied even within one tract of moorland or across one newly enclosed area. Micro-variations in rainfall and ground temperature, in frequency and strength of wind flow, in the details of relief and drainage, and in the amount of humic acid in the ground, can all affect lime requirement. Modern estimations of lime requirement vary. Searle suggested 2.5 tonnes per hectare for slightly acidic soils with double that for very acidic ones, whereas Gardner and Garner recommended 0.6 to 5.6 tonnes per hectare with 7.4 to 11.1 tonnes for more acidic soils.[45]

Rates of application in the past also varied considerably but, as will become clear, meaningful comparison is very hard to achieve. Fig. 1 summarises the recommendations of the main proponents of change in the period under review. The difficulty derives from a lack of precision in the units used. A bushel was a dry measure equivalent to eight gallons, though there was some regional variation from the standard Winchester bushel. A chalder was the equivalent of sixteen bolls, which sounds easy to compute until one realises that a boll ranged from two to six bushels across northern England alone. Thus, Young's one chalder could have

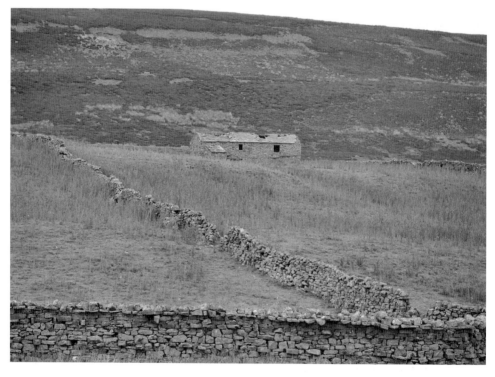

12. Inbye meadows at Brownsey House above Low Row in Swaledale, drained and limed to reclaim them from the waste, but now the preserve of the rabbit and the nettle.

Fig. I. Rates of lime application recommended by selected agricultural improvers.
(*Source: See under each improver's name in Notes and References*)

YEAR	IMPROVER	RECOMMENDED DOSAGE per acre
1712	Mortimer	150 bushels
1756	Hale	150 bushels
1757	Maxwell	50-70 bolls
1770	Young	1 chalder
1788 & 1794	Marshall	2-3 chalders
1799	Brown	60-70 bushels
1815	Lord Kames	60-80 Winchester bushels
1849	Wilson	150-240 bushels (arable)
"	"	Up to 400 bushels (soupy land)

been anything from thirty-two to ninety-six bushels. Even accepting variations due to local topographic or climatic detail, the range of measures recommended by the improvers must have left landowners and farmers somewhat bewildered.

The improvers either observed or recommended methods of applying lime to the land. All were in agreement that it was of no use whatsoever simply sprinkling lime onto moorland grasses. The land had to be treated in a systematic way so as to allow the lime to penetrate into the soil, to 'get to the seat of the trouble'.[46] It goes without saying that the detail of the methods used varied according to local best practice, which had been built up empirically over the years to fit in with local conditions and land use.

In Nidderdale, as across much of our area, crop farming still played an important part in the farming economy in the late eighteenth century. Here, deep ploughing – as deep as their simple ploughs would permit – preceded draining and liming with a year or two of root crops before the land was seeded for pasture. It was common practice across the Dales, in reclaiming moorland pastures, to begin by paring, or tirring, the existing vegetation, that is stripping or scraping it off and then leaving it to dry so it could be burnt as it lay. The potash derived from this was raked out so that the rain would wash it into the ground before lime was applied. Alternatively, moorland grasses and rushes were burnt as they stood, the ash being spread out and lime quickly sprinkled onto the ashes so that both potash and lime would be absorbed into the soil simultaneously. The new enclosures could then be planted or seeded and, given annual applications of lime, the soil would be sufficiently sweetened after three seasons to support a sward of good grass. Marshall described a third way of using lime to reclaim moorland. He observed lime being piled in heaps on the ground, then being mixed thoroughly with cut turves and peat (and sometimes dung) before being burnt.[47] Those who practised this method believed the lime would break down more readily. The Board of Agriculture advised a ratio of three parts turf to one part dung to one part lime.

It will be of value to our survey to briefly consider chronologically how the actual application of lime was undertaken during the period under review. As the chemistry of lime became more understood, and in the light of experimentation over the years, one might logically assume that the science of liming would have become more precise. Not so. Hale preferred using lime hot from the kiln, thus locally burnt, piling it in small heaps across the field being treated.[48] Early-sixteenth-century thinking, in the absence of scientific knowledge, accepted that it was the very heat of the lime that improved the soil. It is interesting, therefore, to see Hale still tending to this view. Each pile, he said, should be covered with soil and left for rain to slake the lime before it is raked across the pasture or ploughed in to an arable field. He considered early summer to be the optimum time for liming pasture, but had no real preference for when crop land could best benefit from liming.

Maxwell, writing at the same time as Hale, took the opposite view.[49] Lime, he wrote, should indeed be laid out in piles, but in October and not early summer. The piles should be allowed to stand and slake for forty-eight hours before being raked out. The pasture is then to be left idle for a full year, then ploughed up, left fallow for a second winter, ploughed again in spring and finally planted. He claimed that his technique would improve the quality of the grass to the extent that the capital costs incurred would be recouped from increased milk or meat yields with the first year of pasturage. He also advocated the use of marl with lime on soupy land, building up layers of lime and marl to give an improved soil for five times longer than by just liming.

In the West Riding, Brown recorded that some farmers collected lime from the kiln in summer but only applied it shortly before the next planting time, presumably late autumn, if he was referring to winter-sown crops.[50] Brown felt this was too late in the year, that the lime would not slake adequately, and he urged bringing the spreading forward to summer. Given the fact that few people fully understood how lime worked, this seems to have been very sound advice. He also believed lime had a greater effect on pasture than crop land, particularly if pasture was grown in rotation with crops. Brown described the experiments he had carried out on his own estate in Craven over a period of eighteen years to ascertain the most fruitful way of going about it, before he committed his ideas to print.

The advice from Lord Kames could not be more different.[51] Apply lime immediately before planting; do not let it stand on the land over winter before mixing it in: such was his counsel. Do not apply it in quicklime form, he continued, but in slaked form, because rain alone will not sufficiently reduce it.

Wilson provided us with an insight into what he deemed best practice.[52] Two methods were of equal value in his estimation. One involved piling the lime in small heaps about 6 m apart across the field in question, and covering them with soil.[53] They should then be left for the rain to slake the lime before raking the piles out and harrowing the whole field. The alternative was to create large piles at the edges of the field and to water the piles thoroughly one week before spreading. He did not explain the relative advantages of the two techniques, but he did stress the

need for both men and horses to wear protective clothing, a rare example indeed of health and safety awareness in that era.[54]

It should, perhaps, be noted in passing that burnt lime had its competitors as a soil improver in the later nineteenth century. Guano was being imported from Peru and Chile from the 1840s and was being advertised in the 1850s and 1860s by William Howson at Low Gill in Bentham and in Settle.[55] Chemical manures were available from the 1850s. A Mr Gibbins of Settle was acting as an agent for the sale of Kenworthy's phosphate of lime imported into the country, while nitrate of soda could also be purchased in the town.[56]

As regards the value of lime as a soil improver, let us leave the final word to one of the nineteenth century's foremost proponents of scientific farming, James Johnston: 'Lime is really indispensable to the fertility of the soil.' (13/14)[57]

Having considered how and why lime was used in agriculture, both in village industry and domestically, the next logical step is to examine the design and technology of lime kilns in use in the area in the pre-industrial period.

IF TIMES ARE BAD---
USE LIME
AND GIVE YOURSELF A CHANCE TO SUCCEED.

IF TIMES ARE GOOD---
USE MORE LIME
FOR OBVIOUS REASONS.

P. W. SPENCER LTD. ---- SKIPTON.

13. An advertisement in the *Craven Herald* from 2 August 1929 suggesting agricultural lime is essential.

14. 'Lime is indispensable to the fertility of the soil.' An advertisement in the *Craven Herald* from 1 July 1940, encouraging the use of lime on the land.

The Design and Technology of Pre-Industrial Lime Kilns

In a nutshell, the purpose of a lime kiln is to burn limestone rock in order to convert it into quicklime. It sounds simple and in a sense it is, yet operating a lime kiln successfully was both an art and a science. With modern hi-tech kilns the science aspect is dominant, but in pre-industrial kilns it is fair to describe kiln operators as 'artists': the technology at their disposal was primitive and, in any case, they probably would not have understood the science behind the technology. They did not need to, perhaps.

The actual process of converting limestone into lime is called calcination. This involves the reduction of the stone by thermal decomposition into two compounds, namely calcium oxide and carbon dioxide. The chemical formula for limestone is $CaCO_3$. When it is subjected to temperatures in excess of 800-900°C, the calcium oxide (CaO) is left as a residue after the carbon dioxide gas (CO_2) has been given off. Calcium oxide to the limeburner is quicklime. Once burnt, the limestone pieces packed into the kiln have lost much of their original weight. Approximately 56 per cent of limestone content by weight is calcium oxide; the remaining 44 per cent is carbon dioxide. It follows that quicklime is lighter than the original stone.

A popular misconception is that calcination converts rock into powder. This is simply not the case. What lies at the bottom of a kiln after the burning process is still recognisable as lumps of stone, albeit fused together and lighter in colour. Lump lime, incidentally, is what many farmers would call quicklime, because it comes out of the kiln in lump form. For agricultural purposes the quicklime has to be slaked. If this were done in a tank to make mortar, one-third of the weight of quicklime would be added as water, and then it would be mixed to form a slurry or paste. For application on the land, though, slaking was normally achieved by exposing quicklime to rain water or even damp air. Either way, slaked (or fallen or slack) lime, also called hydrated lime if dried out again, is created. Calcium oxide (CaO) added to water (H_2O) gives calcium hydroxide – $Ca(OH)_2$ – which is hydrated lime, or 'bagged lime' to the builder.

KILN FUELS

To achieve calcination you obviously need some sort of kiln, but before we consider the types of kiln that have been used in the Dales, it may be useful to

compare alternative fuels available to pre-industrial limeburners. Until transport systems began to improve, most limeburners would not have had the luxury of weighing up the virtues of one fuel against another. They would have utilised whatever was locally available. The smaller kilns generally produced lime for use on contiguous land: their lime was not being sold commercially so such kilns had no direct income, which meant costs had to be minimised. Fuel brought from afar incurred high transport costs, not to mention purchase costs, so if they could be eliminated by choosing a local fuel, that was well and good.

It has been suggested that wood is 'technically the ideal fuel' for burning lime,[1] and that it 'still produces some of the best quality limes' in developing countries.[2] Wood burns with a longer and lazier flame than many other fuels, while giving off steam as the moisture within it evaporates, and this steam helps to prevent overburn of the stone. Heat from the flame also tends to penetrate further into the stone to give a more even burn right through each piece of stone. Up to the medieval period the dominant fuel was indeed wood, except in upland areas where trees were scarce and too valuable to consume in this way. As early as the thirteenth century, though, fears were being expressed about the rate at which woodland was being destroyed to feed lime kilns, and it is perhaps fortunate that coal increasingly came into use in the following century.

In Yorkshire, as across much of upland Britain, peat, gorse and even bracken were collected for use in kilns. Peat was very labour intensive in the sense of having to cut the turves on the moor, cart them down, and then stack them to allow them to air-dry over the ensuing months. It also burnt with much more smoke than flame, so would have extended the time needed for calcination. Peat was not the ideal fuel. Despite its low level of efficiency, and the time and effort involved, peat had been used in kilns since time immemorial. In many isolated upland communities it was the only realistic source of fuel at hand. Gorse acts in very much the same way as wood, but bracken gives a very hot fire and burns with a 'surprising Force'.[3] There was certainly enough of it about in the Dales, on the lower and steeper fell sides, and it was a relatively easy task to scythe it, to bundle the fronds, and to carry them down to the kiln.

The use of culm as a fuel appears in many early accounts of lime burning, and herein lies a problem. Culm is given different meanings. To the miner or geologist it is either carbonaceous shale (shale with high carbon content) or anthracite coal that is fissile. In certain parts of the country the term culm was reserved for any kind of anthracite, while in others it referred to small or powdery coal. Whatever it actually was, its use in kilns stretches back to the medieval period, when it was generally known as sea-coal to distinguish it from charcoal. Huge quantities of coal were brought down from pits on hills such as Fountains Fell and Pen-y-ghent for consumption in lime kilns, but this was not true coal. Thin seams of carbonaceous shale between beds of sandstone have carbon content sufficient for combustion. Perhaps this was called culm in former times. This type of coal was much cheaper than 'real' coal and it tended to be the first choice for smaller, non-profit-making kilns, despite the problems it caused. Its small particles and

dust tended to clog up the spaces between the pieces of stone, thereby hampering air circulation and, as air flow was the key to a successful burn, this was rather a critical point. Yet it was considered perfectly acceptable for burning in lime kilns and estate accounts frequently refer to purchases of lime-coal destined for local lime kilns. Anthracite, on the other hand, came in larger pieces with little dust, but was much more expensive.

C. G. Stuart Menteath, a Scottish landowner and designer of a prize-winning kiln, experimented with fuel combinations and concluded that the ideal mix was coal and coke in equal proportions.[4] Coal can only reach maximum efficiency, he said, when the bitumen within it has been burnt off. When coal is burnt in a kiln it turns to coke anyway, and during that period of time it is not fully functioning as a fuel to burn the limestone. By adding coke at the start, he not only saved on costs of transporting fuel – coke being much lighter – but also allowed the coke to act directly in the calcining process. Output of burnt lime, he maintained, could thus be increased threefold in a given period of time by using a coal-coke mix.

Another factor that had to be taken into account was the carbon content of the limestone. Normally stone with a high content would combust more readily and therefore consume less fuel, so there was considerable variation in the quantity of fuel used per unit of stone from kiln to kiln. The ratio of coal to limestone varied from 1:1.5 to 1:6.[5] The basic problem with coal, however, was controlling the fire. Whereas wood gives a long and lazy flame, coal's flame is short and aggressive, and there was always the possibility that this could cause overburn and clinkering of the stone, making it virtually unsaleable. In terms of fuel efficiency, though, coal won hands down. To burn a cubic metre of lime in mid-nineteenth-century kilns required 1,420 kg of hardwood or 2,285 kg of peat, but only 230 kg of coal.[6]

One fact is very clear: that those estates with easy access to coal reserves were at a distinct financial advantage in producing lime, whether for mortar or for liming, and could thus produce more and benefit more in terms of outcomes. The Danby family's Swinton Park estate, to the west of Masham, was especially well placed. They worked their own collieries in Colsterdale producing both fire- and lime-coal. In 1696, for instance, hundreds of loads of lime-coal were delivered from their pits to the estate lime kiln for building and for liming, and daily colliery accounts have survived for the years 1723 to 1851, providing a wealth of detail on lime-coal sales and lime sales.[7]

CONTINUOUS OR INTERMITTENT?

There has been extended discussion among industrial archaeologists and historians about how early lime kilns were worked, and attempts have been made to agree a typology of kilns. It has to be said that, thus far, little agreement has been reached.[8] The single issue that continues to cause the most grief is whether a particular kiln ran on a continuously burning basis, with fresh stone and fuel being added to

the already burning kiln, or intermittently, with the whole mass being allowed to burn through and cool down before being emptied. It is very difficult to look at a kiln in the field now and declare with certainty how it operated. We shall return to this issue later.

Perhaps the other critical matter concerns nomenclature. Different writers in the past have used names for kiln types but it is not always possible to cross-reference from one part of the country to another: a name used for a kiln here may be used for a different type elsewhere. The Royal Commission on Historical Monuments for England (RCHME) Yorkshire Dales Project, carried out in the 1990s, listed a number of sites in my own field research area as 'Unknown medieval. Pye kiln.' Having inspected each of these sites, I cannot accept the nomen '*pye* kiln' for any of them. To me they are sod or *sow* kilns, which are much smaller in size and rounded, distinct from the rectangular pyes. Is this use of the word pye an error, or is it down to different meanings being given to the term?

The rest of this chapter will look at different types of kilns known to have been used in the Dales at various times in the past. No conscious attempt has been made to fit them into any formal classification system. Rather, the terminology used here reflects my interpretation of that chosen by historical sources.

CLAMP KILNS

The most basic design of kiln was the clamp (or sod or sow) kiln, in use at least from the medieval period and still operative in the twentieth century in some areas.[9] A shallow pit was dug out, the dimensions dependent on how much stone was to be burnt. It was either round or rectangular and had a funnelled opening on the downslope side. The pit was often dug as a platform into a slope or at the foot of a natural scree slope. This obviated the need for quarrying: stone could be added from the scree directly into the kiln. The pit was lined with stone and a small banking was built around the edge, leaving the funnelled hole for poking and extracting burnt lime. Alternate layers of stone and fuel were laid within the pit, building up to form a dome.

We have no evidence from the Dales regarding the height of clamps but evidence from elsewhere gives an idea of what might have been the case here. In the Lothians height varied between 2.15 to 2.50 m, while in Sussex the range was 2.45 to 3.10 m.[10] The whole would have been covered in turves or clay, to control the burn, which took anything from two days in small rounded clamps to ten days in the large rectangular clamps (or pyes) constructed in the Lothians.[11]

One clamp kiln in South Wales was excavated in 1980 and the conclusions drawn from that tie in with early accounts of clamp kilns, and with observations of such kilns in the Dales. This particular site was dated to the period 1770-1820 and it was thought to have been used for more than one firing episode.[12] (Some clamps may have been built for a one-off burn.) Almost all the sow kiln sites observed by this writer in the Dales had similar characteristics, including a

funnelled entrance into the pit. They must all have been intended for multiple firings. If not, why would there have been a need for an entrance? A single-use clamp would have been totally dismantled after use and would not need an entrance as such. In addition, the average width of the entrances (700 mm) was far too large to have only been for poking or for checking on the fire.

Small, sub-rounded clamp kilns such as the ones seen in the Dales can be referred to as *sow* kilns (15). In areas such as the limestone Dales, which abound in surface archaeology (small walling quarries and natural stone outcrops), it is easy for the untrained eye to miss a sow kiln site completely or to assume it is a prehistoric hut circle. Once the eye is attuned to sow kiln configuration, however, they do tend to jump out of the land surface. Without really making any determined effort to identify sow kilns, over 100 sites have been recorded and measured by this writer within the Dales. They are all remarkably similar in design and dimensions. Internal size in more than half of them ranges from 2.7 by 3.4 m, with only three above this range and only one below it. Depths vary from around 0.8 to 1.2 m.

Until recently lack of excavation precluded dating of any sites but archaeological investigation of a series of sow kilns in the southern Dales, led by this writer, and excavation of several along the easement of a gas pipeline by a commercial archaeological unit, also along the southern edge of the Dales, have provided a range of dates. Dates were obtained for five kilns from this writer's work within the Craven area of the Yorkshire Dales, and they ranged from 1440 to 1700

15. A sow or sod kiln, showing as a shallow banked hollow, near Askrigg in Wensleydale.

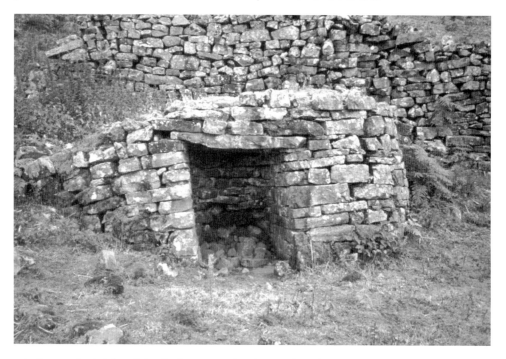

16. A stone-built kiln of simple design, on the slopes of Kisdon in Swaledale.

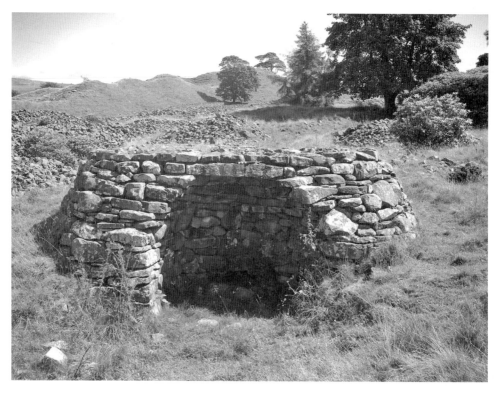

17. A simple kiln at Shedden Clough.

(Col. Pl. 4),[13] while dates have been proven for two kilns along the pipeline, both between about 1450 and 1650.[14] Excavation of the sow kiln at Halsteads, referred to earlier, came out much earlier: between 1202 and 1280.

At the other end of the dating scale, this type of kiln was still being used as late as the nineteenth century: it worked and was cheap to operate, so the technology endured. Two examples will illustrate the point. In 1782, one W. Stephenson was paid 13s 6d for 'burning sod kiln' on the Chaytor family's properties at Spennithorne in Wensleydale to produce agricultural lime.[15] In the following century the Garth family at Summer Lodge in Swaledale were engaged in widespread improvement of their pastures, carting in lime from various kilns, and also producing their own. Their daily memoranda books recorded, for example, their 'making sod lime kiln in Low Pasture' on 4 and 5 June 1851 and 'men leading coals and stones to sod kiln' on 12 July 1879.[16] Thus, simple sod kilns had a long pedigree.

Of true pye kilns – rectangular structures reaching up to 15 m in length, described by Leach in Derbyshire, Green around Walsall, and Skinner in the Lothians[17] – there is, for me at least, no convincing field evidence as yet in the Dales. Raistrick mentioned them for the Pennines[18], and the RCHME Yorkshire Dales Project lists many pye kiln sites but, as was said earlier, they are not pye kilns at all, but sow kilns. Such are the difficulties of terminology.

FIELD KILNS

Kilns built entirely of stone, as permanent structures, appeared in parts of the north in the seventeenth century but they were of a very simple design (16). In some the burnt lime was drawn directly from the bowl: there was no arch or draw hole opening as such. They tended to be very small in both height and internal diameter. Firing and drawing of these kilns were carried out on an intermittent basis, the firing process taking up to sixty hours to complete. A remarkable nucleation of such kilns can be found on Worsthorne Moor to the east of Burnley, where numerous kilns processed limestone rocks dug from glacial clays in Shedden Clough (17). Between Shedden and Skipton there were at least twenty localities where this was done and a further site, once part of the West Riding but now exiled to Lancashire, had a collection of thirteen such kilns, all out of use by the time of the first Ordnance Survey mapping in the early 1850s.[19] A kiln similar to the ones in the Shedden-Skipton area was illustrated in a remarkable collection of drawings first published in 1808.[20] William Pyne's etching of a lime kiln shows the simplicity of these early stone kilns, as well as the tools used by the limeburner (18). He captured the whole scene admirably, with billowing black smoke, the limeburner stoking the fire from the kiln top, and his assistant with an empty basket that would have held either stone or fuel.

It was the development of improved transport links – first canals and then railways – that brought an end to all these simple undertakings. Lime could now be brought in from more accessible and easily worked areas within the Dales, where it was produced in larger and more efficient stone-built kilns.

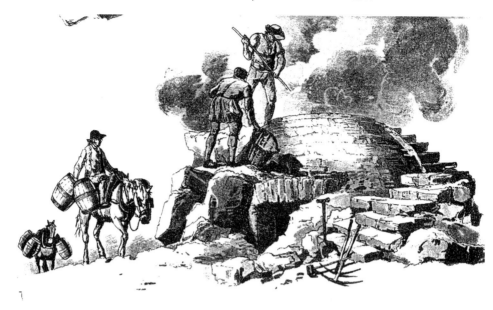

18. Etching of a lime kiln from the early nineteenth century, showing the limeburners' tools and acrid smoke billowing from the bowl top. (*Pyne, 1808*)

We are fortunate in having a wealth of detail concerning the more advanced field kilns that were developed from the eighteenth century onwards. The documentary record provides us with a series of time capsules of kiln design and technology over a 100-year period. There is also field evidence of surviving kilns in the Dales. In total, 1,184 field kilns have been surveyed on the ground within the Yorkshire Dales National Park and a further 290 around the margins of the Park.[21] Of the sites within the National Park, only twenty-eight have been afforded the protection of scheduling and listing.

The first detailed description of how a kiln should be built was provided by Robert Maxwell, secretary of the Edinburgh Society of Improvers, in 1757 (19a).[22] His ideas were based on designs submitted by landowners in both Scotland and England, and Clitheroe was suggested as the one place to observe best practice. An ideal kiln, Maxwell suggested, was about 6 m high and the bowl increased in diameter from bottom to top, being only about 1 m at the base, about 3 m at the midpoint and about 6 m at the top. Such a kiln was capable of discharging twenty bolls: by his calculation a boll was equivalent to 203 kg, so the total daily output was almost 4 tonnes, a not-inconsiderable quantity.

A kiln with the sort of profile that Maxwell was encouraging had one rather fundamental flaw. Heat obviously rises within a kiln and the general idea is that burnt stone was cooling at the base of the kiln with firing in the central portion. Rising heat from here dried out and warmed up fresh stone in the upper part. A kiln could only operate at maximum efficiency if that rising heat could indeed be utilised. In Maxwell's kilns much of the heat was lost through the top of the kiln, even if it was covered over with turves. There was nothing to hold the heat in and

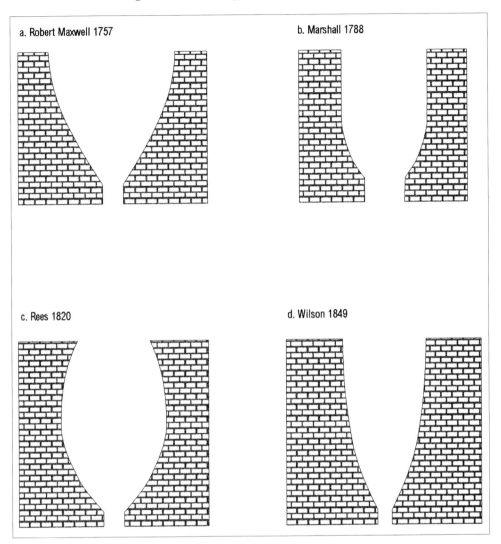

19. Cross-sections of lime kiln designs from the mid-eighteenth to the mid-nineteenth century.

the funnel shape tended to throw heat outwards and upwards, away from where it was needed.

Within just a few decades a new cross-sectional form had been introduced (19b).[23] The lower part of the bowl was still an inverted cone, but this became more elliptical halfway up and cylindrical in the uppermost part (Col. Pl. 5). The elliptical nature of the bowl had the effect of throwing the heat back into the burning material, rather than to the sides, but the cylindrical form at the top still allowed heat to escape. In these kilns the diameter of the bowl top should have been one and a half times smaller than the total height of the bowl. So, if we assume a kiln 6 m high, the top diameter had to be just over 4 m. Technology had thus moved on since Maxwell's day.

By early in the next century, the preferred design had been further modified. In

1820 Rees wrote, with reference to areas where 'the art of burning is practised with superior attention and correctness', that the shape of the bowl had been 'gradually changing from conical to elliptical' in recent years (19c).[24] Kilns were now shaped like an egg set on its narrower end. This design prevented heat from being lost at the kiln top because the upper, inward sloping face of the bowl directed the heat back into the middle. The direct knock-on effects of this were a saving in fuel consumption and a reduction in costs. The other, and no less important, advantage of being conical lay in the way stone would settle in the kiln. In old designs stone tended to get stuck to the sides of the bowl, but in a conical bowl gravity pulled the stone down as burnt lime was drawn out of the bottom. The result of this was a more even firing and a superior end product.

The agricultural improvers were not going to stop here and, in the 1820s, a competition was held and submissions were invited of the best way to construct a kiln so as to maximise the output of lime while minimising fuel consumption. The conquering hero was C. G. Stuart Menteath, whose design was oval: 600 mm wide at the bottom, 1.5 m in the middle, narrowing again at the top, which was capped with a conical cover. He maintained that daily output could be increased by up to 25 per cent compared with older types of kiln.[25] He also claimed that his kiln could operate even in winter because the fire could be controlled – damped down or boosted – more readily.

Strange it may seem, then, that Wilson's compendium, published in 1849, described kilns in the form of an inverted cone, the diameter at the top being equal to the height of the bowl (3.7–4.6 m) with the internal diameter at the base just less than 1 m (19d).[26] A cap to the bowl was not necessary, he felt, as enough heat would be generated within the kiln without wasting fuel.

A few years later another compendium had reversed the advice: an inverted cone is 'not considered by practical limeburners to be equal to the elliptical, or ovoid' kiln.[27]

To what extent the new technologies and designs readily caught on is impossible to quantify. No doubt the furthest-seeing and more prosperous landowners took on board the new ideas when the time came to rebuild a kiln or erect a new one. They had the financial means and, equally important, they had access to the knowledge. The small-scale farmer in remote and inward-looking areas of the Dales probably had neither. It is more likely that they continued to use whatever design of kiln had been erected by their forbears. If they were only burning lime seasonally for their own use, there was no incentive to invest in new and expensive technology. If this attitude did prevail in the uplands, it may help to explain why, as late as 1878, it was written that the old inverted cone design had only 'recently' been abandoned.[28]

THE STRUCTURE OF A KILN

A large proportion of the kilns constructed in the period under review shared the same basic principles of design and build, though the detail varied enormously. If

one were to scrutinise a field kiln (that is, one producing lime for local agricultural use), or an early commercial, or selling, kiln, the immediate impression would be of a rather squat stone structure standing some 6 m high (20). What one would be looking at is the outer shell of the kiln, dry-stone walling that gave the structure stability and, in many cases, an aesthetic finish. In later kilns the stonework may have been semi-dressed; in earlier and more basic kilns the stone was coursed in horizontal layers but not dressed. Indeed, many isolated field kilns were crude in the extreme (21).

The kiln was generally built into a hollow carved out of the hillside, or was free-standing with a ramp of earth and rock piled behind the kiln. In the centre of the kiln was the bowl, or pot, of the shapes described earlier (22). In field kilns the bowl was normally lined with native stone, dominantly heat-resistant sandstone, and few kilns incurred the luxury of a firebrick lining. This was too expensive, often hard to come by, and simply unjustifiable in a kiln that was only fired spasmodically. Even if a firebrick lining were used, there was no need to line the bowl from top to bottom. The lower part was the cooling zone, the top part the drying and preheating zone, and neither of these reached the high temperatures of the central, calcining zone. Only this section really needed firebrick. It is all too easy now to look down into the bowl of a kiln, with only the very top visible, and conclude that it was not lined. This would be a premature conclusion: who knows what might be hidden by rubble infill?

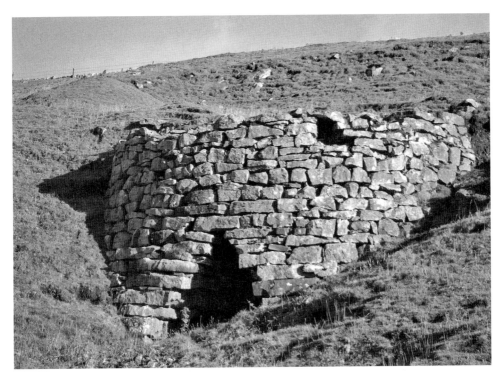

20. A squat, rounded and coursed field kiln above Kettlewell in Wharfedale.

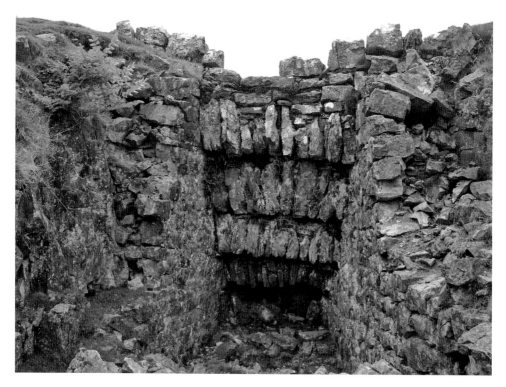

21. A crude square-fronted field kiln built into a natural rock crevice in Lodge Shaw Cow Pasture near Ribblehead.

In a well-constructed kiln the inner shell was completely separate from the outer casing. One such kiln near Pen-y-ghent comes to mind. The outer shell is squared and part of the frontage has collapsed to expose the rounded inner shell. Between the two shells is a space that varies in width from top to bottom. This void would have been packed with rubble and other material such as sand or ashes, acting as an insulator to minimise heat loss through the masonry. In essence a kiln was built like a dry-stone wall with two faces of coursed stone and infill. As with a wall, the stone shells had to be tied in to each other to give added strength. Bearing in mind the dominant weather in the Dales, there was the ever-present inevitability of rain water seeping through the outer masonry to the infill. It does not take much to visualise a disastrous outcome. The high temperatures within the bowl convert this water in the kiln fabric to steam: at best the masonry may well crack, weakening the kiln; at worst an explosion within the kiln could occur. To minimise the potential for partial collapse, the void had to be well packed and the two shells tied together by using 'throughs', large, flat slabs of stone stretching from outer shell to inner shell. Again, in more substantial kilns the facing stone was often bound together using lime mortar.

Apparently, the shape of the outer shell was significant in this respect. It was found 'by experience, in some of the northern districts, that lime-kilns are

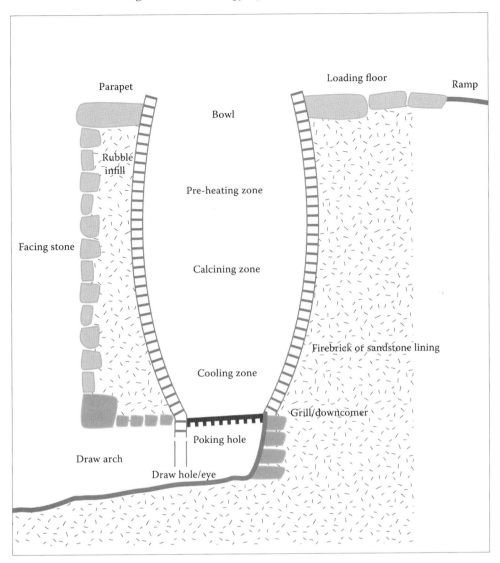

22. Stylised section through a field kiln showing its component parts.

rendered much less liable to crack and burst by having the outside walls carried up in a square manner, than on the usual circular plan' (Col. Pl. 6).[29] Within the old county of Westmorland the vast majority of kilns are squared, but within the Dales there is much more variety with 54 per cent of all surviving kilns having a rounded form.[30]

On top of the kiln was the bowl rim or parapet. For ease of filling, this was usually level with the top of the hollow carved out of the hillside, or was accessed by a ramp. The vast majority of non-industrial kilns had only one bowl, and in very few cases was there any protection for the limeburners. A wall or fence around the top would have been in the way and, no doubt, would have been viewed as an unnecessary bit of nannying.

At the bottom of the kiln front was the draw arch or draw hole opening. In simple kilns this was the merest of openings in the kiln face, but in more substantial kilns it could take the form of a series of recessed arches with carefully cut voussoirs, each held together by a keystone. At the inner end of the opening was the actual draw hole, or eye, the aperture through which burnt lime was drawn. The arched or vaulted draw arch allowed the lime drawers to bag or barrel the lime in the dry and thus avoid the possibility of it slaking immediately in the rain. Across the Dales most kilns had one draw arch, but in the northern dales there is a nucleation of double-arched kilns (Col. Pl. 7).[31] If a kiln had a larger, oval-shaped bowl rather than a round bowl, there would often be two eyes to permit more efficient drawing of the lime.

In better kilns the eye had cast iron doors set on cast iron fixings, to shut the bowl off to prevent unregulated ingress of cold air. In simpler kilns this must have been achieved by cruder means, possibly using a movable screen. Better kilns also had a poking hole above the draw hole. There was a tendency for the burning stone to fuse together in large clumps, which became stuck in the bowl, did not fall to the bottom, did not fire adequately and, in short, could prevent the kiln operating as desired. This clumping was known as 'scaffolding' and it could be avoided by ramming a rod through the poking hole to break up any incipient clumps. In smaller kilns this was achieved by forcing a long rod into the burning mass from the kiln top, an effective if dangerous method of keeping the fire loose.

Some commercially-operated kilns had a lime shed attached, either extended out from the kiln front with wing walls and a roof or tagged onto the kiln side. The use of a shed provided more dry working space for the men, allowed burnt lime to be stored in the dry, and enabled carts to be backed in and loaded with loose lime in the dry. Lime sheds were eminently sensible but the cost could only be justified if the kiln was a money-making venture.

It is not uncommon to find recesses, or niches, in the walls of the draw-hole opening. We can only conjecture what they were for, but the most likely possibility is that they held a tallow candle or a carbide lamp to give some light on dark and miserable days.

The arrangement at the bottom of the bowl varied from kiln to kiln. Unfortunately, field evidence of this in the Dales is scant because most of the bowls have either been infilled, as a personal little landfill site, or have collapsed downwards. Many had a cast iron grid or grate, sometimes known as a 'brander', built into the lining of the bowl. Thick bars were set across the lowest part of the bowl with the ends tied in to the masonry and supporting less robust bars on which the initial fire was set. This arrangement would stop burnt lime clogging up the draw hole. An alternative arrangement was to use a large stone cut into a wedge shape, technically known as a downcomer, or smaller stones built up to form a wedge, historically referred to as a 'feather' or a 'horse'. The purpose of the downcomer was twofold: it prevented the whole burning mass collapsing to the bottom and scaffolding, and it funnelled the burnt lime towards the draw hole ready for drawing. In a single-eye kiln the horse would guide the lime to the front

of the bowl, in a double-eye kiln to whichever draw hole was to be used. There must have been some sort of control mechanism for this. Hale described the use of a horse but said nothing about control methods.[32]

One large commercially operated kiln, near Masham, had two oval bowls, each with two draw holes, and this writer led the excavation of one of the bowls. At its base the bowl was divided into two by a low firebrick-built wall with parallel cast iron bars still lying across the bowl and resting on the dividing wall and on a ledge above each draw hole (Col. Pl. 8). The fire would have been set on these bars – acting like a grate – and they would have prevented burnt lime clumping at the bottom of the bowl. What was particularly of interest in the bowl was its floor: it was composed of softwood planks with absolutely no signs of scorching. This confirms beyond doubt that temperatures at the base of the bowl were not extreme.

FIRING A LIME KILN

To work a lime kiln the operator must first acquire and bring to the kiln top both stone and fuel. The majority of kilns in the Dales – but by no means all – had an adequate source of stone nearby, either a quarry, a scattering of what can only be called surface scratchings, or a substantial scree slope. Field surveying has shown that one in five kilns within the Dales are associated neither with an adjacent quarry nor with limestone geology.[33] In these cases the unburnt stone was led to a kiln sited at the fuel supply or at the point of end use of the lime. Marshall wrote that the breaking of the stone, to the size of 'two hands', was the preserve of women and boys, using hammers or mauls; Evans quoted a letter to the 3rd Duke of Richmond in 1786 stating that the stone should be broken down to a maximum of 1.4 kg; Mortimer believed that the best lime came from the hardest stone. We have a good deal of evidence to confirm that firing a kiln was slowly becoming more of a science than the hit and miss affair it had long been.[34]

There are many references in the historical record describing how a kiln should be filled up and fired,[35] but the most local source to come to light is a letter sent from Robert Lucock to Andrew Huddleston of Hutton in 1845:

My Dear Sir,

As you are about to erect a Lime Kiln on the principle of those in the South a plan of which I sent you sometime since I have much pleasure in sending you a few hints as to its management. As the Stone is burnt into lime in the neck of the kiln, I see no use in lining any other, but that part with fire bricks. In lighting we commence by filling the kiln with broken stones until they reach the bottom of the neck, then we place on plenty of heavy logs of wood and coal, a barrowfull of stones, then more fuel, and more stones, until it reaches the top of the neck. If this work is commenced in the morning, there should be sufficient stones drawn out in the evening at the bottom of

the kiln to lower the fire two thirds of the way down the neck, which should be filled again with stones and fuel, this process to continue night and morning. [36]

Lucock went on to explain how to slow the fire down on Sundays when the kiln was unattended, by throwing on very small stone or 'rubbish' [presumably chippings and dust] and he declared that 'from the system I have adopted, they [the results] have exceeded my expectations'.

It is pertinent to ask how limeburners knew when the lime was ready to be drawn. In those days this had to be art rather than science because they relied on experience and intuition. The specific time span mentioned in Lucock's letter is too rigid because a range of factors influenced the time needed to achieve calcination. The weather was half a dozen factors in itself and could make an enormous difference: wet or dry; hot or cold; sunny or cloudy; frosty or snow covered; calm or blowing a gale; wind blowing towards the draw hole opening or onto the kiln top. Only practical experience could enable a limeburner to get his head around that lot. Inclement weather led to one lime business breaching wartime blackout regulations in 1943. One of its kilns was seen glowing red at night. In mitigation, the manager pleaded that a severe overnight gale had caused 5.5 m^3 of stone in the kiln to burn through in forty-eight hours instead of the usual fourteen days. [37]

So, how did the limeburner know? He could perhaps have looked at the colour of the flame. Darker and duller reds indicate temperatures rising to 700°C, but brighter reds and oranges signified much higher temperatures. This would not tell him when calcination was complete but at least it would give him an idea of how the fire was progressing.

There is a story – apocryphal or otherwise – which neatly sums up how a limeburner went about his daily business. One particular limeburner was asked by a passing traveller, 'How much lime does that kiln hold?'

'Oh, I don't know. I just keep putting it in and them fellers keep pulling it out at the bottom.'

'Well, how much coal is needed to produce one ton of lime, then?'

'Sure, I don't know that either. I don't go by the coal. I go by the fire.'

The traveller gave up. [38]

Another anecdotal hint is a quote from a limeburner in 1848 concerning the precision needed to fill a kiln: 'I was put on the kilnhead, enveloped in smoke, to throw in stones and coals'. [39] Art... or science?

Let us return to the question of continuous or intermittent. If field kilns were emptied completely after each firing, a prodigious quantity of fuel would have been required on the next firing to force water out of the packed stone, to heat up the stone and fuel, to dry out and warm up the kiln masonry, and to heat the air within the bowl. It would not have been cost-effective to burn on an intermittent basis. Yet could demand for agricultural lime have maintained production continuously for a whole season? The answer lies somewhere in between. Field kilns were fired up and worked to run continuously for only a few weeks, and then shut down again until needed again. One observant

traveller provided us with an inkling – in 1783 Bray described continuous usage:

> The stone of the hills about Maum [Malham] is burnt into lime ... It takes up a week in burning, and when it begins to be calcined, the lowest stratum is drawn out at the mouth, and more stone and coal put in at the top. [40]

Many of the more remote kilns, on the moorland edge, had a very short life indeed. They were erected specifically for the initial improvement of formerly 'waste' land (that is, land not productively used) and may never have been used again. In other instances, kilns were only fired up for a short period of time to top-dress existing pastures. The long-held notion that kilns were in use continuously for months – or even years – has to be discarded. One only has to look at the small size of many quarry workings near remote kilns to realise that the amount of stone removed could not have fed more than a limited number of individual firing events.

TRANSPORTING LIME

In a sense the real problems began once the lime had been drawn from the kiln. Quicklime is notoriously unstable and, if exposed to moisture, would spontaneously slake. In the words of Hale, 'on very wet days lime has sometimes fired the sacks on the horse's back, and the carriages it is taken in from the kiln'. [41] Lime was not normally sold at the kiln as slaked (or fallen) lime, but as unslaked (or unfallen) quicklime. The overwhelming majority of extant documentary records note purchases of lime in terms of so many loads of lime, or simply as lime purchased or led. In a few cases, however, they are more specific. In 1733 Robert and James Rucroft took up, or renewed, the lease of South Leighton Farm on the Swinton Park Estate and were required to spread 'well burnt and unfallen lime'. [42] The preferred practice here was to allow the lime to slowly air-slake, in other words to let atmospheric moisture break down the lime for release into the soil. The Garth memoranda books suggest that this family was of a different opinion: on 15 May 1815 work involved 'leading lime to pasture – low heap most of it fallen', while on 30 June a farm worker had 'led lime all fallen 13 loads'. [43] Here, the lime was slaked prior to carting it to the fields. Later that century the Morleys of Marrick Park Estate in Swaledale took the same view as the Garths. Their accounts note purchases of '3 load of fallen lime' on 4 and 7 July 1870. [44] It was basically a matter of personal practice and belief.

Various means were used to distribute lime from kilns. If it were only going from kiln to nearby field, a wooden sled or a crude, two-wheeled tumbrel cart was more than adequate but, for longer distances, something more substantial was needed. Sturdy box carts were in use, but only where the road network made wheeled vehicles possible. Oftentimes it was farmers who came with their own carts early

23. Mary Alice Hartley, known as Ailse O'Fussers, the last of the limegal drivers on the lime and coal circuit on the Lancashire moors. She lived in a small farm above Shawforth between Bacup and Rochdale, and died in 1879 or 1880. She is pictured here with her favourite animal of her later years, Jerry the donkey. (*Rochdale MBC*)

in the morning to collect lime, if they had no kiln of their own. It was cheaper in money terms to do this than to pay a premium to have the lime delivered. In areas like the Dales, where weather and topography militated against the use of carts, the main mode of conveyance was the packhorse (23). In the Dales and Pennine moors immediately to the south there was a veritable network of packhorse routes and a well-developed triangular trade. Lime came down from Lothersdale on the southern edge of the Dales to the growing urban areas of the West Riding, and corn was then carried across the moors to the Burnley area, from where coal was ferried back to Lothersdale to feed the kilns and complete the triangle. Teams of eighteen to twenty Galloway ponies, called 'lime-gals', carried up to 104 kg each in a sack strapped onto a well padded, wooden saddle.[45] In the 1820s, no less than twelve packhorse owners lived in the area around Cliviger, Worsthorne and Briercliffe, in north-east Lancashire, operating between them about 180 ponies. It was big business indeed. Other teams of lime-gals were based in the Kendal area.

Pyne's etchings of a lime kiln illustrate two ways of carrying lime by pony (24). One etching shows two wicker baskets straddling the pony. In the north Pennines these were known as 'coops'.[46] The other method shown is wooden crates.

Because land transport was so slow and subject to the vagaries of the weather, canals were seen as a more attractive proposition from the eighteenth century onwards. Quite a number of northern canals were built with lime traffic as a projected major source of income,[47] while in 1780 plans were proposed for cutting

24. Pack ponies transporting lime in wooden crates and wicker baskets. (*Pyne, 1808*)

a 24 km-long canal from Parkfoot Bridge, near Burton in Lonsdale, to Langcliffe Place, north of Settle.[48] In the original plans prospective investors were enticed with potential revenue from carrying lime from Giggleswick Scar and between Austwick and Clapham, and lime with blue slate from Ingleton. Needless to say, the canal was never built. A promotional pamphlet for the proposed Lancaster-to-Kendal canal suggested that a saving on liming of £8 per hectare could be made if the lime were to be transported by canal rather than by packhorse.[49]

Within the Dales seven canal schemes were put forward, between 1760 and 1791, all of which stressed the potential value of lime as a profitable cargo. All but two came to fruition and all carried large volumes of lime or raw limestone.[50]

4

Industrial Growth

From around 1750 Britain underwent profound economic change that brought about a major transformation of the country's demographic structure. Increasing levels of industrialisation made urbanisation a fact of life. The growing textile industry – cotton in Lancashire, cotton and wool in the West Riding, iron and steel and engineering in the north-east – created an insatiable demand for labour, and drew people en masse from rural areas. Small settlements like Bradford, Leeds and Burnley saw rapid growth in size and population. The new textile industries attracted subsidiary trades like dyeing, bleaching, and the manufacture of chemicals and paper. The new cities needed building materials and city folk needed food – bread, potatoes, meat and sugar. Every single one of these changes required lime.

By the 1840s British farming was enjoying prosperity rarely achieved either before or since, aided by the expanding urban markets and by the spread of the railway network. The 'high farming' movement began at the same time, following the publication of James Caird's ideas on the scientific management of farming.[1] He built on the foundations of the agricultural improvers that we came across earlier, and after he was elected to Parliament in 1857, he devoted his life to agricultural change, propounding the merits of drainage, soil improvement and mechanisation.

For the nascent lime industry this was all manna from heaven, and those who operated or owned kilns could look to the future with cheerful and secure optimism (25/26, Col. Pl. 9/10). Those who had the wherewithal and the vision to exploit these new opportunities began to seek out new resources of stone, began to adopt or even develop new technologies, and began to transform the industry in terms of ownership. Individual leasing and working of kilns on a small scale, and often on a part-time basis, rapidly gave way to the establishment of partnerships and soon after that the formation of limited companies, which operated on a grand scale, as demand consistently exceeded supply. The years from the 1850s to the 1910s witnessed spectacular physical growth and technological development, the like of which had not been seen before.

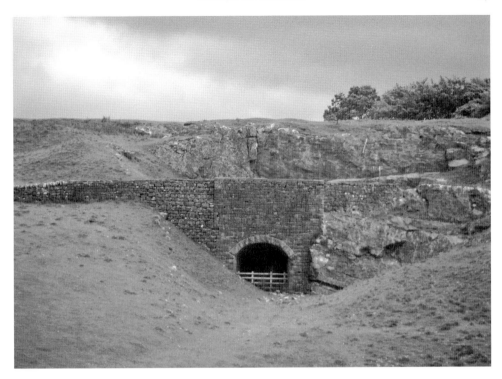

25. A substantial mid-nineteenth-century selling kiln in Scosthrop parish in Malhamdale.

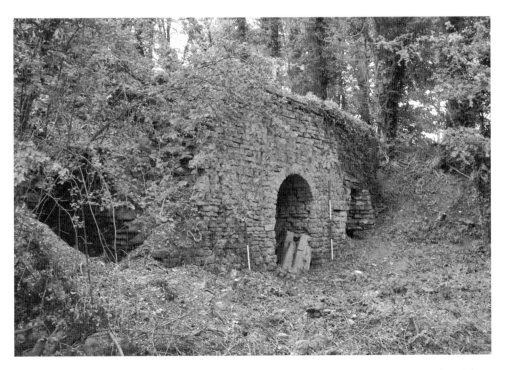

26. A commercial kiln with two bowls and three draw arches between Masham and Bedale in Lower Wensleydale.

Fig. II. List of limestone quarries in commercial operation in the Dales and Craven in the late nineteenth century. (*Source: List of quarries [under the Quarries Act] in the United Kingdom etc., HMSO*)

QUARRY	PARISH	OWNER	MAX. NO. EMPLOYED

Recorded in the annual List of Quarries 1895-1900

QUARRY	PARISH	OWNER	MAX. NO. EMPLOYED
Broughton Fields	Broughton	A. C. Tempest	3
Craven	Langcliffe	Craven Lime Co.	110
Dowshaw	Lothersdale	R. Hartley	2
Foredale	Horton	Ribblesdale Lime & Flag. Co.	64
Frostrow Fell	Sedbergh	W. C. Strickland	2
Giggleswick	Giggleswick	P. W. Spencer Ltd	18
Hambleton	Bolton Abbey	J. Green & Son	80
Harmby	Harmby	Harmby Lime Co.	–
Haw Bank Rock	Skipton	Leeds & Liverpool Canal Co.	101
Horton	Horton in R'dale	John Delaney Ltd	114
Howshaw	Lothersdale	R. Whittam	8
Hush	Redmire	C. Hird	2
Kirksyke	Airton	J. H. Metcalfe	4
Lane Head	Lothersdale	J. Shuttleworth	1
Mealbank	Ingleton	Clark & Wilson (Craven Lime Co.)	76
Raygill	Lothersdale	P. W. Spencer Ltd	43
Ribblehead	Ingleton	Craven Lime Co.	8
Shawl	Leyburn	W. Styan, then Ord & Maddison	7
Swinden	Linton	L. Horner	2
Thornton Rock	Thornton in Craven	P. W. Spencer Ltd	33

Defunct by 1895 according to the lists

QUARRY	PARISH	OWNER	MAX. NO. EMPLOYED
Colt Park	Ingleton	Craven Lime Co.	–
Draughton Rock	Draughton	Lamberts	–
East Marton	East Marton	–	–
Massa Flatts	Skipton	Mercer Flatts Lime Co.	–
North Ribblesdale	Stainforth	T. Murgatroyd, then W. G. Perfect	–
Storrs	Ingleton	H. Robinson, then R. Atkinson	–
Wheelam Rock	Draughton	–	–

This trend could be observed wherever high-quality limestone outcropped, particularly if canal or rail access was available, but certain parts of the country were pre-eminent in the industrial-scale growth of limestone extraction and lime burning. The White Peak of Derbyshire is an obvious example, as are the northern fringe of the South Wales coalfield and the limestone belt that stretches to the south-west from Doncaster. But in terms of number of quarries and scale of entrepreneurial production, the Clitheroe area and the Dales arguably sit near the top of the list, as we shall see in this and subsequent chapters. The sheer number of limestone quarries in the Dales (Fig. II) put the industry on an equal footing in the local economy with agriculture and textiles.[2] The lime and limestone industries brought jobs and prosperity to the Dales (Fig. III) but not everyone welcomed their impact, and environmental concerns were being voiced even before the end of the nineteenth century.

Brown, writing about the Settle area in 1896, wrote 'Unless (which heaven forbid!) commercial enterprise should some day work upon Castlebergh some such vandalism as it has wrought upon the once beautiful Winskill Scar. Think of such beauty being burnt into lime!'[3] He obviously did not know that this limestone knoll, forming the backdrop to Settle, had once supported a lime kiln and had been extensively eaten into by quarrying to supply the kiln.

Writing shortly before Brown, an observer marvelled at the natural beauty of a deep, wooded gill to the north of Harmby near Leyburn, but he could not resist saying it had been 'shorn of its picturesqueness by quarrying operations carried on in the rock for lime burning'.[4]

Yet another local writer had equal misgivings about the destruction wrought by quarrying, but also had the grace to accept the need for it:

> One may perhaps be permitted to hope that the structures which deface our valleys are as efficient for their work as they are hideous in appearance ... does such knowledge of the great and beneficent uses of lime and limestone make us more resigned to the defacement of our beautiful valleys and scars?[5]

COUNT RUMFORD

As the nineteenth century progressed, the ever-growing demand for lime could not be met by existing kilns. They were too small and had too many disadvantages, not least in having a thermal efficiency of only 20-30 per cent, compared to modern kilns' 80-85 per cent, in being wasteful of fuel, especially if operated on an intermittent basis, and in their variable quality – the fuel residue was inevitably mixed with the burnt lime. New kiln technology was needed and men of inventive genius came to the fore to provide it. Perhaps the first to come up with a startlingly new idea was Benjamin Thompson, who was born in pre-Independence America and worked in England, France and Germany. In 1814 he was elevated to the peerage as Count Rumford, a name by which he is better known. He first

Fig. III. Craven: Limeburners and quarrymen listed in census returns

RETURN	PARISH	NAME OF WORKER	OCCUPATION
1841 census	Ingleton	Richard Brown	limeburner
1851 census	Ingleton	John Darwen	limeburner
"	Austwick	Wm. Thistlethwaite	quarryman
"	"	Robert Mason	lime burner
"	Settle (Lodge)	Stephen Parker	farmer & limeburner
1861 census	Settle	Robert Bullock	borer at lime kiln
"	"	John Ball	limeworks labourer
"	"	John Moorby	labourer at lime kilns
"	"	Roger Preston	labourer at lime works
"	Giggleswick	Thomas Taylor	labourer at lime kiln
"	"	Michael Wilson	lime/timber merchant
1871 census	Settle	Thomas Ralph	lime kiln labourer
"	"	John Ralph	lime kiln labourer
"	"	Matthew Ralph	lime kiln labourer
"	"	Robert Ralph	lime kiln labourer
"	Giggleswick	John Clark	farmer & lime burner
"	"	George Clark	lime burner's clerk
"	"	Michael Wilson	lime merchant
"	"	Robert Charnley	lime & coal agent
"	"	Joseph Taylor	quarryman
"	"	John Young	quarryman
"	"	Thomas Hartley	quarryman
"	"	Thomas Taylor	quarryman
"	"	Edward Joss	quarryman
"	"	George Potter	quarryman
"	"	–	8 lime works labourers
1881 census	Giggleswick	James Wiseman	labourer at lime works
"	"	Joseph Smith	labourer at lime works
"	"	John Morphet	labourer at lime works
"	"	Miles Knowles	labourer at lime works
"	"	John Jackman	labourer at lime works
"	"	Henry Hawkins	quarryman
"	"	John Taylor	lime and coal agent
"	Stackhouse	John Davy	labourer at lime kilns
"	"	John Fox	quarryman
"	Langcliffe	George Yeomans	foreman at lime works
"	"	Richard Johnson	packer at lime works
"	"	William Syers	packer at lime works
"	"	William Whaites	lime drawer
"	"	–	8 quarrymen

RETURN	PARISH	NAME OF WORKER	OCCUPATION
1881 census	Horton	Walter Bain	quarryman
"	"	John Capstick	quarry labourer
"	"	Septimus Capstick	quarry labourer
"	"	Octavus Capstick	quarry labourer
"	"	Henry Towler	quarry labourer
1891 census	Settle	–	4 labourers at lime works
"	"	–	16 quarrymen or labourers
"	"	John Stephenson	quarry owner's clerk
"	"	Robert Clark	quarry manager
"	"	John Delaney	quarry owner & coal merchant
"	Giggleswick	George Wilson	quarryman
"	"	Edward Lester	quarryman
"	"	Patrick Cox	quarry labourer
"	"	Joseph Knowles	quarry labourer
"	"	Edwin Longmire	labourer at lime works
"	"	Joseph Smith	limeburner
"	"	Thomas Chester	limeburner
"	"	John Jackman	lime drawer
"	"	John Taylor	lime works manager
"	Langcliffe	–	12 quarrymen or labourers
"	"	–	20 lime works labourers
"	"	Thomas Oakden	stone packer
"	"	William Atkinson	lime drawer
"	"	George Yeomans	lime works foreman
"	Stainforth	Henry Parker	labourer at lime works
"	"	William Parker	labourer at lime works
"	"	John Parker	labourer at lime works
"	"	William Parker	joiner at lime works
"	"	Robert Parker	joiner at lime works
"	"	Henry Dorbell	quarryman
"	"	John Kitchener	quarryman
"	"	John Hancock	quarryman
"	"	W.G. Perfect	managing director, lime works
"	Studfold	James Makinson	lime works foreman
"	"	James Redmayne	lime drawer
"	Horton	Andrew Percy	foreman at lime kiln

RETURN	PARISH	NAME OF WORKER	OCCUPATION
"	"	Joseph Hall	foreman at lime kiln
"	"	Samuel Wilshaw	limeburner
"	"	William August	quarryman
"	"	Edward August	quarryman
"	"	William Cowper	quarryman
"	"	William Maunders	quarry booking clerk
1901 census	Settle	John Delaney	quarry owner & lime burner
"	"	John Taylor	lime works manager
"	"	George Clark	lime works clerk
"	"	–	36 quarrymen
"	"	–	7 kiln men
"	Giggleswick	–	13 quarrymen
"	"	–	4 kiln men
"	Langcliffe	–	17 quarrymen
"	"	–	32 kiln men
"	"	–	3 others
"	Stainforth	–	6 quarrymen
"	"	–	1 weighman
"	Horton	–	60 quarrymen
"	"	–	11 kiln men
"	"	–	5 others
1803 Craven muster roll	Carleton	Thomas Tillotson	limeburner
		John Smith	limeburner
"	"	Henry Bulcock	limeburner
"	Linton	John Lambert, senior	limeburner
"	"	John Lambert, Jr	limeburner
"	Ingleton	William Tomlinson	limeburner

promulgated his ideas for a new style of kiln in 1799, though the invention itself is ascribed to 1802. Rumford kilns, as they became known, are said to have been used worldwide, though I have failed to locate any examples in Britain. The kiln was six-sided, and the fuel was burnt in furnaces (three to five of them) around the sides of the bowl rather than being tipped into the bowl with the stone. In other words, the Rumford kiln was a separate-feed kiln. Two fine examples, built in 1804 and 1816, have been fully and beautifully restored at a site to the east of Berlin.[6]

Rumford's separate fuel-stone arrangement gained acceptance in this country and other designers began to adapt his basic plan. In 1889, for instance, Alfred Bishop designed and patented the Brockham kiln for chalk burning; John Briggs of Buxton lodged a patent in 1883 for an hourglass-shaped kiln, in which fuel was kept apart from the stone,[7] and three other patents were applied for by John Briggs of Clitheroe. Contrasting the latter's designs with the 1883 patent suggests that there may have been two inventors of the same name. The Clitheroe patents (1881, 1892 and 1894) all introduced fuel into the main body of the kiln.[8] It will become apparent in due course why Rumford and Briggs are brought into this story.

THE WINSKILLS OF SETTLE

Two residents of Settle also patented a 'new or improved construction of lime kiln'. John Winskill, a stonemason, builder and farmer, is something of a mystery. He appears in various trade directories,[9] and the census records his precise address and the fact that he employed thirty men in 1881.[10] We also have his patent specification.[11] There is, however, no documentary evidence to link him to any particular quarry or lime works in Craven. There is no evidence to confirm that he put his design into practice by building a working kiln. Furthermore, none of the extant or recently demolished kilns in Craven entirely fits his design. On the other hand, it seems improbable that someone – especially a builder – would go to the trouble and expense of patenting a kiln if he had no intention of seeing it in operation.

The Winskill kiln, if that is what we may call it, was like no other previous design (27). Unfortunately, the specification drawings do not show a scale so it is difficult to appreciate the size of his kiln. All we can say, vaguely, is that it can only have been big, in both the horizontal and vertical planes. The kiln consisted of a calcining bowl, traditional in design, with an aperture at the bottom to extract burnt lime. The rest is totally novel. Fresh stone was added into an upper, curving funnel arrangement through a trap door. As the stone burnt through and was withdrawn through the draw hole, stone in the upper part of the bowl settled further down, enabling more stone to be tipped through the trapdoor. In most kilns fuel was also added through the top, but Winskill introduced fuel at a lower level than the stone by way of a door or doors. The fuel would, therefore, fall directly on to the stone in the calcining zone of the kiln instead of into the upper, preheating zone, thereby removing one of the main drawbacks of earlier kilns. As

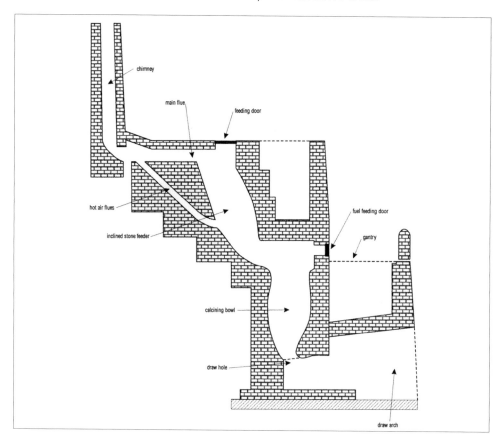

27. Kiln design by John Winskill Sr, patent no. 2495 of 1872.

the stone burnt, the rising heat preheated fresh stone in the funnel while waste gases and smoke were drawn out at the top of the funnel through a horizontal flue to a free-standing chimney. There were also smaller flues leading to the main flue. These had a dual purpose. They helped to create sufficient draught to draw hot air and waste gas through the main flue and up into the chimney, as well as distributing heat within the funnel more evenly instead of allowing it all to escape to the top.

Winskill had developed what seems on paper to have been a plausible design, albeit drawing to an extent on Rumford's ideas, so why is he such an unknown quantity?

The mystery deepens because his son, also John, when only twenty-seven years of age, followed in his father's footsteps and lodged his own patent (28).[12] He calls it 'my invention' when in reality he was refining his father's design, but this only serves to emphasise that the Winskills must have built at least one kiln somewhere. If not, why would he be improving something his father had designed seventeen years earlier? John Jr kept the lower chamber, as in his father's, and modified the second and higher chamber, connected to the lower by what he called a 'bend or

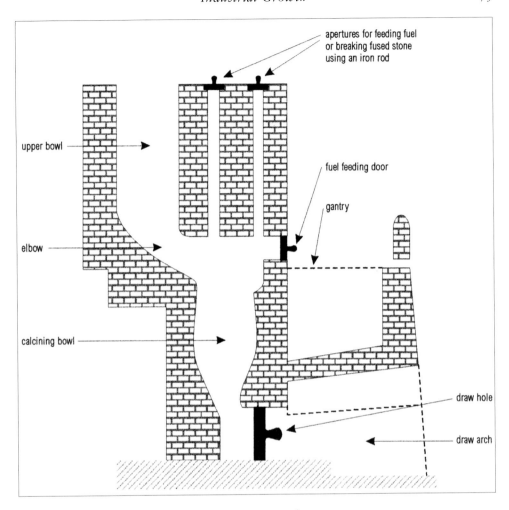

apertures for feeding fuel
or breaking fused stone
using an iron rod

upper bowl

fuel feeding door

gantry

elbow

calcining bowl

draw hole

draw arch

28. Kiln design by John Winskill Jr, patent no. 4286 of 1889.

elbow'. Fresh stone was added from the open top of the upper chamber, while fuel was loaded from a gantry through a door at the top of the lower chamber. Drawing of burnt lime was through a door rather than through a hatch as in his father's kiln. Exhaust gases and smoke escaped through the open top of the kiln and not along a flue. This might seem a retrograde step, unless his father had built a kiln that proved too troublesome to operate successfully. However, the new specification did allow for a chimney to be added to the open top of the kiln, if desired. The younger John also included two 'openings', down each of which an iron rod could be fitted for the purpose of breaking up any scaffolded or fused stone, and down which fuel could be dropped. Again, frustratingly, we are given no idea of scale unless we assume the draw arches were just high enough for a man to stand upright in, which was often the case in nineteenth-century commercial kilns. If we take this to be 1.7 m, the early kiln must have stood about 13.5 m tall with the later one about 12 m. That *is* big.

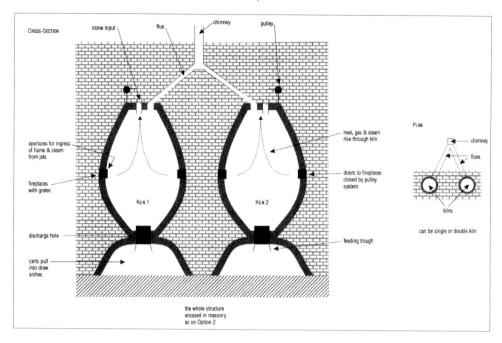

29. Kiln design of Henry Robinson, patent no. 2048 of 1863.

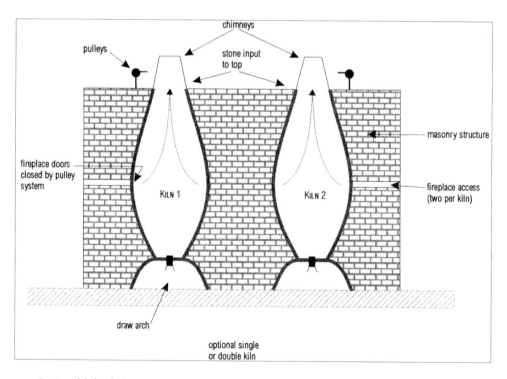

30. Optional kiln design as per patent no. 2048 of 1863.

HENRY ROBINSON OF SKIPTON

Another local figure has an equal air of mystery about him, namely Henry Robinson of Newmarket Street in Skipton. Several men of that name crop up in the area, all at the same general time, and it is not easy to decide if they are the same person, two men or three men. One Henry, described as a deceased coal merchant of Newmarket Street, appears in a deed, dated June 1883, concerning his property on that street, and in another, dated May 1884, concerning property in Ingleton.[13] This Henry is pertinent to the lime industry, as we shall soon see. The 1851 census has a Henry Robinson, aged twenty-nine, of Skipton, coal agent, living in Chapel Street in Settle. Is this the same man? It may well be, as Settle is more or less equidistant between Skipton and Ingleton, so he could have moved to Settle to keep an eye on his interests in both places. A third Henry Robinson was a solicitor in Skipton and first thoughts would suggest he can be eliminated, but life is not that simple. He was one of the sons of Dixon Robinson, of Clitheroe, who owned the Bold Venture Lime Works at Chatburn near Clitheroe.[14] When Dixon died his four sons carried on the business, changing its name to the Bold Venture Lime Co. On what is now Snaygill Industrial Estate outside Skipton there was another quarry called Bold Venture.[15] Henry Robinson opened a quarry here in 1866 with that name and a Henry Robinson is noted in the *Craven Pioneer* newspaper as the owner of Snaygill Quarry in February 1875. There is some doubt as to whether this quarry extracted limestone or sandstone – the records do not agree – but that does not really matter. What is relevant is the name Bold Venture: it cannot have been a coincidence that two Robinsons owned quarries both called Bold Venture so close to each other. It must be the same family. The question remains: was this Henry the same as the other two? If the two Bold Venture Henrys are the same man, this would provide a link between Robinson and Briggs of Clitheroe, but would the same Henry have been both solicitor and coal factor-cum-quarry operator? The point of all this is that one Henry Robinson of Newmarket Street in Skipton, described as a coal merchant, filed three patents for lime kiln designs in the 1860s which definitely do tie in with Ingleton, as we shall discover. Prior to these, in 1857, he had also patented a new haulage technique, so he was clearly a man of entrepreneurial spirit.

His first patent, of 1863, aimed at producing better quality lime by keeping fuel and stone quite separate (29).[16] This was Rumford's influence again. In this patent Robinson offered two distinct options: in the first was a complex kiln – in fact it could also be twin kilns sharing a common chimney – with draw hole openings large enough to accommodate a horse and cart or a rail wagon to avoid the need for hand-shovelling burnt lime out of the kiln. Burnt lime dropped through a discharge hole into a feeding trough. Each kiln had two fireboxes on each side of the bowl, and the doors to these fireboxes were opened and closed using a pulley system set on top of the kilns. Fresh stone was dropped through an opening on top of each kiln. Heat and gases rose from the calcining zone, as in all kilns, but the rate of combustion was enhanced by installing steam jets behind the fireboxes linked to the bowl by an

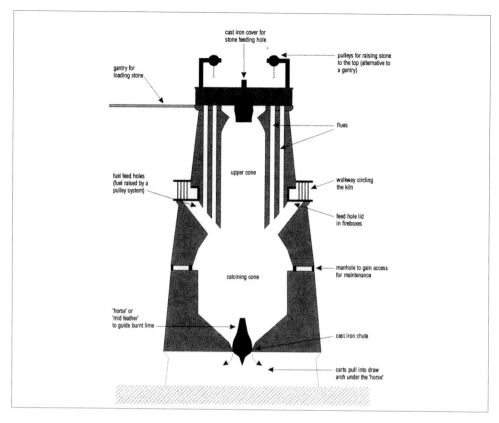

cast iron cover for
stone feeding hole

pulleys for raising stone
to the top (alternative to
a gantry)

gantry for
loading stone

flues

fuel feed holes
(fuel raised by a
pulley system)

upper cone

walkway circling
the kiln

feed hole lid
in fireboxes

manhole to gain access
for maintenance

calcining cone

'horse' or
'mid feather'
to guide burnt lime

cast iron chute

carts pull into draw
arch under the 'horse'

31. Kiln design of Henry Robinson, patent no. 3244 of 1869.

aperture. Waste gas and smoke were carried along horizontal flues to the chimney. Apart from the flues and chimney, the whole structure was encased in masonry. His second option was to build the chimney (or chimneys) directly on top of the masonry structure (30).

Robinson's second patent, which described him as a lime and coal merchant, did not receive normal patent protection because he failed to submit the full specification within six months of the provisional specification, as required by the law.[17] This patent, of 1869, was markedly different in concept.[18] The masonry casing contained twin bowls – lower cones, as he called them – for calcining and cooling, both fed from one common upper cone for preheating. Stone was fed into the upper cone from the top as before, but it was now fed down chutes from the kiln top directly into the lower cones. He claimed this was a more fuel-efficient design, so presumably this took precedence over keeping the burnt lime untainted with ash.

His third and final patent, also of 1869, was quite different again and it bore many of the characteristics of steel-clad shaft kilns that were to arrive on the scene some thirty years later (31). If his drawings for this patent are compared with the Winskill and Briggs drawings, Robinson must surely win the prize for originality and attention

The Trustees of the late W^m Greenwood Esq^r

To ~~From~~ HENRY ROBINSON, D^r

INGLETON LIME WORKS.

OFFICE :—NEWMARKET-STREET, SKIPTON.

Date when sent from the Works. 1867	No.	BEST.		SMALL.		Rate.				DESTINATION.	
		Tons.	Cwt.	Tons.	Cwt.	£	s.	d.	Name.		Place.
May 24	300	Bricks at 9/6 per 100					7	6			

Settld

May 27 1867

for H Robinson

N. Y. Cowan

32. Invoice, dated 24 May 1867, supplying 300 bricks (firebricks?) to Henry Robinson at Ingleton Lime Works.

to detail, as well as for versatility. This kiln, he proffered, was suitable for limestone, chalk, cement and ores, 'part of which being applicable to blast furnaces'.[19] This design, he went on, would save on time, labour and fuel and would provide an end product 'of a more regular or even kind'. The sheer size and complexity – gantries, hoists, tramways, pulley systems – made this a very expensive proposition indeed.

The question is if any Robinson kilns were built and the answer is an emphatic, if at times rather farcical, yes. Let us trace his story, as far as it has been possible to piece it together.

In 1861 he established himself in the quarrying business on the lower part of Storrs Common in Ingleton, and in 1862 he took up the lease on the kilns in Mealbank Quarry across the river, as we shall see in Chapter 6 (32). In the autumn of the following year it was reported that he had installed a steam engine for crushing limestone, in addition to two 'immense' kilns capable of producing 300 cartloads of lime per day.[20] These, we must conclude, were according to his 1863 patent design. In the flowery journalese of the time, he was turning the 'grey and hitherto useless rock … into a cheap and valuable manure'. Seven years later he had these two kilns modified and upgraded and, during these alterations, some gas managed to escape from one of the kilns into the nearby stables, killing two horses.[21] Soon after this he completed his new kiln, which was over 12 m high. This was the third patent, and the local newspaper reported that it should give a better-quality lime using less fuel, because fuel was to be added part way down and not at the top. When this kiln was completed Robinson threw a 'grand

supper' to celebrate and put a notice in the local newspaper for the attention of 'Agriculturists, gas companies, builders, plasterers etc.' to the effect that he had invented a new way of calcining limestone, 99 per cent pure calcium carbonate.[22] It was available on sale at the kiln at 8*d* per load or, at a higher price, at any station on the railway line from Lancaster to Skipton, at Nelson and Colne, and at any station in the South Lakes. Robinson was doing well, and just a week after the opening he let off a proud blast in the quarry that surpassed 'in quantity of powder used and the lifting and scattering of solid rock anything that had ever been known at Ingleton'.[23]

Robinson was not always blessed with good fortune, however, and 1869 was definitely his annus horribilis, despite his having lodged new patents. Apart from losing the two horses to the gas, he had to deal with a blasting accident in his quarry and, far worse than that, he very soon had to abandon his magnificent new kiln. It did not work. Whether it was his construction or his design that was to blame is unknown. Quite possibly his technology was too advanced for the 1860s. The ultimate horror soon befell him: his new kiln collapsed.[24]

Undaunted, he carried on at Storrs, using his two original kilns, and he introduced agricultural lime in dust form, made by finely crushing unburnt limestone rock. Though this idea had been around for decades, it had never really caught on and he, too, faced failure in this respect as farmers would not buy it. His misfortune continued and 1881 was another year he probably wished had never happened. In July one of his employees, William Howson, was carting stone from the quarry face to the kilns when he lost control of the cart and it crushed him badly. The very next week Howson's younger brother was involved in an accident while doing the same job. He was backing the cart to the top of the kiln, to tip the stone in, when the cart slipped back, pulling the poor horse with it (he managed to rescue the animal). Four months later a huge, natural fall of rock nearly demolished the kilns.[25]

Robinson was not having much luck with officialdom either. The only way to get lime and crushed stone to the railway in Ingleton, and to get coal back again, was by horse and cart. This was slow, laborious and very labour-intensive so, like the rival Craven Lime Co. across the river, he applied for planning permission to install a tramway. Unlike his rivals, he was refused. In disgust or utter frustration he threw the towel in and gave up the lease early in 1883, despite the fact that it was generally agreed he had been very successful in his twenty years there.[26] Richard Atkinson took over the lease and effected repairs to the two kilns Robinson had built. He, too, prospered.

A year or so later Atkinson fell foul of the law. He was accused of tipping inadequately burnt (dead burnt) lime, in other words waste, down the bank below the kilns. Some of this had been washed into the river in a storm and fish were wiped out for nearly 2 km downstream. Atkinson's limeburners were called as witnesses, including John Downham, who was then aged seventy-six, as well as Lindsay and Ernest Balderston. In mitigation it was said that Robinson had done the same, as had the Craven Lime Co., but at least they had put an end to

the practice. He was found guilty. In 1886, incidentally, Atkinson bought Beezley Grange, a short distance downstream from the kilns, from the Robinson estate. Atkinson worked the two kilns for the rest of the century, eventually selling out to W. George Perfect of Stainforth in 1899. [27] He was Secretary of the Craven Lime Co. across the river, and the Storrs kilns and quarry were effectively operated by that company. After Perfect died, in 1909, his widow assigned the Storrs site to the company. [28]

Robinson, meanwhile, moved his centre of operations to Haw Crag Rock Quarry near Bell Busk, west of Gargrave, which he had worked since at least 1875 as H. Robinson & Co. [29] Now, if the Skipton Henry and the Ingleton Henry were one and the same man, he must have died very soon after leaving Storrs, given the 1883 indenture mentioned earlier. However, the order book of Charles Roberts & Co. of Horbury, near Wakefield, recorded sales of ten new rail wagons in the 'ferric red' livery of Henry Robinson & Son, Skipton, in 1898, fifteen more in 1902, and a further ten in 1904. [30] He may have died, but his coal factoring business endured.

One cannot but admire Robinson for his vision, his achievements and his obvious determination to overcome the setbacks he faced. His third kiln design was brilliant in concept and far in advance of any other contemporary vertical shaft kiln design. At the same time, though, one senses a certain degree of pathos. What would be nice to know is how he was perceived at the time – both among the inhabitants of Craven and in the trade – and exactly what his kilns looked like in the flesh, as it were. The precise location of his big kiln is unknown and there has been so much activity associated with Storrs Quarry since he left that not a lot remains of his twin kilns. The large masonry structure at grid reference SD 6985 7346 is basically all that has survived. The very size of this structure – nearly 15 m long and 6 m high, with massive stone buttressing to the west end and a stone ramp below – indicates that whatever purpose it served was industrial in scale. In the rubble below the structure are some scrap iron remains and vitrified firebrick, stamped '? Airedale Co., Shipley'. This would point to a kiln or kilns in this vicinity, and it is probable that the structure as we now see it was the base or the buttress of his kilns, but this was definitely the site of his double kiln. Of that, there is no doubt and the buttress puts his early patent kiln into a size perspective. Of the rest of Messrs Robinson's Lime Works there is no trace.

TOFT GATE

There is a kiln on the road from Greenhow Hill to Pateley Bridge in Nidderdale called Toft Gate (33, Col. Pl. 11, grid reference SE 130 643). This kiln has exercised the minds of interested parties for many a year. As a form of kiln design it is unique, at least in the Dales, and it is remarkable for its state of preservation though it was, until recent consolidation work reversed the trend, in a very parlous state. It has been classified by English Heritage as being of national importance, [31]

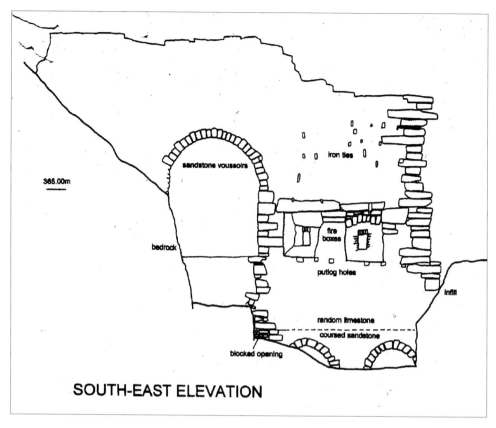

33. Toft Gate lime kiln on Greenhow Hill above Nidderdale. (*Kevin Cale and Stephen Haigh*)

and has been given statutory protection as a scheduled monument that is fully accessible to public view.

When Toft Gate was erected is anybody's guess, though the late 1860s have been suggested as a plausible possibility. Who designed it and who worked it are other as-yet-unanswered questions despite exhaustive documentary and oral research by Kevin Cale and Barry Nuttall. The 1909 1:2,500 Ordnance Survey map marks the site as 'Old Limekilns', so we do have a cut-off date for its demise. Is it possible to fit Toft Gate into any of the locally patented designs? There are some similarities with the Robinson configurations: the side fire boxes and steeply dipping fuel feed chutes do resemble patent no. 3244, as does the top stone feed, but there are significant differences as a comparison with the drawings will show all too clearly. There is also a parallel with Robinson's patent no. 2048 in the flue system and chimney, but not in the discharging mechanism. There are some common points between Toft Gate and the later Briggs patents, but these came in during the 1890s, so a direct link seems to be ruled out by the long time difference. The imaginative mind can point to similarities with a design patented by P. W. Spencer in 1870 but it, too, is very different in some details. Neither do the Winskill designs fit. There is, however, a very strong similarity in

firing arrangements between Toft Gate and the Rumford design. Both have side fireboxes and sloping fuel feed chutes, and the internal form of the two Rumford kilns this writer has seen in Germany are not dissimilar to that in the Toft Gate kiln. External details, however, are quite different.

THOMAS MURGATROYD

Another lime works has received remedial and restorative work prior to being opened up to the interested public. Locally it is known as 'Murgatroyd's Quarry', and it sits next to the Hoffmann kiln complex on the Stainforth-Langcliffe parish boundary. An almanac for 1876 mentions the 'Craven Lime Company and Mr Thomas Murgatroyd, both of which firms are sending off large quantities of lime and limestone, and they keep a great many men employed'.[32]

Murgatroyd first leased the land from John Sharp of Stainforth to open up a quarry with the coming of the railway north from Settle, and the first direct reference appears in the Rate Book for Stainforth in April 1876, when he was entered as paying rent and rates on 'land, quarry and tramway'.[33] By April 1877 he was also paying 30s annual rent, plus rates on each of two lime kilns. In April 1880 this was reduced to one lime kiln and remained thus until October 1886, when the rate book noted 'property not profitably occupied'. This is all puzzling because the site contains a bank of three vertical shaft kilns, locally known as the triple bottle kiln. As there are three, why was he only paying on one or two? Why was the rental based on one tramway when field evidence shows the site had two separate tramways?

Murgatroyd's Quarry should properly be called the North Ribblesdale Limestone and Limeworks,[34] a long-winded name for a short-lived business venture. In 1881 the site, managed by George Goom, was exporting crushed stone and quicklime. One tramway, the track of which is now almost indiscernible, ran from the quarry mouth to the kiln tops. This was on the flat, so the tubs were probably manually pushed to and fro. The other tramway, carrying crushed stone down an incline to a rail siding, and coal back up, was operated by a drum winch (the gantry structure has survived), no doubt with an endless rope system: full carts descending would have hauled up empty ones.

In October 1886 the rateable value of the kilns and ancillary structures was reduced and, twelve months later, Murgatroyd gave up the lease rather suddenly. He can only have gone bankrupt. It is hardly surprising in retrospect as this bank of kilns utilised outdated technology and could not hope to compete on equal terms with the adjacent Craven Limeworks and its Hoffmann kiln. Murgatroyd's name had been entered in the rate book for October 1887, but was crossed out and replaced by that of W. George Perfect, who was closely involved with the site next door. Perfect ran the lime works, with two kilns running, until at least April 1896, after which date the rate book is missing, but this again is perplexing. According to the 1894 1:2,500 Ordnance Survey map, the kilns are shown as

'Old Limekilns' and neither tramway is marked. Also, the business does not appear in the official quarry industry statistics that were compiled annually from 1895. Even quarries under 6 m deep and employing only one or two men were listed. North Ribblesdale must have been defunct or, more likely, swallowed up by the adjacent business by 1894. So, why was Perfect paying rent and rates, two years later, on land, quarry, tramway and lime kilns? Even if the site had by then been subsumed within the Craven Limeworks complex, one would expect to see something on the map to show how stone was taken from Murgatroyd's Quarry to the Hoffmann kiln, but there is no hint on the ground. The answer lies in the value of Murgatroyd's Quarry to the Craven Limeworks, but not for its stone resources. Rather, an incline was constructed from the northernmost section of the Craven Limeworks quarry to link in with a high-level tramway running northwards, just below the cliff line, to the top of Murgatroyd's Quarry. It is clear from ground evidence that waste stone from the Craven Limeworks quarry was being discarded in the neighbouring quarry: its value was merely as a dumping ground.

Murgatroyd had given up lime burning here, but he maintained his coal business into the next century. Purchases of ten new rail wagons were recorded in both 1904 and 1905, finished in his red livery with the lettering 'Thomas Murgatroyd Skipton'.[35]

THE CRAVEN LOWLANDS

A number of other limestone quarries, roughly on the same scale as Murgatroyd's, were worked across the Craven Lowlands (34). Marton Quarries (SD 91 51), which was operating before the middle of the nineteenth century, consisted of three separate workings just north of East Marton. The main quarry was connected by a tramway to the Leeds and Liverpool Canal. The shaky remains of the bridge that carried the tramway across the lane have survived. There are no signs, either documented or in the field, to suggest that lime was burnt on site. More than likely, limestone was sent to the many kilns that lined the canal close to Keighley and Shipley.

A short distance almost due south of Marton Quarries was a series of independently run quarries, each of which had a lime kiln (SD 19 49). The largest of these quarries became Fence Delf Quarry, but it grew to industrial proportions with the coming of the railway from Skipton to Burnley in 1848. Very soon after that a 140 m tunnel was driven through the southern edge of Fence Hill to take a rail link directly into the quarry. Over time, the entire core of the hill was quarried away in what became known as Thornton Rock Quarry (SD 910 489). Towards the end of that century, in 1881 to give a precise date, the site was being operated by R. Bond, but later on, by 1896, it was in the hands of Tennant & Nightingale, who employed thirty-three men, though the quarry was taken over by P. W. Spencer Ltd in 1897, after which the labour force fluctuated markedly.[36]

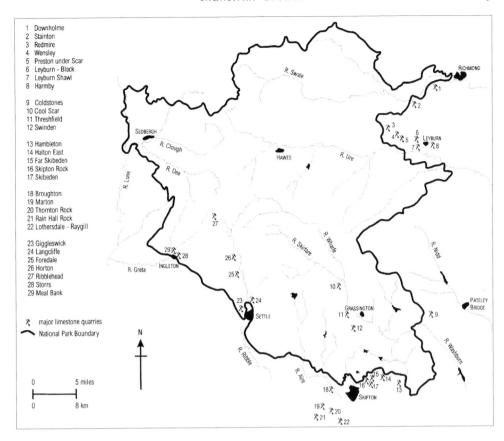

1 Downholme
2 Stainton
3 Redmire
4 Wensley
5 Preston under Scar
6 Leyburn - Black
7 Leyburn Shawl
8 Harmby

9 Coldstones
10 Cool Scar
11 Threshfield
12 Swinden

13 Hambleton
14 Halton East
15 Far Skibeden
16 Skipton Rock
17 Skibeden

18 Broughton
19 Marton
20 Thornton Rock
21 Rain Hall Rock
22 Lothersdale - Raygill

23 Giggleswick
24 Langcliffe
25 Foredale
26 Horton
27 Ribblehead
28 Storrs
29 Meal Bank

⚒ major limestone quarries
〰 National Park Boundary

0 5 miles
0 8 km

34. Distribution of commercial limestone quarries in the Dales and Craven.

Spencers shut the quarry down in 1916 because the high-quality 'blue' limestone had given way to unstable shales.

It would be churlish to leave out another major quarry, not in Craven, that was exploiting the same limestone series as Thornton Rock. Rainhall Rock Quarry (SD 89 47), east of Barnoldswick, was an amazing affair. Now partly filled in, there is still enough left to give an impression of how it was worked. Its history begins with the building of the Leeds and Liverpool Canal. A branch, the 'Little Cut', was tunnelled through to the far end of the quarry, and stone was loaded directly into barges waiting below. This cut was begun in 1796 by the canal company that leased the quarry, and was extended further eastwards in 1799. The objective was to produce cheap limestone to boost traffic on the canal. The venture prospered and, in 1828, the lease was extended to include more land for quarrying, the cut was lengthened accordingly, and a second canal tunnel was built. In 1862 a viaduct was built to carry a road across the yet-again-extended quarry. Rainhall Rock must be one of the narrowest quarries ever worked. The canal company gave up the lease in 1891, but by 1905 it was being operated in partnership by Messrs S. Whitaker and W. Adair, but they too were bought out by the newly-formed Rainhall Red Sandstone Co. Ltd, which exploited the sandstone beds.[37]

In what is now part of the suburbs of Skipton was yet another large-scale quarry operation. The Mercer Flatts Lime Co. (there are alternative spellings of its name) was extracting limestone here in the eighteenth century, and in 1786 it was taken over by the Leeds and Liverpool Canal Co., which continued to exploit Massa or Martha Flatts Rock Quarry (there were actually two quarries) for stone until the middle of the following century. The two quarries, each in a separate wood, both called Bull Ing Plantation, had a tramway connection between them, a tunnel out of the eastern quarry, and a tramway down past the old Union Workhouse and Woodman Inn to join the canal. Ordnance Survey mapping from 1852 shows the tramway as far south as the main road to Gargrave, but nothing beyond there, so presumably the quarries had been abandoned by then.

Finally, in this survey of commercially operated limestone quarries in Craven before 1900, Hambleton Quarry (SD 057 533) cannot be ignored. When the railway was pushed through from Ilkley to Skipton in 1888, land was leased from the estates of the Duke of Devonshire to exploit the limestone deposits at Hambleton, near Bolton Abbey station. Initially the quarry operated on a small scale, burning lime in a kiln near the quarry entrance, with R. Leech listed as operator in trade directories for 1861 to 1881. Towards the end of the century, J. Green & Son of Keighley, and later Silsden, were quarrying stone on a grand scale, the company having been formed in 1895. During the years for which official statistics are available, the labour force at Hambleton grew from sixty in 1895 to ninety in 1901, after which there was a dramatic and then steady decline to forty-five men by 1908, but rising again to hover around sixty between 1909 and 1914. At the turn of the century a rail link had been laid directly from the station sidings to the crushing plant and into the quarry itself. Greens gave up the quarry in 1921,[38] and it lay idle until F. W. G. Hargreaves & Son of Embsay reopened it in 1936. New crushing plant was installed but it proved difficult to recruit the necessary labour, and the shaly nature of the rock now being exposed made quarrying here less straightforward and expensive. So in 1940, the plant was mothballed; it was finally sold off in 1945.[39] Halton East Quarries Ltd, the company Hargreaves founded, held on to the lease at Hambleton until finally surrendering it in 1971, even though they had not worked it since the war. The lease was taken up by A. Ogden & Sons (Minerals) Ltd of Otley, which had grand designs on the quarry and applied for permission to reopen it in a big way, but operations never really started up, except for a short-lived burst in 1986. They too surrendered the lease a few years later.[40]

Apart from the concentration of limestone quarries in Craven and the southern Dales, there is a second important clustering in the limestone belt of lower Wensleydale, particularly between Harmby and Redmire (100). A number of large quarries have been – or still are – in operation in the Leyburn area, but few of them, with the exception of Harmby, were in existence on an industrial scale before 1900. We shall return to this area in a later chapter.

By the end of the nineteenth century, then, we have a major focus within our study area of industrial quarries that had grown from nothing or from very small

beginnings to meet the insatiable demand for lime and crushed limestone. By 1900 Craven alone had ten major working limestone quarries, a number of others had been of significance in the latter part of the previous century, and several others were about to come on line, both in Craven and in Wensleydale.

Some of the most dominant players in the field – John Delaney, the Craven Lime Co., P. W. Spencer, and Skipton Rock quarries – were so important in the industry that each deserves its own dedicated chapter.

5

Haw Park and Halton East

Stretching away from Skipton to the north-east are exposures of steeply folded and contorted limestone that, in part, formed a long narrow hill called Hawbank or Haw Park, which originally rose to 254 m in height.[1] The exposures here have been exploited, initially for lime and later for crushed stone, for hundreds of years and, for a time, five distinct limestone quarries were in existence. Hawbank itself was quarried on three fronts: Haw Bank Rock Quarry at the western end of the hill was the first part to be quarried extensively, later extended into the hill to become Skipton Rock Quarry; Skibeden Quarry ate into the southern side of the hill, and once supported four lime kilns; Far Skibeden Quarry ate into the eastern end. All of these were exploiting the Haw Bank Limestone that formed the core of the Skipton anticline, a great upfold of rock strata from ancient tectonic movements some 280 million years ago (Col. Pl. 12).

On lower-lying ground beyond Hawbank two other quarries worked the younger Embsay limestone, also contorted and full of shales. Berryground Quarry was first worked to feed two lime kilns, which have long since disappeared, alongside Berry Ground Beck. Cocktrain Quarry, a short distance to the east, also fed a kiln and supplied stone for the repair of roads in the Skipton area. These two quarries later grew to form the much larger Halton East Quarry.

Far Skibeden itself began life as five discrete quarries, all small and all facing the Skipton-Knaresborough turnpike road. No evidence has come to light to suggest that the stone was burnt on site, so we must assume it was being sent away, possibly to Skipton and then by canal to the kilns that lined its banks. An alternative destination may well have been Skibeden Quarry, less than 1 km down the road. Again, Skibeden was split into two distinct quarries, both facing the road (35). Each quarry produced burnt lime. The western of these two quarries had one kiln but the other had three, all fronting directly onto the turnpike road, as shown clearly on the 1843 tithe map and an estate plan of 1852.[2] They were named as Skibeden Limekilns on the first edition of the Ordnance Survey map. The estate plan shows two roadways leading off the turnpike into the quarry. At the head of

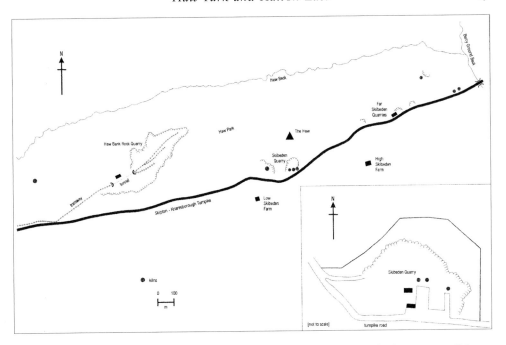

35. Haw Park and Haw Bank Rock Quarry in 1851, showing kilns marked on a 1757 Skipton Castle Estate map. *Inset*: Skibeden Quarry and kilns in 1843, as shown on the tithe map.

the eastern roadway stood one kiln and at the head of the other were two kilns close together. There were other buildings: a cabin near the kilns and another one nearer the road that probably served as weigh house and office. At the time of the plan, the quarry was leased by William Nightingale. The size of this quarry does not seem to have been large enough to have fed three kilns, so stone was clearly being brought in from the other Skibeden quarry or from Far Skibeden. Stone from the latter may also have been burnt in two roadside kilns near Holywell Bridge, a short distance down the road, a site that was swept away when the road was realigned in modern times.

The eastern end of Haw Park also had a kiln associated with a small quarry. On an estate plan, dated 1757, a kiln is shown here but the Ordnance Survey map 100 years later marked only the quarry.[3] At the western end of the hill was yet another small quarry with its own kiln there, most probably supplying agricultural lime and lime for mortar for the Skipton Castle estate that owned Haw Park.

So we have documentary evidence for eight lime kilns on Haw Park as well as further hints from field names: two small fields between High Skibeden Farm and Holywell Bridge were called Kiln Field on the 1757 map, and another field to the south of Skibeden Beck was named Lime Kiln Field. None of these fields had kilns shown on the plan. This 1757 plan predates the true commercial exploitation of Haw Park, but it does have a later pencil annotation, 'Quarry', indicating where large-scale quarrying was soon to begin. It was the 8th Earl of Thanet, Lord of the Manor of Skipton and the owner of the castle – or rather his agents – who saw

the vast potential offered by Haw Park's limestone reserves. However, we must first digress a little.

By the middle of the eighteenth century, some of the landed gentry of the Bradford area were beginning to invest in industry and to recognise the potential profits that could be made by exchanging Bradford's coal for Craven's limestone.[4] Limestone was already being carried by packhorse trains from the Skipton area to be burnt at Bingley for use in newly enclosed pastures around Bradford as well as in the town's building boom of that time. Packhorse traffic was slow and weather-dependent and this acted as a major stimulus to the raising of funds for cutting the Leeds and Liverpool Canal, construction of which began after parliamentary approval was secured in 1770. There had been proposals to canalise the River Aire between Skipton and Bingley in 1744, but these plans came to nought.[5] Within three years of consent being obtained, the section running from Skipton to Bingley and Shipley was complete. Coal and limestone could now be traded more quickly, in greater quantities, more cheaply, and therefore at greater profit.

A parallel development was the building of the Bradford Canal between 1771 and 1774 to link the town to the main canal, and in that latter year the Bradford Lime Kiln Co. was registered.[6] By 1774 there were forty kilns lining the canals between Skipton and Bradford, all burning limestone from Craven.[7] The company itself built eight kilns immediately with a new one added in 1778, and used each kiln on an intermittent basis in rotation, though the company had effectively ceased production by 1784.[8] Perhaps more successful was the canal itself, which carried vast quantities of coal to the kilns within Craven and quicklime and raw limestone on the return journey to the city: particularly lucrative was the delivery of limestone to ironstone smelters at Low Moor in the Bradford area.[9]

HAW BANK ROCK

The Earl of Thanet's agents saw the opportunities and began to open up reserves to the north of the castle, in what is now Skipton Woods, and stone was carted to the canal basin in town. This proved slow and generally unsatisfactory, so his agents applied to Parliament to construct a link canal. As justification for this, they presented Parliament with the notion that districts around Bradford 'have occasion for large quantities of lime and limestone'.[10] In 1773 permission was granted and 'Lord Thanet's Canal' came into being. Quarrying rights had been leased out by the estate to the Mercer Flatts Lime Co. but, in 1786, the lease was transferred to the Leeds and Liverpool Canal Co. for an initial eleven-year period when the canal company bought out Mercer Flatts. Demand for lime and limestone was more than buoyant, so the decision was taken to begin quarrying on Haw Park.

The immediate difficulty here was Haw Park's distance from the canal link and the drop in height from the hill down to the canal. In 1786 the company entered into negotiations with the estate to cut the canal link further back towards Haw Park but permission was not forthcoming until eight years later, and actual

construction of the extended Springs Branch was only completed in 1797. Interest in the whole canal project had waned in the intervening years, partly owing to the disruption to trade caused by the American War of Independence. In an attempt to attract renewed investment, canal promoter John Hustler published a pamphlet in 1788 in which he informed potential investors that 'above every other article, except coals, limestone would produce the greatest tonnage. This necessary article, of the best kind, lies in inexhaustible quantities, in Craven'.[11] His tactics paid off. However, the new canal link still left a distance of more than 1 km for land cartage so, to increase capacity and reduce costs, a tramway was laid from the new quarry to a point on the same level as the castle but about 33 m above the canal: quarry carts ran down under gravity-control while ponies hauled empty ones back up.[12] Stone was tipped down chutes from the tramway to the canal side and into waiting barges: the clatter of falling stone must have been unbearable.

When the entire canal was finally completed, in 1816, trade in limestone and other commodities picked up and Haw Bank Rock Quarry was extended back into the hill to meet the demand. The canal company's lease on the quarry expired in 1833 and the Earl of Thanet tried to re-negotiate on different terms, offering to decrease the rental if the company would take the tramway all the way to the canal basin in town. The company declined, but had its lease renewed anyway. Further change came in 1835/36, when an endless rope incline replaced the high-level chutes, following a different course from the original high tramway, one with a much gentler gradient. Full tubs lowered down the incline hauled others back up again. Two loading chutes, or stages, were built at the canal side at the end of the branch with a weigh bridge and an office or cabin, the remains of which can still be discerned today (36).

During the whole period since taking up the lease in 1786, the canal company had operated an astute business policy. At times of high demand the company sub-leased the quarry to a succession of quarrymen; when trade was depressed they took back the lease and worked it themselves so as to maintain traffic on the canal. Sub-leases were granted, successively, to a Mr Stoddart, then to a Mr Baxter, and, after a company-run interlude, to Messrs Fletcher and Dale, and then back to the company.[13]

In 1852 the estate owner, now Sir Richard Tufton, descendant of the earls of Thanet, had a detailed plan of the quarry compiled.[14] It extended over almost 15 ha, including areas set aside for spoil, with a further 5.25 ha outlined for expansion in an easterly direction. A further plan, drawn a few months later, shows more details of the planned extensions and gives a breakdown of the quarry: 7.7 ha of actual quarry in 1839, 1.2 ha added in 1849, and 4 ha to be added in 1852.[15] Before 1836 a tunnel had been cut through the older, western section of the quarry to carry the tramway under spoil heaps that were encroaching onto it. The original workings were now abandoned and new ones started up, extending the quarry further to the east around the north flank of the hill, under the supervision of quarry foreman, Mr Hall.[16] These new extensions became known as Skipton Rock Quarry.

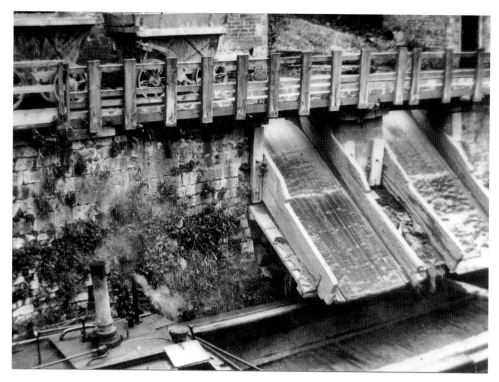

36. Springs Branch, Skipton – loading chutes and carts, photographed in 1934. (*The late W. Riley via the late B. D. Stoyel*)

The next significant development in the complex's life came three decades later. The railway from Ilkley to Skipton opened in 1888 and, shortly afterwards, a spur was laid into the newer part of the quarry, so stone could be despatched in two directions, by rail and by canal. This spur, however, could not be tied in to the mainline track as the gauge was slightly different. Stone had to be transferred from wagon to wagon. On the incline to the canal, the steam winding engine, which had earlier replaced the ponies, was itself replaced by a locomotive in 1893, and a new tramway line was laid three years later from the quarry to the incline, avoiding the 1836 tunnel.[17]

SKIPTON ROCK

However, three days after Christmas of 1895, there occurred the legal incorporation of the Skipton Rock Co. Ltd, established by a partnership between Messrs Sugden and Hunt. They did not purchase the quarry but sub-leased everything from the canal company, as they had done before turning themselves into a limited company. Before incorporation the quarry had given work to seventy-eight men, but within less than a year it had risen to 107,[18] though the payroll steadily dropped after that, bottoming out at fifty-five by 1909.[19] The rail spur to the north

ALL GRADES OF ROAD-MAKING MATERIALS

TARRED & BITUMINIZED LIMESTONE

A SPECIALITY

OUTPUT CAPACITY

1,000 TONS DAILY

SKIPTON ROCK CO., LTD.

EMBSAY

NEAR SKIPTON

Telephone: SKIPTON 17 & 18

MODERN & EFFICIENT LOADING

FACILITIES FOR ROAD, RAIL & CANAL

ALL ENQUIRIES RECEIVE PROMPT ATTENTION

37. Advertisement in a trade journal for the Skipton Rock Co. in the 1930s.

was widened and keyed into the mainline, and the company continued to prosper despite a severe downturn in trade caused by a depression in agriculture from the late 1870s through the 1890s. As Skipton Rock relied entirely on exporting stone, and burnt no lime, this recession largely passed them by.

By this time the quarry lessees were mechanically crushing stone on site: prior to that stone had been hand-broken into fist-sized pieces. In one week in August 1895, for example, thirteen men were employed solely to operate the 'stone breaking machine'.[20] From January 1896 to December 1903 the quarry was managed by Thomas Potts, but the clerk, F. W. G. (Fred) Hargreaves, was promoted to the top job in the following year. He was a far-seeing person and we shall encounter him later.

With the installation of new crushing and tar-coating plant early in the new century, quarrying requirements led to a further extension of the quarry towards the south-east,[21] and Skipton Rock was soon turning out 30,500 tonnes per annum.[22] The company was marketing over a wide area, not only to the Leeds, Bradford and Burnley areas but even as far as Glasgow (37). The West Riding County Council was a regular customer for crushed stone and tarmacadam, and two lime and stone producers in the Settle area, John Delaney and the Ribblesdale Lime Co., and P. W. Spencer of Lothersdale, are listed frequently in the royalty books and customer ledgers for the company.[23] Skipton Rock, in common with other local quarry companies, benefitted in the 1910s from an unprecedented boom in council road building programmes, though it was noted that sale prices were not overwhelmingly attractive, being only 1s 6d per tonne.[24]

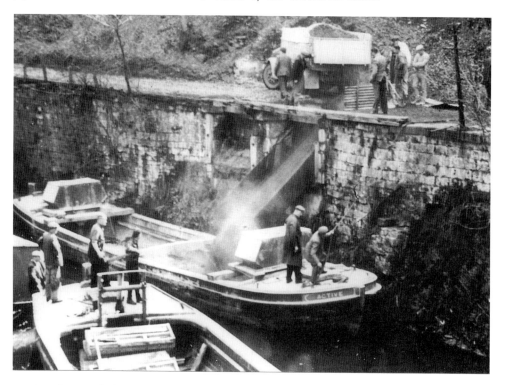

38. Loading crushed stone at Springs Branch from motor lorries in 1964, part of an experiment to revive canal traffic in limestone. (*Mrs F. V. Rowley's collection*)

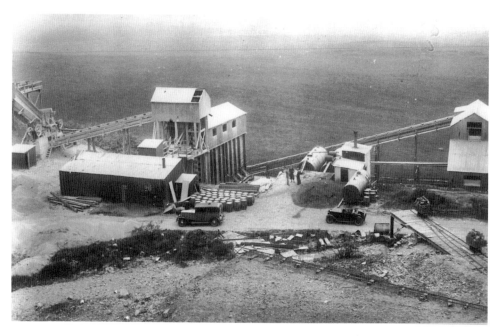

39. Crushing plant at Skibeden Quarry, photographed in 1932. (*Weatherill Collection via D. Binns*)

By 1930 the company had expanded its operations yet again and a plan, stamped 'Leeds and Liverpool Canal Co.' and dated that year, shows the future extensions of the quarry to the north and east.[25] Shortly after this canal transport was abandoned in favour of rail, apart from a short-lived and unsuccessful attempt to revive canal traffic in the early 1960s with stone being transported from quarry to canal by lorry (38). Immediately after the Second World War all the rail links within and into the quarry were taken up to be replaced by road haulage. By 1954 output had risen to 1,060 tonnes per day, of which half was as tarmacadam.[26] Many minor roads in the Dales, connecting one dale to the next, were being given a tarmacadam coating at this time, providing a local and assured market for coated stone.

Two years later the Skipton Castle estate came on the market and the Skipton Rock Co. purchased the lease for quarry and surrounding land. In 1964 they finished installing new crushing and coating plant in a major drive to modernise and mechanise the complex.[27] Bearing in mind that a major proportion of their sales was by now rail ballast, this decision to invest may not have been especially wise, given the swingeing cuts made to the rail network in the 1960s. Perhaps this was why the company was bought out in 1968 by the Hargreaves Group (not connected with Fred Hargreaves), which continued to work new faces. In 1970, the company installed more new plant to screen and wash stone that had been cast aside in earlier quarry operations. The quarry was estimated to have a working life of eighty years when the Hargreaves Group took over, and a potential annual output of 305,000 tonnes.[28] In 1980 Tilcon bought Skipton Rock Quarry from the Hargreaves Group, their motive being to replace Lothersdale Quarry, which was soon due to close down, but the company drastically reduced the scale of operations at Skipton Rock three years later, restricting blasting to the summer months. In 1994 quarrying here ceased completely.

SKIBEDEN AND FAR SKIBEDEN

Meanwhile let us put the clock back to the nineteenth century. We saw earlier that William Nightingale was working three lime kilns in the small Skibeden Quarry (SE 01 52) on the south side of the hill, and that another quarry and kiln were nearby. These two small quarries were both expanded to form one larger quarry but, by the 1880s or early 1890s, the kilns had been shut down and the combined quarry was abandoned. In 1931 it was resurrected. Others had known of the rock at Haw Bank, and of its geological structure, recognising that its 'blue' limestone produced excellent hydraulic lime and that its strength and hardness made it very suitable as roadstone. So, in 1931, an outside concern took over the lease on Skibeden and established the Embsay Rock Co., incorporated in that same year. Two of the old kilns had become ruinous in the interim but the other two were still capable of being fired up again, but the new owners decided to concentrate on roadstone and tarmacadam, such was the demand, and new plant was installed (39).[29]

Further east along the hill, the long-abandoned Far Skibeden Quarry (SE 02 53) was also given a new lease of life in 1931. Another new company, Skibeden Quarries Ltd, was incorporated by an existing firm called Arthur Newsome Ltd, which installed crushing plant at Far Skibeden with a daily throughput of 200 tonnes.

So, in 1931, we had what might seem a confusing situation: the Skipton Rock Co. was leasing Haw Bank Rock and Skipton Rock Quarries on the north side of the hill; the Hargreaves Group Ltd's Embsay Rock Co. operated Skibeden Quarry on the south side; Arthur Newsome Ltd's subsidiary, Skibeden Quarries Ltd, worked Far Skibeden Quarry at the east end. Three totally separate companies all had claims on distinct sections of the hill.

The Newsome Group also owned Scientific Roads Ltd, based in Shipley, and Far Skibeden was geared towards supplying stone to its tarmacadam plant in Shipley. However, as urban people's environmental awareness grew, pressure was put on Scientific Roads to re-locate, and the solution was obvious: new crushing plant was installed at Far Skibeden in 1962, with a daily output four times greater than in the 1931 plant, and new tar-coating plant was built there in the following year.[30] Eventually they were able to close down the Shipley plant. The Newsome Group became part of the Tilcon empire in 1974 and Far Skibeden was closed down a year later, but output was maintained in Skibeden Quarry, which Tilcon also now owned.

HALTON EAST QUARRY

To the north-east of Haw Park were Berryground Quarry, with its two kilns, and Cocktrain Quarry, with one. Neither quarry had seen other than spasmodic activity for many years when, again in 1931, Fred Hargreaves secured a lease on both from Chatsworth Estates. No relation to the Hargreaves Group, he had served the Skipton Rock Co. for forty years, as clerk then manager from 1904 and finally director until 1931, when he took the momentous decision to strike out on his own.[31] As at Skibeden Quarry, new crushing and tarmacadam plant was put into Cocktrain Quarry and over the ensuing decade quarrying removed the area between the two small quarries to form one large quarry that became known as Halton East Quarry, with the company name Halton East Quarries Ltd, incorporated in 1933.

Fred Hargreaves died in 1937 and his son, R. H. (Raleigh) Hargreaves, took control of the family business at Halton East and Hambleton. By 1955 he was quoted as saying 'reserves of limestone at the Halton East Quarries were now within weeks of complete exhaustion' and that the only workable stone left in the Skipton area was on Haw Park.[32] Thus began a battle, almost a war of attrition, to secure fresh reserves to keep the company going. It was to last for eleven years.

The directors had not left everything to the last minute because they had been trying for years to open a new quarry in the Dales and, in 1951, had been granted

permission by the county council to develop an existing small quarry on Eshton Moor (SD 91 57).[33] Ten conditions were attached to the consent but at least the company had a new site... or so they thought. Planning permission had been granted, no doubt because the Government owned mineral rights and stood to gain from royalty payments. Hargreaves wanted the site for its 'blue' limestone, which councils preferred to the white stone of most quarries for roadstone. The problem was that the landowner refused permission, so the plans for Eshton were stopped in their tracks. Consent to quarry, however, was only revoked in 1979.

The company then turned to Marton, south-west of Gargrave, but the landowners here also refused. Not to be put off, attention now focussed on the Cracoe area south of Grassington. A series of conical reef knolls lie at the foot of the millstone grit plateau that separates Wharfedale from the low-lying hills of Flasby and Hetton. The company had specific designs on one particular knoll that enjoyed good road access. They applied for permission to open up Butter Haw Hill (SD 996 608) and in the summer of 1954 carried out exploratory drilling to determine the potential tonnage: 4 million tonnes. Hargreaves applied to have crushing and tarmacadam plant included in the plans but Skipton Rural District Council first objected strongly to the whole idea, then modified its objections, and finally came out against it. Alternative proposals were submitted to site the new quarry at Threaplands (SD 988 604) rather than Butter Haw, but the council still stood in the way. Bearing in mind that this quarry would have entailed eating into Skelterton Hill, another of the reef knolls, it is hardly surprising that objections were so strongly raised in the area.

The newly formed Yorkshire Dales National Park's commission considered, and amazingly voiced no objections to, Threaplands. They said they would prefer a quarry here to the Eshton Moor proposal and would grant consent for the former but, in return, revoke consent for the latter. However, they refused the tar-coating plant. Arthur Raistrick, geologist, archaeologist, and campaigner, probably spoke for many local folk saying Halton East could easily be extended. Hargreaves retorted that he had looked at twenty-eight possible sites and that Butter Haw would have a projected life of sixty years. Halton East, he said, employed forty men and they could not all be thrown out of work by a refusal to allow a new quarry.[34]

Finally, the matter went before the Minister of Town and Country Planning with a request for an official enquiry, due to sit in August 1955, but the company withdrew the request.[35] 'Tremendous opposition' from residents and council alike had won the day.[36]

How did Halton East Quarries resolve the matter? They maintained the lease on Halton East but bought in stone from rival companies to keep the business going. For example, they negotiated a deal with the Skipton Rock Co. for stone for a period of ten years, but at a price favourable to the vendor. The long-term future of the company was secured, however, in 1966, when they bought the lease on Threshfield Quarry on a twenty-five-year agreement, and a new company name entered the Hargreaves family portfolio – Mountain Limestone Ltd.[37]

By this date Halton East had modern crushing and screening plant along with four tar-coating plants, turning out various grades of tarmacadam.[38] The quarry and plant remained in Hargreaves' hands until Tarmac bought the company out in 1979.[39] Now owned by Bardon Asphalt, a subsidiary of Aggregate Industries, in turn part of the Swiss Holcim Group, Halton East acts as a processing site for preparing coated limestone from Over Kellet Quarry near Carnforth in north Lancashire, and hardstone from Holmescales Quarry at Old Hutton near Kendal and Ghyll Scaur Quarry at Millom in west Cumbria, for sale across West Yorkshire and Lancashire. Current planning consent expires in 2013 but is likely to be renewed on a rolling basis.

Clark, Wilson and the Ingleborough Patent Lime Works

Approximately halfway between Settle and Ingleton lies the small village of Austwick. Into this self-sufficient early-nineteenth-century farming community were born two boys, both from relatively humble families. They were to grow up together and to make a significant impression on the lime industry in the Dales. Together they were to reach heights of which their parents could never have dreamed.

Michael Wilson was born in 1816, the son of a stonemason called Robert. Michael began his working life as an apprentice shoemaker, and in 1856 married into a prosperous local farming family, the Grimes of Wenning Bank House at Lawkland.[1] John Clark was born in either 1819 or 1821: different census returns give conflicting information. It has proved more difficult to trace his origins, but he may have been the John born to Robert Clark, who was farming at the hamlet of Wharfe a short distance from Austwick village. We do know that John's first occupation was as a carpenter, and that he married Elizabeth, who came from Crediton in Devon.

The two young men became firm friends and clearly shared the same ideals and ambitions. Both had drive, determination and vision. Both had a social conscience and a clear set of values, as evidenced by their involvement with the Independent Order of Rechabites, the third largest of the Friendly Societies that developed as a response to the many social problems generated by England's rising urban and industrial growth. The Order was formed, in Salford, in 1835, with the aims of promoting temperance (its motto being 'we drink no wine') and assisting those family members who might fall on hard times. Each branch of the Order was called a 'tent' and all tents in Craven were branches of the Lancashire-Yorkshire District No. 3, Rochdale District. The Castlebergh Rock branch met in the Mechanics Hall in Upper Settle. The newly formed Austwick Tent had no meeting place until a group of local men combined resources to provide a meeting house. On 8 February 1851 Michael Wilson and John Clark, with others, signed a memorial deed to present the new Austwick branch with Norcliffe Parrock – a

house with 'clubroom over'.[2] This three-storey building still stands, opposite the village school, but it has lost the external staircase at the rear that gave access to the meeting room on the top floor.

The two men were to retain a close connection throughout their lives, not only in business but also in terms of comradeship. Nevertheless, they went their separate ways in some respects. Wilson eventually moved out of Austwick to live at Brunton House near Feizor and he developed close family links with Canada,[3] while Clark went to live at Swabeck Farm near Giggleswick station, and later at Ribble Terrace in Settle. Through the 1870s he bought up many parcels of land around Bridge End in Settle, as witnessed by a series of deeds and indentures.[4] This was all in connection with the laying out of a new housing estate bounded by Middle Craven Road, Craven Terrace and Ribble Terrace.

Michael Wilson died, aged seventy-four, in 1891 while John Clark died early in 1884, aged sixty-three or sixty-five.[5] Such were their lives in brief: let us now examine their contribution to the development of the limestone industries of Craven.

AUSTWICK WOOD AND GIGGLESWICK SCAR

Not being at all content with their respective roles as shoemaker and carpenter, the two young men put their drive and enthusiasm to work. The railway from Leeds to Settle and Lancaster had been completed in 1850 and the two men organised a day excursion from Austwick to Morecambe. Hire of the train had cost the two men £15 and they allowed children and old folk to go free. This was the first of a number of trips Clark and Wilson organised from Skipton and Austwick and the stations en route to the seaside town, and the venture grew into a profitable source of income for the two, still only in their early twenties.[6]

They used the profits from this to go into partnership, in the early 1850s, with William Thistlethwaite, who lived at either Lower or Higher Bark House to the north of Feizor. He was a limeburner who had operated a kiln and quarry (40) in what was then called Austwick Wood for at least ten years. He is listed in the 1841 census as a limeburner. The site of the lime kiln can still be clearly seen (SD 7790 6851) below the quarry, but the wood has been mostly cleared away except for the parcel that is now considered to be part of Oxenber Wood. It is not known exactly when the partnership was formed, or what induced the two young men to take up limeburning, but a cutting in a local unpublished scrapbook refers to an incident that occurred on 13 July 1853:

> ...as the cart driver of Messrs Clark and Wilson, lime burners, was leading coal from the pits at Fountains Fell, and coming down the hill into Stainforth, one of the horses commenced kicking, and getting loose, galloped away. The horse was so unruly that whilst the driver had hold of its head it pitched him completely over the wall into an adjoining field.

40. All that remains of the kiln operated by Thistlethwaite, Clark and Wilson in the former Austwick Wood.

This short account gives us useful detail. Firstly, by 1853, Clark and Wilson must have been working the kiln without Thistlethwaite. Had he retired, perhaps, or died, or been bought out? Secondly, it tells us exactly where the fuel came from and which way it was routed, giving us an idea of the logistical difficulties involved. From the old pits on top of Fountains Fell to the crossing of the Ribble at Stainforth involves a descent of 450 m, and the drop down into the village is especially steep. Assuming the carts took the most direct route from Stainforth over the top to Feizor and then past Wood House, or the longer route over Sunny Bank and Jop Ridding – all routes then being equally rough – there is a total distance of 14-16 km. With a heavily laden cart, and small hills to climb on the way, that was a long day's journey and a considerable expense.

The partners soon developed a market for their lime in Bradford and they despatched it from sidings that then existed at Lane Side (SD 746 663) near Eldroth, some 8 km from the kiln. If we assume that the kiln was operated on a continuous basis, we have to accept a daily traffic of coal carts in and lime carts out and several men must have been employed as carters and shovellers, and they must have maintained or hired in a fleet of horse and cart units. To fill one rail wagon with lime required thirty to forty cartloads of lime, so the supply chain to Bradford can only have been a drawn-out and costly business and a logistical nightmare.

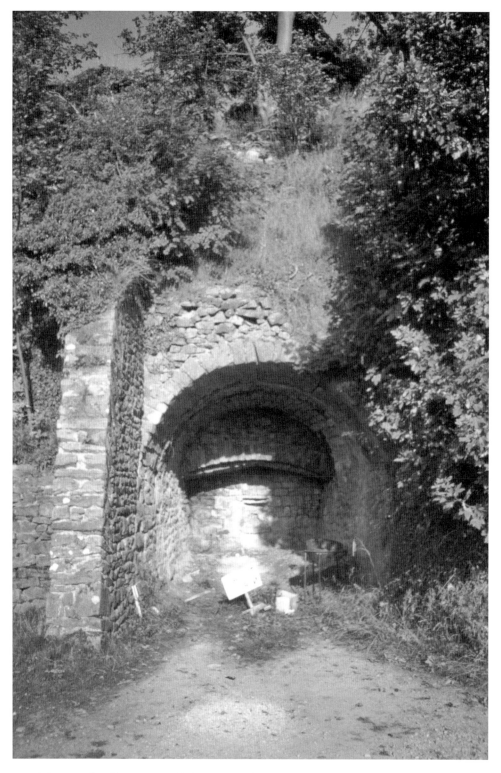

41. 'A large and well constructed kiln' on Giggleswick Scar, most probably the one leased by Clark and Wilson in 1856.

We cannot even begin to guess what their weekly transport costs were, but they obviously found the venture profitable. At the same time they were also earning extra income from selling timber, and one wonders if this is why the old Austwick Wood no longer exists.

They were not ones to stand still and were on the lookout for new opportunities. On 5 June 1856 an advertisement appeared in the local press for a 'Lime Kiln with Limestone Quarry' on Giggleswick Scar. John Proctor of Duke Street, Settle, was advertising the lease of a 'large and well constructed' kiln, hitherto leased by James Midgley.[7] Clark and Wilson left the Austwick site and took up this lease on an annual basis. In 1861 Wilson was entered in the census returns as a 'lime and timber merchant', employing thirty men, so even then he was building up his empire and, as at Austwick, they did not limit their activities to lime burning and timber, but soon established themselves as Messrs J. Clark & Co., selling coal at Settle station. Orders, incidentally, could be placed with Michael Wilson at New Street, Settle,[8] or with Mrs Thistlethwaite of The Shambles in the centre of town,[9] which brings us back to the initial link-up at Austwick.

Field and documentary searches by this writer have identified and located eight lime kilns on Giggleswick Scar, but most of them were too small to be as described in the advert and most of them are not associated with a quarry. However, two 'large and well constructed' kilns of the traditional top-fed, mixed feed variety lie at either end of the golf course clubhouse (41, SD 8080 6490 and 8081 6486). Whichever of these two is the one in question is unknown, but the more western is less substantial in construction and is clearly the older of the two. Both were associated with the quarry behind.

The advantages of operating from Giggleswick Scar rather than Austwick Wood were both financial and commercial. The distance between kiln and railway at Giggleswick was only 3 km and there were no hills in between. Lime could be carted out and coal carted back in again relatively quickly, thus maximising the use of horse and cart. Transport times and costs were slashed. It is possible that Clark and Wilson contracted out this cartage because, on 27 January 1865 for example, Proctor, now of Close House opposite Giggleswick station, was advertising between the station and the kiln in question: 'To Be Let. The cartage of lime, coal and coke.'

By this time, however, our two partners were ready to branch out again. In 1864 Proctor had re-advertised the same kiln and quarry 'To Let' that was 'now in the occupation of Messrs Clark and Wilson'. They had decided to move to Ingleton.

MEALBANK QUARRY

There had been small-scale quarrying at Ingleton for hundreds of years before Clark and Wilson arrived on the scene in 1864. We have seen that Henry Robinson developed the industry at the foot of Storrs Common, but he was not

the first commercial operator here. The 1851 Ordnance Survey map shows several limestone quarries and kilns immediately north-east of the town. Four kilns stood on Storrs, two of which were associated with a quarry that is now an unofficial parking area. Another quarry and kiln were located in Lenny Wood, below which the scant remains of the kiln can still be seen. Within what is now Mealbank Quarry (Col. Pl. 13/14) were two small quarries: the southern one had two lime kilns, including what the 1851 map called 'Mealbank Limekilns' (42). Other individuals were producing lime on a commercial basis somewhere in the vicinity, since in April 1862, William Clarkson placed an advert in the local paper for 'limestone quarrymen'. This site has not been located, and neither have the kilns that Joseph Hunter and William Preston once leased near Ingleton.

The existing Mealbank kilns, however, were leased by John Downham but sub-let in 1854 to R. Brown & Co. as the Ingleton Lime Kilns (Col. Pl. 15)[10]. Several

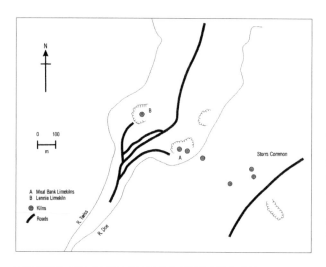

42. Meal Bank Quarry, Ingleton *Left:* Kilns and quarries in 1851 as shown on the first edition of the Ordnance Survey map. *Below:* Ingleborough Patent Lime Works, Mealbank Quarry, as shown on a deed plan of 1939.

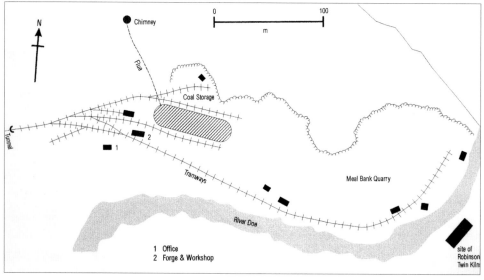

conditions were attached to this seven-year lease, including a requirement that Brown was to construct a new kiln at a cost of £63, to be shared between him and Downham, and to pay an annual rent for the site of £24. Brown declined to renew the sub-lease in 1861 and Henry Robinson – who operated Storrs Quarry across the river – considered taking it on. This he duly did, though only for two years at a rent of £50 per year. He soon came to realise that the new kiln was less than satisfactory, describing it as a 'complete wreck' and threatening not to renew the lease unless the Ingleborough Estate, which owned the site, put it right. They did, and he renewed for two further years but in 1864 it reverted to Downham.

Joseph Bentham operated the large Lennie Lime Kiln in Lenny Wood as the Ingleton Works, and he was also a timber merchant.[11] Bentham was the last to work this site and his abandoned kiln came crashing down in early 1893. It is interesting to note that Brown charged 42 per cent more per load for his lime than Bentham (43). Brown was a bigger operator, so presumably felt this gave him the justification to charge more. Some things never change. Brown had been at Mealbank for a number of years prior to taking the sub-lease from Downham and had advertised in 1851 in the *Lancaster Guardian* his 'superior quality' Ingleton lime, delivered at stations between Wennington and Lancaster at prices varying from 10d to 11½d per load, depending on the distance. The significance of Brown, Bentham, Clarkson and so on is illustrated in the middle years of the nineteenth

43. Invoice from Joseph Bentham of Ingleton Lime Works for lime supplied to the Greenwood Estate in November 1864.

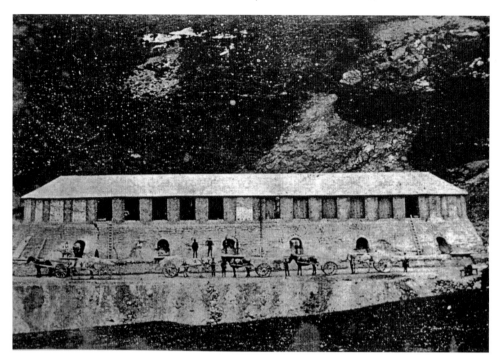

44. The Hoffmann kiln built in Mealbank Quarry in 1868, photographed before the rail link was installed in 1892. (*W. R. Mitchell Collection*)

century, when lime burning was ranked as one of Ingleton and District's main sources of employment, along with a colliery, a slate quarry and a small cotton mill.[12]

It was the Mealbank lease that Clark and Wilson took over on a twenty-one-year lease, effective from 11 November 1868, though they were installed there at the beginning of 1866. The 1868 lease was renewable and reduced the annual rental of £75 to £20, with a royalty of 1*d* per tonne over and above the first 7,000 tonnes. The lessor, James Farrer, the lord of the manor of Clapham who owned much of the land in and around Ingleborough, inserted a clause into the lease giving him and any of his many tenant farmers unlimited right to take lime at 40 per cent below the going rate, a clause that came to be seen as an irritant by Clark and Wilson. For the first four years of their time at Mealbank they used the existing kilns, but in June 1868 they began what was described as an 'important and expensive undertaking, this week … they have commenced building a new and large lime-kiln on a new principle'.[13] This was a Hoffmann continuous kiln, 50 m long and 23 m wide, containing fourteen burning chambers (44). The two existing kilns were abandoned two years later, once the Hoffmann had proved its worth.

CLARK, WILSON & CO.

It has often been written that this was the first Hoffmann kiln to be built in Britain. It was not. At least four lime-burning Hoffmanns predated this one, as well as a number of brick-firing ones. The story of the Hoffmann kiln will be discussed in more detail in Chapter 8. Briefly, Hoffmann patented his new invention in Britain in 1859. The law at the time required a foreign patentor to be present in London to register the patent or to assign a British patent agent to represent the inventor. Hoffmann appointed Alfred Vincent Newton, a London patent agent, in his stead, which is why Hoffmann's patent has been recorded as 'Newton's Specification'. In 1863 the assignment of the patent licence passed from Newton to three other patent agents, namely Hermann Wedekind of Surrey and Humphrey Chamberlain and John Craven, both of Wakefield. They now enjoyed exclusive licence over the Hoffmann patent within the entire British Isles as well as 'full and free power and authority' to issue sub-licences for their own financial gain.

One such sub-licence was issued to Clark and Wilson, sealed on 5 May 1868.[14] This gave them exclusive use of the patent process within a radius of 11 km of Ingleton, Skipton and Settle respectively, and within 8 km of Clitheroe (Col. Pl. 16). It was valid for fourteen years, renewable, and cost Clark and Wilson £500, to be paid off in three instalments starting with an immediate payment of £100. In addition, they had to pay a royalty to the licensors of 3d per ton. The kiln cost them £2,000 to build and, at a grand opening ceremony in January 1869, an old limeburner was heard to say he was 'fairly cap'd wi' seet' of the new kiln.

Shortly afterwards, Clark and Wilson relaunched themselves with a new business identity. They entered into a new partnership with Charles H. Charlesworth, a Settle solicitor, and William Shepherd (who died in 1871), as Clark, Wilson & Co., though they had been using this trading name as early as 1857 (45). The Mealbank site was henceforth known as the Ingleborough Patent Lime Works: in common with a number of other Hoffmann-using quarries across the country, they added the word 'patent' to their business name.

The company pioneered a new method of blasting, aimed at bringing down a greater tonnage of rock to keep the new kiln fed with stone.[15] Shot firers and borers sought out natural crevices in the quarry face, hollowed them out to a depth of nearly 4 m and packed powder in. An eyewitness to the first such blast thought it resembled an earthquake, such was the size of the explosion; other contemporary observers claimed to have witnessed blasts strong enough to hurl pieces of rock into the heart of the village, and others complained of the frequency of such blasts. One particular blast, in 1871, brought down a staggering 229,000 tonnes in one go. The company had sent a bellman round the village in advance to warn everyone, but in the event they turned out en masse to watch.[16]

The new kiln turned out 40-60 tonnes of burnt lime per day, lime which 'could not be surpassed' in quality in England.[17] The company had secured markets

45. Invoice from Clark, Wilson & Co. for lime supplied to the Greenwood Estate in May 1870.

in Halifax, Bradford, Widnes and Gateshead for regular shipments, and it was recognised that they had no real need to advertise their wares. Word of mouth seemed to spread the message widely enough.

It seems puzzling, though, to read that in 1870 the partners were appealing for a reduction in the site's rateable value. A hearing was held in Settle and the bench did indeed reduce it from £225 to £205, but the company deemed even this to be '£100 in excess',[18] so they appealed to the Ingleton court. They cited the tonnage royalty, Farrer's demands, and the annual rent as evidence that their profits were being eroded to the extent that they had had to raise their sales prices above those of their competitors. The case was adjourned *sine die*.

Despite the purity of Ingleton lime, and the good name that the company enjoyed, the profitability of the works was at times subject to external forces. In the autumn of 1876, as an example, and by which time Clark, Wilson & Co. had become the Craven Lime Co. Ltd, all the staff connected with the kiln were put on short-time working because a fire had knocked out a major customer's chemical plant at Widnes.[19] Four years later it was reported that the Hoffmann kiln had been fired up again, having been shut down 'so long' because of a severe depression in the lime trade.[20] This closure had been so protracted that many

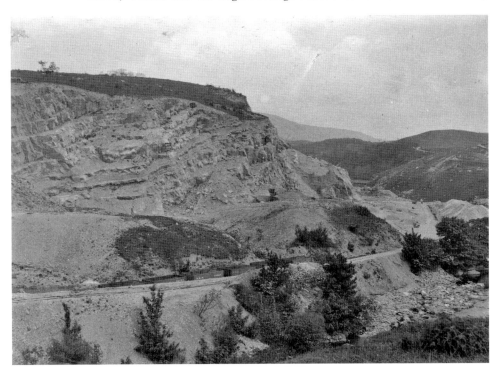

46. Mealbank Quarry, photographed in 1898, showing rail wagons within the quarry. (*British Geological Survey* © *NERC. All rights reserved. IPR/127-55CT. P236100.*)

local families who depended on the kiln had been suffering dearly. Little more than twelve months later, the kiln was fired up yet again, having been partially closed for many weeks.[21]

The lime industry has always been at the mercy of its consumers, predominantly agriculture, chemicals, iron and steel. To paraphrase an old maxim, if those industries sneezed, the lime industry caught a cold. The opposite was also equally true and it did not take much for a quarry to bounce back once trade was restored. By late summer of 1882 the company felt confident enough to purchase Mealbank Pasture, to extend the quarry, to boost the throughput of stone in the kiln,[22] and to buy out the lease (46).

Purchase of the site had become something of a saga, with acrimonious correspondence passing between the company and the estate for six years prior to agreement.[23] The company first offered £2,500, which was rejected out of hand with the estate threatening to re-let the lease or to increase the annual rent now that the Hoffmann kiln was in full operation and boosting company profits. The company retaliated, saying their Langcliffe site, with a newer and larger Hoffmann kiln, incurred lower operational costs whereas the Mealbank kiln needed upgrading, and anyway they had taken out a lease on land at Ribblehead to start quarrying there, so were quite prepared to give up Mealbank. In the end, the estate relented and accepted the offer of £2,750.

On a day-to-day basis the works faced one major problem. All lime had to be carted out, and coal carted back in again, to and from the railway station north of the viaduct at Ingleton. As at Austwick, this was an expensive and time-consuming business, and the company aimed to do something about it. As early as 1882 they had been lobbying for consent to construct a rail link from the kiln to the station. Robinson, across the river, had tried and had been refused and, as we have seen, he upped his Ingleton sticks and moved elsewhere. The directors of the Patent Lime Works had considerably more clout in terms of providing employment and being the economic mainstay of Ingleton, so they persisted... and persisted.

Early in 1889 they called a public meeting for the folk of Ingleton and Thornton to put the case for building a link, and those present voted unanimously in favour because of the 'immense and permanent benefit' it would bring to the town's economy and residents.[24] Armed with this support, the company then approached the landowner whose land the link would cross. The company's general manager, Robert Charnley (born in 1851 in Stainforth), pleaded a strong case, claiming they were crippled by having to rely on horse and cart. It was, he said, costing them £1,000 a year. Charnley, incidentally, was Wilson's nephew and a lime and coal merchant in his own right. They promised to landscape the route with trees and shrubs, and the landowner soon gave his consent for the plan to go ahead. The church bells were pealed, shots were fired in the quarry, and a band marched through the town, so overjoyed was everybody when the news came through.[25] Legal formalities to transfer land necessary for the tramway were completed in 1890, and the contract for the masonry work was awarded to a local mason called John Atkinson: was he of the same family as Richard Atkinson, who had taken over from Robinson on Storrs six years earlier? The rest of the construction work was effected by the company's own men.

Construction finally began and it was believed – fancifully perhaps – that the rail link and the portals for the bridge and tunnel would add to Ingleton's list of tourist attractions. It was opened on 15 August 1892. A small locomotive 'christened' the line by hauling a token load of coal in and a load of lime out. Output was boosted and a new market was opened in Newcastle. So optimistic was the company that they planned to double the size of the kiln 'at no distant date'.[26] It seems such a pity that John Clark and Michael Wilson had died before all this came to fruition, the latter just a few months before the grand opening. At least they could both rest easy in their coffins and be proud of what they had achieved since that first train excursion at Ingleton and in Ribblesdale.

Work to extend the Hoffmann kiln began in July 1893. The number of chambers was increased from fourteen to eighteen, increasing the weekly output of 255 tonnes by nearly one third, and considerably increasing the size of the work force.[27] Atkinson was again the preferred contractor. Already a major employer in the district, Mealbank now became the mainstay of the economy.[28]

The Patent Lime Works weathered the agricultural depression of the 1880s and the 1890s as most of its output was destined for manufacturing industries, and the optimism of the early 1890s was maintained beyond the end of the decade.

Charlesworth, co-director in the former Clark, Wilson & Co., just made it into the new century before dying: the last of the company's founders had now gone though, seeing as he was by then living in Bayswater, he may have bowed out of running the business sometime earlier.

The twentieth century brought increased profits for Mealbank. Apart from the local building trade, 'by far the greatest part' of the output was sent hither and thither to different chemical plants, which valued the lime's purity, and there was an assured market from iron works in the north-east.[29] However, no one could have foreseen what was to befall the works a few years later. The 1906 trading year was 'steady and satisfactory' and 1907 was deemed a 'good average year'. Chemical fertilisers were beginning to reduce the demand for agricultural lime and council road building programmes were being cut back, but there were steady sales to the traditional industrial customers.[30] Within a year, though, disaster had struck. 1908 was described as 'one of the worst experienced for some considerable time'.[31] The company had been on short time for much of the year, but, putting on an optimistic face, the directors did say they foresaw signs of imminent improvement in the lime trade.

Sadly for all concerned, this was not to be. On 19 May 1909 the directors of the Craven Lime Co. called a public meeting to announce and explain their decision to shut down Mealbank Quarry and its Hoffmann kiln. Only three men were to be retained on a care and maintenance basis. Some crushed stone was still being sent to their iron and chemical customers in 1910, but no lime was produced. A decision to close the site permanently had not yet been made, but a company announcement to the effect that 'there was no immediate prospect of their once again becoming busy' can only have depressed the whole community, particularly as a granite quarry further up the dale was also in dire circumstances.[32]

For the next six years the annual Ingleton trade reviews all expressed the hope that Mealbank would reopen and hope did indeed come in 1913 with the placing of a large order for stone. A kind of poetic injustice came into play here: the company could not find any men willing to come back to work. They had all found alternative employment.

The site was never to reopen, and during the First World War the lime works and the Hoffmann kiln were stripped of all salvageable material. All that remains of note there today are the sad and rather overgrown remains of the kiln (Col. Pl. 17), the chimney flue, a cluster of industrial buildings, and the line of the rail link, complete with bridge and tunnel.

This was the end of the works but not of the company. It had long since transferred its main centre of operations to a site at Langcliffe. It is to this that we will turn in the next chapter. Meanwhile, the closure of the site had a negative impact on local farmers who now had to travel to Giggleswick to purchase agricultural lime. With this in mind, Ingleton parish council proposed in 1921 that a disused lime kiln on Storrs Common should be rebuilt and put back into use.[33] The matter was referred to Settle Rural District Council but nothing more was heard.

The Craven Lime Company

Clark, Wilson & Co.'s new Hoffmann kiln at Ingleton proved to be an immediate commercial success but, far from satisfying the partners' ambitions, it acted as a catalyst for further diversification. Within little more than a year of building the Mealbank Hoffmann, they were actively seeking out a site that would satisfy their main criteria: ample reserves of high-quality limestone, adequate space for a Hoffmann kiln and ancillary buildings and sidings, direct rail access, and a location within the radii permitted by their sub-licence. The site they chose nestled on the boundary of Stainforth and Langcliffe, at what was to become their main centre of operations from 1872 onwards. It was quickly to become one of the major industrial enterprises of the Ribble valley and was to dominate the communities of Stainforth and Langcliffe for many years.

It was not appreciated by all, however. A late nineteenth-century guide decried 'that most unsightly piece of business called the Craven Lime Works. It now stands out before us in all its naked ugliness. We do not begrudge the Company its profits or the workman his wage; but why ever did they plant themselves here?'[1]

INCORPORATION, TRANSFORMATION AND LIQUIDATION

To make the new venture possible Clark and Wilson needed to raise extra capital. The time-honoured way for a partnership to do this was to form a joint stock, limited company. This could not be achieved on their own so they sought, and secured, backers willing to invest in their proposed Langcliffe site. No doubt it was Charlesworth, co-partner and solicitor, who had the necessary contacts to make it all come about. Five men came forward as trustees of Clark and Wilson in the new company: Lorenzo Christie of Stackhouse, who formerly owned Langcliffe's cotton mills; Reverend Hogarth John Swale of Ingfield in Settle; Harold Eugene Stansfield of Kendal, barrister; Francis Ellis of the Craven Bank in Settle; and Thomas Dixon, clerk to the same bank (47). Clark and Wilson remained as the principal shareholders.[2]

NAMES, ADDRESSES, AND DESCRIPTIONS OF SUBSCRIBERS.

Lorenzo Christie
 Stackhouse nr Settle – out of business

Hogarth John Swale
 Ingfield. Settle, Clerk in Holy Orders

Harold Eugene Stansfeld
 Bank Top, Kendal. Barrister at Law

John Clark, Swabeck
 Settle Lime & Limestone Dealer

Michael Wilson
 Giggleswick nr Settle Lime & Limestone Dealer

Francis Ellis
 The Craven Bank Settle. Cashier to the
 Craven Bank Co Settle

Thomas Dixon
 Settle, Clerk to the Craven Bank. Co. Settle

Dated the 9th day of April 1872

Witness to the above signatures

James Twisleton
 Clerk to C. H. Charlesworth
 Solicitor
 Settle

47. Initial list of subscribers to the Craven Lime Co. Ltd, 9 April 1872.

№ in allot. Book	Name	No of Shares	Sum payable	Sum paid	Balance due
1.	John Clark	600	1200	1200	nil
2.	Mich¹ Wilson	500	1000	1000	nil
3.	C. H. Charlesworth	800	1600	1600	nil
4	Lor: Christie	200	400	400	nil
5	G. Stansfeld	800	1600	1600	nil
6	Rob. Tennant	800	1600		
7	I. F. Easby	200	400		
8	Edw⁴ Thistlethwaite	5	10	10	nil
9	Will. Robinson	25	50	50	nil
10	Jas Twisleton	25	50	50	nil
11.	Henry Coates	50	100	100	nil
12.	Abᵐ Clapham	100	200	200	nil
13.	I. Thistlethwaite	50	100	100	nil
14	Chris. Wilcock	25	50	50	nil
15	Rob. Hinde	20	40		
16	H. A. Stansfeld	150	300	300	nil
17	B R Stansfeld	150	300	300	nil
18	Fras. Ellis	15	30	30	nil
19	Thos. Dixon	15	30	30	nil
20	H E Stansfeld	200	400	400	nil
21	I. I. Darley	50	100	100	nil
22	I. C. Peters	50	100	100	nil
23	H. I. Swale	200	400	400	nil
24	John Smith	10	20	20	nil
25	Jos: Smith	20	40	40	nil
26	Will: Dowitt	100	200	200	nil
27	W. G. Perfect	100	200		
28	Hen: King Junr.	20	40	40	nil
29	Will. Bissett	10	20	20	nil
30	I. B. Akiroyd	50	100	100	nil
31	John Ellershaw	10	20	20	nil
32	Hector Christie	300	600	600	nil
33	R. C. Christie	200	400	400	nil
34	Will: Ingham	40	80	80	nil
35	Thos. Marsden	20	40	40	nil
36	John Wilkinson	30	60	60	nil
37	Henry Brassington	10	20	20	nil

48. Initial list of shareholders in the Craven Lime Co. Ltd, 2 May 1872.

The Articles of Association of the Craven Lime Co. Ltd state that it commenced operations on 1 January 1872, and the Memorandum of Association states that it was legally incorporated on 10 April of that year (Col. Pl. 18). The objects were, firstly, to purchase and pursue the business interests of Clark, Wilson & Co. as 'lime and limestone dealers and lime manufacturers' at Giggleswick, Ingleton and elsewhere in the West Riding; secondly, to 'purchase and sell again of licences to use Hoffmann's patent kilns'; thirdly, to manufacture tiles, bricks and cement; finally, to trade in coal, coke, timber, guano, manure, slates, flags or stone.

Clark and Wilson did not feature as directors in the new company but remained as joint managers of the Langcliffe and Ingleton sites. Initial appointments to the board were Christie and Swale, along with Robert Tennant Esquire of Leeds, George Stansfield, a Keighley banker, and John Faint Easby, a coal, lime and iron merchant from Bradford. At the company launch 6,000 shares of £5 each were offered on option and virtually all of them were taken up (48). The smaller investor was not ignored. Ellis bought fifteen and the coachman from the Malham Tarn estate, John Whittingdale Ellersham, took out ten shares (49). Encouraging 'ordinary' folk to dabble in stocks and shares is not a modern invention. The matter of share value is a trifle confusing. The memorandum stated, as all such documents are bound by law to do, that the share capital was to be £30,000, made up of the 6,000 shares of equal value. The first list of actual shareholders, however, tells a different story. All issued shares were listed at only £2 each.[3] Had it proved impossible to attract firm investors at £5, or was the balance to be paid at a later date? Share value was quoted at the annual shareholders' meeting in 1873 as being £2 10s,[4] which would lend credence to the former possibility.

Company fortunes gathered pace in its early years and two extraordinary general meetings, held on 10 and 31 October 1877, doubled the share capital by issuing new shares again at £5 each. Perhaps the directors were overly optimistic because by the time the next extraordinary meetings were called, on 8 April and 1 May 1907, only 1,000 of the new shares had been sold, and at only £1 each, so these meetings reduced the company's paid-up capital from £60,000 to £42,000.[5] In February of the following year this was confirmed by the High Court in London. It is probable that the company's fortunes were being adversely affected by the impending downturn at Mealbank.

In the meantime, just before the new company was incorporated, Clark, Wilson & Co.'s entire interests at Langcliffe, Ingleton and Giggleswick were bought out by the new company. In an agreement made in 1872, Christie, acting as trustee, signed an agreement with the erstwhile partners to purchase all their assets for £11,000, to be paid off in stages (Col. Pl. 19).[6] Clark and Wilson were bound by this agreement not to set themselves up in opposition to the new company 'within a radius of 50 miles from the Post Office in Settle'. One must assume that the transfer of ownership was for financial reasons. The old partnership had purchased the leasehold on the Langcliffe site, from Reverend George Paley, on a seven- to thirty-five-year lease with effect from 1 July 1871. They had wanted to build

Malham Tarn
 Bell Busk
 via Leeds

 April 17th 1872

H. Stansfeld Esq.
 Settle

Sir
 In reply to yours, I beg
to accept 10 shares in the
Craven Lime Co. as allotted
to me, & will pay the deposit
in a few days.
 Yours truly
 John Whittingdale Ellershaw
 Coachman
 Malham Tarn, Bell Busk
 via Leeds

49. Letter from John Ellershaw, coachman at Malham Tarn House, recording his purchase of shares in the Craven Lime Co. Ltd, 17 April 1872.

a Hoffmann kiln here, significantly larger than the Mealbank one and with much more ancillary plant than they had ever had at Ingleton. By raising external capital to do this, they lost control of their own business. They still remained major shareholders and did see the Langcliffe site developed, but they had no day-to-day control any more. Christie was the chairman and effective boss.

To backtrack a little, another initial shareholder's name takes us back to Clark and Wilson's early days at Austwick.[7] When they had begun lime burning there twenty or so years earlier, they had teamed up with William Thistlethwaite. When the new company was created, John Thistlethwaite – presumably William's son – was farming at Bark House, and he purchased fifty shares.[8] The link between the families had endured. A second name on the list of shareholders to note was that of William George Perfect (50), listed in 1872 as a farmer at Barrel Sykes between Settle and

50. William George Perfect, 1841-1909. (*The late G. M. Perfect*)

Langcliffe. We met him at a later date in the North Ribblesdale Limestone and Lime Works and at Ingleton, and we shall meet him again. He became an important shareholder in the company, and by 1875 had become company secretary and by 1881 the manager.

Charlesworth also rose to dominate the company with Christie, in terms of shares held, and John Clark brought his sons George and Robert into the business as employees and shareholders. George was the bookkeeper and clerk, rising by 1891 to a position described in census returns as 'stone quarry manager', while Robert was initially a foreman. By 1878 Wilson's name no longer appeared on the lists of shareholders and John Clark was dead by 1884. The old team, apart from Charlesworth, had given way to new faces, with Perfect coming to be dominant. He was further elevated in 1891 to managing director and later company chairman, all this being in addition to his functioning as an independent land agent for limestone quarries in the district. Among the new faces was Leonard Cooper, an iron factor from Hunslet in Leeds who was the managing director before Perfect. A coal merchant from Settle, John Delaney, became a director, along with William Spencer, a lime merchant from Lothersdale near Skipton. Each

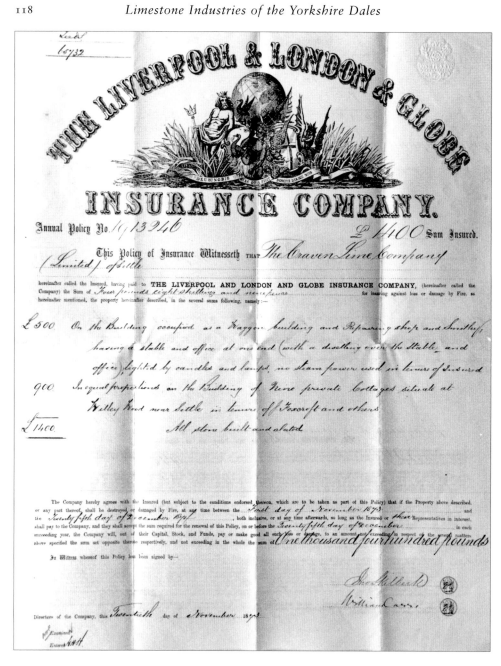

51. Fire insurance policy issued to the Craven Lime Co. Ltd, November 1873.

of these three new faces has his own story to tell, which will be picked up in later chapters. Perfect died in 1909.

An as-yet unexplained transformation came about ten years later. On 14 July 1919 George H. Archer of Burley Grange near Leeds was appointed liquidator of the Craven Lime Co. On 22 July the Craven Lime Co. Ltd, the 'New Company', was incorporated in its place.[9] The documentary record does not indicate why

this change took place, why the 'Old Company' was dissolved just to be replaced by the 'New', unless it was connected with the outright purchase of all the lands at Langcliffe that had previously been leased from Paley, the absentee landlord who lived at Ampton Hall at Bury St Edmunds.[10] Whatever the reason may have been, the legal formalities to effect the change were complex: it took five separate assignments to transfer the Ingleton possessions to the 'New' company and to similarly transfer the property that they owned at Langcliffe prior to purchasing the lease from Paley.[11] Other than giving us these few transactional snippets, the records remain silent. The 'New' company continued operating the Langcliffe site until it was swallowed up by Settle Limes Ltd in October 1939, when three local quarrying concerns were each liquidated and then amalgamated to form the larger and more efficient business. The names Delaney and Cooper were prominent in this change.

THE CRAVEN LIME WORKS

The Langcliffe site was chosen because the Midland Railway Co. was building a new line from Settle to Carlisle. Clark, Wilson and their backers recognised the potential offered by the limestone deposits in the locality: the new railway would give them direct access to their existing markets in Scotland, the north-east, the industrial West Riding and Widnes. The first sod for the line was cut at Anley, just south of Settle, and construction work began in 1869. Within a year Clark and Wilson were actively considering quarrying at Langcliffe, and they took out the lease in July 1871 and began construction of the Hoffmann kiln in the following year, going into full production in 1873 as the Craven Lime Co. Ltd. The directors were not willing to wait until the railway was officially opened up to goods traffic (in August 1875), and as soon as the kiln was completed they were petitioning Midland for sidings to be constructed for them.[12] This was readily granted as no rail line could carry passenger traffic until safety inspectors were satisfied that the bed had been well tamped down: allowing freight traffic ensured this was achieved at no cost to the railway company. According to a contemporary source, the company was already sending off lime to iron foundries in Bradford, so they must have had some temporary loading arrangements in place before the sidings were put in.[13] By 1876 the extensive network of sidings was complete and in full use.[14] Even though they were in Langcliffe parish, for some reason the sidings were known as Stainforth Sidings from the beginning.[15]

Details of the first buildings to be erected on site are provided in a surviving fire insurance policy, dated November 1873.[16] For an annual premium of £4 8s 9d, the company received full fire protection for a wagon shed, a repair shop, a smithy with a stable and office at one end, and a dwelling on the upper floor (51). The total sum insured on all buildings was £500. The whole lot was to be illuminated by 'candles and lamps' and steam-powered machinery was not permitted by the terms of the policy. In addition, nine cottages at Willy Wood nearby were insured

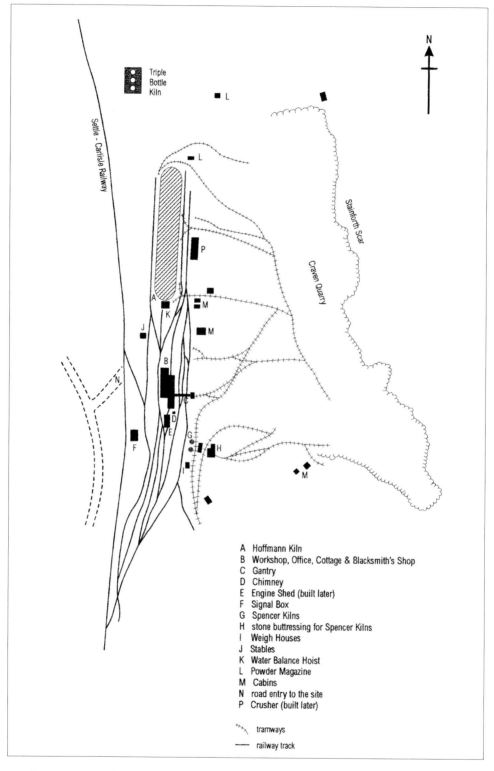

A Hoffmann Kiln
B Workshop, Office, Cottage & Blacksmith's Shop
C Gantry
D Chimney
E Engine Shed (built later)
F Signal Box
G Spencer Kilns
H stone buttressing for Spencer Kilns
I Weigh Houses
J Stables
K Water Balance Hoist
L Powder Magazine
M Cabins
N road entry to the site
P Crusher (built later)

tramways

railway track

52. Craven Limeworks, Langcliffe, site plan, based on a railway estate map of 1912 and a deed of 1919.

on the same policy for £900. The Hoffmann kiln was not covered: a structure that was meant to be permanently alight was hardly likely to burn down, so why bother to insure it?

The 25-inch Ordnance Survey map of 1894, surveyed two years previously, shows that little had changed in the meantime. No map has been identified for the 1870s, so a reliable comparison cannot be made, but the 1894 map shows several very small buildings not mentioned in the fire policy. These would have been cabins for the men, weigh machine houses and powder magazines. The next available maps show major changes to the site.[17] The entire operation had expanded in scale and complexity (52). What had been the original smithy and stable became an engine shed and workshop and a new smithy, with its own chimney, was built just to the south of the old one. The stable block was moved across the yard but the most significant change, however, was the erection of twin, vertical steel kilns at the south end of the site (53). The precise construction date of these is unknown, but they are depicted on the 1907 version of the Ordnance Survey map and the design was first patented in 1900. In 1910 the entire structural assets of the site – quarries, kilns, buildings, tramways, sidings and whatever else – were valued at £746 18s. Each 'upright kiln' – i.e. the steel kilns – was assessed at £77. The only substantial building not in place by then was the crushing plant. It does not appear on any of the maps mentioned so far, and its date of construction is also unknown.

METHODS OF OPERATION

Documentary research, study of old photographs and the oral evidence of former employees have made it possible to draw up a detailed picture of how the whole limeworks operated.[19] The site itself has been appropriately described by Michael Trueman as being important as an 'archaeological document of one stage of development of the Pennines and specifically the Settle area,' because of 'its role within the latter stages of the development of the lime industry' in this country.[20] In the years since he carried out his research many gaps have been filled in and we now have a sounder grasp of the finer details. As this is such an important site, and as many of the features have survived more or less intact, the following narrative will attempt to describe in some depth what actually went on here.

The quarry – Craven Quarry, as it is locally known – has had at least four separate phases of development. For the first twenty or more years of its life, quarrying operations were focussed immediately to the east of the Hoffmann kiln and large workshop building. The natural 'long cliff' (hence 'Langcliffe') of Stainforth Scar was attacked at its base and eaten into. It was worked as one face and all its stone was destined for the kiln. The 1894 map shows one main tramway running the length of the working face with two tramways, south and centre, to carry stone down to the kiln, and a third (north) tramway to return empty carts to the quarry. There is no evidence as yet that stone was being crushed in the early days of the quarry.

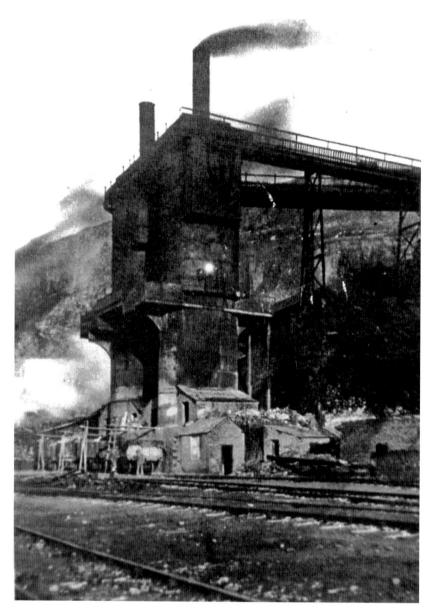

53. The twin Spencer kilns at Craven, showing the upper gantry for loading limestone, the lower gantry for feeding coal, and the planks for barrowing burnt lime into rail wagons below. Probably photographed in the 1920s. (*Roger Worthington Collection*)

A new working face was opened up, sometime after 1894, at the north end of the site. W. George Perfect had taken on the lease of the North Ribblesdale Limestone and Lime Works across the parish boundary in 1886 and had shut down the triple bottle kiln there, but was still leasing the site in 1896. He was by then company secretary for Craven and circumstantial evidence would suggest that he had taken on the smaller concern either to close it down – since it was a competitor to Craven and was a suitable place to dump unwanted spoil from the larger quarry – or to merge it with Craven. At some point a tramway was laid part way up Stainforth Scar from the parish boundary to the edge of Murgatroyd's Quarry. Most of its length has been since destroyed by slippage downslope, but the two branched ends can still be clearly seen. Much of the upper part of Murgatroyd's has been infilled with spoil from Craven. The hypothesis being suggested here is that the north end of Craven Quarry was initially opened up at a high level: waste stone from here was carried north on the tramway to be dumped in Murgatroyd's, while stone destined for the Hoffmann kiln was sent down an incline – which is still extant higher up but lost under later spoil lower down – to the north end of the Hoffmann. This quarry within the main quarry was deepened over the ensuing years, the tramway and incline were abandoned, and a new double-track incline was built to take stone down to the main quarry floor with the waste from here being tipped either side of that incline. This and the drumhouse and cabin at the top are still in situ. Carts were lowered down this incline on an endless rope system, linked together, and full ones descending pulled empty ones, in links of four to six, back up again. A brakesman kept it all under control – most of the time. This was phase three in our sequence. Phase four, which may have been contemporary with phase three, pushed the southern part of the main quarry to the east towards Dicks Ground Plantation. This new extension, which was probably called Meal Bank, was opened up specifically to feed the twin steel kilns.[21]

As Slippet – the name for the northern part of the quarry – grew in size, its spoil heaps began to encroach on the existing tramway from the main quarry to the Hoffmann kiln. To solve this problem, the tramway was encased in a vault, still standing, and the spoil was allowed to spill over it, leaving the vault as a tunnel. As with much else, the date this happened is unknown, but it is not depicted on either the 1907 Ordnance Survey map or the 1912 Estate Map.

A complex network of tramways connected the various parts of the quarries to the three kilns and directly to the rail sidings between the kilns (52). The 1894 map shows three tramways all feeding the Hoffmann, branching from a co-axial tramway running north-south. By 1907 an extra link from quarry to Hoffmann had been laid, and the steel kilns were connected to the main network by a spur, with a separate system feeding in from Meal Bank. In addition, four tramways led directly to the standard gauge rail track alongside or south of the Hoffmann, and these most certainly carried crushed stone (hand crushed in early years) for despatch from the site. A separate tramway link fed a small, unidentified building on the railside. This may have been a small powered crushing mill. That

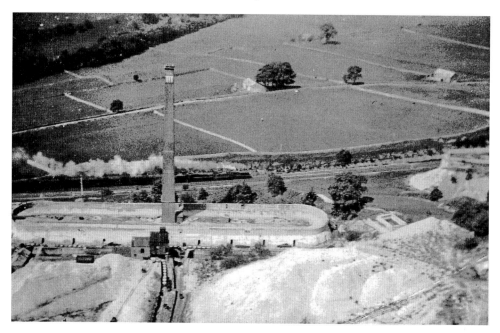

54. The Hoffmann kiln at Craven Limeworks, photographed from the top of Stainforth Scar. The crusher is visible halfway along the kiln with tramway tracks leading directly to it. The incline from Slippet is visible bottom right. Photographed in the 1930s. (*Roger Worthington Collection*)

is pure conjecture on my part, but there seems no other reason for a tramway to terminate there. Later on, again at an unknown date, a large building was erected to the east of the Hoffmann kiln to house crushing and screening plant that was in use until the quarry closed down. Extra tramway lines were laid to feed this building directly (54).

The tramway system so described was permanent but, in addition, there were up to thirty movable tramway lines connecting each working face to the permanent way. As the working face changed, according to the blasting regime, the temporary track was lifted, if necessary, and transferred to where needed. The quarry floor was also crossed by an intricate network of compressed air pipes, set on stilts, feeding air to the borers on the working face. Each borer had his own air supply, his own branch of the network. When a blast had taken place, the rail was laid and the breakers and fillers prepared to move in. Before they could, though, the quarry face had to be made safe. This was achieved by a worker – the barer – shinning down the face, with a rope coiled round his thigh, to prize off any loose rock that might fall on the breakers and fillers below. Each of the thirty lines had its own man whose job was to smash up the rock to the desired size – large, fist-sized pieces for the Hoffmann kiln and small stone for the mechanical crusher, the steel kilns and the rail wagons dedicated for hand-crushed stone. Two types of cart were in use in the quarry. Jubilee carts carried stone to the crusher and spoil to the tips. These had solid sides and a sidewards tipping mechanism,

and were so called because the track they ran on had the manufacturer's trade name of Jubilee. Kiln carts ferried stone to the Hoffmann kiln. Flat-bottomed and open-sided, with wooden ends, they had stone carefully stacked like an upturned 'V', high enough to fit through the entrances to the kiln. Because it took more time and effort to fill a kiln cart than a Jubilee, the breakers and fillers earned slightly more for the former. In the 1930s, for example, filling a Jubilee earned each man 7½d per tonne, a penny less than for a kiln cart.

It was the responsibility of the breakers and fillers not only to smash the stone up by hand, and to fill their tubs, but additionally to push the full carts from the quarry to the appropriate weigh machine, where each man's tally was recorded for his paysheet. This was no easy task on the uneven, temporary track; it was much easier on the permanent way, which was graded slightly, down towards the weighing machines. The carts ran here under gravity, occasionally picking up too much speed. The only way to slow them down was to thrust a wooden sprag into a wheel. On occasion, they ran out of control and were derailed by excess speed, much to the chagrin of the man concerned. There was many a 'spill up', according to one former employee. The journey from working face to weighing machine was undertaken up to twenty-five times each working day when conditions conspired to allow maximum production. Empty kiln carts were linked together and hauled back to the quarry by ponies through the tunnel, on a strict one-way clockwise system. Pony men or boys walked them back to the breakers and fillers they were teamed up with. Once onto the temporary track, they then had to be manually pushed to the face. Being a breaker and filler was not a job to be taken on lightly.

The operation of the Hoffmann kiln was complex, and discussion of this will be resumed in the next chapter. The steel kilns – the 'tin pots', as the men affectionately called them – were Spencer kilns, a very common type of kiln designed within Craven in 1900. We shall return to the Spencers and their kilns in Chapter 10. It might, however, be useful here to make sense of what remains on site. Two massive stone buttresses remain intact. At the base is a flat platform on which the two 3 m-diameter kilns stood, and where a section of steel casing lies forlornly among the rubble. Coal was loaded into the firing chambers from a gantry on the top of the lower buttress. Limestone was trundled from the upper buttress along two metal gantries to the top of the kilns. Stone was then simply tipped in. Brick-built cabins for the kiln operatives nestled against or behind the steel chambers, utilising free heat to keep the men warm, and a weighing machine and office stood against the railway track. Standard gauge rail wagons were shunted under simple, broad-plank walkways so that burnt lime could be barrowed from the kilns and tipped into the wagons. Two lime drawers per kiln spent their eight hours shovelling, barrowing and tipping in a monotonous sequence.

In 1927 one of the tin pots was being re-lined with firebrick. The brickies were halfway up the chamber when a halt was called to their work. Without warning, the Spencer kilns were both shut down and never relit.[22] An entry in the company ledger book, dated 31 July 1942, sealed their fate.[23] The kilns were demolished, and

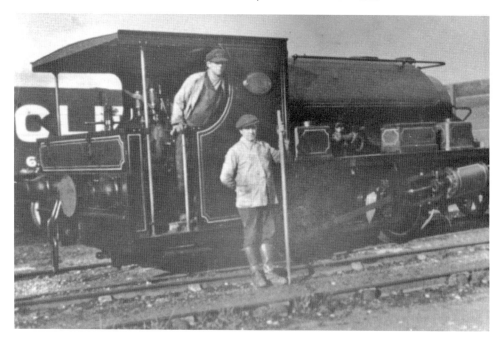

55. The shunting locomotive at Craven Limeworks with the driver, Joe Forster, inside, and the driver's mate, Billy Bullock, outside. (*Kathleen Handy*)

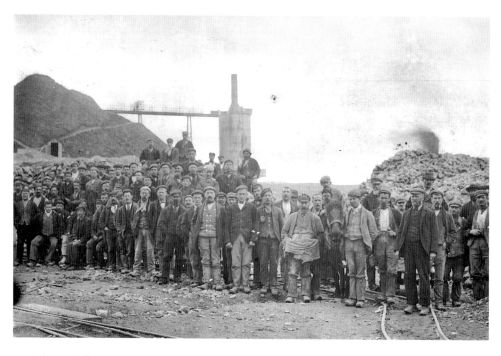

56. The workforce at Craven Limeworks with the Spencer kilns in the background. Date unknown. (*Langcliffe Archive*)

the steel was sold for scrap, raising £161, while the firebrick lining fetched £120. What some of us would now drool over was surplus to requirements and of more value to the war effort than to the firm that succeeded the Craven Lime Co.

The extensive area of what, until recently, could have been mistaken for wasteland, between the Hoffmann kiln and the present road access to the site (which was not there when the site was in use), was Stainforth Sidings. A whole network of tracks linked the main line to every part of the site except the quarry itself and the company's own locomotive spent its days shunting backwards and forwards: coal to the kilns and boiler house, burnt lime from the kilns, crushed stone from the direct tramways and crusher (55). It is difficult today to imagine the hustle and bustle of the site in full operation. In 2008 an archaeological excavation was undertaken to see if any trace of the tracks had survived under the modern tarred surface. It came as a surprise to see that wooden sleepers were still in place, complete with junction mechanisms.

The scene in the 1920s, when the limeworks was operating at full capacity, was of a scale of operations very different from the early days when the Hoffmann kiln was the only major structure here. It was a very different picture to the late nineteenth century, when special rail battens were sent up and down the line to stop trains passing the site when blasting was about to take place.[24] Then, the working face was comparatively near the railway; by the 1920s it had been pushed back to where we see it today. At its height, the limeworks employed well over 100 men, but by the late 1930s only forty or so had work with the company here (56).

A SAD AND UNNECESSARY INTERLUDE

The Craven Lime Co. was one of Ribblesdale's two main employers in the closing decades of the nineteenth century, and not just at Langcliffe. In 1876 the company opened up a quarry near Ribblehead alongside the newly completed railway. The intention was to install crushing plant – probably a small mobile system – in Salt Lake or Colt Park Quarry (SD 773 785), which were worked right through the 1880s for crushed stone. The company also leased land at Ribblehead itself and worked Ribblehead Quarry (SD 767 786) for crushed stone for many years (57). In 1895, for instance, six men were gainfully employed in this quarry. In 1907 they were paying out £63 10s for three months' rent for the lease of the quarry to William J. Brown of Rotherham.[25] This compares with a rental of £83 18s 10d at the same time for the Langcliffe site, which seems incongruous given the complexity of the latter compared with what little there was at Ribblehead.

Working conditions in quarries left a lot to be desired by modern standards. Health and safety concerns were often of no import, and quarry owners and managers certainly got value for money from their workers, especially in lean periods. Men were glad of a job, and management knew it. Many late-nineteenth-century industrial concerns provided housing for their workers, not necessarily

57. Billhead of the Craven Lime Co. Ltd.

from any philanthropic motive but from a desire to have them close at hand. For whichever of these motives applied, management at the Craven Lime Works bought a row of nine cottages, called Willy or Willow Wood, in autumn 1872 on a mortgage arranged by a Bristol relative of Charlesworth.[26] Later on they also bought Ribble Bank, the next row of cottages along the road from the quarry. In 1871 no one connected with lime burning lived at Willy Wood or Ribble Bank; in 1881, however, all the houses were occupied by limeburners, lime drawers, quarrymen or general labourers, according to census returns.

Occupancy of these cottages, or rather the conditions imposed by management on the occupants, was to lead to a long and bitter dispute that erupted in September 1902.[27] At the end of August the men living in Willy Wood were given notice to quit their houses, but all steadfastly refused. George Perfect and George Clark responded by threatening to evict them. That sort of tack tends not to go down very well when relations are already strained, and eighty-five of the men employed at Craven walked out. Management's response was swift: the strikers were all locked out. By October the strike was affecting around 100 men and boys and threatened to escalate even further, so talks between management and men were convened. The men agreed to call off their action if management would drop their demands concerning what the men did out of working hours. Management accused the men of pressurising them to only employ union members, claiming this was the sole cause of the dispute as far as the company was concerned. The union representatives, of course, denied this and the strike dragged on. Management brought in, under cover of night, strike breakers from the Free Labour League, but Settle Rural District Council threatened the company with action for accommodating these men in the wagon shed, which was an infringement of local by-laws. Perfect pleaded ignorance of this law and asked for leniency for the company, and was granted it. The strike breakers stayed, production was returned to near normal, the strikers could not stop rail shipments going out, and management dug its heels in very firmly.

1. The Craven Basin – 'well cultivated and rich in soil'.

2. A landscape of dry-stone walls and field barns on Gunnerside Bottoms in Swaledale.

3. Acidic soupy pastures near Ribblehead, with Ribblehead Quarry in the foreground.

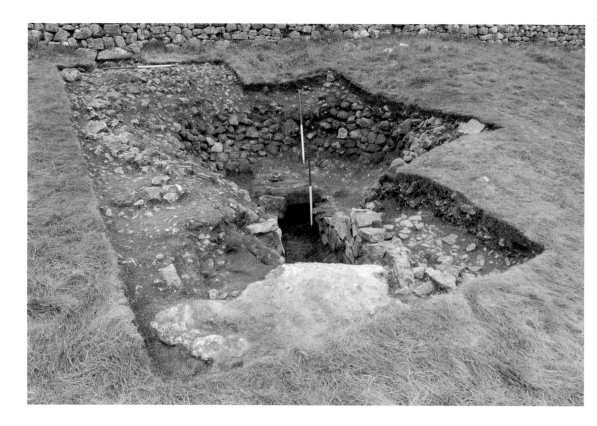

Above: 4. A mid-seventeenth-century clamp kiln at Kilnsey in Wharfedale after excavation in 2007

Left: 5. Interior of the cylindrical bowl of a commercial kiln at Broughton Fields Quarry.

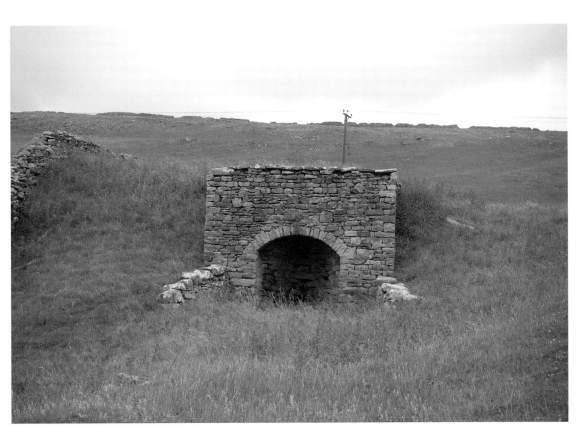

6. A square-fronted field kiln near Marrick in Swaledale.

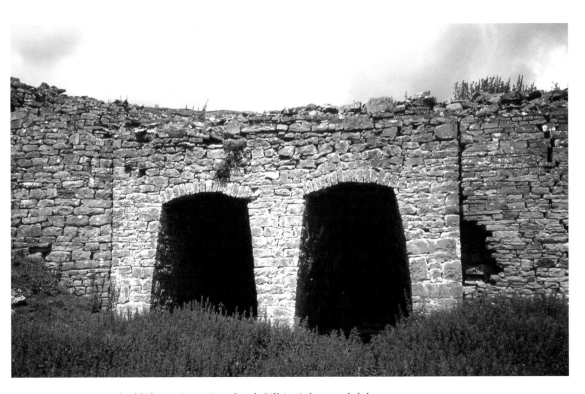

7. A twin-arched kiln in Great Punchard Gill in Arkengarthdale.

8. The oval bowl of a large, twin-bowl commercial kiln at Watlass near Masham, after excavation in 2007. Note the two opposing draw holes, or eyes, and the wooden floor.

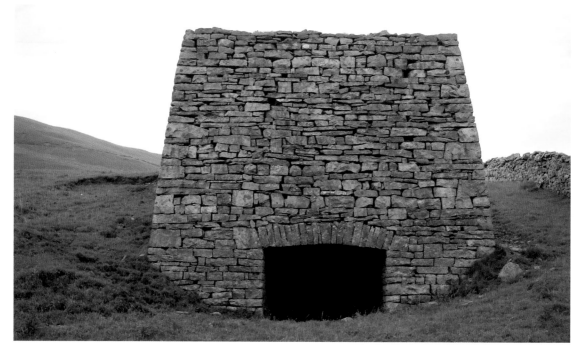

9. A large and well-constructed commercial kiln above Dentdale.

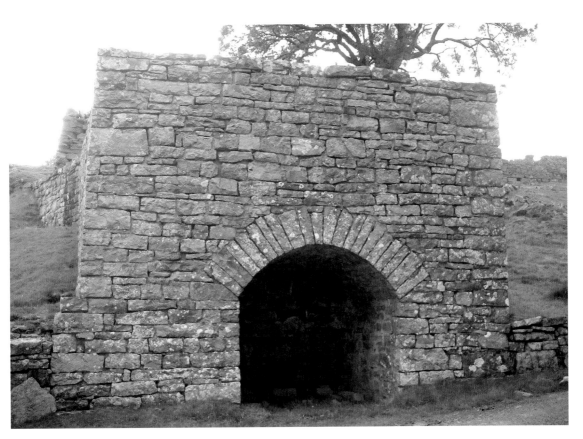

10. A nineteenth-century commercial kiln at Seal Houses in Arkengarthdale.

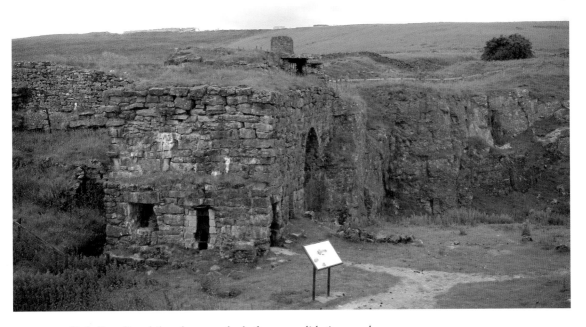

11. Toft Gate lime kiln, photographed after consolidation work.

12. Quarrying into the core of the Skipton anticline in Skibeden Quarry.

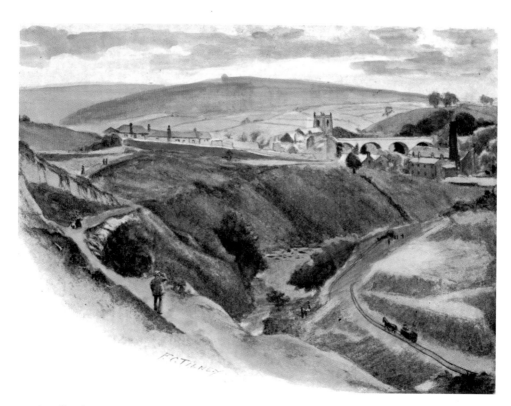

13. Mealbank Quarry from Storrs Quarry, Ingleton, prior to the installation of the rail link in the 1890s. Painted by F. G. Tilney.

Above: 14. Mealbank Quarry, Ingleton, as it is now.

Right: 15. Invoice from R. Brown & Co. of Ingleton Lime Kilns for lime supplied to George Denny in May 1864.

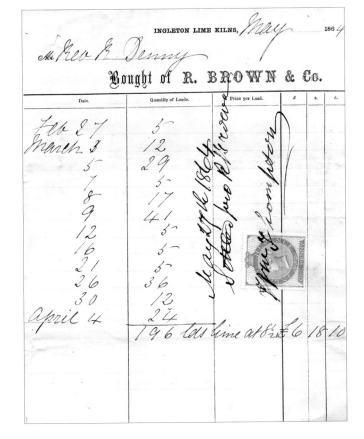

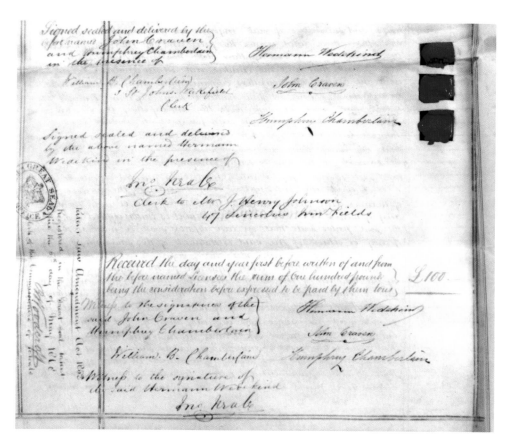

16. Signatures of Hoffmann's patent agents – Hermann Wedekind, John Craven and Humphrey Chamberlain – on the licence issued to Clark and Wilson, dated 29 May 1868.

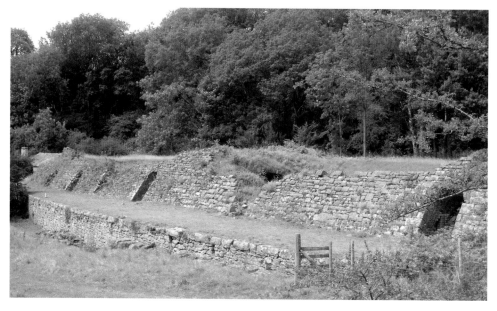

17. The Hoffmann kiln at Mealbank Quarry, photographed in 2010.

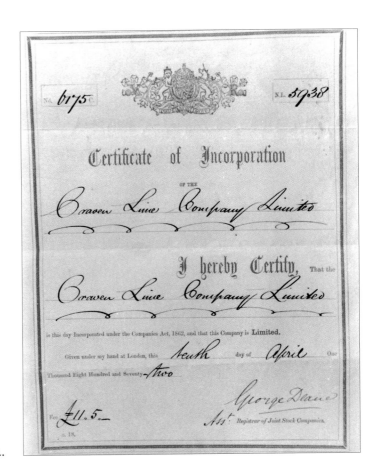

Right: 18. Certificate of Incorporation of the Craven Lime Co. Ltd, dated 10 April 1872.

Below: 19. Signatures to the transfer of assets from Clark, Wilson & Co. to the Craven Lime Co. Ltd, 29 October 1872.

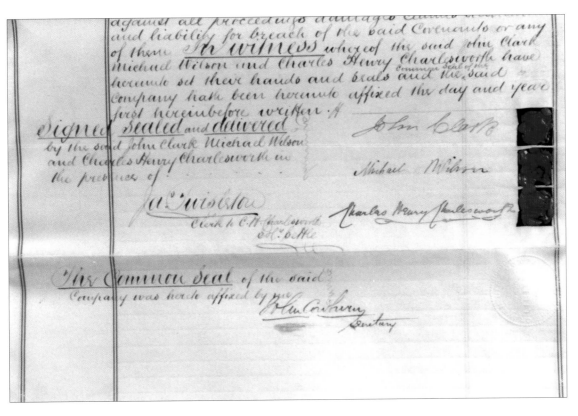

Left: 20. The original drawings submitted with Hoffmann and Licht's Prussian patent application of 27 May 1858. (*Geheimes Staatsarchiv Preußischer Kulturbesitz*)

Below: 21. Inside the Hoffmann kiln at Craven Limeworks, with daylight highlighting the individual chambers.

Right: 22. A reconstruction of the Hoffmann kiln at the Craven Limeworks during its working life. (*Yorkshire Dales National Park Authority and Anne Leaver*)

Below: 23. A Ruston-Bucyrus navvy introduced to Horton Quarry in the 1950s. The rock face collapsed on it in 1981 or 1982. (*Hanson Aggregates Ltd, Horton Quarry*)

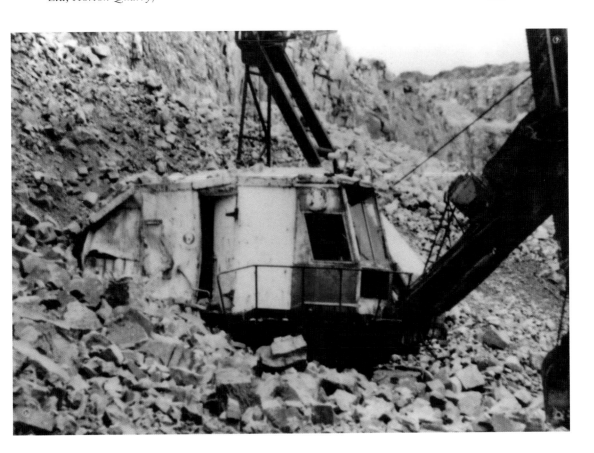

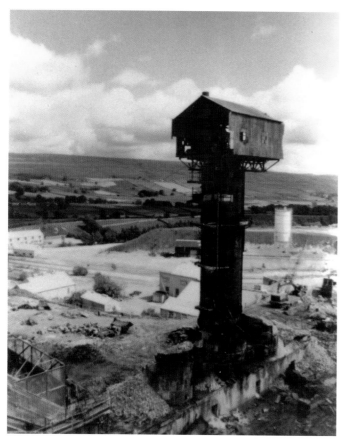

24. The last Priest-Knibbs kiln at Horton Lime Works being demolished in 1985. (*Hanson Aggregates Ltd, Horton Quarry*)

25. Plan of Small House and Garrow Copy with areas to be quarried marked in pink and pencil, in a deed dated 28 February 1922.

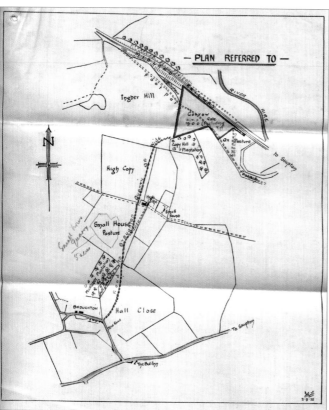

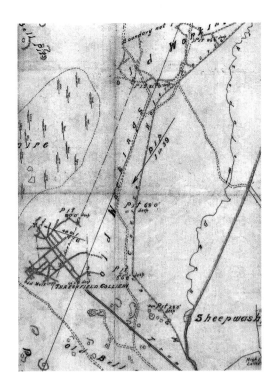

Right: 26. Coal Abandonment Plan of
Threshfield colliery, dated 4 November
1905. (*The Coal Authority, Mining
Records Office,* 4862)

Below: 27. Kilns at Ribblesdale
Limeworks being demolished in the early
1980s. Note the vaguely hourglass shape
of the bowl. (*Jessie Pettiford Collection*)

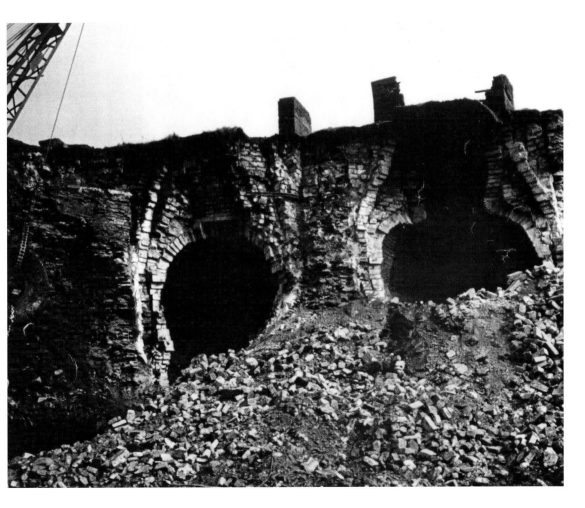

Above: 28. Thornton Rock Quarry, photographed in 1999.

Below: 29. Giggleswick Lime Works, photographed in the 1970s.

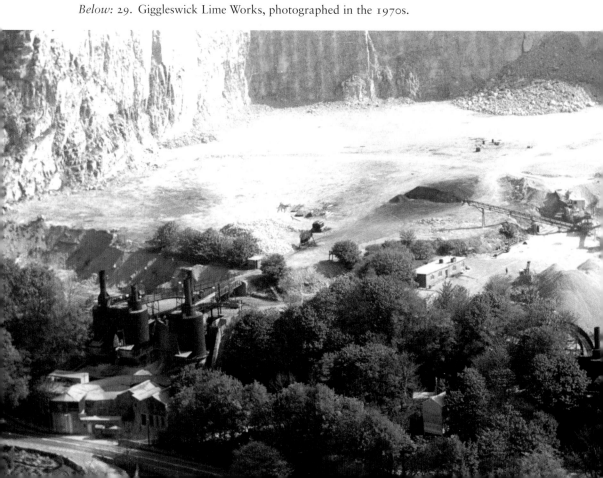

30. The kilns at Ribblesdale Limeworks, photographed in 1982 just before demolition.

31. The weigh house and office at Ribblesdale Limeworks, adjacent to the old rail siding trackbed. (*Jessie Pettiford Collection*)

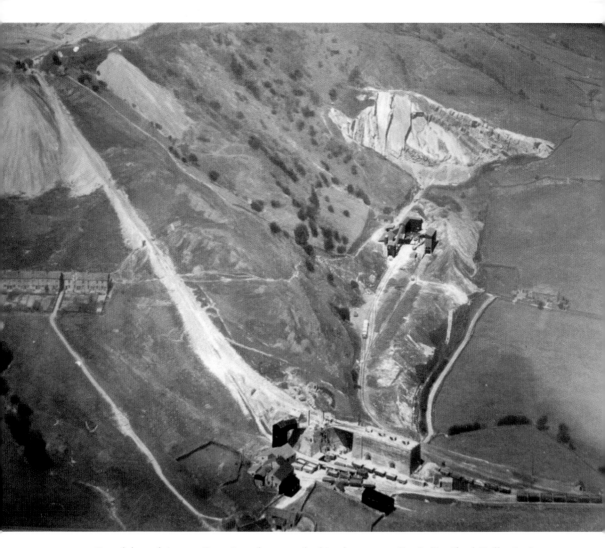

32. Foredale and Arcow Quarries, photographed in the 1950s. (*Jessie Pettiford Collection*)

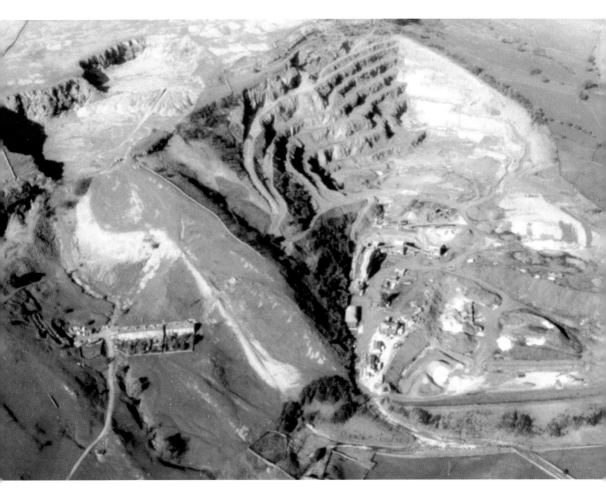

33. Foredale and Arcow Quarries, photographed in 2000. (*Tarmac Ltd*)

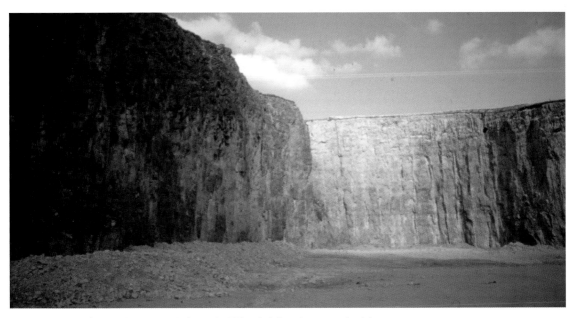

34. Cool Scar Quarry at Kilnsey in Wharfedale, photographed in 2003.

35. The eastern part of Harmby Quarry, now an inaccessible haven for birds.

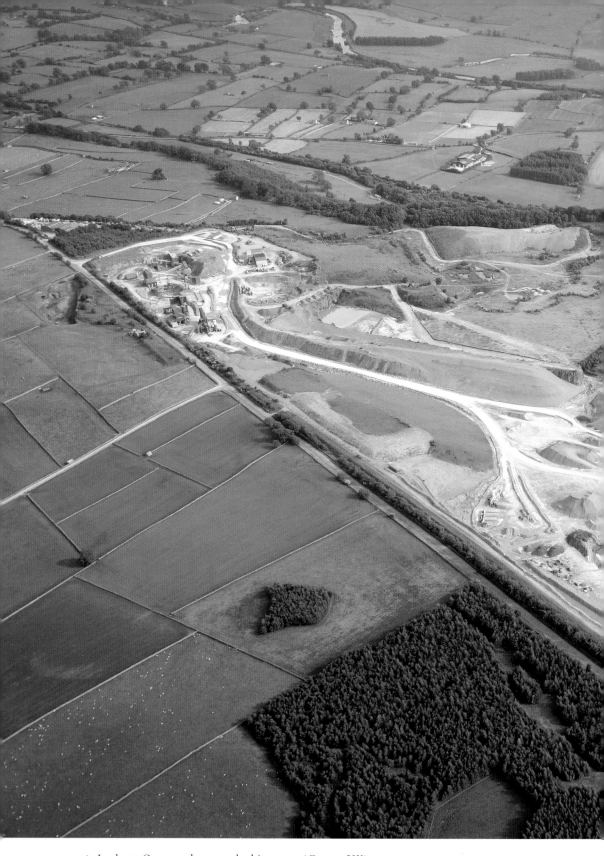

36. Leyburn Quarry, photographed in 2007. (*Cemex UK*)

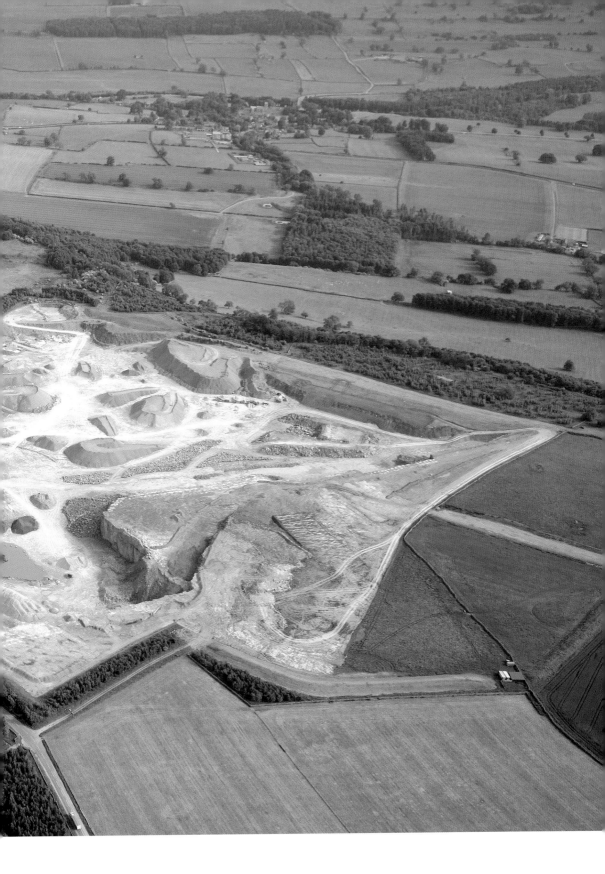

37. Redmire Quarry, photographed in 1993 after its closure, looking towards the plant.

38. Concrete standards for the conveyor belt in Preston-under-Scar Quarry, installed in 1957.

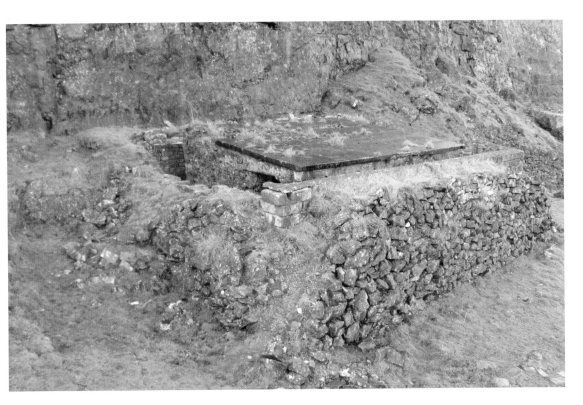

39. The powder house in Foredale Quarry.

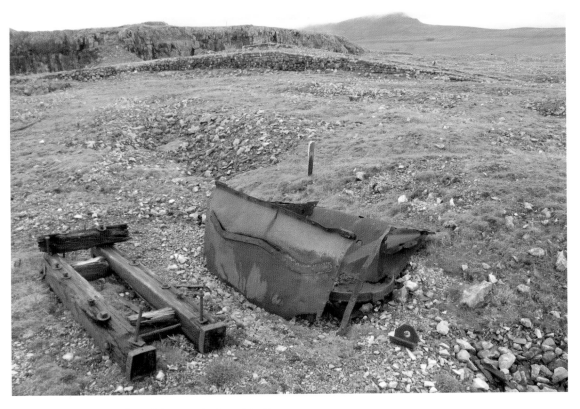

40. Remains of a Jubilee cart in Foredale Quarry.

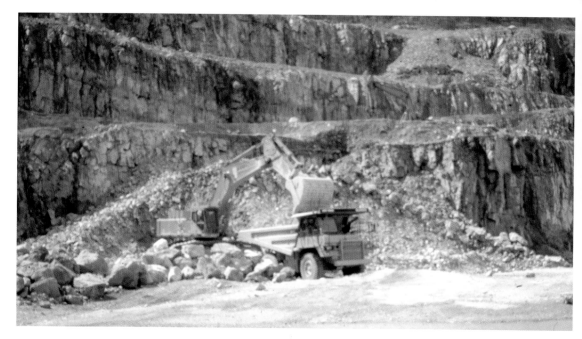

41. Mechanised quarry face and haulage plant in Coldstones Quarry, photographed in 2001. A Hitachi EX800 is loading a CAT771 40-tonne haulage truck.

42. Modern quarry face and haulage plant in Leyburn Quarry, 2007. (*Cemex UK*)

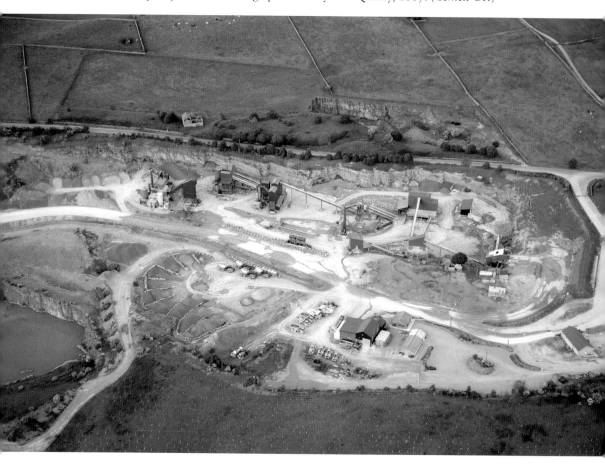

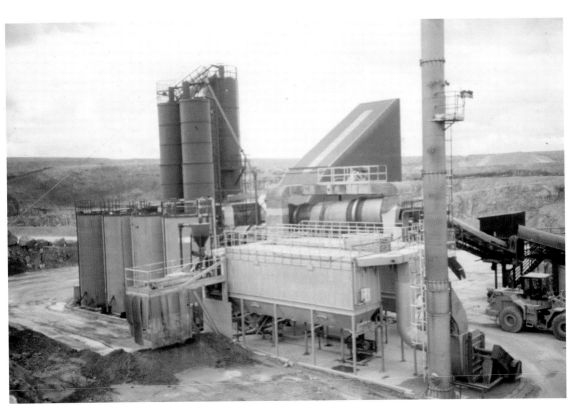

43. Tar-coating plant at Coldstones Quarry, photographed in 2001.

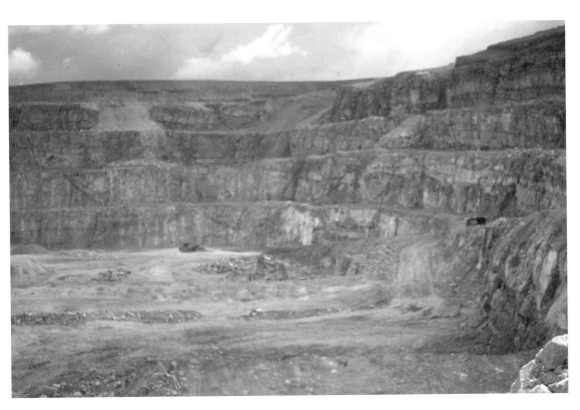

44. Coldstones Quarry, photographed in 2001.

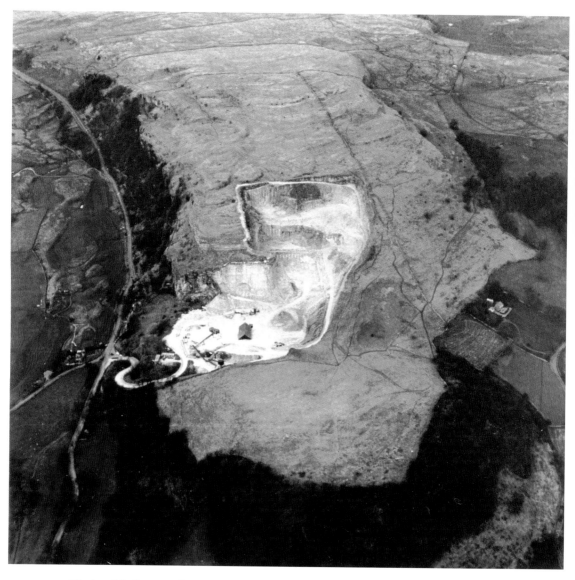

45. Giggleswick Quarry, photographed in 2001. (*Hanson Aggregates Ltd, Horton Quarry*)

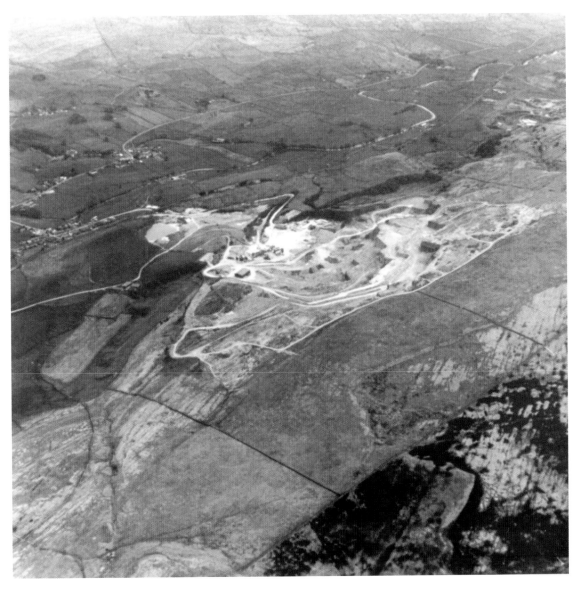

46. Horton Quarry, photographed in 2000. (*Hanson Aggregates Ltd, Horton Quarry*)

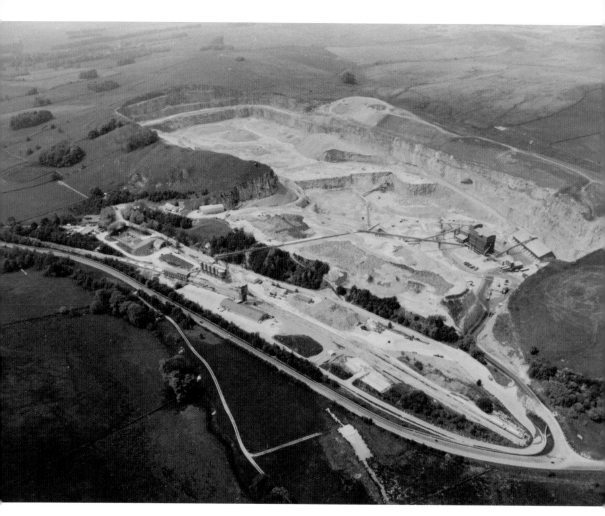

47. Swinden Quarry with its state-of-the-art plant, photographed in 2001. The mobile crusher is below the main bench (top centre) and a mobile conveyor feeds a fixed conveyor taking stone to a stockpile, then to the main crushing and screening plant (centre right), then to the toastrack storage bunkers behind, or to the automated lorry-handling station. A further conveyor carries aggregate to the rail loading facility (centre left). (*Tarmac Ltd*)

More strike breakers were brought in, from Leeds, but this time the pickets got wind of what was afoot and persuaded all of them to return home. The union called a public meeting in Settle's Victoria Hall on 7 November, which gave unanimous support to the strikers and called upon management to accept arbitration. The request was turned down. In February 1903 the company was still refusing to give an inch as they were able to recruit sufficient compliant labour. They even offered to take back any of the locked-out men if, and only if, they gave up their union membership. On 10 February Hector Christie, chairman of the board, read out a long and precisely argued statement at the annual shareholders' meeting. He said:

> In July, 1901, the Gasworkers' and General Labourers' Union held meetings in the Settle neighbourhood for the purposes of enlisting members. A number of the Langcliffe workmen joined. On April 3rd, 1902, a letter demanding an advance of wages for every union man and boy at the Langcliffe works were [*sic*] received from ... the above union. He [the union rep.] was informed that the company did not recognise his right to interfere ... Meetings of the union men were then frequently held, and great pressure brought to bear on the non-union workmen ... to make them join the union. Those that refused were bullied and threatened. [28]

As a result, Christie continued, the whole situation had become so unsettling that the men concerned were given notice to leave the company. Of the 118 then employed at Langcliffe, only forty-one chose to remain. The rest formed pickets and used every means, including 'abuse, intimidation, assault and advertising', to put pressure on the forty-one. Christie accused the union of using the grievances over the cottages as an excuse to prolong the strike. The conditions imposed on their tenants were reasonable in his view and surely could raise no objection. The conditions imposed were that no tenant could be a member of any trade union; any tenant wishing to take in lodgers could only take in employees of the company; all tenants had to keep their cottage in a good state of repair. [29] Christie maintained the company had been a good employer from the start and simply could not understand why it had been 'singled out for attack'.

As always, there are two sides to every story. The company did not pay the going rate and it galled the men to see John Delaney Ltd at Horton Quarry, higher up the dale, paying the full amount to its employees, up to 1d more per hour, in fact. It also galled the men that management at Craven demanded from the men about 1,120 kg per tonne instead of the accepted 1,016 kg. Nor did Craven charge the shot firers, who worked on a contract basis, the accepted amount for the powder the company supplied. Craven overcharged them by 25 per cent compared to Delaney and Spencer's quarries. Furthermore, according to the union, the men who lived in company houses were *required* to take in lodgers and to repair the houses at their own expense, which was considered grossly unfair.

Management might have taken fright at these facts being aired in public but they took an alternative course of action by evicting all but three of the tenants.

They refused to employ any union members, and continued to bring in men from outside. They also took legal action against some of the men. Twenty-eight pickets were hauled before the magistrates and fined; William Whaites Sr and Joseph Smailes were sued for repossession of their cottages at Ribble Bank; Robert Bentham, David Potter Jr, Thomas Oakden and Thomas Taylor were all summoned for non-payment of rent for living at Willy Wood. The court ruled they must pay up and then move out.

In March 1903 Reverend Father Parkin of Settle tried to arbitrate but Christie stood firm. Under no circumstances would he budge. The strike began to fizzle out: some men took up jobs with Delaney, a dozen or so moved to Otley, others dribbled back under management's terms. By May it was effectively over. Management had all the non-union men it needed, production of crushed stone was back to pre-strike levels, and the second fire in the Hoffmann kiln was lit again to bring it back up to full production, the kiln having been operated at only 50 per cent of normal capacity since July of the previous year.

A strike that had endured for nine long months, through winter, had ignominiously ended with total victory for the company. Despite the loss of sales during the strike, they still managed to declare a dividend of 33 per cent in March 1903, 10 per cent up on 1902, and to pay a bonus to all the forty-nine employees who had by then returned to work.[30] The strike was not officially declared over; it merely faded away.

CLOSURE

The Craven Lime Works prospered for another twenty or so years, but from the mid-1920s external factors began to erode its profitability. The 1926 General Strike caused a partial shutdown of the site, not because lime and crushed stone could not be produced, but because it proved well-nigh impossible to obtain rolling stock for despatching the stone and lime and bringing in coal. The company never really recovered from this. The tin pots, as we have seen, were shut down soon afterwards, the same year that the company entered into a business agreement with two other quarry companies in the dale, which meant that the three constituent parts effectively operated as one business. They were henceforth combined under a unified management structure effective from 1 August 1927, which was intended to last for twenty-one years.[31] Though the three quarries and their kilns still marketed in competition with each other, they were selling under a common name, 'Setelime', a portent of what was to come. In August 1931 a severe downturn in trade over the summer, coming on top of increasingly severe competition from elsewhere, led to the closing down of the Hoffmann kiln. It had lost out to more cost-effective kilns within the group. Fifty men were laid off, though some were kept on to maintain intermittent output of crushed stone from the quarry.

There was a somewhat touching coincidence in 1931. The kiln was allowed to go out on the last day of August. On 10 April that year the death of Richard

Johnson was announced. He was one of those whose job it had been to strip off the turf to start the very first quarrying here back in 1871. One feels thankful, in retrospect, that he did not live to see the place close down.

In 1935 the declared capital of the company was formally reduced from the £42,000 authorised in the 1919 transformation from 'Old' to 'New' company to a mere £15,750 – sufficient, it was deemed, to keep the site ticking over.[32] The kiln and quarry had effectively ceased working in 1931 but the crusher and stacking yards continued in use. Foredale and Arcow Quarries, part of the triumvirate, were turning out more stone than they could store, and much of the excess was transferred to Langcliffe.[33] The necessary equipment and machinery were installed and the site was relegated to a storage and distribution centre.

Closure of the Hoffmann kiln was intended to be temporary, and indeed it was – if the meaning of that word can stretch to six years. It was fired up again in 1937, on one fire, but on 19 May 1939 the remaining forty employees were given final notice. The kiln was shut down permanently, though again the crushing and screening plant was kept running for another year or so. On 25 August 1939 the Craven Lime Co. Ltd went into voluntary liquidation and its entire assets were transferred to the newly formed Settle Limes Ltd, along with the assets of the other two companies in the triumvirate.[34] John Delaney Ltd had changed its name to Settle Limes Ltd shortly before taking over the assets of Craven and the Ribblesdale Lime Co. Ltd. Even before 1939, though, effective control had passed out of local hands, though William Hill Parker of Settle was the new company's first managing director. He had started his career as an office minor for John

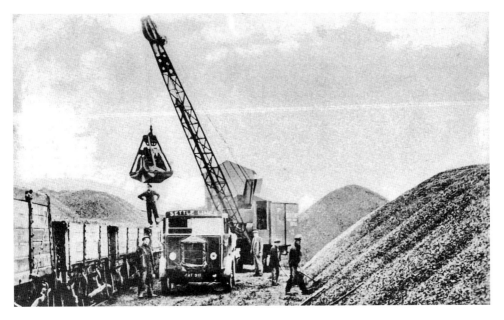

58. Craven Limeworks site in use as a storage and distribution depot for Settle Limes Ltd from the late 1930s. (*R. Worthington Collection*)

Delaney, had progressed to being a travelling salesman for him, and then became chief of the office staff. When Delaney died, Parker to all intents and purposes ran the company for Carrie Delaney. Parker died in 1937 and he was the last local man in the management of the company. After Parker it was Leonard Cooper, father and son, who ran John Delaney Ltd and then Settle Limes, though the joint chairmen were A. and F. Woolley-Hart of British Tar Products and the Breedon and Cloud Hill Lime Works in the East Midlands. Michael Miles-Sharp became general manager of Settle Limes at its inception, rising in time to become deputy chairman. In 1965 he was promoted general manager of ICI Mond, which had taken over Settle Limes in 1961. None of these men were local to the Dales.

To move back a little, the entire Langcliffe complex shut up shop in 1940. The two previous years had been less than promising and 1940 was described as 'a most difficult year' in the trade across Britain.[35] The agricultural season had been disappointing, the building trade was in recession, and production in the steel industry lunged from one extreme to another. The Craven Lime Works had to be sacrificed, but not totally abandoned. The site was maintained for at least twenty years and used as a stocking ground for crushed stone from the non-limestone Arcow Quarry at Helwith Bridge (58).[36]

In 1967 Settle Limes leased 'all the lands buildings and premises known as Craven Quarry' to Settle Rural District Council as a landfill site for a period of twenty-one years effective from the previous autumn.[37] It was a rather ignominious end, but one that has been a common fate for many redundant quarries across the country.

Before we leave Langcliffe, however, let us have a closer look at the Hoffmann kilns here and at Mealbank in Ingleton.

The Hoffmann Continuous Kiln

Of the many kiln types that were tried and patented during the latter part of the nineteenth century, the Hoffmann kiln proved to be the most enduring. Indeed, the technology is still in use in many parts of the world today for brick manufacture, though the use of Hoffmann kilns for burning lime died out in Britain nearly sixty years ago. The principle was first conceived in 1856 by Friedrich Hoffmann in what was then Prussia, and it was patented by Hoffmann and his collaborator, Albert Licht, in Vienna on 17 April and in Berlin on 27 May 1858 (Col. Pl. 20). The first patent in Britain was lodged by Hoffmann's English patent agent, Alfred Newton, on 22 December 1859.[1] Use of the technology spread rapidly across Europe and the rest of the world and, by 1898, there were more than 5,000 such kilns in operation.[2]

The early patents described a circular kiln with a continuous firing chamber, or annulus, divided into twelve compartments of equal size arranged around a central smoke chamber and chimney.[3] In 1865 Hoffmann and Licht registered a further patent, modifying the original concept to a sub-rectangular or elliptical form, containing twelve or more compartments. Over the next twenty years further modifications were carried out, all protected by further patents.

German literature invariably refers to these kilns as ring kilns or circular firing kilns but in Britain they have, from the beginning, been known simply as Hoffmann kilns, often losing the final 'n' in the process. The technology was revolutionary, though the inventors faced legal and political opposition in Germany,[4] and had their patents annulled in 1870 by the Prussian Government.[5] But the invention was still seen across Europe as the most fuel-efficient lime and brick kiln available. Hoffmann was showered with accolades, including an *honoris causa* medal in London,[6] in recognition of what he had achieved in furthering kiln technology.

This is what Clark and Wilson had bought into in 1868 when they obtained the sub-licence to build a kiln at Ingleton. The sub-rectangular kiln they erected was by no means the first Hoffmann kiln to be built in this country: a number of brick kilns preceded it, as well as at least three circular lime-burning kilns. However,

it was one of the earliest such kilns in Britain, and was one of only twenty or so lime-burning Hoffmann kilns so far identified and located by this writer in England and Wales.[7]

Though all Hoffmann kilns share the same basic technology, it was never the inventors' intention that every kiln must be identical, especially with the sub-rectangular kilns. There could be variation in size, number of chambers, and layout. The number of chambers could vary from twelve upwards, the internal volume of each chamber could vary within a workable range, and the type of fuel used depended on what the kiln owner preferred or had available. The position of the chimney was flexible and its height depended on local topography. All these points of flexibility will be exemplified by comparing the kilns at Ingleton and Langcliffe.

KILN STRUCTURE

Total chamber length was critical to the successful operation of a Hoffmann kiln. For effective combustion and cooling, chamber length needed to be as long as practicable. The Ingleton kiln had an original length of 84 m, later increased to 130 m, with fourteen and later eighteen chambers. Langcliffe's was 244 m long with twenty-two chambers, and both had a height of 2.6 m and a chamber width of 5.2-5.5 m.[8] The average length of each chamber, measured from door to door, is 7 m at Ingleton and 11 m at Langcliffe, in both cases ignoring the fact that the end chambers are much longer than the side chambers.

Total chamber length was important because it directly affected fuel consumption. A longer annulus (the continuous chamber) contained more cooling chambers, and the waste heat from these could be recycled to preheat other chambers awaiting the fire instead of using fresh fuel in the heating process. More cooling chambers meant more heat could be utilised in this way. A longer annulus also facilitated control of fire travel, the rate at which the fire progressed around the kiln, particularly at weekends and holidays when the fire had to be slowed right down. The annulus was built in the form of a vault, using roughly cut stone lined with firebrick and an outer shell of coursed stone, battered inwards at an angle (Col. Pl. 21). The internal flue chambers were built into the core of the kiln and the space between the roof and the walls was packed tightly with a mixture of rubble and sand to reduce heat loss from within the kiln. If a kiln was erected on clay or impermeable rock, where rising water might cause damp within the kiln, it was often set on a bed of asphalt, cinders, cement or stone. The top of the kiln was finished off with a layer of cobbled or semi-dressed stone.

In the original patents Hoffmann included a wooden roof over the whole kiln, structurally independent of the kiln itself. Early photographs of both Ingleton and Langcliffe show a roof in place, resting on a curtain wall, which was unusual because many Hoffmanns had a wider, free-standing roof. The Craven variety of roof, if we may call it that, would have been easier to construct, and thus cheaper, though it obviously gave no protection to those working at the kiln entrances (59).

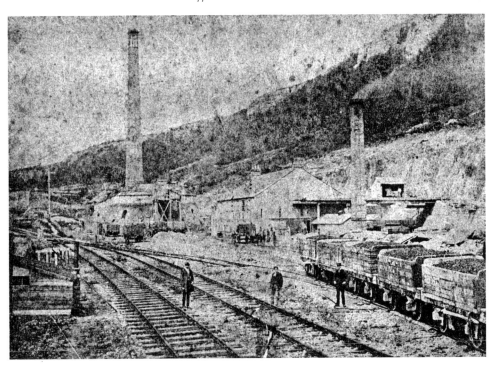

59. The Hoffmann kiln at Craven Limeworks with its roof in place and the first water-balance hoist at the near end. Details of the railwaymen's uniforms suggest the early to mid-1890s. Details of the wagons indicate 1880s or early 1890s: these are dumb-buffered wagons (with a wooden buffer), but new regulations introduced rounded metal buffers in the 1890s.

The kiln at Langcliffe did have a roof when first built in the 1870s, but it was later removed. Archaeological evidence indicates that the kiln was substantially modified and increased in size in the late 1890s, and the roof may have been taken off for this and just not put back. The puzzle is why it was not replaced. A roof would have kept rain and snow off the kiln top and out of the fuel feed holes and it cannot have been pleasant for the firemen working on top of the kiln in foul weather without a roof. Apart from these issues, there were other more practical considerations that gave sense to a roof. Both kilns were made of limestone blocks and limestone is permeable: rain water would find its way through the joints between the blocks into the kiln fabric, thus weakening the structure and the vaulted roof. Perhaps this is partly why surviving kiln workers speak of constant running repairs inside the kiln.

Fuel efficiency must also have suffered without a roof. Some heat from the fire would be 'wasted' drying out the kiln fabric instead of drying out fresh stone. One can only assume that the owners weighed up the pros and cons of putting the roof back on and decided extra fuel consumption was the cheaper option.

Fuel was added to the chambers through feed holes using a small scoop and a funnel. Each chamber had a series of such holes, about a metre or so apart, in lines across the width of the chambers. The diameter of the holes varies from

75-125 mm in both kilns and, to ensure coal reached the outermost edge of the chambers, it was important to locate the holes at each side as near to the edge as possible. Each chamber has, on average, thirty holes per chamber.

Coal – 'one and a half inch nuts' – was raised to the kiln top in different ways. At Ingleton it was barrowed by hand up a ramp and across a gantry, but at Langcliffe it was raised using a water-balance hoist. Full Jubilee carts were lifted on top of the kiln by lowering a tank full of water. Once on the kiln top at Langcliffe, the carts were pushed along by hand and coal was stacked by the feed holes of the chambers that required fuel on that day. Two men were employed at Langcliffe for this job. One at the bottom filled the carts and pushed them onto the hoist one at a time. The other operated the chain-and-pulley system, filled the tank with water, and pushed the carts off the hoist onto the tramway track. A third man's task was to manhandle the carts across the kiln top and to make the piles. In the late 1920s and early 1930s two members of the Greenbank family from Stainforth (Jack and Billy) looked after the hoist. Apparently they 'worked like mad and went home early'.[9] Each feed hole was sealed from above with a cast iron cap, or bell, which was lifted when fuel needed to be added or when cool air was allowed in to a chamber to ease the fire or to increase the draught to feed the fire.

The entrances to the chambers are called wickets, and each chamber had its own wicket. These are 1.7-1.8 m high in both kilns with round arched tops. By sealing or breaking open the wickets, the fire could be advanced or slowed down as required. Breaking one open here allowed in cold external air to cool burnt lime; sealing another one there prevented cold air from entering and interfering with the firing process. Careful wicket management was a vital part of the successful operation of a Hoffmann kiln.

The vaulted roof inside the chambers was not even throughout its length, at least not in later kilns like Langcliffe's. It was found that some hot air would escape over the top of the burning mass as the limestone shrank in size and was thus lost from the burning process, increasing burning time and fuel consumption. To avoid this, a design change was introduced to the chamber roof and drop arches were inserted when the vault was built. At Langcliffe the ceiling of each chamber is on a slight slant with a vertical break every so often, which diverted the escaping air back down into the burning material.

THE FLUE SYSTEM

The flue system, designed to dispose of waste gases and smoke, was a complex matter and underwent several modifications from patent to patent in attempts to achieve the optimum. The original idea was to set a flue opening into the inner wall of each chamber, as at Ingleton and Langcliffe, and each flue fed through into the core of the kiln to the central smoke chamber, which ran most of the length of the kiln and fed into the chimney. In both kilns these lead horizontally into the core and then rise about 2 m up into the smoke chamber. Each flue could be closed

off at the inner end by means of a long rod damper operated manually from the top of the kiln. These rods, with a grab handle at the top, ran down through the smoke chamber into a funnel within the masonry of the kiln core, and the rod was sealed to make it airtight by running the rod through a cast iron bell set on a bed of sand. If the rod was raised, the bell opened, but if the rod was lowered, the bell fitted tightly onto its bed to effect the seal. The rods were locked into place, open or shut, using pegs. At Langcliffe these rod dampers have survived in situ. The flues from each chamber were just large enough for someone to crawl through to periodically scrape off smoke residue (but impossible to turn round in – I found out the hard way). The smoke chamber is tall enough to walk through stooped.

It was no doubt found by all kiln managers that this flue system did not work to perfection. Because the flue was on the inner wall of the chambers, heat tended to be drawn to the inner part, leaving the outer part cooler with its stone not always fully burnt. This was a serious problem and not one that Hoffmann found the answer to. Others, however, did come up with a solution; they were men who actually operated kilns and had the chance to see what was happening. A brickworks manager from Poole in Dorset, called William Sercombe, lodged his own patent in 1894 to improve continuous kilns 'such for instance, as the Hoffmann kiln'.[10]

He modified the original Hoffmann design by placing a second flue on the outer wall of each chamber, and he carried this flue under the floor of the kiln to the central flue. The inner and outer flues were controlled with the same damper rod from the kiln top. It would seem that the Langcliffe kiln was substantially modified, as mentioned earlier, in the late 1890s, to take advantage of Sercombe's improvements. To have done this required the kiln to be shut down while the extra flues were inserted. Many Hoffmann kilns were modified according to Sercombe's principle or to the principles of two other modifiers, Warren and Osman, who both advertised in trade journals that Hoffmann kilns could be modified at reasonable cost.

The kiln at Mealbank is something of a puzzle in terms of its flue arrangements. Several parts of the chamber roof have collapsed, making it impossible to understand the entire picture, but in two surviving chambers there is a blocked flue. The degree of sintering on the blocking brickwork makes it clear that they were blocked up while the kiln was still fully in use. What is odd is that in one chamber it is a flue on the outer wall that has been blocked up while in the other it is an inner wall flue. They obviously had a reason, but it is difficult to fathom it now. There is also evidence that one or maybe two flues in the Langcliffe kiln were similarly done away with while it was still in operation. A further point of detail at Langcliffe is difficult to interpret now: there is no inner wall flue in any of the end chambers.

The design and build of the chimney was equally critical to the success of the kilns because it controlled what was happening in the smoke chamber and flues. The whole principle depended on sufficient draught being maintained to draw the waste gases out of the kiln and up into the chimney. If that did not function

properly, neither would the kiln, so it was imperative to keep the chimney warm. A cold chimney, as those of us who have domestic open fires know well, will not pull. The best place to site the chimney was in the centre of the kiln – the warmest part. Langcliffe's was fine, but Ingleton's chimney was on top of a hill at the end of a 65 m-long ground flue. They had no choice here, because of the natural lie of the land. A chimney attached to the kiln would have been ridiculously tall, but this flue arrangement must have given the firemen constant trouble in maintaining sufficient draught.

The recommended dimensions of the main flue where it entered the chimney were 1.2 m square, but Ingleton's was 1.5 m, perhaps in an attempt to create a better draw.

FIRING A HOFFMANN KILN

As the fire progressed around the kiln, burnt stone was removed from chambers behind the fire while fresh material was packed into empty chambers well ahead of the fire. Limestone was brought to the relevant chamber entrances in kiln carts, approximately 1.2 m by 900 mm, holding about 1,500 kg of stone, with open sides and solid ends (60). Stone was stacked on these as if building two sides of a dry-stone wall with carefully layered courses, infilled with more stone, tapered to fit through the entrances. Once the kiln carts had gone past the weighing machine, they were pulled by ponies around the berm of the kiln on a narrow-gauge Jubilee

60. An empty kiln cart outside the Hoffmann kiln. The pile of firebrick against the kiln was for sealing the wicket behind the brickie.

tramway track that encircled each kiln. Movable, 1.5 m-long lengths of Jubilee, complete with inbuilt points, were laid from the berm tramway into the chamber being packed. These standard lengths enabled the lime packers to push the carts right inside the chamber. As it was progressively packed, sections of Jubilee were taken up as the men retreated to the entrance. Once the carts had been emptied, they were pushed out again onto the tramway, linked together with others, and hauled back to the quarry by ponies. At Langcliffe the return trip to the quarry was through the tunnel at the north end of the kiln: a strict one-way system operated here.

In the Langcliffe kiln two pairs of packers worked inside the chamber (61). One lime packer who worked

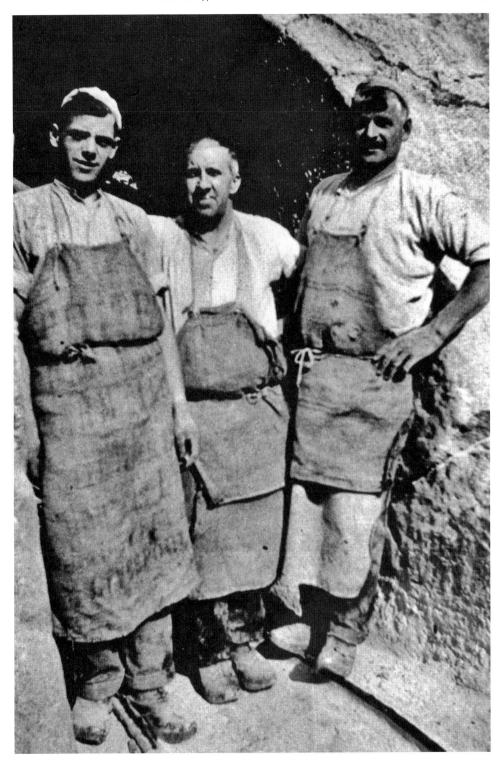

61. Three lime packers, photographed in 1927. From left to right: Ted Ramsbottom (aged twenty), Ted Marsden and George Syers. Note the Jubilee rails. (*Edward Ramsbottom Collection*)

here in the late 1920s and early 1930s kept his small notebook in which he noted the tally of how many kiln carts he and his mate emptied each day.[11] They could, of course, only process what the breakers and fillers sent down from the quarry and they, in turn, were at the mercy of the weather. The odd day in his notebook has the mournful entry 'no work' or 'rained off'. As they were all paid on a piece-rate basis, no work meant no pay for that day. The daily totals he recorded varied from fifteen to twenty-four on weekdays, and from nine to eleven on half-day Saturdays. It could take them four or five days to completely fill a chamber, depending on how frequently carts came down.

Stone, fist-sized or larger, was packed to the roof of the chamber. It had to be large enough to prevent it congealing – or scaffolding, to use old parlance – but the pieces could not be so big that they would take too long to burn through. Stone was very carefully packed and built up in layers, again as with dry-stone building, and pillars of stone filled the chamber from side to side, following the contours of the roof (Col. Pl. 22). Voids were left below the fuel feed holes for coal to drop to the floor. To allow the fire to move from pillar to pillar, chamber to chamber, small holes were left in the lower part of each pillar. These slough holes, four in Langcliffe's kiln, were 450 mm high and 350 mm wide. To prevent air flow in the wrong direction, to stop cold air going the wrong way, these holes were temporarily sealed with paper – ordinary paper – until there was sufficient heat from the advancing fire to burn them away. If they did not burn away, the fireman pushed a long hook down a fuel feeding hole to rip the paper away.

As the fire continued night and day, and had to be fed round the clock, the firemen worked in shifts: two shifts daily at Ingleton, at least in its early days, but three at Langcliffe.

One clear advantage of a continuous kiln was that, once it had been lit, the fire could travel round the annulus for as long as it was fed with coal. Maintaining the fire was the job of the shift firemen. It is what they did and they knew their job well. To start a kiln up from cold, after a stoppage, was anything but routine. Langcliffe's kiln must have been shut down when the flue system was redesigned in the 1890s and when the kiln was actually closed between 1931 and 1937, and it must have been partially closed down during the 1902/03 strike, discussed in the previous chapter, and in the General Strike of 1926.

It was essential to build up the temperature slowly to enable the heat to permeate the entire fabric of the kiln and to warm up the flues, the smoke chamber and the chimney. The easiest way to warm the chimney up was to light a fire at its base.

Warming the entire kiln removed residual moisture from the masonry and saved on fuel consumption once the kiln was fully fired up. Approximately one third of the heat needed to burn limestone was derived from this stored heat, with the rest coming from the previous firing chambers. If the structure was not warmed up first, 30 per cent more fuel would be needed to preheat the fresh stone. In addition, a Hoffmann kiln still lost 16 per cent of latent chamber heat through the masonry, so warming it up first was absolutely essential, even though it could take three days to warm up the first three chambers and used enormous

amounts of fuel in the process. Hoffmann kilns were only allowed to cool as a last resort.

SEALING THE CHAMBERS

When the kiln had been fully warmed up, the firing process could begin and the first chamber to be fired had to be very carefully sealed. The up-side of the chamber was shut off with a cast iron partition at both Ingleton and Langcliffe. A long-retired kiln operative has described this process.[12] The partition came in three sections that two men could just drag in, lift up and lock together. It was important that the curvature of these sections – dampers, as they were confusingly called – fitted the curvature of the chamber roof, but to make sure, the edges were sealed with slaked lime paste. Every time he and his mate fitted the doors to a chamber, they were paid an extra *6d*. The wicket door also had to be carefully sealed once the chamber was ready, to prevent any cold air seeping in from outside. Two skins of brick or stone were built in the wicket, by the wicket man, the space between was packed with sand to act as an insulator, and the edges were sealed with lime paste or mortar. An incorrectly sealed wicket could reduce the temperature inside by 50°C. It was the wicket man's job, incidentally, to break open wickets ready to be emptied as well as to seal up packed ones.

ADVANCING THE FIRE

The process of advancing the fire around the kiln was as much a combination of art and science as it was in the old pre-industrial kilns. The success of a Hoffmann kiln, in terms of quality of finished product and fuel efficiency, depended on the skill of the men working it. The packers had to stack the stone in the correct manner and the wicket man had to ensure a tight seal, but the key man was the fireman. The technology he had at his disposal was primitive by modern standards, and to an extent he was working blind because he could only see into the kiln by peering down the feed holes. A good fireman knew by experience what was going on inside. 'The fireman couldn't see the fire. He just knew his job. He knew when to advance the furnace by experience.'[13] One particular fireman at Langcliffe, called Proctor, started working on the Hoffmann kiln when it was first built in 1872 and he was still working there as fireman over fifty years later. The skills derived from such experience were invaluable and could not be learned from a book.

The fire in a Hoffmann kiln had several chambers associated with it: this was known as the chamber range. In smaller kilns there was only one chamber range but larger ones, like Langcliffe, had two fires chasing each other round the kiln. Ingleton had only one chamber range and it was made up as follows:

chamber 1 was standing empty
chamber 2 was being packed
chambers 3 to 9 were drying and preheating
chambers 10 and 11 were burning
chambers 12 and 13 were cooling down
chamber 14 was being drawn

In each of Langcliffe's two chamber ranges there were:

chamber 1 standing empty
chamber 2 packing
chambers 3 to 6 drying and preheating
chambers 7 and 8 burning
chambers 9 and 10 cooling
chamber 11 being drawn [14]

The rate of advance of the fire, called fire travel, was ideally maintained at 150 mm per hour, or about 4.7 m per day. At weekends, when no lime was drawn, the rate of fire travel had to be slowed down by closing dampers to reduce the draught that fed the fire.

Let us follow the fire around Ingleton's kiln in its early days. Chamber 1 is empty and is being cleaned out with minor repairs effected, before the lime packers move in. Chamber 2 has had the twin Jubilee rails laid down and the four packers are hard at work filling the chamber. When this is completed, the cast iron partitions will be slotted into place to seal chamber 2 off from chamber 1 (the next to be packed), to force waste fumes and gases through the open flue and into the smoke chamber and chimney. The iron partition between chambers 2 and 3 has been replaced by a temporary paper damper. Chambers 3-9 are the drying and preheating chambers. Hot air is drawn forward from the fire through the slough holes to dry out and warm up the stone. Moisture within it must be drawn out slowly: if not, the drying would be uneven, giving a poor-quality end product. As we move from chamber 3 to chamber 9, the stone is becoming progressively drier and hotter. No fuel is added to any of these chambers. This was the beauty of the Hoffmann process: surplus heat from the fire is utilised to warm up and dry out fresh stone, thus economising fuel consumption. By chamber 8 the temperature has reached 850°C – this chamber is known in the trade as the 'coming hot' or 'comer'. Chamber 9 is the easing chamber. The fuel feeding holes above this chamber are opened a little to allow some cold air to hold the temperature at a constant 1,000-1,050°C. If the heat exceeded this, stone might be over-burnt and spoiled.

The actual burning of the stone takes place in chambers 10 and 11. Coal is poured down the feeding holes to take the heat up to 1,100°C in chamber 10 – the main fire – while less is added to the next chamber – the back fire – which brings the temperature back to 900°C. In chambers 12 and 13 the stone is allowed to

bake while the temperature is reduced. A hole is knocked through the brick seal of chamber 13 to allow in cold air to bring the temperature down further. This is the knocked wicket. Finally, in this sequence, the temperature in chamber 14 has fallen to 60°C and the lime drawers can get to work emptying it.

The whole sequence then moves on one chamber. The cast iron partitions are dragged out and repositioned. When this kiln was increased to eighteen chambers, they would probably have added to the number of chambers being packed and emptied, as well as adding a chamber to the drying and cooling stages. As seen earlier, a longer chamber length – a longer chamber range – was more fuel-efficient.

Exactly how long a sequence lasted was subject to a number of variables. The breakers and fillers could not work in snow or frost or torrential rain, so there was no guarantee of a regular supply of stone. In winter the stone and kiln masonry were obviously much colder and needed a longer time to heat up. As the kilns operated around the clock, on a shift system, there was always the possibility that one fireman would work in a slightly different way from the next, again introducing variation in the rate of fire travel. Every so often a chamber roof or wicket needed more substantial repairs, so fire travel had to be slowed right down to accommodate this. Every so often, too, the flues had to be scraped clean. Using high quality bituminous coal minimised soot deposits but, every so often, a 'lile fella' had to crawl up the flues and the fireman had to do likewise in the main smoke chamber.[15]

An indication of how long an average sequence might have taken is provided by the daily work record of the former Langcliffe employee.[16] By writing 'doors' in his book every time they repositioned the partitions, we can deduce the time scale involved. In June 1930, for example, he noted 'doors' on Wednesday 11, Saturday 14, Thursday 19, Tuesday 24 and Friday 27. If we exclude Sundays and Saturday afternoons, this works out as an average of three to five days to move a chamber forward, considerably slower than the optimum single day and slower than the daily drawing mentioned in an account of the Ingleton kiln in 1873.[17] Moving the fire on was, of course, the fireman's prerogative and, even in the 1930s, there was no reliable way of knowing exactly when to do this. A skilled fireman could tell by removing a bell cover and peering down at the state of the fire and the colour of the flame, or else a cast iron rod was used. It was lowered down until its foot rested on top of the unburnt stone and a chalk mark was made on the rod level with the top of the kiln. The same rod was lowered again when the fireman thought the fire was done, and by measuring the difference in height on the rod he knew intuitively whether the stone had settled enough to be moved on to the next stage.

DRAWING A HOFFMANN KILN

The process of emptying, or drawing, a kiln was a most unpleasant job, which explains why lime drawers were paid more than other kiln operatives. As soon as the wicket man had fully opened up the entrance to the chamber, and had

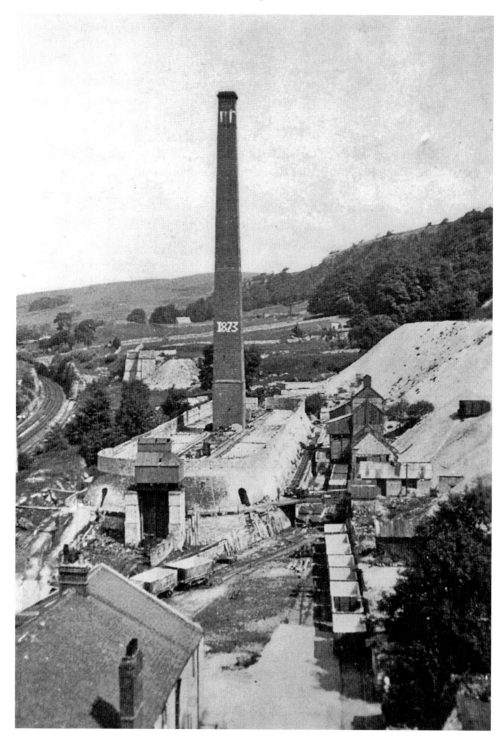

62. The Hoffmann kiln at Craven, recently disused when this photograph was taken. Note the two planks on the western (left) rail dock used for barrowing lime into rail wagons, the coal cart on top of the kiln, and rail wagons waiting to load at the crusher to the east of the kiln. (*Roger Worthington Collection*)

carefully stacked the bricks to one side on the berm, the leading man, as he was called, could get to work. He made the first inroads into the burnt mass, which had been congealed by the heat into a fused, steaming mass of quicklime lumps. Quicklime slakes easily, and this proved a hazard for the drawers as it inevitably found its way down their shirts and into their boots and actually slaked on their skin when they were sweating, causing itching and rashes, and leading to copious applications of Vaseline, goose fat or grease. Airborne lime dust found its way into throat and lungs, adding to the unpleasantness.

Lime drawing was a manual task. To loosen the congealed mass, the leading man attacked it with a pick and, as it became looser, he and his two fellow workers would fork out the larger pieces and shovel the smaller, loading it into wheelbarrows at Langcliffe to be tipped into rail wagons waiting in the dock alongside (62), or into horse-drawn carts at Ingleton before the rail link was built.[18] It was a laborious task and most demanding, as each drawer aimed to shift 16 tonnes each day. Ingleton's chambers each yielded an average of 60 tonnes and Langcliffe's 90 tonnes, so it could take a good two days to empty one chamber. The job was made more onerous, if less mindless, by the drawers having to sort lime as they drew it. The best quality lime, called specials, was destined for those consumers that needed the purest lime, such as chocolate or sugar manufacturers or tanners. Seconds, less pure but still high quality, went into different wagons for despatch to a range of industrial end users, while bullheads – large and only partly burnt lumps – were loaded for despatch to steel mills. There were also special orders to be consigned, so lime drawing was far from a mere repetition of shovelling and barrowing.

Hoffmann kilns were fuel-efficient but not labour-efficient. Whereas a vertical shaft kiln could operate with perhaps two packers and two drawers who did everything, the Hoffmann kilns at Langcliffe and Ingleton were much more demanding of labour. Langcliffe with its two fires needed, per fire, four packers, three drawers and one wicket man, while each shift had its fireman, hoistmen and top feeders. In addition there was a small army of breakers and fillers, pony men and boys, weigh machine operatives, incline brakesmen, fitters, blacksmiths, shunter drivers, labourers… Over 100 men in all kept the site going in its heyday. It was partly labour costs, in fact, that led to the kiln being shut down.

THE END FOR LANGCLIFFE'S HOFFMANN KILN

By the middle of 1926 the kiln was down to one fire because of the knock-on effects of the General Strike.[19] This did not entirely cut off supplies of coal to the site, but the main problem was that rolling stock to distribute the lime to customers was hard to come by. As burnt lime cannot be stored for long, the company had no choice other than to put the kiln on a care and maintenance basis, with one fire put out and the other one slowed right down for the duration of the strike.

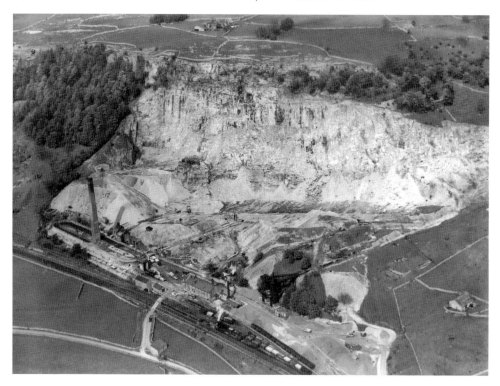

63. Aerial view of the Craven Limeworks and Hoffmann kiln, photographed in May 1938 during the kiln's short-lived reprieve. (*Aerofilms Ltd. 57360*)

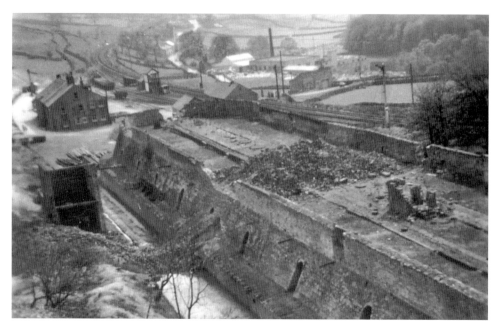

64. The Hoffmann kiln, photographed in 1954. The chimney collapse can be clearly. seen (*Craven Museum, Griff Hollingshead Collection*)

A working agreement between the Craven Lime Co. and the other two local concerns led to the common management pool we have already seen. The inevitable outcome of this was rationalisation: the Hoffmann kiln was the second victim, the Spencer steel kilns having been shut down immediately. On 2 September 1931 the fires in the Hoffmann kiln were extinguished.[20] It was, as we have seen, reprieved six years later. In July 1937 the Agriculture Act completed its passage through Parliament, and one of its main goals was to subsidise the purchase of agricultural lime by farmers. The Land Fertility Scheme boosted demand for burnt lime and a direct result of this was the reopening of the kiln. A grand ceremony was held on 15 November 1937 and Mrs Leonard Cooper, wife of the managing director of Settle Limes Ltd, which now owned the site, formally relit the kiln.[21] The chambers were filled with 2,100 tonnes of stone and one fire, not two, was charged (63). However, less than two years later, it was shut down completely, never to reopen.

The Hoffmann kiln had the final word. Settle Limes had decided to demolish the chimney in 1951 'for the sake of maintaining the Craven natural amenities'.[22] Thomas Normington & Sons, steeplejacks from Bradford, were making preparations to demolish it on Saturday 20 January. The press had been invited to witness the spectacle and all the charges were in place ready for the blast the next day. But at 11.30 a.m. on the Friday, the entire chimney came crashing down of its own accord, in the intended direction. No one was there to see it go. The kiln had maintained its dignity (64).

John Delaney Ltd

Of two matters we can be sure. John Delaney was Irish and he was born in 1846 (65). Where he was born is rather contentious. One supposedly true story has him born in Ireland, the son of a land agent who had the unpleasant task of collecting rents for landlords from the starving tenants who were struggling against the potato blight for survival.[1] John's father was allegedly murdered by a band of discontented and desperate tenants, and his sister is said to have taken the family to Stalybridge outside Manchester to start anew. Fine, but the 1881 census tells a rather different story. John is listed as having been born in Stalybridge. Maybe he was born in Ireland, and maybe it was not politic in those days to admit to having been a refugee from the Hungry Forties. Or maybe it is just a romantic story.

Here is another Delaney conundrum. The first account referred to above states, quite accurately, that he married Annie Calver in 1870. She, the story goes, was a cotton weaver from Lancashire. The 1881 census again begs to disagree: according to this, she was born in Norfolk.

How did they both come to end up living in Langcliffe? Annie is easy to explain. In 1861 Lorenzo Christie bought the large but inactive cotton mill just outside the village and, because most of the mill operatives had left the district to find work elsewhere when it closed in 1855, Christie had to look far and wide for new staff. He sent his scouts to hire labour in Devon, Cornwall and Norfolk. Annie answered the call. John's mission is not so straightforward. We can postulate without going beyond the bounds of reason. Some of the Delaney clan managed to find their way from Stalybridge to Norfolk. Was it the case, perhaps, that they heard of Christie's recruitment drive and passed word back to Stalybridge, or had John himself been in Norfolk at the time?

I suppose we shall never know. None of this really matters, but it does illustrate the difficulties in trying to piece together even fairly recent social history. Anyway, like so many of his compatriots of that era, Delaney did not sit back and wait for things to happen. He proved to be a redoubtable character, on a par with John Clark and Michael Wilson.

In 1871 he was happily married and living in lodgings in Langcliffe, working at Christie's mill. By 1881 he was described in the census as 'coal merchant and grocer'. By 1891 he was living at 27 Craven Terrace in Settle as a 'stone quarry owner and coal merchant', with his wife and daughter Caroline, universally known as Carrie, and a live-in servant girl, Elizabeth Fothergill. In less than thirty years he had transformed himself from a relative pauper into a successful businessman. It might well sound trite and sentimental, but it was men like Delaney, Clark and Wilson who made Britain the successful nation it was in the late nineteenth century.

Delaney had far too much drive and energy to remain a mill overlooker for long, and even his spare time tinkering and later his shop in the village were too restrictive for him. The coming of the Settle-Carlisle railway in the early

65. John Delaney, 1846-1921.
(*W.R. Mitchell Collection*)

1870s provided the opportunity he needed. He borrowed £40, apparently from a Quaker in Sheffield, to buy a horse and cart. How he came to meet this man, how the latter was persuaded to part with his money on what must have seemed an unsafe bet, are mysteries, but the Quaker banker can only have been a very astute man. At the latest by 1876, possibly earlier, Delaney was well established as a 'coal and coke merchant, Settle station'.[2] In that same year he became a Quaker himself.[3] His wife and daughter became attenders but delayed actually joining the Society of Friends until thirteen years later.[4] In 1912, however, Delaney wrote to the Friends to tender his resignation. Reading between the lines, there may have been some acrimony between him and the society because he declined to receive the delegation sent to Settle to dissuade him from leaving. Annie and Carrie tended their resignations a month later, so something had obviously gone seriously wrong. Eventually the elders accepted the inevitability of the family's decision and their resignations.[5]

Delaney kept the Langcliffe shop going, meanwhile, with his wife in charge, and at some point took the momentous step of going to university in Manchester to study geology. His mentor in Sheffield was clearly more than just a financial backer: we have to assume that he had encouraged Delaney in this direction. Delaney was obviously aware of what Clark and Wilson had achieved from humble origins and, for all we know, they well have been in close contact with each other. Settle and Langcliffe in those days were tight-knit little communities.

Telephone No. 2, Settle. Telegrams—DELANEY, SETTLE.

JOHN DELANEY, Ltd.,

Coal Factors & Colliery Agents,

SETTLE.

Agents for Monk Bretton, Cortonwood, St. John's and
J. & J. Charlesworth's Collieries.

BEST GROUND LIME

FOR

AGRICULTURAL PURPOSES.

APPLY

JOHN DELANEY, Ltd., Settle.

ALL ORDERS PROMPTLY ATTENDED TO.

66. Advertisement placed in the trade press by John Delaney Ltd.

Again, for all we know, Clark and Wilson – and W. George Perfect for that matter – may have encouraged him.

Whatever the case, on his return from university he developed his coal business. In 1881 he may have been a 'coal merchant and grocer': by the end of that decade he was described as 'colliery agent and coal factor'.[6] It was rather nobler to be a factor than a mere merchant. In fact, by 1904, he was acting as agent and factor for six collieries across Yorkshire (66).

He was also well aware of the potential for lime production in Craven, and he launched himself into the quarrying business in 1888. He recognised an obvious symbiosis: expand his coal interests by supplying his own lime kilns; secure a market for his own lime in the iron and steel mills of Sheffield. He would maximise sales of both coal and lime and maximise profits by minimising transport costs. His sole horse and cart soon was soon replaced by an extensive fleet of rail wagons in his own dark red livery. In 1895 alone he purchased twenty new wagons for immediate delivery, but not to any of his quarries. Rather, they were to be delivered to collieries – Monk Bretton near Barnsley and St John's at Normanton – and to gasworks in Keighley and Bradford to be loaded with 'best coke', presumably to supply his kilns.

He did not confine his energies to business. Typical of Quaker entrepreneurs, he threw himself into public life as a Justice of the Peace from 1910, though this did not last long. Possibly his Quaker pacifist beliefs were at odds with what the law required him to dispense. He also entered local politics, and on 15 December 1894 was elected to Settle council with the sixth highest vote.[7] His affiliation was with the Liberal Party until the Great War pricked his pacifist conscience and caused him to turn away from liberalism. In 1887 he had showed support for the party by assigning to it part of a building in Settle's Duke Street.[8]

In the 1890s he bought up plots of land in the newly developing part of Settle called Halsteads, selling some plots on it for residential development,[9] and building himself a large house called Overdale. In 1899 he invested in the purchase of a weaving shed and other property in Earby.[10] He also served as director, and was a major player, in a company of construction engineers, Messrs Jenkins & Co. Ltd, in Retford, and he had financial interests in coal mines in County Durham as well as across the West Riding.[11] How far he had come in such a short time. He also became a director of the Craven Lime Co. in 1909, the first step in the eventual amalgamation of the three companies we have discussed in earlier chapters.

He was a wily businessman, too, always on the lookout for a new opportunity and not averse to getting one over on his competitors. The managing director of Northern Quarries Ltd, J. Ward, who operated a Hoffmann kiln at Trowbarrow Quarry in Silverdale, made an entry in his diary on 13 February 1905. Northern Quarries had been selling burnt lime at 14s 6d per tonne but, he noted, John Delaney was undercutting him by a full 2s per tonne in Lancaster.[12]

Delaney died, aged seventy-five, on Christmas Day in 1921, leaving his entire estate to his daughter, who henceforth ran all the various business interests on her

late father's behalf.[13] He was buried in Settle's Quaker burial ground. Surprising perhaps, given his resignation in 1912.

HORTON LIME WORKS

John Delaney chose Horton in Ribblesdale to establish his first venture in quarrying. He would not have wanted to go too far from Settle, as he was firmly based there with his various interests, and he wanted direct access to the railway. Limestone reserves near Settle were already accounted for by the Craven Lime Co. at Langcliffe, by P. W. Spencer at Giggleswick, and by the Ribblesdale Lime and Flag Quarry Co. at Helwith Bridge. The nearest untapped resources, accessible to the railway, were at Horton. There had been a very small quarry at Beecroft, already in existence in 1850 and still extant today (SD 798 727), but Delaney set his sights on a much grander scale. He negotiated a lease with the landowner, Mr Ford, in 1888 and began to develop what soon became known as Horton Lime Works, exploiting both the limestone and the underlying Silurian strata known to quarrymen as granite (which it is not) or hardstone (67).

Very little is known of the early days at Horton. It is known, though, that he erected two lime kilns and that the quarry contained the usual panoply of tramways, compressed air systems, crushers and rail sidings. Of the detail, however, virtually

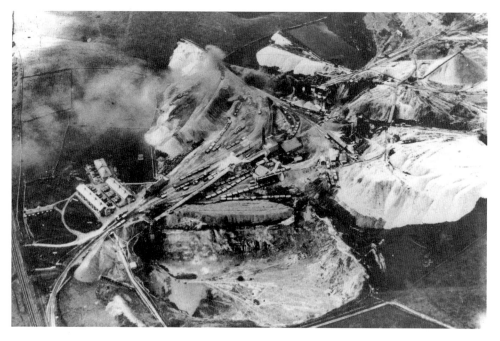

67. Horton Lime Works, photographed in July 1936, showing the extensive rail sidings, the 'granite hole' (bottom left), the hoist system to raise stone out of the granite hole, and the Spencer kilns (top centre right). (*Aerofilms Ltd. C12844*)

nothing can be confirmed. We have to wait for the dawn of the twentieth century for the first established facts, and they did not show Delaney in a particularly good light. The 1890s were a time of severe agricultural depression and there was a consequent fall in demand for burnt lime that, in turn, had a negative impact on the profitability of all limeworks. In October 1897 the sale price of lime showed a particularly steep decline, and the company reacted in the tried and tested way of business: it sought ways of cutting costs, and employees were the target.[14] Limeburners' and drawers' wages were cut by 7.5 per cent, with the promise that they would be restored once prices recovered. Prices did indeed recover, but the promise was not kept, so the workers responded in the time-honoured way. On 30 December 1901 they called a strike. Management offered a compromise settlement. The men turned it down. Strike breakers were brought in, but the strikers' wives gave the blacklegs short shrift. The strike was duly settled.

In the summer following this, the company was in the wars again. To the council's satisfaction, they had been supplying crushed stone to the local council since the quarry was opened. One delivery, however, was deemed to be both overpriced and of inferior quality. The two parties were in dispute, but only temporarily.

The old adage 'no news is good news' seems to have proven true as regards Horton because it sunk back into quiet obscurity and did not surface again, so to speak, until 1911, when the manager, Mr Hall, oversaw the biggest blast ever witnessed in Yorkshire.[15] A new form of explosive had been pioneered, known as ammonal grain, which was not only three times as strong as the traditionally used black powder, but was also much more user-friendly. Powder had a disconcerting habit of going off spontaneously, reacting to heat, friction, flame or being knocked. Grain, however, behaved.

As the Great War approached, Delaney, described as the governing director of John Delaney Ltd, was busy buying up land around the quarry with a view to future extensions and, just after the war, he purchased all the lands containing the quarry that he thus far had been leasing from the Ford family (68).[16] At this time the Horton Lime Works complex was already huge, with an internal railway system, seven lime kilns and extensive plant. Five of the kilns were 1900 patent Spencer kilns (69), with the other two being the original masonry vertical kilns he built at the start. Still not content, he continued extending his acquisitions of land in and around Horton. He would surely have been pleased to see his creation described as being among the finest, largest and most modern works in Yorkshire.[17]

The 'granite hole' was becoming ever deeper and the limestone workings ever more extensive. An endless wire rope system hauled the bogies, filled with 1,000-1,300 kg of stone, out of the quarries to the kilns or crushers. Modern crushing plant using 'bells' fed the stone through screening plant into hoppers which, in turn, fed stone directly into rail wagons shunted underneath. Limestone from the breakers and fillers fed the array of kilns as well as the tar-coating plant and concrete flag plant. Horton was modern, businesslike and successful. Set against the

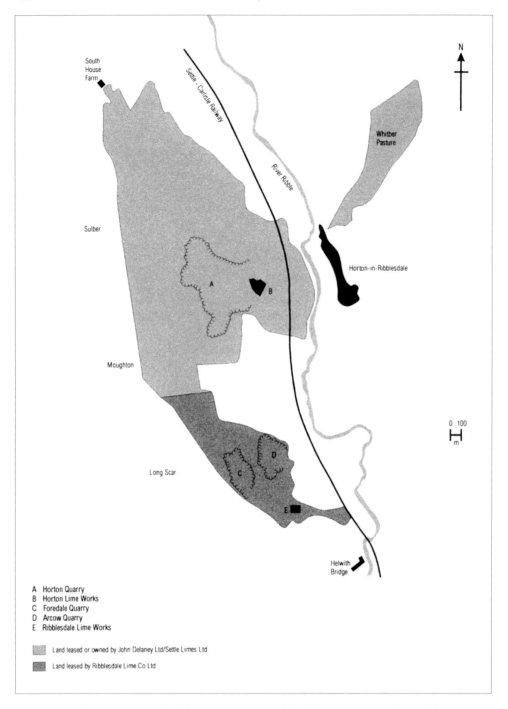

68. The maximum extent of land leased or purchased for limestone quarrying in Horton parish.

scale of it all, the Craven Lime Co.'s set up at Langcliffe must have seemed quaint. Delaney, the new player in the field in 1888, was now the leader of the pack.

Demand for tarmacadam and burnt lime for the West Riding steel industry was so buoyant during the Great War that Delaney had had to mothball the 'granite' operations to concentrate on limestone. He could barely keep up with demand,[18] even though he now ran other quarries as well.

His death in 1921 did not affect the success of the company and Carrie gave it as much time as had her father. Very shortly, though, the command structure of the company was reorganised. The quarry and limeworks at Horton were hived off from the rest of John Delaney Ltd to form John Delaney (Horton Limeworks) Ltd. The former was headed by Carrie and W. H. Parker, with its registered office in Settle, but the latter was headquartered in Pall Mall, London. Local control of Delaney's interests was beginning to slip away, but the Horton company continued to buy up land all around Horton village, ensuring the long term viability of the concern.

In 1925 a legal conveyance recorded the purchase by the company of 'land known as the "Horton Lime Works"' from the three Hammond sisters of Amerdale House in Arncliffe and The Raw in Horton for the sum of £10,525. In the same year the Horton company took over the entire assets of the other Delaney company with A. and F. Woolley-Hart as the principal directors, though with Carrie still on the board of the latter, the separate identity of which was preserved.[20]

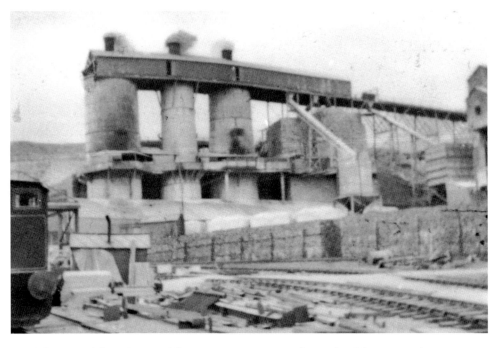

69. A battery of three Spencer kilns at Horton Lime Works, with a kiln cart on the upper gantry. The other two kilns had been demolished by then. Date unknown. (*Hanson Aggregates Ltd, Horton Quarry*)

New tar-coating plant was installed as well as a new crusher for renewed hardstone extraction, with stone fed directly from the working face to the crusher, and then through new screening plant onto a conveyor to the coating section.[21] With a daily capacity of 300 tonnes, output could now easily keep abreast of demand. The economic tribulations of the early 1930s had a serious effect on Horton,[22] though the boom in agricultural lime and steel markets saw renewed growth at Horton in the late 1930s, and new hydrating plant and agricultural ground limestone plant was put in during 1939. The company had faced another testing time in 1935. On 22 June all 160 men walked out on strike. Management had foisted a new pay structure onto nine stone fillers, who would have none of it, and understandably so.[23] They had always been paid according to the weight of stone fed into the kilns, but management had decided to manipulate the system to the tonnage of burnt lime drawn out of the kilns, which led to their tonnage payment falling from 7½d to less than 6¼d[24] The nine went on strike, so management dismissed them and the rest of the workforce came out in sympathy, supported by the National Union of General Workers. The managers refused to negotiate and the men stood their ground, but eighteen days later the two sides agreed to talks and the strike was called off and the men all returned to work.

Everything returned to normal very quickly – so rapidly that the parent company was able to purchase 50 per cent of the capital of the Craven Lime Co.[25] and to replace most of Delaney's original stock of rail wagons in 1936. By the late 1930s, production of hardstone had been phased out because Settle Limes Ltd, which now owned Horton, also owned Arcow Quarry at Helwith Bridge. The company chose to concentrate its non-limestone operations at Arcow, where the stone was more easily extracted than in Horton's ever-deeper 'granite hole'.

During and after the Second World War further investment was made at Horton to replace the crusher and mechanise quarry face operations, (Col. Pl. 23) with breakers and fillers replaced by machines in 1943-44, while output virtually doubled in 1947-48, and in 1949 a new Priest-Knibbs kiln came on stream. Much more efficient than the ageing Spencer kilns, the Knibbs could handle smaller pieces of stone. This one kiln alone boosted burnt lime production by 15 per cent,[26] and it was one of only two in the country at that time, and gave Horton an assured market for top-quality lime in the tanning and chemical industries.

In 1954 two massive, gas-fired Priest-Knibbs kilns were commissioned, with a further two in 1960.[27] (70, Col. Pl. 24) Stone was hoisted automatically and fed in at the top of these ultra-modern kilns, with burnt lime being drawn out through hoppers every hour. Two of the Spencer kilns were pulled down, with the others being mothballed on a care and maintenance basis. In addition, one special kiln was constructed for experimental purposes, originally gas-fired but, in 1961, modified to oil instead. New hydrating plant was also installed, doubling capacity, and the internal rail network was extended, with three locos put into use as shunters. When all this work had been completed, Horton could claim to be the most modern plant in the north, as well as a major employer in

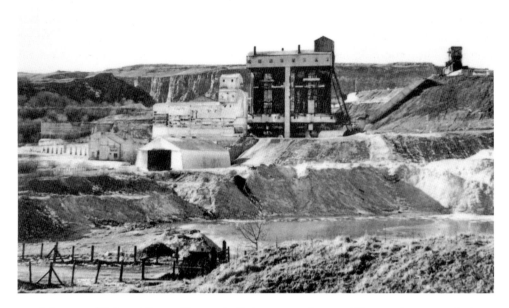

70. A battery of Priests kilns at Horton, built in 1954 and 1960. (*Hanson Aggregates Ltd, Horton Quarry*)

the district with 110 men on the roll, a far cry from the present total of eleven on-site staff.

There are those who decry the impact that quarries as large and prominent as Horton have had on the landscape, but they can perhaps take solace from the fact that it could have been infinitely worse. In a series of legal transactions in the late 1940s and 1950s, Settle Limes either leased or bought substantial tracts of land around Horton with a view to future exploitation of the stone. The company held all the land between the Crown Hotel and Whitber Pasture, as well as much of what is now National Nature Reserve between South House Farm and Moughton, and the pastures between Beecroft Hall and Low Moor (68). However, when Settle Limes was taken over by ICI Mond in 1962 all these lands were sold off. Horton, within ICI Mond, remained a wholly owned subsidiary until it was totally subsumed within ICI in 1970. Ten years later, Horton was put on the market.[28] For ICI's purposes, it was no longer producing the requisite quantity of lime, so it had to go. By this time the labour force had dropped to only sixty-three.

BROUGHTON QUARRY

Quarrying on a commercial basis began in the Broughton area before 1853, when the first Ordnance Survey maps show two small quarries in Small House pasture,

a quarry with kiln in High Copy, and a small quarry near the railway. All these were worked on a low-key, as-and-when basis. Slightly to the west of Broughton in the 1850s were two other quarries, each with an attendant kiln worked on a selling basis. Of Micklethorn Quarry (SD 928 507) virtually nothing is known, but Broughton Fields Quarry (SD 925 506) was managed on a commercial basis for many years. Owned by the Tempest family of Broughton Hall, this quarry appears in Government statistical returns from 1896 onwards. In the 1890s the quarry employed two men under the management of W. Dawson Marsh, though in 1904 and 1907, the workforce was double that. It then passed to Messrs Bancroft, Harrison and Gibson of Broughton.

In 1899 John Delaney expanded his field of operations from Horton to Broughton, going into partnership with a stone merchant from Leeds, John Smith, as Broughton Quarries Co. Ltd. A lease was signed with the Tempests, on a twenty-one-year basis, to open up Broughton Quarry (SD 947 527) to extract limestone, to build lime kilns and erect more plant and six cottages.[29] Tempest drove a hard bargain, claiming royalties on each tonne – which was normal practice – annual rental, a charge for loss of agricultural land, and the inalienable right to take 'best burnt lime' at a maximum of 7s per tonne and 'small lime' at 3s. A further lease was granted in 1903, giving the partners more land in High Copy pasture to open up a second quarry, which became known as Small House Quarry (SD 942 521, Col. Pl. 25).[30] Delaney and Smith cut a new road, now lost, from the quarry area to the main Skipton road, and a tramway was laid to carry stone from Small House to the plant in Broughton Quarry. Two years later the lease was amended to allow Small House Quarry to be dug nearly 8 m lower than initially agreed, and to erect onsite a pumping station to drain the quarry and a crane, presumably steam-powered, to lift the stone out. The height of the water table here was to prove a thorny problem at both quarries, and the constant flooding of Broughton Quarry was only solved in 1914.[31]

The original lease expired in 1920, by which time Smith's widow had assigned her late husband's interest in Broughton Quarries to Delaney. He, of course, died the following year, bequeathing 'all his real and personal estate whatsoever' to Carrie, who renewed the 1899 and 1903 leases in 1922, on the same rents and conditions as in 1899.[32] The lease renewal, incidentally, was witnessed by W. H. Parker of Fernleigh in Settle, who was company secretary and later manager at Horton until his death in 1937.

By 1922 a third quarry had been substantially developed in between the other two. This was Smellows Quarry (SD 943 523), which also required a crane to lift the stone out. As far as can be ascertained, no kilns were built at Broughton, but crushing plant and tar-coating plant were installed next to Broughton Quarry, near the railway siding that then existed.

These quarries yielded high-quality 'blue' limestone, which was valued as hard wearing roadstone. But once they began to give way to shales, the three were abandoned to the water. They were still operating in 1929, but by 1931, the statistical returns record 'not working', so they had most probably shut down the year before.

During the Delaneys' occupation of the three sites, the labour force had fluctuated quite markedly between twenty and thirty-two: given their relatively small size, it is clear they were worked in a very labour-intensive way.

Small House Quarry was eventually filled in and returned to pasture, Smellows Quarry is now completely water-filled, and Broughton Quarry is partially flooded, with some remains of the loading gantry still extant. It could all have been very different, however, if Amey Roadstone (ARC) had had its way. In 1975 the company put forward proposals to reopen Broughton Quarry on a massive scale. The whole complex would have been spread over 78 ha, would have obliterated an entire farm and whittled several others down to an unworkable size. Had this plan gone ahead, Broughton would have ranked as the country's largest limestone aggregates quarry. It was planned to begin production in 1981 and to continue for forty years, with the site then being turned into woodland, a lake and farmland. A new road was to be built from the A59 near Broughton Copy Farm, and rail sidings were to be installed.

The proposals were given conditional approval by Craven District Council, despite widespread uproar, but nineteen stipulations were laid down. There was to be no lime burning or tar-coating, for example. The county council would have none of this and in 1976 it refused consent, partly on environmental grounds, partly because of the effect on local roads, and partly because the council felt national demand for stone did not warrant yet another quarry. And that was that.

THRESHFIELD QUARRY AND LIME WORKS

Having firmly established himself at Horton and Broughton, Delaney then expanded his horizons again, this time to Threshfield near Grassington. Some of the stone here was different from that across much of Craven, being magnesian limestone, which has a brown rather than a grey hue. The original quarry was locally referred to as 'the brown hole' for this reason. Apart from the normal markets for lime and limestone, Threshfield's magnesian was in demand in ground form for treating hypomagnasaemia in cattle, while its carboniferous limestone was preferred by those who farmed on the magnesian limestone belt to the east of the Dales.

Delaney purchased 'mining rights for coal as well as lime-getting rights' on Threshfield Moor in 1902.[33] His idea was sound, at least in theory. By working the coal reserves on the moor, he would have a ready source of fuel for the kilns he planned to build in the new quarry. He would save on the expense of transporting coal in from outside. Threshfield's coal reserves were extensive and had been extracted from shallow shafts for lead smelting for around 300 years before Delaney arrived on the scene. Construction of the Skipton to Grassington railway, also in 1902, was a major factor in his decision to set up operations here: without a rail link the quarry would not have been viable.

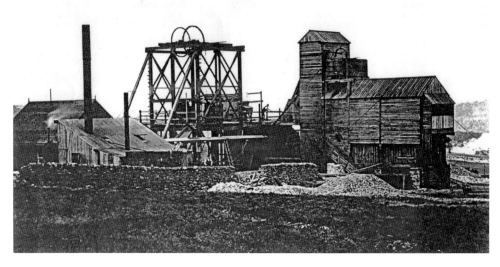

71. The 'towering pithead scaffold' at Threshfield Colliery. (*Rita and Arthur Berry*)

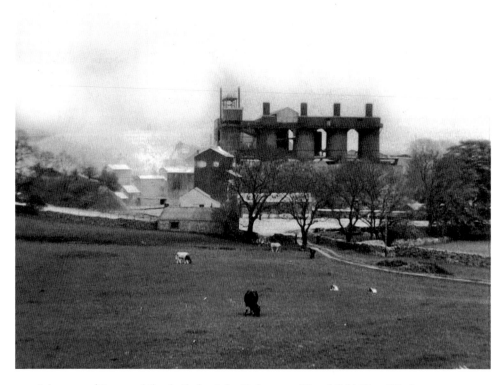

72. A battery of Spencer kilns built for John Delaney at Threshfield Lime Works, photographed in 1963. (*Clive Midgley Collection*)

He invested heavily in his new mine, sinking a shaft 19 m deep with steam-powered head gear. 'Right out on the moors ... where nothing but heather was visible a few weeks ago, a new winding engine is being put down and a towering pithead scaffold stands against the sky...' is how one account described it (71).[34] A tramway was also laid to connect the mine to the quarry, a distance of over 1,200 m, and the coal tubs were lowered and raised using an endless rope mechanism. The main seam, however, proved to be a disappointment: the coal was of poor quality and contained a lot of impurities. To get around this problem, he had washing plant constructed near the shaft. Unfortunately, however, the coal in the seam soon petered out as his miners encountered geological faults and the workings of the 'Old Man' from long ago. In November 1905 the colliery was abandoned (Col. Pl. 26). Delaney had accepted failure and resigned himself to writing off the entire investment, thereby losing £30,000. He did not give up the mining rights, though. Kelly's trade directory for 1908 still lists Delaney as possessing Threshfield Colliery.

Scant remains of the colliery still stand on the moor (SD 973 628), and the bed of the tramway can be seen across the moor and the fields below.

Delaney built five kilns at the lime works and they were of an unusual design, all more or less the same even though they were not all built at the same time (72). They were a variant of the Spencer kilns already seen at the Craven Limeworks, and the method of feeding them was the same as in a conventional Spencer kiln. Stone was hauled up in Jubilee carts on an incline to a level platform that was connected by a gantry to the top of the kilns where it was tipped in, while slack coal was fed in part down the shaft, direct to the calcining zone. What was atypical of these kilns was that the iron structure of each kiln was set onto solid rock that had been hollowed out so that burnt lime could be drawn out through rock-hewn tunnels. Why he chose this design is not recorded, but the topography of the site may have given him no real alternative. Four of the kilns produced burnt lime for despatch as quicklime, and the fifth one was built to supply the hydrating plant once that had been commissioned in 1934. This kiln was fed with smaller stone than the others,[36] and it had an automatic feeding mechanism, unlike the manual feed of the four older ones.[37]

Up until 1935 John Delaney Ltd had leased the lands and quarries at Threshfield from the Wilsons of Eshton Hall near Gargrave, but in that year the company purchased the freehold as part of its post-depression expansion plans.[38] Over ensuing years further purchases of land were made from various landowners to enable the quarry to extend to the north, beyond Round Hill and into Whitworth Pasture, the brown hole having been abandoned by 1949. The company had also recently commissioned the new Knibbs hydrating plant, linked to the site's wire rope haulage system.[39] Stone was hauled to the top of the kiln from the quarry, burnt lime was hauled across to the hydrator, and bags of hydrated lime were hauled away to the narrow gauge railway that ran to the main line sidings 1.6 km away in Grassington (73/74). In addition, the limeworks had a regular contract to despatch tankers full of hydrated lime to Scotland. When first installed in 1904,

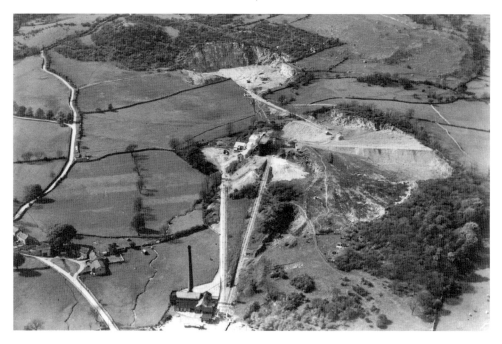

73. Threshfield Lime Works, photographed in May 1938. The kilns and hydrating plant are in the centre, with tramways leading from both past workshops and the boiler house at the bottom. (*Aerofilms Ltd. 57363*)

74. The main incline leading from the battery of kilns at Threshfield Lime Works, photographed in 1963. (*Clive Midgley Collection*)

the narrow gauge railway had been operated with a stationary steam engine, and later on an electric drive, to haul wagons of lime and coal in and out. At its maximum level of operation the railway was hauling 1,100 carts every week to the main line railhead at Grassington.[40] As a portent of what was to come, the trade name for Threshfield's hydrated lime was 'Setelime' (as in Settle Limes Ltd), and the hydrating plant had been sheathed in sheet steel supplied by Leonard Cooper Ltd in Hunslet: the Coopers, as we have seen, were leading players in Settle Limes Ltd.

During Delaney's time at Threshfield, production had oscillated quite markedly, as indicated by the number on the roll. In its first full year of operation, 1904, twenty-nine men were employed here; the lowest number recorded was eighteen in 1908, while the highest was sixty-six in 1918-20. Once the new hydrating and crushing plant came on stream, the labour force rose to eighty and remained more or less constant throughout Settle Limes' tenure. This was despite mechanisation immediately after the Second World War that made breakers and fillers redundant (75/76).

In 1964 ICI Mond, Settle Limes' parent company, was faced with a choice: modernise the kilns and plant, replace it all, or shut the plant down altogether. The chosen course of action was the last of these options. The hydrating plant and all the kilns were decommissioned that year to enable the site to concentrate on producing crushed stone and ground agricultural limestone. There were the

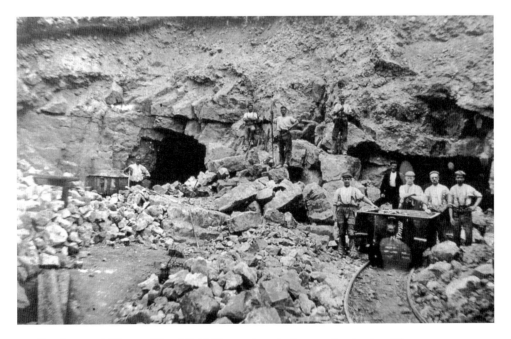

75. Breakers and fillers at Threshfield Quarry long before mechanisation. The men are tunnelling into solid rock for the basal section of the Spencer kilns. Second from the right is 'Darky' Dicken, brother of George Dicken, the quarry manager at that time. (*Rita and Arthur Berry*)

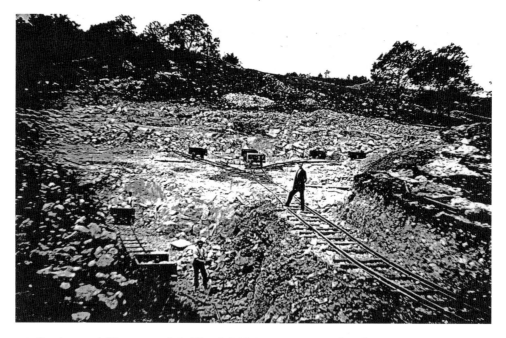

76. Breakers and fillers at work in Threshfield Quarry. (*Rita and Arthur Berry*)

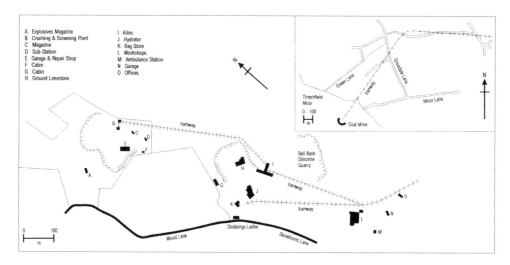

77. Plan accompanying a deed of transfer of Threshfield Quarry from Settle Limes Ltd to Mountain Limestone Ltd, 31 December 1965. *Inset:* Line of the tramway from Threshfield colliery to the lime works.

inevitable lay-offs, but many men were transferred to Horton limeworks. Ultimately, Threshfield Quarry was sold to Tarmac which, in 1966, signed over the upper parts of the quarry, but not the limeworks site, on a renewable twenty-five-year lease to a newly formed company called Mountain Limestone Ltd (77).[41] Settle Limes – or ICI Mond – had decided to rationalise its lime business by concentrating on Horton Lime Works, which could easily satisfy the demands of its customers for all types of lime and stone.[42] In addition, Threshfield had been supplying Halton East Quarries with substantial amounts of crushed stone since 1964 anyway, so the transfer from Settle Limes to Raleigh Hargreaves' new company made perfect economic sense for both parties. At last, he had secured sufficient stone reserves to keep his tarmacadam plant at Halton East going into the foreseeable future. For this reason, output of crushed stone at Threshfield rose from Settle Limes' 160,000 tonnes annually to 610,000 tonnes under his management. Successive planning consents enabled workings to extend northwards. By the time Hargreaves took over the site, the kilns and hydrating plant had been shut down, in 1964 in fact, though new hydrating plant was reinstalled some years later. The kilns were old by then and very inefficient, and the black smoke and fumes they pumped out led to more than a little local opposition. Hargreaves had no use for them anyway, and all five were pulled down and sold for scrap. The rock-cut tunnels, of course, remain. The other major change made by Hargreaves was to completely switch from rail to road transport. In Delaney's and Settle Limes' time, burnt lime had been exported to Scunthorpe and Scotland: it made economic sense to use rail. Hargreaves was mainly sending crushed stone to Halton East, which had no rail access, so there was no alternative, though he also had markets for hydrated lime in the Teesside steel works and various local water treatment facilities, and finely sieved limestone flour was despatched to Brown & Polson's custard factory in Manchester.[43] Hargreaves worked Threshfield until his Mountain Limestone Ltd was purchased by Tarmac in 1979. It became a wholly owned subsidiary, keeping its separate name for a while.[44] Output of crushed stone increased incrementally, as further consents enabled the quarry to be more than doubled in size.

From very humble origins, John Delaney had displayed quite remarkable business acumen in developing his various quarries and limeworks as well as his coal factoring business. Nevertheless, he was quite a different person from the Spencers, the last of Craven's lime entrepreneurs in our survey.

Messrs P. W. Spencer Ltd

There are several remarkable concentrations of lime kiln sites in Craven to the south-west of Skipton, in Cowling and Lothersdale parishes. In the valley of Gill Beck, between Ickornshaw and Glusburn, there are sixteen sites; on Coppy Hill there is a cluster of eleven; in Lothersdale twelve kiln sites have been identified. Much of southern Craven and adjacent parts of Lancashire is millstone grit country, characterised by acidic, peaty soils and nutrient-poor pastures. It is a reasonable assumption to suggest that when these moors were being carved up during the enclosure process, any suitable outcrop of limestone was exploited commercially for its lime, and a number of limeburners here collected glacial erratics from the boulder clay deposits that plaster the lower moors, and from within the becks that drain the moors.[1] These stones were gathered and burnt in small kilns, probably like the simple flare kilns we saw earlier in Shedden Clough. A newspaper report in 1938 recorded that several such kilns were still being used here 'up to 60 years ago', including one belonging to Tommy Shaw at New Hall Farm.[2]

An old packhorse route, Limer's Gate, ran across the moors from Cowling to Oakworth and Halifax, passing through Slippery Ford and Limer's Croft, and, as its name suggests, lime was a major commodity on this route for several centuries.

Within Lothersdale there were three clusters of commercial activity. One kiln operated from Hawshaw Slack Delf (SD 940 446), delf being dialect for quarry; Lothersdale Lime Works at Dowshaw Delf (SD 935 449) had two kilns; a second Lothersdale Lime Works at Raygill Quarry (SD 941 453) had eight kilns in 1851 when the area was first mapped by the Ordnance Survey. Lime was certainly being produced in the seventeenth century: a sale of land in 1600 included the right to 'digg and get limestones and other stones needfull for the meantaining and manuering of the said premises',[3] while Thomas Smith of Marleclough Beck conveyed to Robert Smith in 1681 'the messuage and tenement of Marlecloughbecke with liberty to get limestone in the delfs next unto the said messuage – situate in Raygill'.[4]

From the late seventeenth century the quarry and kilns at Raygill were owned by the Aldersley family, who sent lime far and wide.[5] In 1820, on the marriage of Mary Aldersley to William (1800-68), the whole site passed into the Spencer family. Three generations of Spencers proved to be as forward-looking and ambitious as our other 'local heroes', Clark, Wilson and Delaney, and they too developed business interests beyond their home base of Raygill.

The Spencers – William, his son Peter William (1821-83), and his grandson William (1861-1949) – operated limestone quarries at Lothersdale, Thornton-in-Craven, Giggleswick and Swinden near Grassington. They had interests in the limestone region of Derbyshire, and the second William served as a director of Buxton Lime Firms Co. Ltd, an amalgamation of twelve independent lime concerns in that area. He resigned in 1910, however, having been invited to join the board three years earlier when BLF bought out his lime works at Brierlow, close to Buxton.[6] As part of this agreement, Spencer granted BLF licence to use his patent steel kiln anywhere except in Yorkshire and Lancashire, so as not to enter into direct competition with his company here.

The family was also active in the Clitheroe area, having established the Swinden Macadam Co. Ltd at their Horrocksford Quarry in 1924. Until his death in 1883 the business was run by Peter William purely as a family partnership, trading as Messrs P. W. Spencer (78). His son William maintained the same legal structure for a while but decided to have the business incorporated as Messrs P. W. Spencer Ltd with its head office in Skipton, actual incorporation being registered in January 1924.[7] William, his brother Edward, and Asa Smith, an accountant in Keighley, sold their individual lime interests to the new company with William, Edward and John Spencer as co-directors. William, the force behind the business, died in December 1949,[8] and his wife Elizabeth was also dead before the month was out.[9] Their daughter, Mary Hayes, inherited her father's part of the business, and helped run it along with Edward and co-director H. C. Anson. William, whose life had been devoted to quarrying, was as wily a businessman as any. A graphic illustration of this

78. Letterhead and logo of P. W. Spencer, 20 June 1919.

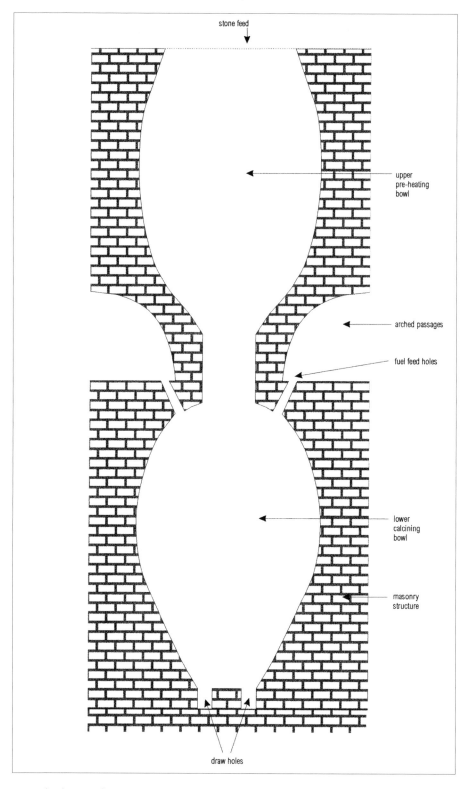

79. Kiln design of P. W. Spencer, patent no. 767 of 1870.

is provided by his taking Buxton Lime Firms to court in 1910.[10] He had maintained his right, while director of that company, to trade in Craven as a 'lime merchant and stone worker'. He became concerned when BLF announced its intention in 1909 to purchase a limestone quarry in Silverdale in north Lancashire. Spencer believed this was too close to home for comfort: he was afraid of the competition from such a complex company, so he tried to claim in the High Court that BLF had insufficient funds for its proposed acquisition. He lost the case, and this explains his resignation from the board in 1910. He also seems to have been a benevolent employer and no evidence of any industrial action at any of his quarries has been unearthed. It may even be said that he managed in a paternal way. Few bosses would have done what he did on his Golden Wedding anniversary in August 1938: he and his wife took the entire workforce to Blackpool for the day.

As with the Craven Lime Co. and John Delaney Ltd, control of what had been a family firm eventually passed into external hands. P. W. Spencer Ltd was swallowed up within the Farnley Group, which was itself taken over by Lime, Sand & Mortar Ltd in 1965. Five years later this, too, lost its independence by being subsumed within the Thomas Tilling Group, otherwise known as Tilcon. P. W. Spencer Ltd had maintained its separate identity within the group until the Tilcon acquisition.

SPENCER PATENTS

Three lime kiln patents were lodged by the Spencers: in 1870 by Peter William, and in 1894 and 1900 by William. It was the most recent of the three that came to be regarded as among the best designs of kiln in the twentieth century. Knibbs, one of that period's foremost technical writers on lime burning, and a kiln designer himself, regarded the 1900 kiln as 'probably the best' of its type,[11] and as recently as the 1960s the Spencer kiln – and its direct derivatives – was still producing the 'bulk of lime output' in Britain.[12] In terms of the number of kilns built, and in longevity, the Spencer 1900 kiln must be almost on a par with the Hoffmann kiln.

P. W. Spencer had learnt from experience with the kilns he came to possess at Raygill that adding fuel and stone in through the top was inefficient in the extreme. It was wasteful of fuel and the quality of the lime could not be guaranteed. His design was to create a kiln consisting of two distinct bowls separated by a narrow neck (what he called a dome), giving an hourglass shape to the whole structure (79),[13] though an alternative design had the upper and lower bowls separated by three transverse arches rather than by a constricting neck. Stone was fed in through the top of the upper bowl, but coal was added through eight small apertures at the top of the lower dome. Fuel was added where it was needed, in the calcining zone, and the heat generated could rise through the neck to heat up and dry out fresh stone higher up. Air was also drawn into the lower bowl to cool lime that had been fully calcined. In some respects, particularly the fuel feed arrangement, there are distinct similarities between this design and Henry Robinson's 1869 patent.

There is also some common ground between Spencer's patent and the kilns that were built at the Ribblesdale Lime Works at Helwith Bridge, which were also built in a vaguely hourglass format (Col. Pl. 27).

William's first patent, of 1894, was a modification of his father's design.[14] Instead of having two domed chambers, William introduced a third, narrow dome above the existing two, different in cross-sectional form from the 1870 design and with the aperture for feeding in stone at the top square rather than round as before. He felt this would somehow have the effect of deflecting heat to all parts of the dome, thus spreading it to all parts of the burning and preheating stone. Fuel feed was more or less as in the 1870 patent, with provision for fuel feed at two levels, into the middle and lower bowls.

William's 1900 patent modified his first one (80).[15] He introduced a complex system of flues within the structure of the kiln, controlled by dampers, which extracted surplus heat from the lower part of the kiln and recycled it to the upper part. Maintaining currents of air within the walls of the kiln also reduced the deleterious and costly impact of the high temperatures on the fabric of the kiln. Spencer broke with tradition in a most emphatic way, not least by doing away with stone as the outer casing. He proposed two methods of casing: to sheath the entire kiln in airtight sheet steel or to sink the lower chamber in an earthen embankment with just the upper chamber sheathed in metal or, as at Threshfield,

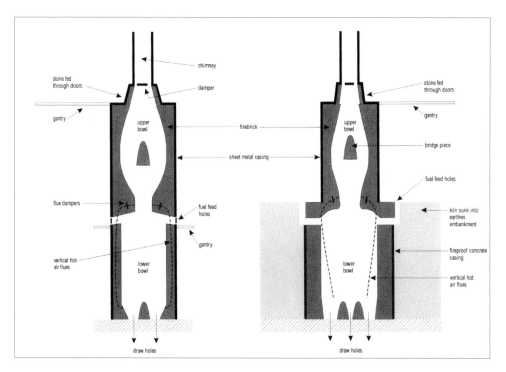

80. Kiln designs of William Spencer, patent no. 3094 of 1900. Left, fully encased in steel, as at Swinden, Giggleswick and Craven Limeworks. Right, sunk into an earthen (or rock-cut) embankment, as at Threshfield.

with the lower part cut through bedrock. The former came to prevail as the preferred option.

The 1900 design was brilliant in concept and as revolutionary to vertical kiln technology as Hoffmann's had been for horizontal continuous kilns. In one matter, though, William's claims did not stand the test of time. He asserted that his recycling of hot air would be 'obviating all possibilities of the nuisance that of producing dense smoke'. Those who have lived downwind of a Spencer kiln know only too well that this did not happen. They billowed smoke.

Spencer kilns of the 1900 design were built at his own company's quarries at Raygill, Giggleswick, Swinden (81) and Brierlow, as well as at the Craven Lime Works in Langcliffe, at Horton Lime Works, and at Threshfield. They may have varied in dimensions, but in essence they were identical. Photographic evidence confirms that the pair at Langcliffe were indeed identical in almost every detail to the first pair erected at Brierlow, down to the size, scale and design of the stone buttresses, which have survived at Langcliffe. In the six Craven quarries, stone was taken to the feed holes in carts pushed along gantries, set on massive stone buttresses or metal trusses. At Langcliffe coal was delivered by Jubilee carts

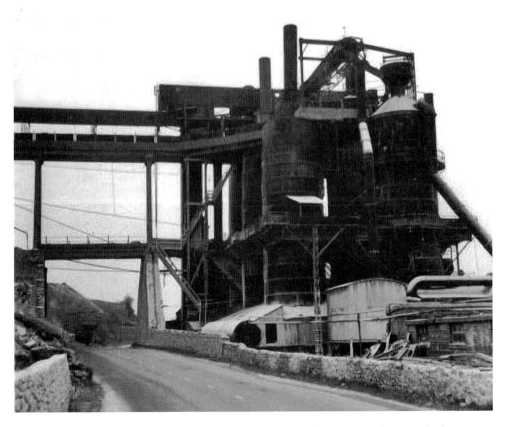

81. A battery of Spencer kilns at Swinden Lime Works, built 1902-14, photographed in 1963.(*Clive Midgley Collection*)

pushed along a lower gantry from a lower buttress, but at Swinden and Brierlow coal tubs were raised in a vertical lift to the charging levels.

A detailed description of a pair of Spencer kilns was written in 1905.[16] Each was set on a massive concrete plinth and had a steel casing weighing 41 tonnes, lined with firebrick. Each kiln was 22 m high and had a capacity of 90-110 tonnes of lime per day. The kilns could be cylindrical or bulbous and slightly oval, though the former seems to have been the dominant form. Though wind, temperature and air pressure changes could affect the rate of combustion and calcination, in general terms 1,780 kg of limestone with 200-400 kg of coal would yield 1,000 kg of lime.

According to Knibbs, some Spencer kilns had an infill of sand or ash to act as an insulating layer between the firebrick lining and steel casing.[17] It may have been deliberate on Spencer's part, or purely coincidental, but at the turn of the century the costs of masonry had risen significantly whereas sheet steel was cheap. So, not only was a steel-clad kiln much stronger and more airtight, it also achieved lower construction and fuel costs than masonry kilns, but not necessarily lower maintenance costs. Every five years or so a Spencer kiln had to be shut down and opened up to allow replacement of the firebrick lining. Nevertheless they were much cheaper to run than a horizontal, highly labour-intensive Hoffmann kiln.

A number of Spencer kilns, certainly those at Langcliffe, included a thoughtful human touch. Cabins were built onto the lower casing of each kiln. On cold days the workmen could find shelter and warmth from the kiln without costing management a penny in extra fuel bills. Details of the Spencer kilns have also been provided by two former employees at Swinden.[18] Carts of stone were pushed across the top gantry with their 2.6-tonne load to be dropped into the preheating chamber of each kiln, while coal tubs were hoisted by lift to one of the charging levels. At the upper level eighty shovels of coal were thrown into the calcining chamber eight times a day, with 120 at the lower charging level. Two lime drawers per kiln had the 'horrible' task of shovelling 2.5 tonnes of lime out eight times a day, each batch of stone having been in the kiln for three days.

LOTHERSDALE AND THORNTON ROCK

The Lothersdale Lime Works at Raygill produced lime until the 1950s, when market conditions made lime burning less profitable than hitherto (82). From then, production was focussed on crushed stone and tarmacadam while the lime burning side of P. W. Spencer Ltd was concentrated at Swinden and Giggleswick, both of which had rail access within reach. Tilcon invested heavily in the quarry after they took it over in 1970 but, as the stone had to go out by road through Lothersdale village, public concern and opposition began to grow. This was strengthened when the company began to ship in stone from Swinden to maintain production of coated stone at Lothersdale, which no longer had sufficient reserves. In 1972 the quarry was given a maximum life of ten years and production ceased in 1980.[19]

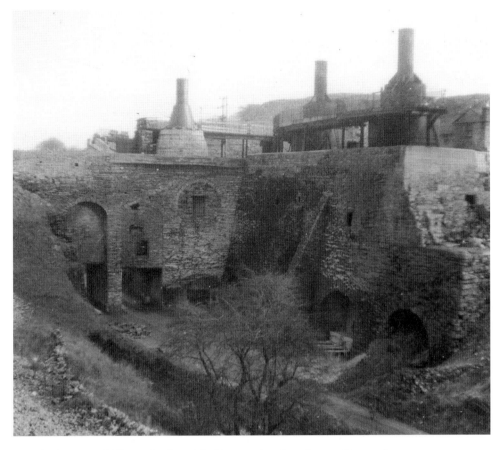

82. The battery of kilns at Lothersdale Limeworks after closure. Date unknown.

P. W. Spencer Ltd also worked Thornton Rock Quarry (Col. Pl. 28) in 1897-1916, abandoning it only two years after investing in new tarmacadam plant and taking on more men.[20] Perhaps the company managed to recoup its financial outlay quickly, or else had miscalculated its profitable life span. The quarry did not shut down, as it was run by W. Pollard of Nelson until final closure in 1921 or 1922, by which time the labour force had been whittled down from twenty-four to a mere four.

SWINDEN QUARRY AND LIME WORKS

The reef knoll of Swinden Hill was quarried for stone and lime long before William Spencer showed an interest, with seven small quarries around its flanks and William Fairbank as the principal limeburner and merchant, as noted in a trade directory for 1887. The most productive kilns – a pair of traditional stone draw kilns – were in use throughout the nineteenth century, but were disused by the end of the century. Scant remains of one of them can just about be seen near

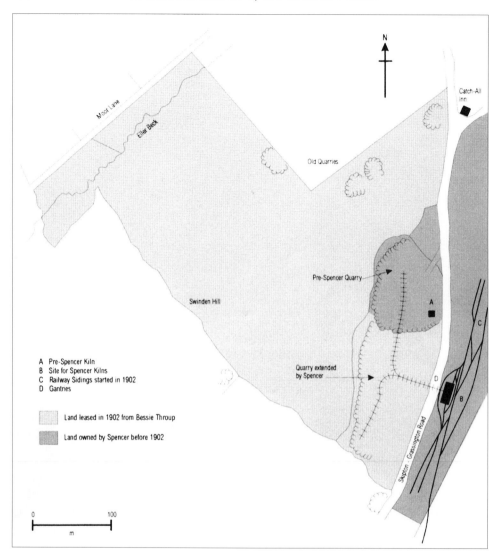

83. Swinden Quarry in 1902, based on a deed map.

the modern entrance to the quarry. Lime produced here was destined for local use on the land.

William Spencer, like John Delaney, was drawn here by the construction of the railway from Skipton to Grassington at the turn of the century. Acquiring this site gave him the opportunity to create a complex much greater in scale than Lothersdale. In 1901 he acquired the existing quarry and kilns just south of the then Catchall Inn, with the intention of working the reserves 'on a considerable scale' (83).[21] A few months later, Spencer purchased a fifty-six-year lease from Bessie Throup of Skipton on a large portion of land on Swinden Hill.[22] This agreement gave the company carte blanche to quarry stone, burn lime and erect whatever buildings and plant they deemed necessary.

Construction of the first of six Spencer patent kilns began immediately, with each one nearly 27 m high. The first was formally opened on 29 September 1902. Treating the kiln like a ship, Mrs Spencer smashed the mandatory bottle of champagne against its 'hull' and named it 'Una', before igniting its fire to start it up.[23] Construction of the second kiln – called 'Secundus' and opened in early 1903 – had already begun. Cottages were also constructed near the road for the workforce, and rail sidings were laid in 1902. The last of the kilns was completed in 1914.

Tonnage of lime and stone despatched grew incrementally as each kiln came on line. The total tonnage for the second half of 1903 already exceeded 13,000 tonnes, with each kiln having a capacity of about 80 tonnes. The quarry remained unmechanised for the first half of its life. Breakers and fillers smashed stone by hand until the first crushing and screening plant was installed in 1948, and which was itself replaced with new plant in 1967.[24] The wages ledger covering the period August 1924 to February 1927 still survives at the quarry, and it lists all the men with their allotted roles on a daily basis. For most of that period fourteen breakers and fillers were employed at Swinden and there was considerable variation in the amount of stone broken up and despatched to the kilns by different workers. Overall the maximum quantity processed by individuals ranged up to a maximum of 12-14 tonnes, which is an impressive amount to have been broken by hand in a single day. One man managed 17 tonnes in a single shift – a truly staggering feat. It should be remembered, of course, that the men worked on a piece-work basis: the more they processed, the more they were paid at the end of the week. It is sobering in today's world to consider that a good week's wage for a breaker and filler was less than £4.

In about 1967 the original 1930s tar-coating plant was phased out, and the six coal-fired Spencer kilns were shut down and demolished. They had served the company well, but their technology was now dated and they were too expensive to keep going. In their place were built two oil-fired West's Catagas kilns (84), fully automated and able to turn out as much lime as the six old kilns. Stone was fed through a bell chamber on the top of the West's by an automatic conveyor belt mechanism every forty minutes. As burnt lime was drawn out at the bottom, the bell chamber released fresh stone into the kiln. Drawing was also automatic, achieved by trap doors releasing lime onto another conveyor. These kilns were then the latest in British kiln technology and they seemed so promising that the Lime, Sand & Mortar Group (LSM), which now owned P. W. Spencer Ltd, applied for planning permission to build a third. This, however, caused something of a stir locally as the oil-fired kilns emitted copious quantities of black smoke, just like the Spencer kilns had done.

LSM increased output of roadstone as well as ground agricultural limestone, and when Tilcon took this company over in 1970 a further major development did get the go-ahead.[25] Yet more of the plant was replaced to make Swinden capable of producing stone and lime of the highest quality as well as concrete blocks, a new addition to the quarry's product list. Two new kilns were erected in 1972 in response to Swinden's being awarded a major new contract to supply British

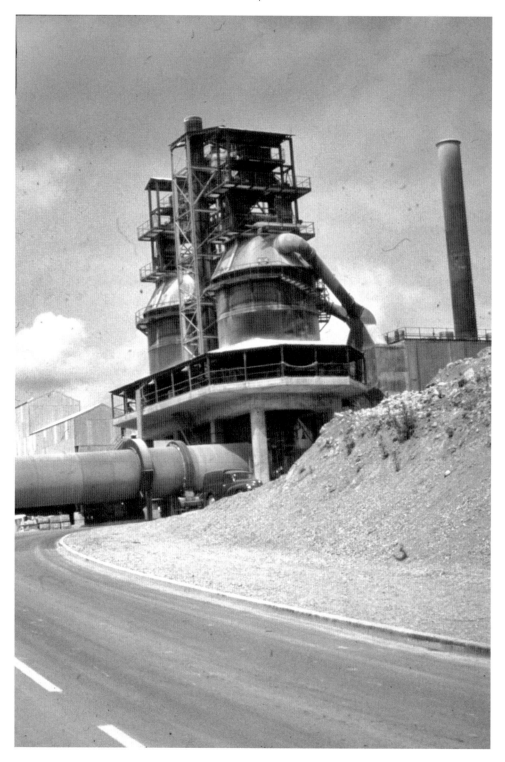

84. West's kilns, like those at Swinden, photographed in the 1980s.

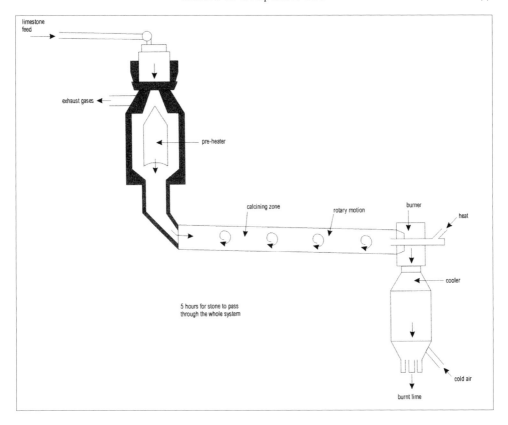

limestone feed

exhaust gases

pre-heater

calcining zone

rotary motion

burner

heat

cooler

5 hours for stone to pass
through the whole system

cold air

burnt lime

85. A Kraus Maffei rotary kiln, as built at Swinden in 1972.

Steel's Lackenby plant on Teesside with top grade lime. These new kilns – German Krauss Maffei rotary units, the first to be built in Britain – ran on natural gas (85).[26] The use of gas had come late in limeburning, at least in the Dales. The first use of gas in British lime kilns was recorded at Dyserth in Flintshire at the end of the 1890s, and one of the pioneers of gas kiln technology, along with the inventor T. J. Humphreys, was William Spencer, who had played around with one of his Lothersdale kilns trying to perfect the method, but with no great success. Yet again, we find our Craven entrepreneurs at the forefront of innovation in the industry.

As a gas supply had been installed to Swinden for the rotaries, the Catagas kilns were converted to justify the cost of putting in the pipeline. This turned out to be a mistake as gas seemed unable to generate and maintain the necessary temperature to guarantee an even burn. Try as they might, they could not obtain the quality of lime their customers expected. Eventually the West's kilns were re-converted to oil.

Stone, in much smaller pieces than in vertical shaft kilns, was automatically fed into the vertical preheating zone of the kilns before passing through the horizontal rotating calcining drum, and then through the lower vertical cooling chamber into storage hoppers. To complete the redevelopment of Swinden in 1972, the public road was diverted out of the quarry area to its present line.

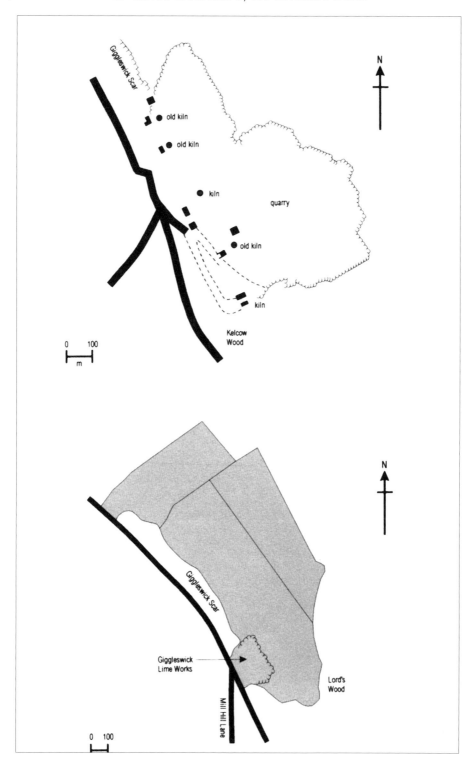

86. *Top*: Giggleswick Lime Works in 1909, based on Ordnance Survey mapping.
Bottom: Land purchased from the Ingham family by P. W. Spencer Ltd around
Giggleswick Quarry.

On 4 July 1973 the new Swinden Quarry was officially and formally opened. The workforce had grown from sixty in Spencers' days to ninety-four, and stood at 119 in 1980. The works despatched 1.2 million tonnes of stone that year plus 340,000 tonnes of burnt lime, three times as much as in 1969. It was now a massive operation.

As the 1970s passed by, Swinden opened up new markets. Lime was sent to British Steel at Scunthorpe, and burnt lime found a ready market for bulk and bagged hydrated lime in parts of the developing world, where it was used for treating water and sewage. All seemed to be going well, but not with the new kilns. The rotaries were no more successful than West's kilns, and their black smoke emissions were even worse. After a working life of only eight years the rotaries were decommissioned and demolished, in essence written off as a costly failure. The British Steel contract had expired and was not renewed, but the crunch came when the gas supply company increased its price, on expiry of the contract, by 662 per cent.[27] The kilns could not continue. Redundancy notices were issued to fifty-one men as an unwelcome Christmas present in 1980.

The Catagas kilns survived much longer; they were finally shut down in 1996, and demolished a year later. That was the end of lime burning at Swinden, much to the relief of all those who decried the 'whitewashing' of all trees, meadows and buildings downwind of the kilns.

GIGGLESWICK QUARRY AND LIME WORKS

Giggleswick Scar had been quarried for burnt lime for hundreds of years, with a string of small kilns dotted at intervals between the road and the scar. In 1830, for example, Thomas Clarke was listed in a trade directory as a commercial limeburner in Giggleswick, which can only have been on the scar, with Stephen Parker similarly listed in 1848. The rest are unknown. As we saw in an earlier chapter, large-scale commercial burning at the lower end of the scar was stepped up in the 1850s. We do not know for sure who took over the lease when the Craven Lime Co. eventually surrendered it in the 1870s, but it may have been P. W. Spencer Ltd, who took out a forty-two-year lease in February 1899,[28] giving us one of the rare insights into Giggleswick Quarry's early history.

The 1909 Ordnance Survey 1:2,500 scale map shows the site's layout with clarity (86). The quarry itself was small, extending just behind the present golf clubhouse and where the present road climbs up into the quarry. Three 'old kilns' were marked, one on either side of the clubhouse and one further back. Two operational kilns were depicted, including Woodend (or Lower) Kiln, which had a gantry to its feeding hole from a huge stone buttress that still exists.

Giggleswick had the major disadvantage of not having immediate rail access. Indeed, the nearest loading point was at Giggleswick station, 1.6 km away. For decades coal and lime had to be trundled back and forth by horse and cart. This

was slow and expensive in labour terms so, in May 1920, Spencer acquired a small fleet of wagons from Manns Patent Steam Cart and Wagon Co. Ltd of Hunslet in Leeds (87). These were cumbersome, ponderous, noisy and smoky beasts that ran a shuttle service along Mill Hill Lane and Raines Road, carrying 8-11 tonnes of lime out, destined for steel works on Teesside and in Sheffield, with coal for the kilns carried on the return leg. Burnt lime or crushed stone were tipped from the steam wagons directly into rail wagons by means of a ramp, while coal was fed into them by a chute. They were, however, unbelievably slow, with each return journey taking two and a half hours. Apart from the time spent on the journey, roads at that time were not metalled so they more often than not resembled a quagmire, churned up by the wagon's solid wheels (88). Spencer complained that the state of the road increased transport costs and necessitated constant running repairs on the wagons. For its part, the local council abhorred the mess that was the road.

A solution had to be found and Spencer decided an aerial ropeway was the answer (89). In a series of conveyances, beginning on 1 January 1920, the company acquired leases for building concrete piers, or standards, to support the ropeway towers. It was initially to be set 3.7 m off the ground and carried across the fields to sidings and loading facilities at the station,[29] though the height of the towers varied from 7.7-18.5 m high, depending on the lie of the land.[30] Several leases record purchase of land with rapid re-sale transactions, which gave the company wayleave for the ropeway. The main leases stipulated that, should the

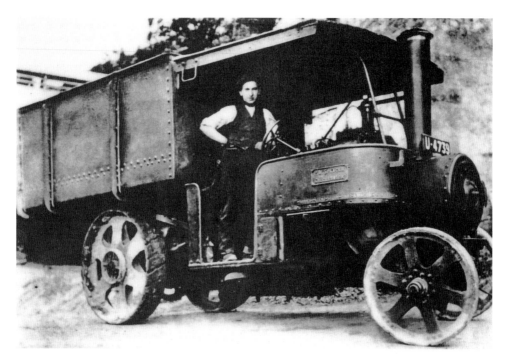

87. Joe Parsons at the wheel of a Mann's Patent Steam Wagon at Giggleswick Quarry. (*W. R. Mitchell Collection*)

88. A Mann's steam wagon reducing Mill Hill Lane to a quagmire. Edgar Hudson is at the wheel.

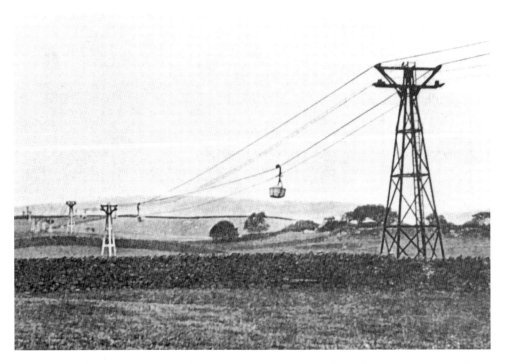

89. The aerial ropeway from Giggleswick Lime Works to Giggleswick station, photographed when newly built in 1922.

ropeway go out of use at some future date, all standards were to be removed, which explains why no trace of most of them is to be seen.

The proposed height of the ropeway caused conflict between Spencer and the authorities. He petitioned the West Riding Highways Committee to have the main road past the quarry entrance lowered, and he graciously offered to contribute one third of the £928 cost of doing this. It will come as no surprise that the committee turned him down and insisted that he raise the cable instead and sling protective netting underneath where it crossed the road.[31]

Work to build the ropeway should have begun immediately, but it was delayed. Whether this was due to extremely wet weather, as William Spencer insisted, or to a stubborn intransigence on his part after the debacle over the road crossing, remains conjectural. He did, however, threaten to close the quarry and limeworks if Mill Hill Lane was not repaired.[32] The council retorted, naturally, that by agreement the ropeway was to have been complete by 11 December 1920, so the state of the road was entirely the fault of the company. Furthermore, they informed him that repair costs would be charged to his company from 1 February 1921. Not only that, they also decided that stone from Giggleswick was not suitable for putting the road to rights, so he would be billed for stone from the council's own Brunton Quarry at the top of the scar. One can draw one's own conclusions from this.

The ropeway was not commissioned until 1922. It had cost the company dear. At first the ropeway was powered by steam, though in later years electricity was used. It supported twenty tubs, or carriers, in each direction, ferrying 500 kg of lime out and coal in. It had a capacity of 30 tonnes per hour, one tub being despatched from the terminal every minute at a running speed of 60 m per minute.[33] When tubs came into the quarry terminal, the fuel was automatically discharged into hoppers, which fed the fuel along chutes to each kiln. Empty tubs then passed along the ropeway to one of the kilns to be filled with lime, and then back onto the main ropeway (90). When they reached the station, the tubs were stopped and the lime tipped into rail wagons waiting below, which, in turn, were winched in and out from the feeding hopper. Empty tubs then passed round to be automatically filled before going back on to the main line. It was all very sophisticated and highly efficient in its early years. The entire system had been supplied and erected by a Widnes company, R. White & Sons.

The steam wagons were not retired when the ropeway came into use, but were put to work within the quarry until old age required them to be put out of their misery in the 1950s. The ropeway did not outlive them by more than a decade or so. Like other ropeways in the Dales, this one had not been without its peccadilloes and, when the principal landowner demanded a massive increase in wayleave rent, the company decided that was the final straw. The entire system was dismantled, and henceforth two lorries ferried lime and stone to the station on the now metalled roads.[34] When the sidings at Giggleswick were themselves taken up, two lorries continued on a shuttle service, but this time to Swinden Quarry, where lime was loaded onto rail wagons.

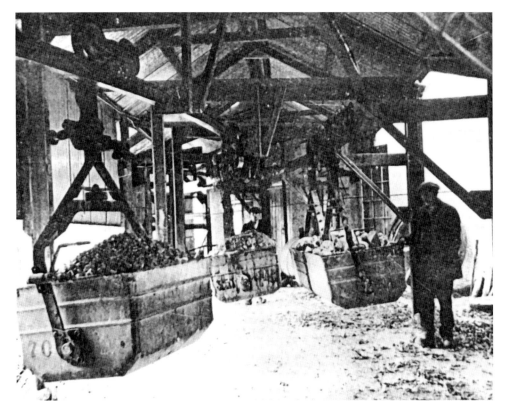

90. Tubs at the aerial ropeway terminal in Giggleswick Lime Works.

It was not only transport that gave Spencers grief: the perennial issue of pollution from the kilns generated its fair share of complaints from residents of Giggleswick. Predictably the local council felt moved to debate the matter and, in 1925, to write to the company insisting they institute remedial measures. One notable voice begged to disagree, however. Councillor Metcalfe warned against backing the company against the wall with his observation that 'it was amongst the dirt where the money was'.[35] I suspect he meant 'where there's muck, there's brass'.

Under the Spencers, Giggleswick had five kilns in operation (Col. Pl. 29). No. 1 kiln was Woodend Kiln, also known as Lower or Low Kiln, and this one predated the Spencers' tenure here. It was sited to the east of the present quarry entrance, not far from the main road. An overhead wood and steel gantry connected the kiln top to the stone buttress, to transfer coal and lime tubs to the kiln top. The lower part of this kiln was masonry-built, with the upper part steel-clad. It was charged four times a day. As it predated the Spencers it is highly unlikely to have been an 1870 Spencer patent kiln and no one seems to know what type it was. The chances are that it was of local origin and the two designs that idle speculation brings to mind are Robinson's 1869 patent and Winskill's 1872 patent. The former tends to fit the description of Woodend Kiln in that both had an overhead gantry, but other evidence might suggest it could not have been a Robinson. Could it, then, have been a Winskill?

No. 2 kiln was also very old and its position within the pre-Spencer quarry implies that it, too, may predate the Spencers. It was known to Giggleswick employees as the Robinson kiln. It was similar in design to Woodend Kiln, having a steel superstructure set on a masonry base, and coal was tipped directly into the firing chamber from Jubilee carts from a ramp, the kiln having been built into a bank, and it was also charged four times daily. So, we have distinct similarities between No. 1 and No. 2 kilns, which means they may both have been Robinson kilns, yet why would only one be referred to as the Robinson? No. 1 kiln was the first to be decommissioned, after which its stone buttress was used as a ramp for tipping stone into lorries below.

Nos 3-5 were all Spencer kilns of the 1900 patent (91). No. 3 was known as 'the Big Kiln': it had a greater capacity than the others. It was charged up to six times a day, with 6 tonnes of stone going in each time. The other two had five chargings of 5 tonnes. As with most Spencer kilns, stone was loaded from tubs pushed along a raised gantry, with coal being hand-shovelled through chutes on two levels, as described earlier. Plans were approved for the erection of a new kiln in 1938, though there is no evidence it was ever built.[36] At the end of the 1960s the

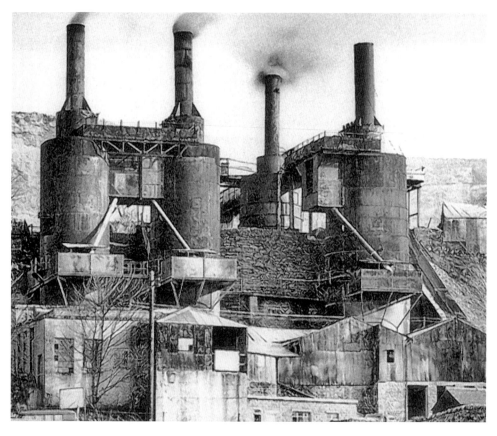

91. The three Spencer kilns, with the Robinson kiln behind, at Giggleswick Lime Works, photographed in 1966. (*Becker, 2003*)

owners had planned to replace the Spencer and Robinson kilns with new Swedish oil-fired units. But, fortuitously perhaps, their plans came to nought and the kilns were phased out completely in 1971. Eleven men were laid off.[37] The kilns had been killed off by an unexpected and deep recession in the steel industry, the main market for burnt lime from here.

Apart from the kilns, most of the buildings in Giggleswick Quarry stood where the quarry entrance now is. Storage hoppers nestled next to the weigh house, above which loomed the structure from which the ropeway emerged. Until the 1960s the quarry had no crushing plant: it was all performed manually by breakers and fillers, making Giggleswick more technologically backward than many quarries.

In 1936 P. W. Spencer Ltd had secured a lease from John Ingham of Langcliffe Place, manager of the cotton mill there, for a large swathe of land between Lord's Wood and Kelcow Wood in the south and on land above Kinsey Cave to the north (86).[38] In 1964, as the company was being swallowed up by the LMS Group, the lease was converted into outright purchase.[39] LMS had designs on the reserves of stone beyond the confines of the quarry they were inheriting, and this was the first step in their strategy. In 1969 plans were submitted for comprehensive redevelopment of the whole quarry area. Apart from building new kilns, as mentioned, they aimed to triple the workforce from what was then sixty or so, to extend quarrying towards Lord's Wood and then north towards Stackhouse, thereby breaking the skyline above that hamlet, to develop a new rail link and a new quarry entrance off Stackhouse Lane, and to boost output fourfold. The plans were duly considered by the National Park authorities, and refused.[40]

Two years later modified proposals were put forward by Tilcon, offering to demolish the kilns, to abandon the new entrance idea, and to reduce the planned scale of working. The district council and National Park authorities were in favour, but this time local opposition became quite vociferous and the matter hung in the air for a further three years. In 1974 the council recommended approval of a second set of modified plans.[41] Tilcon now hoped to get on with the job of demolishing the disused kilns, improving the existing quarry entrance by removing redundant buildings there, and erecting a new powder mill within the existing quarry. Realignment of the entrance enabled lorries to enter and leave on the then A65 through Settle instead of having to go down the narrow Mill Hill Lane – not exactly a popular move with Settle residents. The kilns came down in the following year.

Meanwhile, a new market was opened up by securing an order to supply British Sugar's beet factory at Poppleton near York with finely ground limestone to be burnt in its own kilns.[42] As the years passed by, the scale of operations at Giggleswick tended to be reduced and this quarry, like so many others, came to rely on sales of crushed stone for aggregate.

Of the four sites worked by the Spencers in the Dales, only Swinden has survived as a significant centre of production. Giggleswick closed down in 2008, while Lothersdale and Thornton Rock have long since disappeared from the scene.

A Miscellany of Quarries

The preceding chapters in this book have concentrated on limestone quarrying and lime works associated with individual entrepreneurs who, by their own efforts, came to dominate the industry in the Craven Dales, and whose names have endured to this day. There were, however, a number of other concerns across the Yorkshire Dales, perhaps not so closely associated with single prominent personages. It is to these we shall now turn.

RIBBLESDALE LIME WORKS

Quarrying operations at Foredale above Helwith Bridge in Ribblesdale began in 1878 when a partnership of three men took out a twenty-one-year lease from the landowner, Christopher Deighton, to exploit both limestone and sandstone deposits. Thomas Ritson and Emmanuel Gould, both living locally, joined with Jonathan Ritson, a cashier in Hunslet, Leeds, to form the business, but in 1882 they sold out their entire operation, including the lease, to Leonard Cooper, a Leeds-based iron master. Cooper, Thomas Ritson and Edward Crawley, a Leeds iron merchant, formed the Ribblesdale Lime and Flag Quarry Co. Ltd in that year, with its registered office in Leeds.[1] When this company bought the partners out, it took over all 'plant, machinery, loco, wagons, horses, carts etc.'.

Leonard Cooper was chairman and effectively ran the company, later helped by his son, also Leonard. The first threads of the later merger of the three local companies to form Settle Limes were drawn in 1907, when Ribblesdale bought a significant number of shares in the Craven Lime Co. – £6,000-worth in fact – but to raise the requisite finance, Cooper felt obliged to mortgage the entire Foredale complex. Three years later, the name of the company was shortened to the Ribblesdale Lime Co. Ltd. In 1927 Ribblesdale entered into the pooling arrangement with Craven and John Delaney Ltd, with a joint board of directors, cooperation in operations and sales, and the combining of profits (92). Lime from

92. Advertisements from 1927 for the Craven Lime Co. and Ribblesdale Lime Co., both with the same Leeds address. (British Limemaster, *October 1927*)

all three sites was soon jointly marketed as Setelime (93/94). At the same time, control of the company passed to the Woolley-Harts and the registered office was transferred to Pall Mall in London.

Two generations of the Cooper family ran Ribblesdale: Leonard Sr became vice-chairman of Settle Limes and his son, Leonard, was also prominent in that company after his father's death in 1939. But the name of Cooper is not well known today in the local area, unlike Clark, Wilson, Delaney and Spencer.

When Ribblesdale was swallowed up within Settle Limes, the scale of working at Foredale was stepped up and in 1939 new plant was installed to produce ground agricultural limestone, the demand for which was soaring as a result of the introduction of Government subsidies. This was in addition to the new plant that had been put in during 1931. Extensive areas to the north of the quarry were leased or purchased with a view to extending it north into Moughton Hill and, as late as the 1950s, a further twenty-five-year lease was obtained, which gave the company the right to erect whatever kilns or buildings they felt might be needed (68).[2] In 1958, however, quarry and limeworks had been abandoned, sacrificed in response to a depressed lime trade that led to markets being lost.[3] After Settle Limes was taken over by ICI Mond, the entire complex was sold in 1963 to the Arcow Granite Co. Ltd, a subsidiary of Hillhead Hughes Ltd of Derbyshire, by which time the limestone side of Foredale-Arcow was already defunct.[4]

The size of the labour force varied enormously over the years, reaching a maximum of seventy-six in 1931 but dropping by 1934 to the same number as in 1895, when it employed only thirty-three. A good proportion of the men were breakers and fillers or pony men, whose job it was to guide the carts from the quarry face to the head of the incline (95). In the late 1940s fourteen men actually

12a *CEMENT, LIME & GRAVEL* *November. 1928*

93. Joint advertisement for the three companies in the pooling agreement, now centred on Settle. (Cement, Lime and Gravel, *November 1928*)

94. A trade stall for Settle Limes Ltd advertising *Setelime* at an unknown agricultural show.

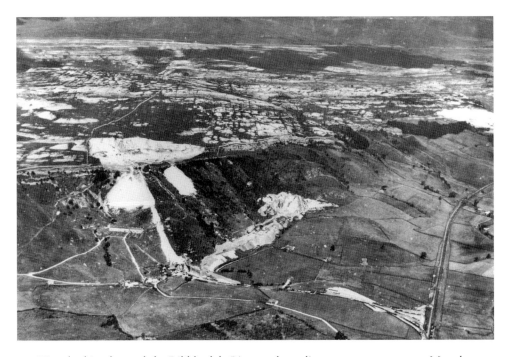

95. View looking beyond the Ribblesdale Limeworks to limestone pavements on Moughton, photographed in July 1936. The kilns and other plant lie at the foot of the steep incline leading down from Foredale Quarry. Arcow 'granite' Quarry is to the right of the kilns. (*Aerofilms Ltd. C12845*)

worked in the quarry itself, mainly at the working face, as by then a locomotive had replaced ponies inside the quarry.[5] The bed of the incline has survived, as have remains of the drum house in the form of stone plinths topped by a corrugated iron building that housed the drum and its operative. A neat but ingenious system of narrow-gauge tracks allowed full carts to be pushed into position waiting to be lowered, and empty ones to be hauled back up. When six full ones had been assembled, they were hitched together and lowered on the endless steel rope. The weight of these pulled six empty ones back up. Either side of the drum house are the remains of cabins: a stone structure to the north and a corrugated shed on iron stilts on the opposite side.

Foredale is unique within the Dales in that it is the only quarry that has the imprint of its internal infrastructure intact. After it was abandoned, and because the quarry is sited high above the valley floor, it was simply left untouched. It avoided the fate of so many abandoned quarries that became landfill or industrial sites. Here, all material that could be salvaged was removed, but the trackbeds for the rail loop, all tramway links to the working faces, the sidings, the footings of buildings, and much of the compressed air pipe system have survived intact.[6]

The incline was single track, except for a passing loop halfway down. At the bottom the track diverged to feed the kilns (96, Col. Pl. 30). These were entirely constructed of masonry, typical of vertical mixed-feed kilns built in the latter half of the nineteenth century. They were squat and solid with a flat top so that quarry carts could be pushed across to the bowls of the kilns. They formed one L-shaped

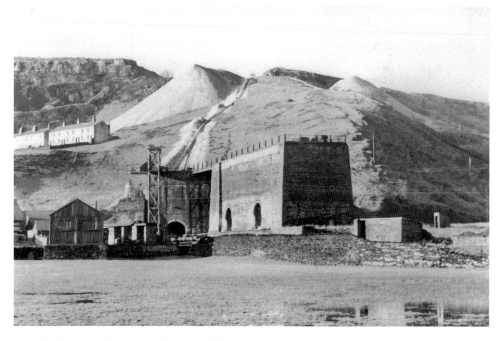

96. The battery of masonry kilns at Ribblesdale Limeworks in the 1920s. (*Jessie Pettiford Collection*)

unit, with four bowls 10.5 m high on the long axis and two bowls of 9 m on the short. Each pair of bowls fed one draw hole opening. Coal was raised in carts on an elevator, and a system of turntables enabled the stokers to push the carts to whichever bowl was being filled. Compared with the Spencer or Hoffmann kilns down the dale, these must have seemed relatively primitive technologically, but they outlived the latter and many of the former. They obviously did the job they were designed to do.

Between the kilns and Foredale Farm were the blacksmith's shop, the loco shed and ancillary structures, some of which forlornly stand today. The kilns were connected to the railway by a standard-gauge railway spur and a network of sidings (97/98). Opposite Wheat Riggs Barn, alongside the railway (now a footpath) were the ambulance station, the weighing machine house and an office (Col. Pl. 31). A stile has survived in the wall, incidentally, which gave access for the paymaster when he brought in the weekly pay.

When the limeworks was operational, the road into the site was along what is now a footpath from the barn to the farm. The present road access is relatively modern. After the kilns were decommissioned, they slowly began to deteriorate and became a hazard, so in 1982 they were all demolished. The spot where they stood has since disappeared under the screening bund at the entrance to the hardstone Arcow Quarry, which lies at the foot of the hillside below Foredale (Col. Pl. 32/33).

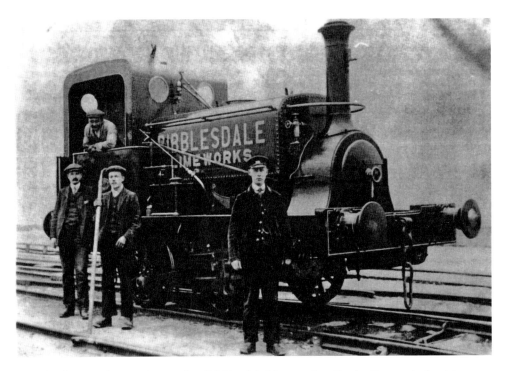

97. The shunting locomotive used at Ribblesdale Limeworks. Charles Forster is the driver, John Procter and Rowley Harper stand next to the cab. (*Kathleen Handy*)

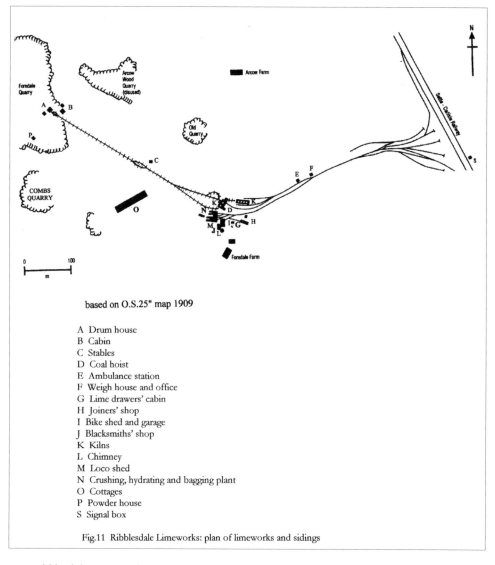

based on O.S.25" map 1909

A Drum house
B Cabin
C Stables
D Coal hoist
E Ambulance station
F Weigh house and office
G Lime drawers' cabin
H Joiners' shop
I Bike shed and garage
J Blacksmiths' shop
K Kilns
L Chimney
M Loco shed
N Crushing, hydrating and bagging plant
O Cottages
P Powder house
S Signal box

Fig.11 Ribblesdale Limeworks: plan of limeworks and sidings

98. Ribblesdale Limeworks as it was in 1909, based on Ordnance Survey mapping.

COOL SCAR QUARRY

The early history of Cool Scar Quarry at Kilnsey in Upper Wharfedale is a mystery. There is no entry for it in any of the Government lists of quarries, and its date of inception is vague. Of the few early references that have come to light is one noting that a steam-powered jaw crusher was installed in the 1880s to replace manual breaking, which must make this one of the earliest quarries in the Dales to be mechanised to an extent. In the 1930s the quarry turned its attention to producing agricultural ground limestone, as did so many other quarries.[7] In 1946 Cool Scar was shut down by its operator, W. D. Roberts of nearby Chapel House,

but was reopened eighteen months later by Better Limes Ltd, trading as Kilnsey Limes. This company almost immediately put in new crushing and screening plant, despite local objections, but the district council imposed restrictions on the extent to which they could push the working face back, and lime burning was expressly forbidden. However, the county council overruled the lesser authority on environmental grounds, so the company took the matter to the Government, citing the fact that local farmers had to journey up to 80 km to obtain their needs.[8] The outcome is not recorded, but the fact that Better Limes applied again in 1957, also unsuccessfully, must indicate they had been refused. Undaunted, they tried yet again, and this time were granted consent in 1960 to install the new plant, which was further extended three years later. The market for agricultural ground limestone was declining, so the quarry switched to producing aggregate stone for the building industry. It was a highly mechanised affair and, in 1963, only employed seven men in total.

Eskett Quarries took over the lease on Cool Scar in 1977 and they submitted proposals in 1981 to extend the quarry from 5.7 ha by either 3.2 ha to give it ten more years or by 9.3 ha to extend its working life by twenty-five years. In an attempt to mollify opposition to their plans, the company re-sited the plant that had stood very prominently on Mastiles Lane within the quarry, where it could not be seen from a distance.[9] Their environmental credentials were already well established, as they had made it mandatory in the mid-1970s for all loaded lorries to be sheeted to reduce the nuisance value of dust. In 1983 a planning decision had still not been made, so the quarry owners appealed to the Government. The council had favoured the lesser extension, and again applied stringent conditions to the permission that was granted.[10] In 1987 Eskett Quarries became a subsidiary of Evered Quarries Ltd (part of the Aggregate Industries Group) and, controversially, the quarry was very soon pushed back in breach of the conditions laid down, but they got away with it. The site was closed down for good in 1998/99 on expiry of the planning consent: it has since been left to slowly re-wild, though the starkness of its faces presents a challenge to colonising species (Col. Pl. 34).

RIBBLEHEAD QUARRY

Ribblehead Quarry had been dormant since the Craven Lime Co. abandoned it in around 1907. It enjoyed adjacent rail access, but was remote from any population nucleation and getting men to travel daily to Ribblehead, when work was available elsewhere, proved to be most problematic. The quarry was resurrected in 1943, when Horace Austin & Sons Ltd of Leeds took on the lease and installed crushing and screening plant to produce pulverised agricultural limestone. In 1952 they applied for consent to vastly increase the size of the quarry, and to deepen it to boost annual output to 60,000 tonnes. However, in the following year, Adam Lythgoe Ltd, a Warrington-based company, diversified into limestone quarrying in the 1950s and bought a sub-lease for Ribblehead in

1952 specifically to produce ground limestone for agricultural use, but also to supply new markets in steel, paper making and construction. It was Lythgoes that installed the new plant planned by Austins. Lythgoes soon bought out Austins completely and twice applied for consent to extend the quarry ever further. In 1962 the company, now known as Ribblehead Quarry Ltd, erected concrete block plant but demand for ground limestone began to rapidly decline, and by 1967 demand generally had fallen away so the quarry was put on the market in 1971.[11] In 1973 ARC purchased the site with an eye to exploiting its estimated 23 million tonnes of high-grade stone, and to replace Middlebarrow Quarry in Silverdale, which was coming to the end of its life. Further plant improvements were made and the new owners sought permission to reinstall the rail sidings to enable a greater tonnage to be despatched to serve a lucrative contract from the new Selby Colliery. However, this contract did not materialise and no alternative markets could be sourced, and the quarry was effectively mothballed. Had it ever reopened, Ribblehead could have rivalled Horton or Swinden in scale.

In fact, the quarry remained idle until 1998 when ARC (now Hanson) formally renounced its intention ever to work it again.

COLDSTONES QUARRY

Limestone had been quarried and burnt on a commercial basis in the Greenhow Hill area between Grassington and Pateley Bridge for generations before documentary evidence began to fit names to specific sites. Mark Dinsdale was born at Greenhow in 1813, and he was sent to work in the kilns on the hill in the belief that the fumes given off would prevent his incipient tuberculosis from worsening.[12] Eight of his siblings had succumbed to the disease; he was to work at the kilns for sixty years. Trade directories for 1830 and 1834 both list Grange Ward of Bridgehouse as a limeburner in the area, while one for 1848 locates Christopher Daggitt on Greenhow and John Daggitt at Street Lane as commercial limeburners, with John – now spelled Dagget – listed for 1857. He was probably operating within Duck Street Quarry, whereas Christopher is likely to have worked one of the kilns on the northern side of the present Coldstones Quarry. Further down the road to the east, Toft Gate kiln was being worked commercially in the middle of the nineteenth century, as discussed in an earlier chapter. Much of the lime was sent away by packhorse teams to the gritstone moors south of Greenhow and Bewerley, down what was called Rowls Lime Road, though once the railway came to Pateley Bridge in 1862, lime was sent there instead and this boosted output on the hill.

Production of lime and crushed stone at Coldstones fluctuated with erratic demand, leaving kilns and quarries on a standby basis for many years. By 1897 the quarry was again more productive, with nine men on the payroll largely involved in winning crushed stone rather than lime. Elisha Newbould was running Coldstones by this year, with Henry Newbould having taken over by 1902

when fourteen men were gainfully employed. Coldstones' boom was short-lived, though, as eleven of these had been laid off within a year. By 1904 it was being run as two distinct units, neither employing more than a handful. Henry ran the larger part of the quarry with Moss Newbould running the remainder. The Newboulds eventually left Coldstones, to be replaced by Arthur Storey who also failed to make it a profitable venture. In the late 1920s, the twin quarries were once again given up.

The county council had the site reopened in 1929 to provide a cheap and plentiful source of crushed stone for its road-building programme and the workforce mushroomed to ten times its 1903 total. Two years after this, Nidderdale Quarries Ltd of Harrogate was formed to produce aggregate for concrete-making as well as to boost tarmacadam output.[13] In 1951 the company was granted planning consent to step up production but, bizarrely, permission was only given for exporting uncrushed stone to crushing plant in the Knaresborough area.[14] Later on, in various hands, as the whole quarrying process here went through the same modernisation routine as in other Dales quarries, production focussed more on making concrete blocks (from 1964) and tarmacadam (from 1979).

In 1982 the Australian-owned Pioneer Group acquired the quarry and undertook a major investment programme from 1986 that lasted beyond the end of that decade. It hugely increased annual output and widened the product range on offer.[15] A new road was cut from the quarry to the south to avoid trucks having to go through Greenhow village and, in 1992, planning consent was renewed for a further twenty years, so Coldstones' medium term future looked secure (99).

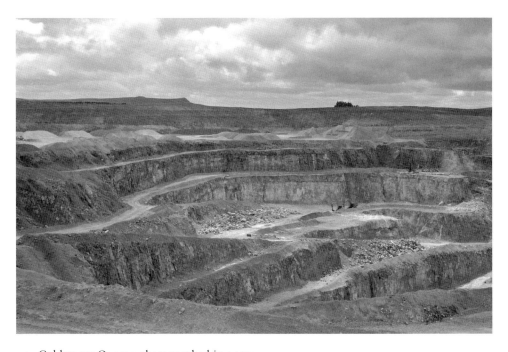

99. Coldstones Quarry, photographed in 2001.

QUARRIES IN THE NORTHERN DALES

Large and accessible deposits of high-grade limestone are less widespread in the northern part of the Dales but, wherever they did outcrop, someone was sure to have exploited them. Around thirty commercially-run quarries have been identified in Wensleydale, Swaledale and their tributary valleys, some worked on a relatively small scale by individual operators, some by councils, with a few working on a massive scale for many years.

The 1856 first edition of the six-inch Ordnance Survey map series locates ten quarries of a scale that would suggest commercial operation, though this is not to say there were not many more low-key quarries and commercial kilns peppered across the landscape. All but two of the ten were in the vicinity of Leyburn. Spennithorne Quarry turned out burnt lime from its single kiln but just to the north, lime was being produced on a truly industrial scale at Harmby. Between Agglethorpe and West Witton, two kilns were worked commercially in Middleham Moor Quarry (SE 080 874) on the appropriately named Limekiln Hill, and there was a significant cluster of activity immediately north-west of Leyburn (100).

Halfway between Masham and Bedale, in Lower Wensleydale, lies the now-disused Watlass Quarry. The earliest surviving record of this site consists of an entry in the estate rental ledger for 1716: 'Johnson's kiln *in Manibus Dom*'. The quarry, and attendant kiln, had presumably hitherto been rented by Johnson, but for some reason it had been taken in hand by the estate at that date. No further record has been located until mid-nineteenth-century censuses list local limeburners: in 1861, for example, George Green from Huddersfield was 'master limeburner' at Watlass, but from 1871, successive generations of the Johnson family worked the four kilns operative at that time. In 2007 this writer led a small team in an excavation of the surviving kiln. This is a substantial structure with two large oval bowls and three draw arches allowing lime to be drawn through four draw holes, or eyes (26). One bowl was cleared down to the floor and

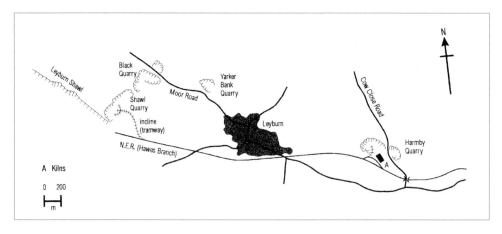

100. Quarries in the Leyburn area in 1952, based on Ordnance Survey mapping.

everything was found intact, including the wooden base of the bowl and the cast iron grill. Last fired up before the Second World War, this kiln is unique within the Dales in the unusual details of its construction and design.

No less than six quarries were worked on Yarker Bank, including the commercial lime-burning concern in Yarker Bank Quarry itself. Further up Moor Road, at the crossroads on Leyburn Moor, there were two kilns associated with what was, in 1856, called Moor Quarry, not to be confused with the Moor Quarry marked on modern maps nearer Leyburn.

A quarry at the eastern end of Preston Scar fed two kilns on a site that was to reach industrial proportions in later years. Leyburn Shawl Quarry (Moor Quarry on current maps) was even then a major industrial undertaking, with five kilns and a rail link to the main line. Above Redmire three kilns were associated with Thornybank Quarry, two of which can still be identified despite the major quarrying associated with Redmire Quarry, which did not exist until long after 1856.

In the Richmond area, two large-scale quarries were operational in 1856. Stainton Quarry (SE 09 97), above Scar Spring Wood, made substantial inroads into Ellerton Scar to extract stone for burning on site, with Downholme Quarry (SE 11 99) on White Scar producing only crushed stone. This was leased by the local partnership of Fred Ward and Walter Scott, trading as the Downholme Park Limestone Quarry Co.[16] They went their separate ways in 1930: Scott took up a quarry near Reeth while Ward remained at Downholme, though its machinery was old and rather primitive, and the quarry was rarely profitable. In 1931 Ward amalgamated this company with the Leyburn Stone and Macadam Co. Ltd and, by 1933, business had grown and thirty to forty men had regular employment in quarrying, crushing and carting. Ten years later, work in the quarry ceased simply because labour was impossible to come by, but the company maintained and even renewed the lease until 1951, when Ward finally called it a day. In 1959 a Richmond builder called G. W. Shaw took out a five-year lease on Downholme, but only to remove rock from previous blastings. Leyburn Stone also worked Cubeck Quarry (SD 956 895) and crushed stone on site, but the hardness of the limestone made it a difficult proposition.

The identities of most of the men who worked these quarries are not known, but a few are. William Blenkinsop was both a farmer and quarry owner north of Leyburn in the middle of that century.[17] William Styan of Moor House was working Leyburn Shawl for lime before 1899, according to Government statistics, though he was listed as farmer and quarry owner six years earlier. Another Leyburn resident managed a rather more arcane work schedule. In 1893 John Watmough was a mere quarry owner, but from 1905 to 1913, at least, he was a tax collector as well as owner of Black Quarry.

Ownership of Stainton Quarry is identifiable from the trade directories published in 1905-29, when it was in the hands of Pearson Brothers, yet the record for 1907 to the Great War has Richmond and Reeth's councils operating it. Perhaps the councils had leased the quarry.

HARMBY QUARRY

Harmby Quarry, to the east of Leyburn, has two discrete parts, linked by a tunnel blasted through a narrow rock rib that supports the minor road from the village to Cow Close Farm. The eastern part, now utterly inaccessible, is a delightful water-filled haven for birds (Col. Pl. 35) while the larger, western half is now a caravan site. *White's Trade Directory* of 1840 records that Thomas Metcalfe was quarrying and burning lime in the older, western part, while the 1856 Ordnance Survey map marks kilns in existence, with a rail spur from the main Wensleydale line to the twin kilns. By the time this map was published, it was already out of date; a magnificent battery of new kilns was erected in 1856, with its own rail spur, to replace the old kilns. Lovingly restored, this bank of kilns is surely one of the most impressive examples of vertical mixed-feed kilns in the Dales (101).

Bearing a datestone 'MW & Co 1856', which may represent 'Ward' or 'Wood', the battery has three sub-rectangular calcining bowls formerly accessed from the rear by an earthen ramp, each bowl being lined with firebrick with a rubble infill to provide insulation between the lining and the outer masonry kiln frontage. Each bowl had two draw arches of a rather ornate design, and each draw arch had three eyes through which lime was drawn. The owner of these kilns clearly went to a good deal of trouble and expense to create an industrial monument with a strong sense of aesthetic appeal.

The next known date for Harmby is 1872, when the kilns were being operated by the Harmby Lime Co., which extended the quarry northwards into what had

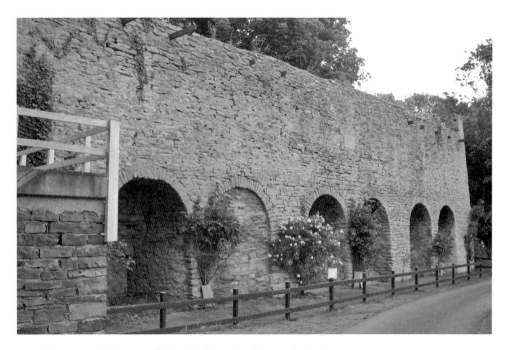

101. The restored battery of kilns in Harmby Quarry, built in 1856.

been a wooded gill, by 1890 'shorn of its picturesqueness by quarrying operations carried on in the rock for lime burning'.[18] Later on the quarry came under the aegis of Harmby Limestone Quarries Ltd, incorporated as a limited company in 1910. Whether this represented a change of ownership or just a change of name is uncertain. In the official return for 1909, ownership is listed as Siddall Brothers, but later as the Leyburn Stone and Macadam Co. Ltd, incorporated in 1924. The labour force was substantial, peaking at seventy-five in 1911. This company, originally a partnership between John Watmough and F. B. Webster, ran Harmby until its assets were bought out by David Wood & Co. of Yeadon near Bradford in 1954, though the local company name was retained. Leyburn Stone also ran Black Quarry on the other side of Leyburn, a much more successful venture than Harmby, which had ceased production in 1952 when the crusher broke down. Six men were transferred from here to Black and, despite the lease for Harmby being renewed the next year, the company had been weakened and made susceptible to the takeover by Wood. Harmby was not to reopen.

LEYBURN (BLACK) QUARRY

Until the coming of the railway in 1860, quarrying rights here were leased out to a succession of local, small-scale operators. In 1870 two local farmers, Kettlewell and Hammond, worked the site for crushed stone for use on local roads. Their descendants and Watmough continued here until 1920. After the 1926 General Strike there were increasing demands for improved roads, so new crushing and screening plant was put in to tap this market. The lease was renegotiated in 1930 by a partnership of four: Fred Kettlewell, a coal merchant from Harmby, Fred Ward from Richmond, Isaac Wood, a road contractor from Yeadon, and Mawer Hammond. It was a partnership that was later to be known as Leyburn Stone. For many years it was worked erratically in terms of numbers employed and output, and the quarry itself remained very small and low-tech up to the early 1960s. Most northern quarries were geared to supplying the steel concerns of County Durham and Teesside, but Black had to rely on local contracts for roadstone, a fickle market at the best of times. New crushing plant was at last installed in 1955/56, after the Wood buyout, and it began to look more like an industrial concern. In 1963 the Hargreaves Group bought out Leyburn Stone and they put in a state-of-the-art crushing and tar-coating plant, and output was boosted by an enormous amount. The quarry workings began to creep northwards in 1968, eating up Moor Farm, and by 1972 the quarry had gone almost as far north as it is now and had also begun to push south towards the boundary with Leyburn Shawl Quarry. Under Hargreaves, Black became a major supplier of various grades of stone and established itself as one of the largest quarries in the Dales.

From the late 1980s Black changed hands four times until it was acquired in 1995 by the RMC Group. It is still worked today as Leyburn Quarry (Col. Pl. 36).[19]

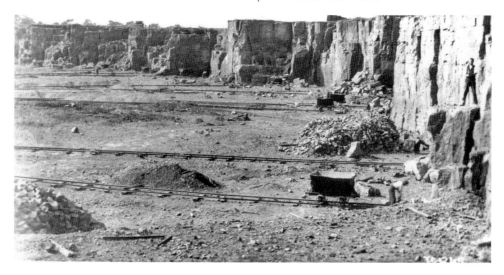

102. Breakers and fillers in Leyburn Shawl Quarry, date unknown. (*Beamish Museum Ltd,* *15509*)

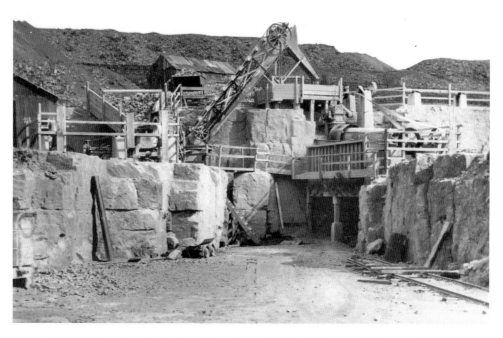

103. Pre-war crushing plant in Leyburn Shawl Quarry. (*Beamish Museum Ltd, 15492*)

LEYBURN SHAWL QUARRY

The quarry that modern maps call Moor Quarry, once a landfill site and now a recycling depot, is the old Leyburn Shawl or Leyburn Moor Quarry. Shawl was leased in 1899 to Ord & Maddison, quarry operators from Darlington, who were involved in supplying fluxing stone to the steel industry in the north-east, making the most of the quarry's almost direct rail access from Leyburn station: the quarry was linked to the main line by an incline, with a continuous rope system being used to guide the carts down the 1:70 gradient. Full carts being lowered pulled a string of empty ones back up. In its early days, Shawl gave work to around fourteen men, mainly breakers and fillers (102), though considerably fewer in 1904-11, and rising to around thirty thereafter.

Shawl had managed to diversify by the 1930s to capitalise on the road-surfacing boom of that era by erecting tar-coating plant and taking coated stone up to a third of its total output. Because the rest went to steel mills, the quarry was still over-dependent on one customer, and recession in the steel trade in 1938 led to Shawl almost being closed. It was saved by the war, however. Afterwards, output reflected the changing fortunes of steel, but generally followed an upward trend, leading to the now very aged crushing plant (103) being replaced in 1962, and the quarry area expanding west and north. Modernisation within the quarry itself was a long time coming, with breakers and fillers in use until the mid-1950s.

The depressed state of the steel market weakened Ord & Maddison's position and the company fell victim to a takeover by Tarmac in 1963, though the old name was preserved for a year or so. This change in ownership had an immediate effect as Tarmac laid off all but two of the men, and stopped blasting operations completely. Had they bought the quarry, a competitor, just to close it down? The lessor estate was understandably alarmed by this turn of events and encouraged the lessees to change their mind, which they did, if at first somewhat grudgingly. Two years later, though, Tarmac updated the plant and took the strategic decision to concentrate on tarmacadam instead of crushed stone.

A complete reversal came about in 1980. Shawl was shut down.

REDMIRE QUARRY

The present (active) Wensley Quarry above Preston Scar is the surviving component of four quarries: Thornybank, Redmire, Wensley and Preston-under-Scar. Variously worked independently or in unison, all four were geared to supplying stone for fluxing purposes to the steel mills of Teesside and the north-east.

Thornybank Quarry was originally the township quarry for Redmire, from which townsfolk could take stone and lime for essential purposes (104). It later grew into Redmire Quarry and production was stepped up by Stringer Calvert, who leased the quarry, extending it to the east. In 1919 he had an aerial ropeway built to carry an initial 140 tonnes of crushed stone per day to Redmire station (105). Trading as

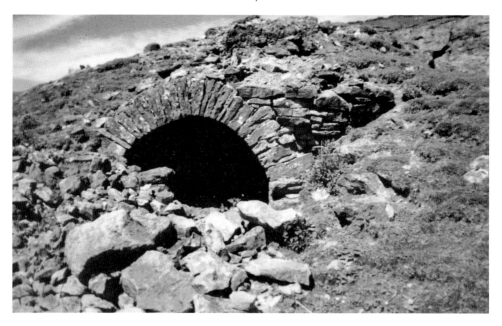

104. Thornybank Quarry and its surviving pre-industrial kiln.

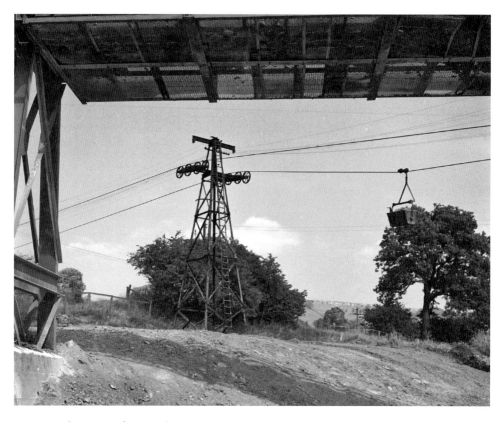

105. Aerial ropeway from Redmire Quarry to Redmire railway station. (*British Geological Survey © NERC. All rights reserved. IPR/127-55CT. P538971,*)

the Redmire Quarry Co. Ltd, Calvert ran the quarry until his concern was bought out, in 1929, by the steel company Dorman Long of Middlesborough. Redmire had been severely run down by this time as a result of a steel depression in the 1920s. Dorman Long traded here as the Redmire (Wensleydale) Limestone Quarry Co. Ltd and, in its early years, this company faced mixed fortunes as the quarry was tied in solely to the steel maker's needs. Further downturn in the industry in the late 1930s led to the quarry being mothballed in 1938,[20] and to a freezing of work in hand to replace the eleven wooden ropeway standards with thirteen new steel ones, so that its capacity could be increased by 40 per cent. In 1948 and 1954 Dorman Long secured further planning consents to push the quarry face further to the east and above the natural scar that had bounded the quarry, but output still continued to be erratic until the industry became more stabilised in 1960.

As elsewhere, new crushing and screening plant was commissioned and the workforce increased correspondingly despite mechanisation in the quarry area in 1957. In 1962 the aerial ropeway was phased out completely and the quarry's entire output was sent by road to the station (106).[21] Redmire was secure now and the workforce was further boosted to thirty-seven. At nationalisation Dorman Long became part of British Steel and, from 1971, Redmire was operated as a joint venture between that corporation and Tarmac, the latter organising the actual quarry work. During this joint venture, the quarry was run by a subsidiary company, East Coast Slag Products, owned on a fifty-fifty basis by the two parent

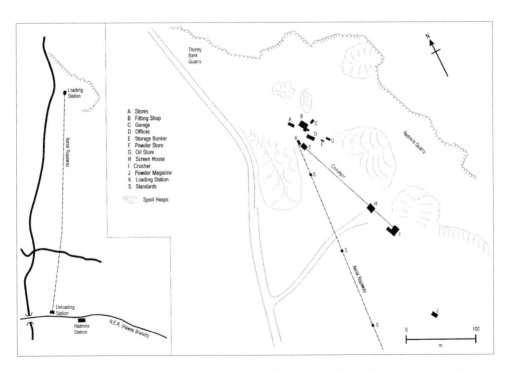

106. Redmire Quarry in 1963, based on mapping by Dorman Long (Steel) Ltd. *Inset*: The line of the aerial ropeway.

companies. When British Steel pulled out, the subsidiary became wholly owned by Tarmac, and was eventually dissolved.

Concerns grew regarding road transport from the quarry as the number of daily movements down the steep hill and through the village increased. British Steel's pulling out left it all to Tarmac, which amalgamated Redmire with its existing Wensley Quarry. At the very end of 1992 Redmire was closed down, with all of the plant removed a couple of years later (Col. Pl. 37) as Tarmac focussed its operations on the more accessible Wensley. The reason Redmire was shut down is easy to understand in business terms. British Steel had closed down its Ravenscraig plant, which had been supplied with stone from the company's own quarry at Shap. Rather than abandon Shap, British Steel transferred its output to serve the mill at Redcar, making Redmire, which it leased, redundant.

PRESTON-UNDER-SCAR QUARRY

Leonard Airey was a stone mason and quarry master at Preston in the 1890s, and George Robinson combined farming with owning the quarry on the scar in 1909, though whether or not the two kilns here were still in use is unknown. Preston-under-Scar opened on a more industrial scale in 1920 when the lease was taken up by the Wensley Lime Co. Ltd, a subsidiary of the Cargo Fleet Iron Co. Ltd of Middlesborough, established to supply high-grade stone to the parent company's steelworks. The scale of production was boosted here, as at Redmire, when the steel lobby took over the quarry, and there is a record of a massive blast in 1930 that brought down enough stone to keep the breakers and fillers busy for three months.[22]

Stone was moved from the crushing plant adjacent to the minor road up from Preston village by a 925 m-long aerial single rope system, carrying fifty-two buckets, to a stocking ground on a rail spur near Wensley station for onward despatch (107). Stone from within the quarry was transferred to the crusher on a rail track, part of which has survived. Two locos ran a shuttle service along the track, which bridged the minor road on a gantry. In 1954 the lease was transferred to the South Durham Steel & Iron Co. Ltd of Wellingborough, as Wensley Lime had been liquidated. The locos were replaced in 1957 by a 740 m-long conveyor belt, mounted on concrete standards, that ran from the new crushing and screening plant at the western end of the quarry – referred to as 'Top Quarry' by the quarrymen – just south of the bridge under the tank road, to the start of the ropeway (Col. Pl. 38).

By 1964 South Durham was running Preston in tandem with Wensley Quarry across the tank road, and the two were connected by the bridge under the road. The workforce was boosted to a total of twenty-one and output of crushed stone to 7,100 tonnes each week. Problems at Preston surfaced in 1970, when the newly nationalised British Steel slashed production here to increase output at its existing Redmire site. It made veiled threats about closing down one or both quarries,

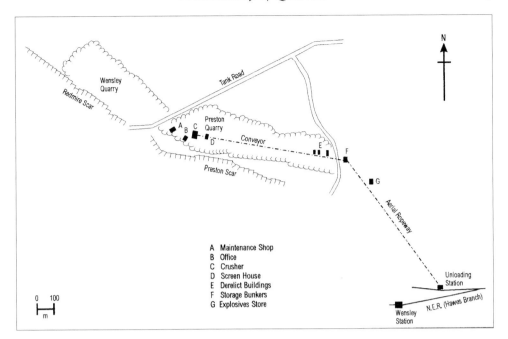

107. Wensley and Preston-under-Scar Quarries in 1971, mapped from estate papers.

threats that were indeed carried out in the following year. Attempts were made to find a new lessee, and Tarmac, the Steetley Group and the Hargreaves Group all expressed an interest, but Tarmac was able to secure the lease on Preston and Wensley in 1972, and the quarry did not reopen.

A local landowner raised quite a stir in 1999 by announcing his intention to begin work at a proposed quarry on Preston Scar for both limestone and sandstone. Consent for this had been on the books since before planning regulations changed in 1947, so he was quite entitled to do this. Opinion in the area was against such a development and the Yorkshire Wildlife Trust became involved in the issue, which was finally settled in the House of Lords: the new quarry was not to be.

WENSLEY QUARRY

This is the most recent of the four quarries in the vicinity. It was opened up by Dorman Long in 1947 but was operated in complete isolation from the neighbouring Redmire Quarry; the two were run as two discrete entities until nationalisation of the steel industry. Quarried stone was moved from Wensley to the plant across the tank road in Top Quarry, as no facilities were provided within Wensley. In 1971, as we have seen, the quarry was shut down but reopened in 1988 when Tarmac effectively merged Wensley with British Steel's Redmire. About one third of output was now destined for aggregates, with the rest going to the steel plant at Redcar on Teesside. Wensley secured its own processing plant

to replace that in Top Quarry, and until early 2010 despatched limestone dust to the steel mill and marketed some crushed stone. The Redcar plant was mothballed by Corus in February 2010, so Wensley lost its prime market in an instant.[23] Average annual output plummeted from 450,000 tonnes to 180,000 tonnes, and the quarry team (now reduced to five) faces the task of securing new third-party markets for limestone dust to build back to optimum output.

LOCAL AUTHORITY QUARRIES

To the commercial quarry owner or manager, council quarries were the proverbial red rag. They were even described as 'unmitigated evil'.[24] There had been municipally run quarries well before statistics were first compiled in 1895, with every council eager to open up its own source of roadstone, assuming its area encompassed accessible and suitable stone (Fig. IV). Road construction and maintenance were a constant problem for councils, which, as ever, had to stretch their meagre budget as far as it would go. To purchase stone from a commercial quarry made alarmingly large holes in the budget, and it was far cheaper to operate a council quarry that could be worked as and when needed by temporarily deploying workmen from elsewhere within the councils' remit. Commercial operators' hackles were raised by this 'unfair' competition. In 1894 most commercial quarries became subject to the controls of the Quarries Act and, in 1938, all commercial quarries came under its aegis. Legislation brought the inevitable extra expenditure on safety and workers' rights issues. It rankled commercial operators no end, because municipal quarries were declared exempt from Government inspection under the act. The Institute of Quarrying lobbied for a level playing field, but in vain.

There was an absolute mushrooming in the number of municipal quarries – not just for limestone – during and after the Great War. This was despite a serious depression across the extractive industries in general, exacerbated in the winter of 1914/15 by appalling weather that made quarrying and construction a trial. Commercial quarries were hit badly, but council quarries, of course, were to a degree immune from economic forces and they, perhaps, used the general downturn to secure favourable terms for taking over some struggling commercial quarries for their own use. Skipton Rural District Council jumped on the bandwagon, taking on two limestone quarries: Dibbles Bridge between Grassington and Pateley Bridge, and Fancarl above Appletreewick.[25] Westmorland County Council, on the other hand, ran thirty to forty of its own quarries: they seemed unsure of exactly how many. Here, as in the West and North Ridings, some council quarries were former parish or township quarries with an origin lost in history. The commercial operator had a particular dislike of these, as they incurred no royalty charges on tonnage.

Some municipal limestone quarries were very small affairs, providing stone for road repair very locally. A Settle Rural District Council document is particularly

Fig. IV. Selected list of council-operated quarries in the Dales (*Source: List of quarries [under the Quarries Act] in the UK etc. HMSO; NYCRO. DC/SET IV, 2 April 1896*)

COUNCIL	QUARRY
Leyburn RDC	Elm House, Redmire
"	Four Lane Ends, Wensley
"	Gale Bank, Wensley
"	Kelheads, Wensley
"	Lambert's Pasture, Redmire
"	Middleham Moor
"	Parson's Barn, Spennithorne
"	Stoneham, Preston-under-Scar
"	Town's Pasture, Leyburn
Reeth RDC	Stainton Wood
"	Spring End, Satron Common
Richmond RDC	Grainger, Hawes
"	Hurgill, Richmond
"	Hush, Redmire
"	Low Pasture, Sedbusk
"	Reservoir, Richmond
"	Seata, Aysgarth
"	Seal Gill, Hurst
"	Spring End, Satron Common
"	Stainton Wood
"	Stone Gill, Gunnerside
"	Thorpe
"	Underbank, Richmond
Settle RDC	Brunton, Giggleswick Scar
"	Fourth Gate, Winskill
"	Newby Cote
"	Sell Gill, Horton in Ribblesdale
"	Storrs, Ingleton
Skipton RDC	Dibbles Bridge, Appletreewick
"	Eshton
"	Fancarl, Appletreewick
"	Knipe, Kettlewell
"	Robin Hood, Coniston
"	Starbotton
"	Windbank, Kilnsey

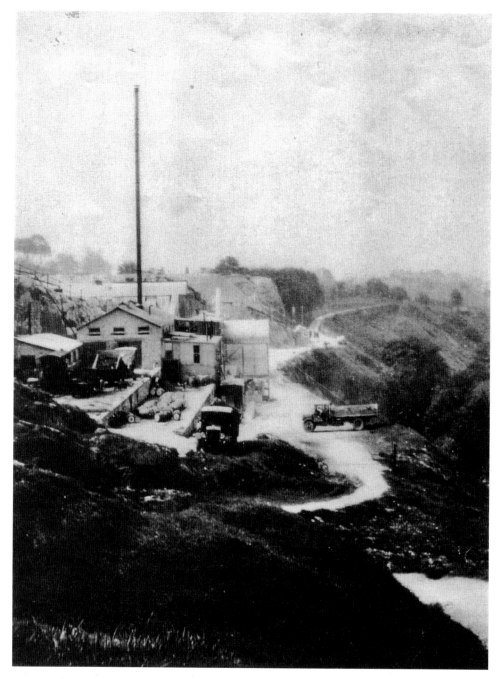

108. Processing plant at Storrs Quarry, Ingleton, photographed in 1926. The nearest building, behind the steam wagon, was the tar-coating section. Barrels of tar await loading on the lorries. The tall chimney served the boiler house, behind which is the crushing plant. (*Mrs Marjorie Ginty*)

useful for listing such quarries in their local context.[26] The minor road from Little Stainforth to Stackhouse, north of Settle, was repaired with stone from Robin Hood Quarry on the Giggleswick-Stainforth parish boundary; the steep climb up from Langcliffe used stone from Fourth Gate Quarry at the junction with the Winskill road; Langstrothdale Road, once an important route linking Horton in Ribblesdale to upper Wharfedale, had been repaired by the Highways authority using limestone from Sell Gill Quarry, near the ruins of Sell Gill House, since 1821.

Councils do tend to come in for a lot of stick from cynical bystanders. Far be it from me to add to this, but a local newspaper does provide a rather amusing anecdote.[27] Settle RDC, among other sites, had worked Newby Cote Quarry, near Clapham, since before 1896 with two to six men spasmodically employed there. If we believe the correspondent, these were 'old men' who bashed away with hammers at rock to break it down into smaller pieces, at the princely cost of 2s 3d per tonne. The council was considering replacing these 'old men' with machines to halve the cost per tonne. The decision-making wheels of the council eventually ground out an outcome. An agreement was reached with the lord of the manor in nearby Clapham for 'opening out' Newby Cote on a twenty-one-year lease.[28] Crushing machinery was installed, and a steam wagon was purchased to cart the stone out of the quarry. The 'old men' were put out to grass.

Settle RDC had also worked Brunton Quarry at the top of Buckhaw Brow since 1908, a site that yielded exceptionally hard stone. As far as our already anxious commercial operators were concerned, Settle went far beyond the pale by actually selling crushed stone and dust from Brunton for a profit to the county council.[29] However, all good things come to an end, and the council announced the closure of Brunton in 1934, but according to official data, seven men worked there in 1937, so they must have temporarily reopened it.

The quarry at Storrs, outside Ingleton, which had caused Henry Robinson so much grief in the 1880s, was for a while leased by Settle RDC once its last private operator realised only major investment could make it pay. In 1925 the West Riding County Council secured the lease on Storrs with the intention of manufacturing its own tarmacadam on site (108). Settle remained contractually obliged to buy a fixed quantity of stone from Storrs, but much to the alarm of the local populace, they proposed opening up their own quarry higher up on the common, where stone had been worked for centuries. One cannot blame Settle RDC's councillors, as they were exercising sound bookkeeping practices: to pay for its own crushing and coating plant, the county had raised its prices and Settle believed they could save money if they quarried their own stone.[30] In 1938 the West Riding laid off eight of its fourteen men at Storrs because it found it could bring in crushed quartzite from Doncaster more cheaply than crushing limestone at Storrs. This made a certain amount of economic sense, though, bearing in mind the extent of the West Riding.

The forlorn concrete ruins that bedeck Storrs today are the relics of council activity.

Men and Machines

THE QUARRYMAN AND HIS LOT

Quarrymen and limeburners are the unsung heroes of the industry. Toiling in difficult conditions, exposed to the vagaries of the weather, and with safety standards non-existent until relatively recently, it is they who are so easily forgotten in today's highly automated quarries. Until the middle of the nineteenth century, few men had full-time employment in either quarrying or lime burning: the hundreds of small quarries and small kilns were largely worked as and when needed by men who had other occupations. Notwithstanding this, they did play an important part in the economy of the Dales. Census records offer few clues as to how many men were stone getters or limeburners, precisely because these were rarely their prime occupations. Trade directories, like *Kelly's*, *Slater's* or *White's*, are more forthcoming for the latter part of that century but, by then, we are into the industrial age of limeburning. Early editions are notable for their absence of entries.[1]

Available documentary and oral evidence would suggest that in the past, management's treatment of the workforce oscillated between paternalism and sheer exploitation. We have considered various industrial disputes in earlier chapters, and the frequency of accidents in various quarries bears witness to the absence of safety procedures or to the appraisal of working practices (see Appendix I).

On the paternal side we have the welfare associations provided by various companies. Clark, Wilson & Co. established the Meal Bank Club, which employees could subscribe to. In return, the club paid all funeral expenses and gave employees who were off work owing to sickness financial help to cover the loss of pay. Any money left in the kitty at the end of each year was apportioned among the members. In 1877, for instance, eighty-five members each received 8s in this way. Yet, when George Sellers was crushed to death by a rockfall at Mealbank, his widow could not even afford a coffin, having only 3d to her name. It was public subscription, not the club, that came to her aid.

Every January the club organised a ball for members and their families and the same company, when it became the Craven Lime Co., instituted the Workingmen's Club in 1872 for its employees to broaden their cultural and social horizons, and in 1907 the Meal Bank Club was transformed into a Benevolent Society.

John Delaney's daughter, Carrie, tried to adopt an attitude of benevolence towards quarrymen and their dependents, and occasionally provided light relief for them all. At New Year in 1925 she brought men, wives and children – 170 in all – from Horton Lime Works to Settle for a meal and an evening's entertainment, at which she handed each child a 'large' box of chocolates.[2]

In 1937 the Settle Limes Sports Club was formed, based at the town's Golden Lion pub, for the benefit of men working at all the quarries. It created sports fields and facilities at Bridge End.

On the other hand, quarrymen and kiln workers were not provided with what we would now call 'PPE' (personal and protective equipment). Lime drawers and packers wrapped hessian sacking around their clothes to prevent them being burnt or discoloured, and nothing was provided for drawers to counteract the problems caused by sweat that made burnt lime slake on their skin around the neck and down the back of the shirt. Indeed, some drawers resorted to smearing goose fat, butter or Vaseline over exposed skin to prevent this, and often sealed the trouser legs below the knee with pieces of string that they called Yorks. Until well into the twentieth century, firing and blasting were on a par with running through a minefield and the only way of prising loose rocks from the quarry face after a blast was for the barers to shin down the face with an iron rod and a length of rope or chain wrapped round their thigh (109).

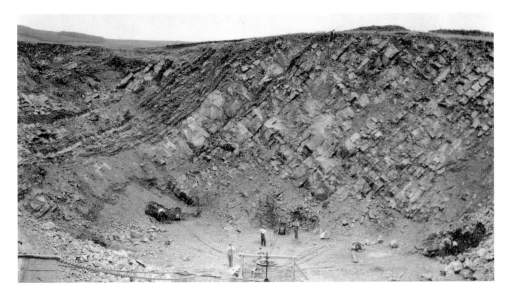

109. Haw Bank Rock Quarry in 1932. Breakers and fillers are at work filling carts or managing the incline, and a barer is beginning his precarious descent down the face. (*British Geological Survey © NERC. All rights reserved. A7242.*)

Mind you, even when hard hats were introduced, many quarrymen declined to use them, citing that they were too cold in winter, too sticky and heavy in hot weather, and a hindrance to all-round vision.[3] On his retirement from Horton Quarry in 1955, aged seventy-four, William Yates bemoaned how soft the modern quarryman had become, especially as in bad weather 'they go like rabbits to shelter, and are paid for it'.[4]

Then there was the miserly pay they received for all their toil and danger, and the attitude of management when men expressed a grievance. Before 1914 quarrymen were paid only 3½d per hour, half that of skilled men, but if severe weather stopped work, there was no pay. Paid holidays only began in the 1940s, and as late as 1961 they were still only entitled to two weeks paid annual holiday. Settle Rural District Council's attitude to a demand for an increase in pay of 3d per hour in 1920 was particularly niggardly: they offered half the amount.[5]

Quarrymen and kiln operatives did have access to trade union representation in the industry's early days, but the unbelievable degree of fragmentation in the union movement made them to all intents and purposes powerless. In 1895 seventy-eight different unions represented quarrymen across the country, though this was whittled down to seven two years later. The National Union of Quarrymen, formed in 1887, only had a fraction of total union membership in quarries when the first Government statistics for the industry were published.[6]

It is no wonder that quarries often struggled to attract men to the job. As early as 1911 they experienced difficulties in attracting young men to the industry. Increased access to education was found to be 'taking them entirely away from the quarrying industry'.[7] In both world wars quarrying was a reserved occupation, so men could not be called up, but some packed up work specifically to volunteer. The start of hostilities in 1914 saw quarries unable to find sufficient numbers of men and boys to cope with the enormous demand for stone and lime and some companies, like Messrs Green & Sons at Hambleton Quarry, took on refugees from the fighting in Belgium.[8] The problem of securing men was always exacerbated by the tendency of many men in the Dales to leave work to help with the harvest, fully aware that they could walk straight back into a job afterwards. Once the war intensified, the shortage became acute as men left in droves to answer the call and, by 1917, many local quarries had only half the staff they required.

The 1939-45 war brought a repeat performance and, even after peace was declared and servicemen returned home, the shortages remained. The only way some Dales concerns were able to maintain output was by making use of prisoners of war from Germany and Italy for two to three years after the war had ended, after which POWs were replaced by Polish refugees in those quarries belonging to P. W. Spencer and Settle Limes.[9] In the summer of 1948, limestone quarries taken as a whole employed one third fewer men than ten years earlier, and it was estimated that 60 per cent of the labour force in some quarries were still POWs.[10] Their departure in 1948 caused real concern about an imminent and dire labour

shortage,[11] and even in 1950 Redmire Quarry relied on six refugees to make up the complement. School leavers were not coming forward, put off by a variety of negative images such as low pay, the laborious, hazardous and dirty nature of the work, the lack of modernisation, and a vapid credo that the modern young man did not work in quarries.

It was this, intertwined with other factors, that forced radical change on the industry at this time – a change to safer working practices, to a cleaner environment, to modernisation and mechanisation, to the higher quality end products demanded by customers. They may well have achieved their objectives in these fields, but they did not solve the labour problem. Throughout the 1950s it remained in short supply, and men could leave one quarry today and start at another tomorrow. The more profitable concerns like Horton and Swinden prospered and could attract sufficient men, some of whom remained loyal for remarkable lengths of time (see Appendix II). Some smaller quarries could not hope to effect all the necessary changes and went to the wall. Downholme Quarry found itself unable to employ any labour at all and remained closed from 1941 to 1949 for this reason. Preston-under-Scar Quarry nearly met the same fate in 1941 and its long-suffering manager, Mr Hornby, was unable to take his well-earned retirement when he wanted to. He turned seventy-two in 1945 and was desperate to put his feet up but, such were the problems of finding a younger replacement, he was only able to step down a year later. The major players in the industry, like ICI Mond, were then able to come in and gobble up the smaller, weaker, locally based concerns.

LEGISLATION

Legislation was first imposed on quarries in 1872 by the Metalliferous Mines Regulation Act, refined in 1878 by the Factory and Workshop Act, which legally defined a quarry for the first time. A quarry was thus deemed to be 'any place not being a mine, in which persons work in getting slate, stone, coprolites or other minerals … more than 20 feet deep'. Neither of these addressed health and safety issues. In 1894 the Quarries Act became law, and it was much more comprehensive. All quarries, as defined by the 1878 Act, had to be registered and inspected, had to submit annual returns to the office of the mines inspector, and had to prominently display regulations concerning working practices, blasting procedures, access to the quarry face area, machinery and plant, and duties of employees, managers and owners. Any quarry employing in excess of twenty-five men had to have an ambulance or stretcher station.

Further modifications to the act were made in 1911 and 1924, specifically aimed at improving safety and first aid provision while, in 1938, quarries less than 6 m deep were brought within the scope of the act. A new Mines and Quarries Act received royal consent in 1954, but only came into force three years later, requiring every quarry to have a resident qualified manager. This act also

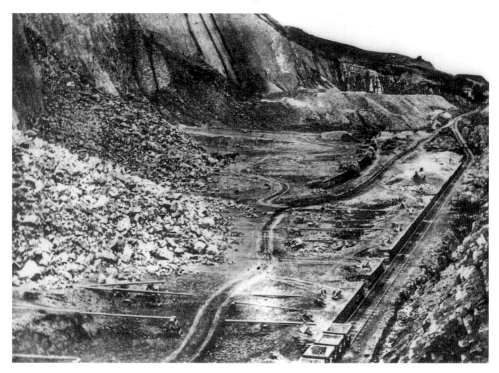

110. Haw Bank Rock Quarry in the 1850s. A large amount of stone awaits the breakers and fillers, whose wheelbarrows lie at the tramway end of the plank walkways. (*Weatherill Collection via D. Binns*)

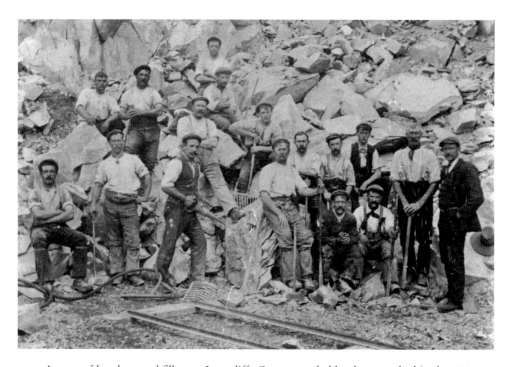

111. A gang of breakers and fillers at Langcliffe Quarry, probably photographed in the 1880s.

redefined a quarry to include all the processing and ancillary plant and storage areas associated with a quarry.

With the creation of the Health and Safety Executive in 1974, all aspects of quarry safety and well-being came within its parameters.

STONE GETTING

An eighteenth-century source provides an insight into who did what in limestone quarries associated with selling kilns.[12] Four men were employed at the kiln described: one was a stone getter, he who actually quarried the rock. He hand-bored a hole 300 mm deep, packed it with powder, covered it with sand and then fired it. It was he who then used bars and wedges to prise away loose rock from the face. This was hard labour in the extreme. Hand-boring was not drilling: it involved holding a pointed metal bar – a jumper – and continually hammering it with a maul, turning the bar a little in the hole to imperceptibly deepen it. To bore a hole of sufficient depth took days. In Threshfield's early days, Delaney paid his stone getters 1s per 300 mm to hand-bore the rock face in addition to their basic pay. The stone getter had to break up the fallen stone with a heavy hammer to the size needed for calcining. The wheeler barrowed or carted the stone to the kiln (110). He was at the bottom of the pecking order and was paid accordingly. The stone getter earned more to recompense him for his hard labour, but the limeburners earned twice as much as the wheeler. Their job required skill, not brute strength. They had to correctly fill the bowl, maintain the burn, draw the lime and load the pack animals or carts. They had status, of a sort.

In the nineteenth century stone workers were organised into a rigid hierarchy for trade purposes.[13] Stone masons and dressers headed the hierarchy: stone getters, limeburners, and other quarrymen came into the third tier, above the lowly wheelers. Looking back on those times it hardly seems fair that stone getters and limeburners sat well down the pecking order, combining as they did physical strength and endurance with a good deal of skill and more than a little in the way of craftsmanship.

Larger quarry operations had correspondingly more men and, if the working face exceeded a certain height, there was the problem of how to prise loose rock that had not fallen away with the blast. This is where the barer came into his own. Risking his life on an almost daily basis, he wrapped a rope or chain round his thigh and scrambled down the face from the top with his metal bar in hand. Balanced precariously, in all but the very worst weathers, he prised loose rock away to make the working area below safer for the stone getters or breakers and fillers, they who broke the stone up by hand and filled the Jubilee or kiln carts, usually on a piece-work basis (111). On a good day they could each break up and fill over 2 m³ of stone, but on a frosty day they would sit idly by breaking nothing and earning nothing. December 1899 must have been a lean time in the homes of Skipton Rock Quarry workers. The day book records the following:

Tuesday 5th	WET
Tuesday 12th	SNOW
Wednesday 13th	SNOW
Friday 22nd	SNOW
Monday 25th	NO WORK
Tuesday 26th	NO WORK
Friday 29th	WET
Saturday 30th	WET[14]

Eight days without pay was a cause of real hardship.

At this quarry in the 1870s men worked in pairs to load stone into wagons, which were linked together to form a train to be hauled down to the canal side for direct despatch.[15] Each wagon held 5 tonnes, making 50 tonnes in all; ten trains were sent down each day, making 500 tonnes hand-loaded each working day, a staggering quantity given the size of the labour force. In 1895 the following were on the pay roll at Skipton Rock: three getters of stone, six cockers and breakers, nine breakers, thirteen wheelers and thirteen operators of the mechanised breaker.[16] If we assume the breakers did the filling, this adds up to around 33 tonnes each per day. It seems beyond belief. The tonnages brought down by the stone getters (James Burgess, George Bruce and Robert Chapman) are equally impressive: they were responsible for shifting about 1,200 tonnes in just one week in August 1895, and significantly more in each week in December.

A stone getter or barer in the 1790s would have instantly recognised a stone getter of the 1890s. The methods had hardly changed at all. Indeed, some quarries in the Dales still operated in much the same way up to the Second World War. In 1931, an observer watched two quarrymen shinning down the face at Skipton Rock to a ledge. One of them finished boring a new hole while the other was temming the charges already placed in completed holes.[17] They 'vigorously' pressed the gelignite into the six holes with a wooden rod, lit the fuses and shinned back up the rope to safety.

BLASTING

There seems to have been a Guy Fawkesian fascination among the public for big blasts in quarries, with specific blasting events being treated as public entertainment, attracting folk from far and wide to witness a bit more of the Dales going up in a puff of smoke. A blast at Mealbank in Ingleton in 1872 drew a particularly large crowd of onlookers as it had apparently been 'advertised' as the last in a series of major blasts.[18] Between the lighting of the three fuses and the actual explosion there were forty-five minutes, during which the assembled mass could anticipate what might be about to happen. What they were not expecting was the enormous pall of black smoke that engulfed many of them, nor the 'very offensive' smell that went a considerable

distance downstream from the quarry, giving the residents of the town a foretaste of hell.

Three years later Mealbank drew up to 700 spectators from as far away as Bradford to witness another blast.[19] A special celebratory dinner was held at the then Ingleborough Hotel for directors and invited guests and no doubt they marvelled at the 40,000 tonnes of rock that came crashing down that day, and at the novelty of having fired the blast by electricity rather than by naked fuses as was normal. The Craven Lime Co. was intent on pushing blasting technology forward and, in 1883, it trialled potentite, a completely new type of explosive mixture, again at Ingleton.

Until about a century ago blasting technology was somewhat primitive by today's standards but safety awareness slowly grew, and quarries were required to store explosives in securely-built powder stores (Col. Pl. 39). Craven's larger quarries had the financial resources to invest in new technology, and the post-1918 years saw the introduction of pneumatic drills to replace the old and slow jumpers or jack-hammers. These new drills were much faster and could make larger holes to hold more explosive, but they too had to be drilled horizontally into the quarry face from ledges, and the barers still had to go in afterwards to risk their lives. A safer method all round was developed in the 1920s that involved drilling a network of vertical holes from the top of the face.[20] This well-drill or well-hole method was adopted widely throughout our area – on safety grounds, and because the explosive in these holes pushed the rock outwards away from the face – but not until many years later.

Retired quarrymen, who worked at a number of quarries across the Dales, have described what they knew as 'chirping'. Holes were pneumatically drilled down into the rock from a bench and black powder was packed in and fired.[21] This would loosen and fracture the rock and the process was repeated until smoke from the latest firing could be seen seeping out from the face. A final drilling was carried out and a full measure of powder was rammed in. The explosion would exploit the weaknesses caused by the chirping, and the whole face would collapse, bringing down up to 10,000 tonnes of rock.

Craven was one of the few regions in the country to introduce the technique of tunnel (or heading) blasting in the 1930s. Heading blasts were months in preparation. A tunnel was driven into the quarry face to be packed with explosive. The first such tunnel outside the Buxton area was cut at Horton Quarry in 1936, going 11 m into the foot of the face, and measuring 1.4 m high.[22] At the inner end of the tunnel a cross tunnel was cut, 9.5 m and 6.5 m for the arms. This whole process had taken three months to complete. The tunnel arms were packed with explosive, sealed and electrically fired by the wife of Settle Limes' head, and supervised by an expert from ICI.[23] The novelty of this blast brought people from all over, but huge clouds of dust prevented anyone from seeing the face give way. It brought down 43,000 tonnes in one fell swoop.

There was, it seems, a degree of one-upmanship in Craven, as the following year saw the 'biggest blast in Yorkshire' at P. W. Spencer Ltd's Giggleswick Quarry

112. 'The biggest blast in Yorkshire.' Giggleswick Quarry in 1937. From left to right:
C. Habberjam, ICI explosives expert, Mrs E. G. Spencer, and George Parry, quarry manager.
(*David Parry*)

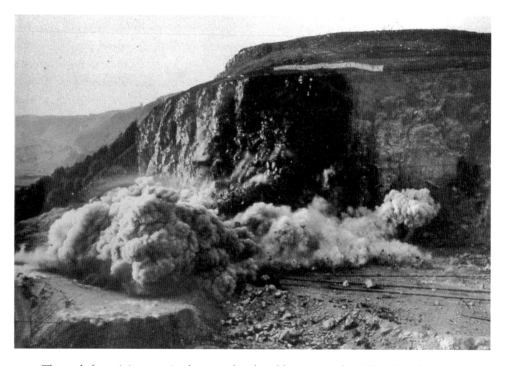

113. The rock face giving way in the 1937 heading blast at Giggleswick. (*David Parry*)

(112).[24] This one brought down 50,000 tonnes (113). Traffic on the main road had been stopped, fortuitously as it happened, because the blast threw rocks much further than the experts – including the man from ICI – had expected. They also lost the weigh house, 90 m away, as rocks came crashing down on it thirty minutes after the firing. No one was hurt: they were all safely watching the blast from on high. The tunnel, incidentally, had been bored by two ex-coal miners from Ingleton Colliery, and the blast was fired by Mrs E. G. Spencer. Setting off big blasts in the Dales was presumably on a par with launching ships, giving a rather different slant to the expression 'there she blows'.

What were the benefits of heading blasts? They worked out cheaper in the long run and also broke the rock up into smaller pieces, reducing the task facing breakers and fillers while also facilitating removal of the stone to the kilns or the crusher.

Horton, meanwhile, was not to be outdone. In 1938 it set off its second heading blast, the 1936 one having kept the men busy till then. This time over 60,000 tonnes came down and, yet again, it was a wifely privilege to press the plunger, but this blast had rather unwelcome side effects, as recorded in the press:

> One stoutly-built stone shelter, 100 yards from the rock face, was completely demolished, a second building further away was also damaged, and a boulder smashed through the roof of an engine room, nearly a quarter of a mile from the scene of the explosion. A photographer, high up on one side of the quarry basin, was struck by a rock fragment.
>
> The blasting operation was an impressive sight. After the dull rumble … the base of a section of the quarry face was blown outwards and then, with a deafening roar, the top of the cliff slid to the quarry floor amid a cascade of stones and a dense pall of smoke and dust. Great blocks of stone were flung as far as 200 yards, heavy trucks … were thrown from the rails … others damaged two gantrys carrying rails leading to the hoppers … The BBC made a record of the blast. The van containing all the apparatus … a quarter of a mile from the scene [was] spattered by small fragments of rock.[25]

The script for another BBC programme, broadcast from Leeds on 14 February 1941, began with a classic piece of journalese: 'A short time ago, away among the hills of Yorkshire, the biggest "bomb" of the war exploded.'[26] This time 120,000 tonnes had been blasted out of the hillside above Horton, and the programme-makers were keen to stress the patriotism implicit in such a massive explosion. The lime was destined for the 'steel works … to add to our great war effort; and on to the meadows and fields, and allotments too, to provide us with more food … Nazism blasted out of Europe, and helped on its way by that effort at a limestone quarry in the peaceful Pennines'. Stirring stuff.

For that blast up to sixty men had been tunnelling away to make the heading, and rails had to be laid within it to bring out the stone. There were no untoward consequences with this blast. In June 1942, another such blast at Horton saw off a further 50,000 tonnes of rock face. The quarrymen had managed to slowly

perfect the science of heading blasts and, after yet another in 1953, a quarryman was quoted as saying, 'That was a peach of a shot. Every piece of stone fell exactly where we want it.'[27]

The Mines Inspectorate was not quite so smug, though, as the annual report for that same year bemoaned the increase in the number of accidents caused by heading blasts. The practice does not seem to have been widely adopted in the northern Dales quarries, but we do know that Redmire set off its first heading

114. 'Preparing for the Big Bang.' Photographed outside the heading blast tunnel at Redmire Quarry, 17 July 1952. (*Frank Knowles*)

blast, described as 'one of the biggest controlled explosions ever to occur in England' in July 1952 (114).

Who had first thought up the idea of heading blasts, and how they came to be so extensively used in the Dales, is not certain. When it was abandoned is also unclear, though by the early 1960s, it had largely gone out of use. One quarry owner, who had used the method at Halton East Quarry in the 1940s, confirmed that heading blasts were stopped because the enormous stone piles were unstable and inherently dangerous.[28]

Other quarries relied on tried and tested well-hole drilling and, by the 1960s, this was the accepted method across the industry.[29] Threshfield Quarry first used well-holes in the early 1950s, preferring the better fragmentation that they believed resulted from this, and because they felt it could bring down just as much as heading blasts anyway. At Swinden Quarry, where well-holes had been in use since 1949, over 120,000 tonnes were blasted on a huge rock face in 1953, but such was the scale of operations by this time, only ten months' worth of crushing and lime burning were produced.[30]

At Skipton Rock Quarry they needed neither heading blasts nor well-holes. The bedding planes here on the 90 m-high face are so steep that all the stone getters had to do was set off a small blast at the base, and the rest would come crashing down under gravity. Blasting here could not have been cheaper.

By way of a final blast, so to speak, Horton Quarry brought down nearly 46,000 tonnes in a firing in November 2000. Villagers complained that they had been subjected to a ground vibration wave and an air blast that was not pleasant to endure.

QUARRY HAULAGE

Once the stone had been loaded into the carts, it was the job of the breakers and fillers or wheelers, depending on the quarry, to transfer them out of the quarry to the crusher or kilns. The arrangements for doing this varied from one quarry to another, but, in essence, almost all commercial quarries had a network of tramways – roads to the quarrymen (115) – along which the carts were manually pushed or linked together and hauled by ponies. A retired quarryman recalls that at Giggleswick Quarry twenty roads led to different points along the rock face, each with its dedicated breaker and filler and Jubilee carts (116, Col. Pl. 40).[31] These same men pushed their cart along the road (which dipped gently) to the kilns and then had to manhandle them back again against gravity. Each man did this fifteen times a day, and the system was still in use in the late 1950s. There was little change in method from the early days of industrial quarrying in the Dales until the 1940s, when creeping mechanisation made ponies redundant (117). At Horton, Walt Thompson had spent twenty-two years of his working life from 1926 as a pony driver shuttling between the quarry and kilns. Swinden Quarry used non-mechanised, gravity-led haulage until 1948, when the first Ruston-Bucyrus shovel was introduced,[32] and this

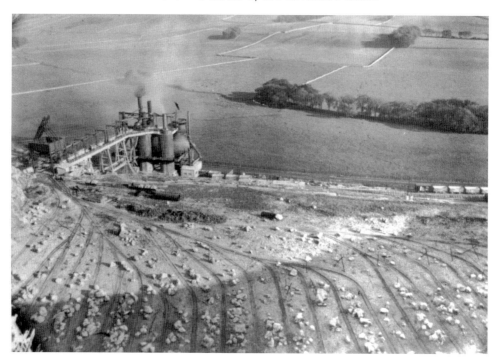

115. An extensive network of 'roads' leading to the Spencer kilns in Swinden Quarry.

116. Two breakers and fillers at the ends of their 'roads'. Note the Jubilee carts. (*Jessie Pettiford Collection*)

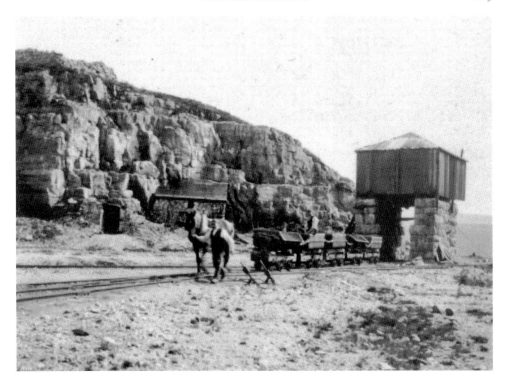

117. Pony Duke leading empty Jubilee carts back into Foredale Quarry, photographed in the 1940s. (*Jessie Pettiford Collection*)

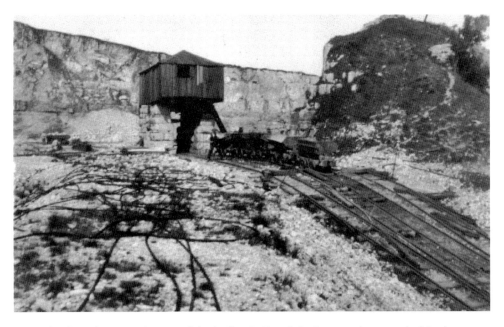

118. The drum house at the top of the incline in Foredale Quarry, photographed in the 1920s. (*Jessie Pettiford Collection*)

type of loading machine was only replaced by hydraulic loaders in the 1980s (Col. Pl. 41/42). Threshfield Quarry, too, only mechanised the loading process at the very end of the 1940s.[33] If the working face and plant were more or less on the same level, as at Mealbank, Swinden and Harmby, haulage was not a problem: the carts could be transferred readily using the lie of the land.

If, however, there was a significant height difference, more complex methods were needed to either lower the carts out of the quarry, as at Langcliffe, Foredale and Leyburn Shawl, or to haul them up and out, as at Skipton Rock or Horton. Various techniques were employed to this end. The older workings at Horton were 20-30 m deep. The breakers and fillers manhandled the carts on the tramways to a mechanical hoist, which lifted them out of the quarry hole for the ponymen to take over. At Skipton Rock carts were again pushed to a central point and linked onto a capstan-like arrangement to be hauled up an incline (109). At Langcliffe's Slippet quarry and at Foredale, carts were lowered down a steep incline from a drum winch sited at the top.

Three variations on the incline theme were to be found across the Dales. Single-rope haulage worked off a top drum, which was equipped with a brake and clutch mechanism. One end of the wire rope was attached to the drum and the other to the tubs. As the rope was let out, the carts were lowered by the brakesman; put into reverse, they were hauled back up again. This method was used on single track inclines, with a passing loop halfway down or on double track with a single rope on each. Main and tail haulage relied more on gravity to guide full carts down the incline. The main wire rope pulled empty ones up, while the tail, a smaller rope, lowered full ones down, and each worked off its own drum. The endless-rope system utilised a single track incline with a drum at each end.

At Foredale six full carts were clipped onto an endless steel rope and their combined weight, dropping under gravity, hauled six empty ones back up (118-120). Slippet's

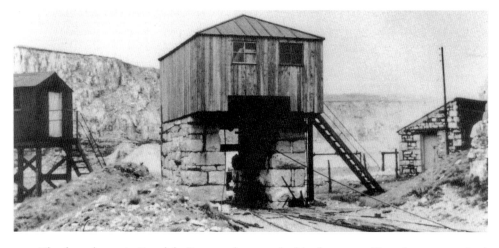

119. The drum house in Foredale Quarry, photographed in the 1940s. Note that a new raised cabin has been built to the left of the drum house. (*Jessie Pettiford Collection*)

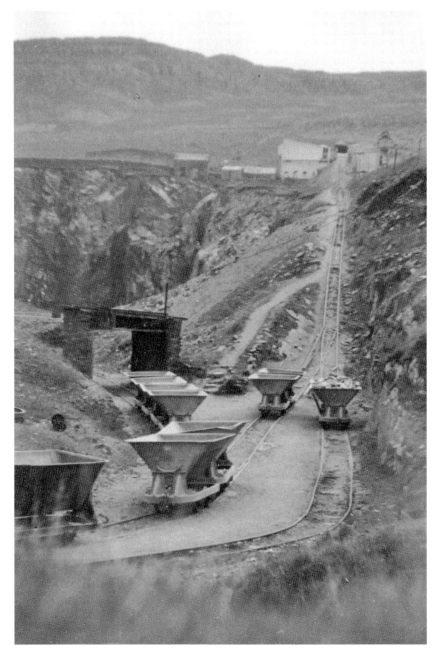

120. Jubilee carts on the lower part of the incline at Ribblesdale Limeworks, photographed in the 1950s.

incline worked off a continuous chain in a single-rope system. At Threshfield the carts were manhandled to an incline and clipped on to a wire rope to be hauled up to the kiln tops, and then lowered down again empty on the single track.[34]

QUARRY PLANT

Apart from haulage systems and kilns, the average quarry held an array of machinery as well as mobile and static plant (121-123). Powder and explosives had to be stored in secure conditions, so a powder house was a basic essential, strong enough to withstand vibration shock from blasts from within the quarry and immune from damage by rock flying through the air (Col. Pl. 39). The powder houses in Foredale and Mealbank Quarries have survived intact, as strong and sturdy as a wartime bomb shelter. If compressed air were used in the drilling process, an obvious feature of the quarry was a compressor house, supported by stilts, with a network of pipes leading from it (124). At the quarry face, once mechanisation began to appear, there would be crude mechanical loaders and possibly a primitive mobile stone crusher first introduced in the 1860s. If this was not provided, large stone that was too big to go through the crusher or into the kiln was smashed up using machines with a single-tonne drop ball, which was continually raised and dropped on stubborn lumps of rock.[35] Colloquially known

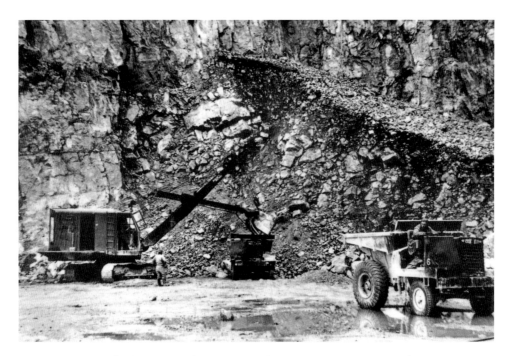

121. Two Muir Hills dumpers, with a capacity of six to seven tonnes, at work in Horton Quarry with a Ruston Bucyrus navvy, photographed in the late 1940s. (*Hanson Aggregates Ltd, Horton Quarry*)

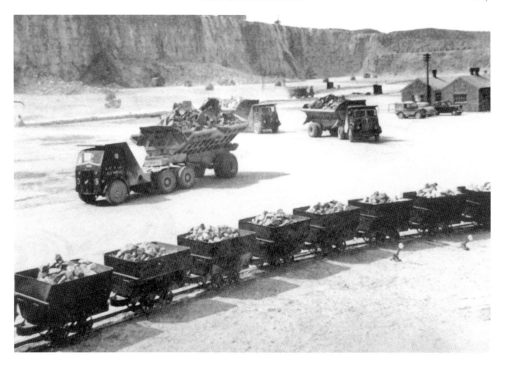

122. Haulage plant within Horton Quarry, photographed in the 1950s. (*Hanson Aggregates Ltd, Horton Quarry*)

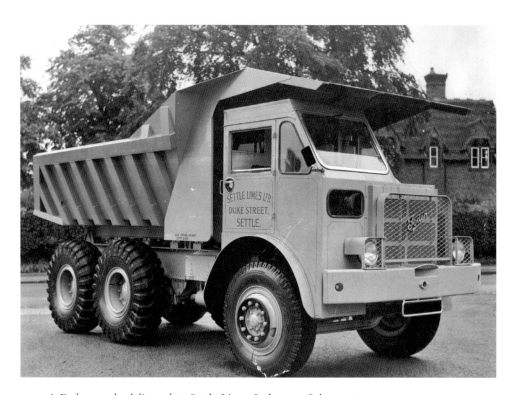

123. A Foden truck, delivered to Settle Limes Ltd on 11 July 1956.

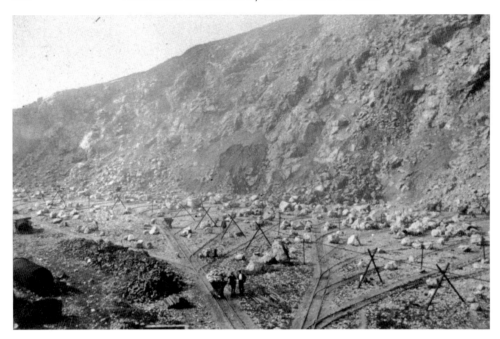

124. Compressed air pipes in Swinden Quarry. Date unknown.

as 'drop bombing', this method was universally applied, along with 'popping' (breaking the rock up with a large pneumatic drill), before the introduction in recent times of hydraulic rams or peckers. (To see a pecker in action is to quickly appreciate why it has earned that name.)

Away from the active quarry itself stood the fixed plant and ancillary buildings: the weigh house, the blacksmith and joiner's shops, the engine shed, offices, cabins for the men to eat and shelter in, and in earlier days stables. There was the crushing plant with its system of conveyor belts, screens, hoppers and crushers and, especially from the 1930s, extra plant to reduce limestone to powder form for agricultural use, in response to the newly introduced Land Fertility Scheme. In many quarries, too, hydrating plant was built to turn quicklime into a more readily usable product.

Some quarries had already had hydrating plant put up over ninety years ago to meet the rising demand for this item. Crushed quicklime was fed by conveyor to a storage hopper and dropped automatically into the hydrator with a predetermined amount of water. The mixture was agitated to thoroughly slake the lime, then dried by direct heat, passed through a separator to remove any impurities, and dropped into hoppers to be loaded into sacks and, later on, directly into road tankers (125). As we have seen in earlier chapters, many quarries in the Dales had their own hydrating plant. Many of them, as we have also seen, had tar-coating plant where hot bitumen was sprayed on to crushed stone to create tarmacadam (Col. Pl. 43). As the twentieth century progressed, quarries became increasingly complex, mechanised and capital intensive.

125. A road tanker designed for carrying hydrated lime, photographed in the early 1960s. (*ICI*)

From the late 1930s to the late 1960s, many of our quarries became dependent on producing burnt lime or hydrated lime to meet the demands of the Land Fertility Scheme.

THE LAND FERTILITY SCHEME

The practice of applying lime to the land decreased somewhat from the 1880s, though it by no means died out.[36] The sale price of lime had been pushed up by increasing production costs – labour and fuel – and transport costs, and cheaper alternatives were making inroads into lime's dominant position. Farmers already had their backs to the wall, memories of the severe agricultural depression of 1879-96 were still vivid and bitter, and another recession set in during 1921, which was to last for a full fourteen years. Liming was hardly the first priority for struggling farmers. Even if some of the farming community still wished to lime their land, there were cheaper alternatives available, including waste lime-rich sludge from paper mills, tan yards, dye works and other such consumers of burnt lime. Waste lime was less than half the price of burnt lime or ground limestone. The Government did make an effort of sorts to stimulate lime usage as, in the 1920s, associations of farmers could secure loans to purchase lime cooperatively. The response from the hard-pressed guardians of the land was predictable: there was very little take-up.[37] A loan had to be paid back, after all.

It may have been this slow response that awakened the Government to the plight of farmers, as 1926 saw hopes being raised that the Ministry would provide financial aid to encourage a resurgence in liming. The need for lime was most definitely there, as evidenced by a survey in the 1940s that found only 20 per cent of permanent grassland in Lancashire and Yorkshire to be non-acidic, with 32 per cent classified as very or extremely acidic. There had been hardly any change since a survey of the early 1920s, which declared Yorkshire to have a serious deficiency, even on limestone pastures.[38] It might be of interest to note that similar surveys, carried out in the 1950s and 1970s, showed a similar pattern, with acidity levels rising.[39] It is very probably the same today.

Writing in 1926, F. E. Corrie was moved to add his own lines to the old rhyming couplet, 'Lime on land without manure/will keep both land and farmer poor.' He wrote, 'This old and oft repeated rhyme/hath little point at present time/when farms are poor for want of lime.'[40] It was not just soil and crops that had deteriorated, but also the quality of livestock grazed on the ever-more acidic pastures. Gradually, the Government came to realise that drastic remedial action was necessary. Loans, encouragement from agriculturists, scientists and the like,[41] and advertisements in the press[42] had not done the trick.

The answer came on 6 September 1937 with the introduction of the Land Fertility Scheme under the new Agricultural Act, which applied a flat-rate subsidy of 50 per cent of the purchase price of lime for all farmers willing to take up liming. Those farmers who had kilns on their land were also eligible for subsidy. The scheme was intended to last until July 1940. Many old kilns – including some in the Dales – were resurrected, repaired and put back into use; Langcliffe's Hoffmann was fired up again after a six-year break; very soon lime producers were struggling to keep up with demand. Nationally, applications flooded in at the rate of 100 each day, and it was reported in 1938 that not a single Craven quarry had been able to complete its outstanding orders for agricultural lime.[43] They lacked the production capacity in the face of a 90 per cent take-up rate for the subsidy among Craven's farmers.[44]

Demand remained high and the 1940 cut-off date was extended, such was the success in boosting farm output in both quality and quantity, as required by the war effort. Quarries still struggled to cope, so Government grants helped specific sites to install new plant to turn out agricultural ground limestone. In 1944, six grinding mills were brought from America under the Lend-Lease scheme. In 1942 the Land Fertility Scheme was modified to increase the rate of subsidy to 75 per cent on summer deliveries in an attempt to even out the demand curve throughout the year. Quarries in the Dales remained under pressure, as did landowners with untapped limestone reserves on their estates as, in 1943, when the Ministry of Supply tried to persuade the relevant estate to open up a new quarry where Wensley Quarry was later to grow, so desperate was the Government for lime. In 1951 the subsidies were largely withdrawn by the increasingly embattled Labour administration, and lime sales plummeted. They were restored two years later with burnt lime attracting a higher subsidy than ground – 5s as opposed to 3s

6d per tonne spread – with the summer seasonal adjustment pegged at 70 per cent. The scheme came to an end in 1947, only to be replaced by the Agricultural Lime Scheme, which was given an initial shelf life of five years, but was extended and then raised in 1960, reduced in 1965, and increased again in 1970, to be permanently scrapped in 1976.[45]

One unnamed Craven farmer was singled out as being a paragon of what could be achieved by liming.[46] He had managed to transform an area of rough grazing into improved pasture over a period of several years by giving the land a good dressing of lime in the first year – tining it to allow the lime to penetrate the soil – followed by an application of basic slag in the second year, and then a light dressing of lime every three to four years, with basic slag applied every other year.

A similar success story was cited in the following year.[47] P. W. S. Fletcher, farming at Winterburn Wood since 1946 on highly acidic millstone grit, had won pastures back from the moor by applying ground limestone at about 5 tonnes per hectare at intervals of three years. A. Lambert, farming at Knott Farm in Lothersdale, told a conference of farmers in 1963 that he had converted his 'poverty stricken' farm into a profitable concern by the judicious use of lime.[48]

Sadly, it all seemed to make little overall difference in the Dales. Perhaps it was the damp climate, low evaporation rates and low mean average temperatures that kept the soil acidic. Even soil based on limestone in the Dales, which is by definition alkaline, will return a pH of 6.0 or 6.5, thus it is slightly acidic. For optimum grass growth, a pH of 5.9-6.0 is required.

So, some farmers were happy, while others remained unconvinced, and quarry owners enjoyed a boom time, yet they still found something to gripe about. The Land Fertility Scheme also allowed subsidy on lime sludge from sugar beet factories and paper mills, even though sludge had only a quarter of the calcium content of lime or ground limestone. The quarrying lobby complained that sludge, once a valueless waste product, was now taking business away from quarries. Indeed it was.[49]

TO BURN OR TO GRIND?

While all the to-ing and fro-ing over the subsidies was going on, a quiet debate raged concerning the respective merits of burnt lime and ground limestone, or limestone dust, as soil improvers. First used extensively around 1920, and pioneered by Joseph Harrison of Flusco Quarry near Penrith, ground limestone soon received the backing of the Government for a variety of reasons. It was disputed whether ground or dust were as efficacious as burnt lime in neutralising soil acidity, but no one could argue with the fact that dust was far cheaper to produce and, therefore, to buy and to subsidise.[50] In the 1920s dust was two to three times cheaper than burnt lime. Dust and ground were both slower to decompose in the soil and thus slower at releasing their calcium content, which

126. Spreading pulverised limestone dust at Helwith Bridge in Ribblesdale, in the late 1940s or early 1950s. (*Jessie Pettiford Collection*)

was a clear disadvantage, and twice as much was required per unit area as burnt lime. On the other hand, though, some claimed they remained effective in the soil for longer. Many farmers were not convinced of the value of dust or ground, even in the postwar period, despite the disparity in cost and the potential problems of applying burnt or slaked lime. When burnt lime was piled across the fields, and left to slake in the rain, there was a tendency for it to clump, making the final raking out difficult. In addition, of course, spreading slaked lime was labour intensive, adding to its cost, whereas dust and ground could be rapidly applied from a mechanical hopper (126).

Whatever their relative merits, ground limestone gradually eroded the market for burnt lime on the land, aided by the subsidy schemes that favoured it. In the twelve months from November 1949, consumption of agricultural limestone products was as follows: ground 48 per cent; dust 23 per cent; ground burnt 17 per cent; lump (burnt) lime almost 12 per cent. By the end of the seventies, ground was in almost universal use.

DUST AND THE ENVIRONMENT

The gradual switch to using ground limestone and dust had direct implications for those quarries in the Dales that had maintained burnt lime production for farm use. Kilns were no longer needed to the same extent, and new crushing and screening plant had to be installed to produce dust and ground. There were also indirect implications. Dust got everywhere and became an increasing cause for concern among those living downwind of a quarry. Trees, fields and buildings all wore their permanent coat of white. Complaints flooded in, councils met to discuss what they might do, Government inspectors were called in to advise (or to spin?). Swinden and Giggleswick were the subject of constant moans and Black Quarry was complained about throughout the 1960s.

In early summer of 1973, Skipton Rural District Council purchased deposit gauge monitors to record emissions at four local quarries – Halton East, Skipton Rock, Swinden and Lothersdale – in an attempt to placate local folk. In June that year an anti-quarrying steering group was formed in the Dales, partly to stop any new quarry developments, but also to force existing quarries to improve their act. The same council created a Minerals Liaison subcommittee to pressurise quarry owners into installing dust suppression equipment. Quarries were given targets to meet, which included remedial measures other than dust control, such as tree planting, reducing discharges into streams, reducing noise levels, and improving public relations with the local communities. However, it was not until 1990 that Tilcon followed the lead taken by Cool Scar Quarry nearly two decades earlier by setting the industry standard in the Dales and introducing compulsory sheeting of all lorries leaving quarries.

These tasks continue even now as the remaining quarries try to stay on the right side of public opinion – not easy given the frequency and size of lorry movements along the narrow roads of the area.

It is easy to knock quarries on environmental grounds. They can be very dusty in dry weather, noise is clearly an issue, especially during blasting operations, frequent lorry movements tend to annoy some residents and visitors, and it is difficult in the extreme to claim that a raw quarry face is aesthetically pleasing. It is also easy to be too negative. There are quarries, limestone and hardstone, that take pride in their efforts to minimise the environmental impact of what they do. To take one example, Threshfield Quarry won the Quarry Products Association's Environmental Award four years in succession. In 1995 it was awarded one star; by 1998 it had five.

Epilogue

Over the last five decades or so the quarrying industry has changed in almost every respect. In the words of one commentator, 'In the past the quarrying industry – rural, unsophisticated and not nationally articulate – simply got on with its job without fuss, coping with a modest demand, generally in a local market.'[1] It has been transformed into a super-efficient, highly automated and competitive industry dominated by a handful of international corporations facing increased legislative and environmental concerns and controls.

It all began to change with the passing of the Town and Country Planning Act 1947, which brought quarries fully within the tentacles of the planners. Overnight it became well-nigh impossible to open up a completely new quarry, and stringent conditions were imposed on extensions to existing quarries. In one fell swoop, landowners had been deprived of a right that to them was 'economically valuable … the right to "develop" land through building or quarrying'.[2]

In 1972, the West Riding County Council received a report it had commissioned from Dr Arthur Raistrick on the future of quarrying within Craven.[3] He made a number of recommendations that would have been viewed with nothing other than acute displeasure by the industry. Ribblehead and Cool Scar Quarries should be phased out, he suggested; development at Swinden, Threshfield, Horton, Giggleswick and Foredale Quarries should be 'rigidly controlled'; only Lothersdale, Skipton Rock, Skibeden and Haw Bank Rock, Hambleton and Coldstones should be allowed to expand; a 'large new quarry' could be opened up between Feizor and Brunton Quarry west of Settle; the disused quarry at Broughton could be resurrected, if demand should warrant it. Clearly not all his recommendations were taken onboard, but the Council formalised the situation in 1973 by deciding to concentrate all future quarrying on existing sites.[4] Meanwhile the Environment Act 1995 decreed that all mineral planning consents issued before 1982 had to be reviewed, which meant negotiating, as necessary, quarry working hours, lorry movements from quarries, permissible noise and dust levels, and restoration measures. As a direct result of this act, the Yorkshire

Dales National Park Authority put its Minerals and Waste Local Plan into effect in 1998. Valid for ten years, this stipulated that no new quarries could be started and that extensions to existing ones could only be allowed if fully justified, and if they showed the highest regard for environmental considerations. Many of the plan's policies were retained when it was revamped in 2007.[5]

April 2002 saw the introduction of a further burden for quarries in the form of the Aggregate Tax, set initially at £1.60 per tonne on 'virgin sand, gravel and crushed rock', with the overt intention of persuading building and construction companies to recycle material instead of using fresh stone.[6] Viewed by some as an environmental tax on the exploitation of aggregates, it was increased to £1.95 in 2008 and now stands at £2 per tonne. Whether it has had the desired effect is another matter: a report in 2010 claimed that the tax had had no measurable impact on demand, despite the economic downturn seen across all sectors of the economy.[7]

Because limestone quarries in the Dales, as elsewhere, have been reliant on other sectors of the economy for sales, they tend to catch cold when their consumers sneeze. We have seen in earlier chapters the impact of a change in orders on several of our quarries: the reopening of Langcliffe's Hoffmann kiln in 1937 in response to the Land Fertility Scheme and the closure after only eight years of Swinden's rotary kilns when a steel contract came to an end are but two examples. In fact, falling demand from steel producers looms large in annual state-of-the-industry reports for the Dales since the early 1950s. Strikes in the coal or transport sectors, fluctuations in fuel prices, Government credit squeezes of the boom-bust era: all had a negative impact on the viability of family concerns in the Dales and made them prone to corporate attack. At the time of writing, the limestone quarrying industry in the area is in the hands of only three corporations: Anglo American, which owns Tarmac and Tilcon (the lesser-known name Tilcon having been buried when Tarmac was taken over in 2000); Hanson, which was bought out by the German Heidelberg Cement Group in 2007; the Mexican conglomerate Cemex, which bought out the RMC Group in 2005. The trends now are to increase the international dimension of quarrying and to focus production in a shrinking number of very large and automated quarries,[8] with smaller ones being phased out or mothballed.

Some quarries in the Dales have suffered the indignity of becoming landfill sites (Langcliffe, Skibeden and Leyburn Shawl), while others have been turned over to nature conservation (Ribblehead, Giggleswick, Cool Scar and Harmby). Some remain abandoned and all but forgotten (Thornton Rock), and others no longer actively win stone but serve as sites to crush and coat limestone from elsewhere (Skipton Rock and Halton East). Yet others slumber in a mothballed state, planning permissions being kept open for some future date (Redmire and Preston-under-Scar).

Though limestone and burnt lime still have a wide range of end uses (Fig. V), crushed stone, or aggregate, dominates quarrying in the Dales now, as indeed it does globally. The year 2001 saw a new and sad use for burnt lime in the Dales. The devastating impact of the foot and mouth epidemic across Craven and in

Fig. V. Current uses of lime and limestone in the UK. (*Source: Oates, 1998*)

> aggregates for roadstone and construction
> agricultural feed processing
> agricultural ground limestone
> armour stone for defensive construction
> cement
> coal mining: limestone dust dilutes coal dust and reduces explosion risks
> de-acidifying forests and lakes
> flue-gas desulphurisation
> flux in aluminium and steel manufacture
> glass manufacture
> leather manufacture
> paper making
> pottery making
> water filtration
> whiting and filler in paint, floor coverings, plastics, rubber,
> pesticides, printing oil, toothpaste, cosmetics, fireworks

Wensleydale necessitated a total clean-up of all infected and contiguous farms. The quickest way to disinfect old and possibly infected animal bedding in barns and shippons was to cover it with a layer of quicklime, topped with moisture-retaining small stone. The lime penetrated the bedding and rid it of the virus before it was removed for disposal.

Currently five limestone quarries are fully functional across the Dales, two lying within the National Park.[9] On average, annual output of crushed limestone from quarries within the National Park has hovered around the 3 million tonnes mark for the past ten years. Hanson's Coldstones Quarry on Greenhow, above Pateley Bridge in Nidderdale (Col. Pl. 44), produces around 750,000 tonnes per year, the majority of which is trucked to concrete manufacturing plant in Leeds and Bradford, with 10 per cent or so used to make asphalt on site.[10] Until very recently, blasting operations at Coldstones blended the hi-tech with the quaint and quirky. The face to be fired is laser-profiled and a grid of holes the full height of the face is drilled using what the firer called 'down the hole hammer drilling'. If, however, the machinery could not access the face to be blasted, an alternative method came into play. The explosive concoction – ammonia nitrate and fuel – was hand-mixed in a homemade 'coffin' using a plastic shovel, and was manually poured down the holes – ingenious and totally technology-free. Now, however, the more modern method is used, whereby external contractors are brought in to pump the ammonia nitrate mixture in slurry form into the blast holes. Coldstones has a maximum life of about fifteen years, depending on rates of extraction.

Giggleswick Quarry (Col. Pl. 45) originally had planning consent valid until 2042, but the previous owners, Tilcon-Tarmac, proposed phasing it out thirty

years earlier. After the merger of Tilcon and Tarmac in 2000, when they were obliged to dispose of some quarries under competition regulations, the quarry was acquired by Hanson, who very quickly began to run the scale of operations down, ceasing actual quarrying in 2007 and only using the site to crush stone brought in from elsewhere, and finally closing the quarry entirely in 2008. It is being left to re-wild naturally.

Horton Quarry (Col. Pl. 46) changed hands in the same way, and it too has consent valid until 2042. Since Hanson acquired the complex, production has been stepped up, with a target of up to 600,000 tonnes per year, three quarters of it destined for Hanson's own concrete facilities across the north-west, 8 per cent going to Hanson's asphalt facilities in Leeds, Bradford and Wigan, and about 5 per cent to chemical facilities in the North East, with the rest going for base fill material. History is set to repeat itself at Horton. Hanson hopes to resume hardstone quarrying, abandoned by John Delaney decades ago, once its hardstone quarry at Ingleton is exhausted in 2018, with projected output reaching 1.5 million tonnes. At the time of writing, limestone reserves above the hardstone at the southern end of the quarry are being quarried in readiness for this. It is also hoped that the company's aim to put back the rail sidings by 2015, to reduce the number of daily lorry movements, will finally come to fruition. Hitherto, the stumbling block to reinstating the rail sidings had been restricted capacity on the line within the signalling system, but this has already been partly resolved. Hanson's new owners, the Heidelberg Cement Group, is currently considering whether or not to go ahead with this course of action. In any case, it looks as though Horton Quarry will work its allotted span, and possibly extend its life beyond that, given that aggregate has to come from somewhere.

Leyburn Quarry (Col. Pl. 36), operated by RMC until the group was bought out by Cemex, had been producing between 350,000 and 500,000 tonnes annually and mainly despatching crushed stone to its concrete and tar-coating facilities across North and West Yorkshire and on Teesside.[11] However, the company secured a three-year contract to supply aggregate for construction of the A1(M) between Dishforth and Leeming Bar in North Yorkshire, starting in 2009, and output soared to about 1 million tonnes per year, securing jobs for the quarry's twenty-two staff, not to mention numerous lorry drivers. Within the Yorkshire Dales National Park planning consents for quarries are based on years of future life but, being outside the Park, Leyburn's consent is based on volume of stone. Currently it has confirmed consent to extract a further 5 million tonnes with an Interim Development Order for 30 million, effectively guaranteeing it an assured long-term future to enable quarrying well beyond the present workings. They cannot deepen the existing quarry because they are already down to the base of the main limestone strata, 9-23 m below ground level, so will extend northwards for nearly 1 km. There is more limestone at depth, but a thick overlying bed of friable sandstone prevents its exploitation.

Leyburn Quarry, with the neighbouring disused Shawl Quarry, has rather unusual limestone bedding. Most limestone in the Dales is greyish in colour, which

reflects the mineral content of the rock, but here the workable beds are varied. Approximately two-thirds by volume is typical grey limestone, but this is overlaid with brownish stone that contains a higher proportion of the mineral calcite. The grey stone is sent for tar-coating, but not the brown: bitumen will not adhere to it, so this is used for concrete and aggregate.

Swinden Quarry (Col. Pl. 47) has reserves sufficient to last until 2035, and consent valid to that date, with a limit on total extraction up to its maximum processing capacity of 2.2 million tonnes per year. It is regarded as Tarmac's premier quarry in the north of England. Swinden has generated more than its fair share of controversy locally, in earlier years because of fallout from the kilns, and in the early to mid-1990s because Tilcon applied for permission to extend the working area as reserves were running low. In 1996 consent was granted in return for environmental improvements, a pledge to despatch more by rail, and full restoration of the quarry as a nature reserve when it is closed down.[12] By 2010, approximately half of all stone was despatched by rail. Stone sent out by rail is destined for Tarmac's facilities in Leeds and Hull, for processing into concrete products or for dry and coated aggregate. That sent out by road ends up at facilities across Lancashire and West Yorkshire, again mainly for aggregate.

The 1996 planning consent also enshrined an undertaking to provide employment locally to quarrymen, plant operators and lorry drivers: in 1999 the site employed sixty-four, though the number has since dropped substantially, with twenty-four currently employed within the quarry, excluding lorry drivers. This decrease resulted directly from the commissioning of state-of-the-art, fully automated crushing and screening plant at Swinden. No longer do mammoth dump trucks shuttle from quarry face to primary crusher. This is now mobile, sited wherever a stone pile awaits clearance, and it feeds stone by conveyor to the main plant.

Wensley Quarry, operated by Tarmac, has a lease valid until 2042, an agreement that includes the dormant Redmire and Preston-under-Scar quarries. Assuming consents are taken up (and they almost certainly will be), the area to be worked will be extended considerably, with Preston-under-Scar Quarry being opened up again as soon as Wensley Quarry is exhausted, and then Redmire Quarry will be opened after that. When Wensley's end comes depends on annual rates of extraction; assuming they soon get back to full production, closure will be about fifteen years hence.

In addition to these existing quarries, there is one further area with planning consent valid to 2042. Centred on the original Black Quarry (SE 101 913), to the east of Moor Road, the area has not been worked for many a decade but could be.

What of defunct aspects of limestone industries in the Dales? A surveying programme has been completed across the National Park – and extended across the rest of Craven – mainly by this writer, wherein all surviving lime kilns and kiln sites have been recorded and photographed.[13] All data have been added to the Heritage Environment Record. In some instances, kilns of particular significance, by dint of a sound state of preservation and access to the public,

have been earmarked for structural consolidation by the National Park Authority. This ties in well with the resurgence of work being carried out elsewhere into the archaeology of lime burning.[14]

Several disused quarries within the National Park have been receiving close attention in recent years for their potential as visitor attractions. The first, and arguably the most ambitious, restoration project is at the former Craven Lime Co.'s quarry and Hoffmann kiln at Langcliffe, funded by the Heritage Lottery Fund and European Union grants. The restoration was carried out on behalf of the Yorkshire Dales National Park Authority and completed in 2002. The rebirth of this site as a low-key, minimum-impact visitor attraction has had a twenty-year gestation period. An initial report was drawn up for Craven District Council's Recreation and Amenities Committee in 1982, as a result of which preventative maintenance was carried out on the kiln using the expertise of the Bradford Scientific Association and the late Griff Hollingshead.[15]

Out of this came the Ribblesdale Trust, which had ambitious plans for a visitor centre at the site 'to rival established museums such as Beamish ... or the slate mines at Blaenau Ffestiniog'.[16] Plans were mooted that would have necessitated the raising of £4.2 million, and would have involved the reconstruction of the kiln chimney.[17] Needless to say, these plans were buried. In 1989 an archaeological survey was carried out, with an in-depth survey following in 1994.[18] Further proposals, penned in 1993, included a hotel on site and a chairlift up the face of the quarry. Thankfully, these were also consigned to the bin. A year later the council agreed to transfer the site to the National Park Authority, with conditions imposed on its level of development, and the trust was wound up. A year after that, a full ecological survey was implemented across the entire site, the results of which confirmed the extreme importance of the Hoffmann kiln as a rich botanical habitat in its own right with a staggering species diversity – eighty-two plant species in all, not to mention one very rare species of cave spider, five species of bats, and nesting peregrine falcons on the scar.[19]

Development of the site – or at least discussions in that direction – stuttered on for the rest of the 1990s, with funds being secured in 1997 and 1999, and several false starts being sounded. Work to consolidate the Hoffmann kiln, the triple-bottle kiln, the buttressing for the Spencer kilns and other industrial remains, finally began in earnest in 2000, working to a deadline that would have all Lottery money spent by September 2001. But foot and mouth restrictions put a halt to work for much of the year, so completion of the restoration scheme was delayed to 2002. A 'consolidate as found' policy was adopted, the whole emphasis being to preserve the quarry and limeworks, to manage the site in a sustainable and integrated manner sympathetic to wildlife considerations, and to present the site as a low-key visitor facility.

Despite having consent to quarry stone until 2042, production at Threshfield Quarry ceased in 2001 and the site was mothballed. Tarmac, which also owns Swinden Quarry, south of Grassington, used Threshfield as a bargaining chip in its quest to secure a long-term future for Swinden, whose planning consent

was due to expire by 2021. If the planning authority would grant permission to extend Swinden's life, Tarmac would give up its consent for Threshfield and close it down. This indeed happened and the company signed a thirty-year Section 106 Agreement under the Town and Country Planning Act 1990, to ensure that the upper parts of the quarry are managed to encourage re-wilding, with supervised access for special interest groups. In the lower parts of the quarry a native white-clawed crayfish sanctuary has been established in one section, while a local charitable trust has formulated proposals for the imaginative and innovative use of another section, which include the establishment of a Limestone Landscapes Centre to facilitate the understanding of the geology, archaeology and wildlife of the limestone dales. In time, it is hoped that it will evolve into a prime visitor and educational attraction to include a working lime kiln, with a trail round the remains of the former Threshfield Limeworks.

Attention has also been given to the long-disused Mealbank Quarry at Ingleton, which contains one of the earliest surviving examples of a Hoffmann kiln in the entire country. At the time of writing, options for its future are being considered and put out to public consultation, but the hope is that the sadly decaying kiln and ancillary structures can be saved for the future, with the quarry possibly being opened up to public access for the first time ever. Given its exceptional geological and archaeological importance, it is hoped these proposals will come to fruition.

Tentative plans are also being drawn up to devise a themed trail to link various former industrial sites across the Dales, including the quarries mentioned. Such a trail, if properly promoted, would provide a new set of visitor attractions and thereby bring more income into the local economy.

As fitting monuments to a lime-burning industry that has totally disappeared from the Dales, to methods and tribulations of a quarrying industry that has changed beyond all recognition, and as a tribute to generations of men who toiled in the quarries and kilns, there can surely be nothing better than to see these former limeworks preserved and made accessible for generations to come.

Appendix I

Fig. VI. Recorded accidents in limestone quarries in Craven, 1868-1983 (*Source*: Craven Herald, Craven Pioneer, Lancaster Guardian)

DATE	QUARRYMAN	QUARRY	DETAILS
Jun 1868	William Cragg	Mealbank	accident while preparing a blast – lost a thumb
Feb 1870	James Fishwick	Mealbank	accident while preparing a blast – disfigured and disabled
Aug 1873	Richard Clapham	Mealbank	accident while preparing a blast – killed
Mar 1874	John Lord	Giggleswick	while backing his horse and cart to a kiln, the horse took fright and fell back into the kiln
Jan 1876	George Sellers	Mealbank	crushed to death by a fall of rock – remains had to be gathered up in a sack
Jul 1881	William Howson	Storrs	his cart ran out of control & crushed him
Jul 1881	Henry Wearing & Howson's brother	Storrs	their cart slipped back into the kiln, taking the horse with it
Oct 1882	James Mason	Mealbank	hit by stone falling off a cart
Nov 1883	Alfred King	Craven	hit in the eye by flying rock
Oct 1884	Leonard Nicholson	Mealbank	seriously injured when buried by a slippage of loose rock
Feb 1885	John Darwen	Mealbank	accident while preparing a blast – blinded & badly injured

DATE	QUARRYMAN	QUARRY	DETAILS
Jul 1887	William Baldwin	Mealbank	accident while preparing a blast – critically injured
Oct 1891	?	Craven	accident while preparing a blast – injured
Feb 1896	Herbert Maxwell	Hambleton	crushed and badly injured by falling rock
early 1899	George Williamson	Hambleton	killed by a rock fall while boring
Jun 1902	Tom Wilson	Foredale	trapped by a rock fall – foot crushed
Jun 1902	George Smith	Hambleton	struck and killed by falling rock
Aug 1903	John Moorby	Craven	accident while preparing a blast – fractured his skull
Mar 1904	John Cooke	Ribblesdale Lime Works	killed by a shunting loco
Oct 1904	William Foster	Giggleswick	lost an eye
Apr 1906	Joseph Hadfield	Craven	run over and killed by a kiln cart
May 1907	James Wilson	Mealbank	struck by flying rock
May 1907	Sam Picard	Mealbank	hand trapped in a wagon – lost a finger
Jul 1907	Joshua Parkinson	Mealbank	run over and injured by his horse and cart
May 1908	William Wiseman	Craven	badly bruised by falling rock while working as a barer
Oct 1908	Fred Hawkins	Giggleswick	slipped and fell 30 m while descending the face on a chain – no injuries!
Apr 1909	Tom Richardson	Mealbank	fell 6 m when hit by falling rock – badly injured
May 1921	Richard Baines	Giggleswick	accident while preparing a blast – blinded and injured
Jul 1925	Robert Inman	Skipton Rock	killed by falling rock
Feb 1929	William Birkett	Broughton	lost an eye to flying rock – he later had a similar accident at Threshfield and injured the other one
Oct 1929	Thomas Wallbank	Embsay Rock	killed by falling rock while working as a barer

DATE	QUARRYMAN	QUARRY	DETAILS
Feb 1931	?	Ribblesdale Lime Works	four fitters fell while erecting new plant
Jun 1931	James Busfield & Joseph Swailes	Swinden	badly burnt while preparing a blast – Busfield later died
Jan 1936	John Riley	Swinden	killed by flying rocks in a blast
Jul 1936	George Towler	Horton	crushed between two rail wagons
Jul 1937	George Voyce & A. Ward	Giggleswick	while tunnelling for a heading blast, badly injured by a spontaneous explosion
Jan 1938	Frank Symonds	Horton	killed by falling rock
Nov 1940	Ellis Read	Horton	killed by falling rock
Aug 1948	Joseph Bullock	Skibeden	killed by falling rock
May 1949	Frederick Case	Skipton Rock	killed when his dumper tumbled 11 m down a slope
May 1961	John Burns	Skibeden	killed when his dumper fell over a drop
Oct 1964	Thomas Chesser	Skipton Rock	killed when he fell into the crusher
Feb 1983	Alan Beecroft	Skipton Rock	seriously injured when he fell from the crushing plant

Appendix II

Fig. VII. Accessible long service records in Craven quarries. (*Source*: Craven Herald *and quarry managers*)

QUARRYMAN	QUARRY	YEAR RETIRED	YEARS OF SERVICE
James Clark	Craven	1938	47
William Yates	Salt Lake, Horton	1955	61
Fred Dicken	Horton, Threshfield	1956	60
William Baines	Horton	1961	56
E. Sarginson	Foredale, Horton	1961	48
G. Summers	Horton	1961	35
G. Mason	Horton	1961	42
R. Towler	Horton	1964	35
Alfred Burroughs	area salesman	1966	50
G. Lupton	Swinden	1968	44
H. A. Rowley	Swinden	1968	44
W. S. Fewster	Swinden	1968	43
E. Hargreaves	Swinden	1968	41
Johnny Harker	Swinden	1979	50
Andrew Lynn	Giggleswick, Horton	2002	44
A. Fairhurst	Horton	2003	33
B. Torr	Horton	2005	31
William Melling	Horton	2005	31
C. Potts	Horton	2008	47
H. Winston White	Horton	2009	32
James Hird	Lothersdale, Skipton Rock, Swinden	2010	45½
R. Ellis	Horton	2011	36

Notes and References

PREFACE

1. Raistrick, A., 1960, 545-54.
2. Boynton, R.S., 1980, 1.
3. Wright, G.N., 1967, 33-5.
4. Cossons, N., 1975, 221.
5. Bick, D., 1984, 85.
6. Cleasby, I., 1995, 16-20.
7. Isham, K., 2000.

INTRODUCTION

1. Gourdin, W. H. and Kingery, W. D., 1975, 133-50.
2. Oates, J. A. H., 1998, 4.
3. Gourdin, W. H. and Kingery, W. D., 1975, 133-50; Cowper, A. D., 1927, 3.
4. Dancaster, E. A., 1916, 1.
5. Quoted in Boynton, R. S., 1980, 3.
6. Quoted in Spackman, C., 1929, 1; Isham, K., 2000, 7. Marcus Porcius Cato (234-149 BC), the elder of that name, was born into a prosperous farming family and was instrumental in pushing agricultural techniques forward on his estate.
7. Quoted in Toft, L. A., 1988, 75-85.
8. Quoted in Spackman, C., 1929.
9. Cowper, A. D., 1927, 4. Pliny wrote and published collections of letters in AD 100-109.
10. Dix, B., 1979, 261-62.
11. Tomson, S . J. N. and McIlwaine, J. J., 1993, 17.
12. Parsons, D., 1990, 1.

13. There is an interesting parallel here with medieval castles in the mountains of northern Cyprus. It cannot be mere coincidence that the mountain fortifications all built on limestone crags have lime kilns at their foot.

14. Steane, J. M., 1984, 228-9.

15. NYCRO. ZBO. Scrope of Bolton Archive. Covenant Sir Richard Le Scrope, kt, John Lewyn, mason, 14 September 1378.

16. Ayers, B. S., 1990, 220.

17. Davey, N., 1961, 101.

18. Faull, M. L. and Moorhouse, S.A., 1981, 41.

19. NYCRO. ZRL1/20, *Ende'tur Ecclesie de Catrik*, 18 April 1412.

20. Brock, J., 1987, 6-21.

21. MAP Archaeological Consultancy, 1998, 8.

22. Johnson, D. S., 2009a.

23. Quoted in Harland, J,. 1856, 768-9.

CHAPTER 1

1. Kames, Lord, 1815, 271.

2. Davies, P. B. S., 1997, 17.

3. Toft, L. A., 1988, 75-85.

4. Moore-Colyer, R., 1988, 54-77; Miles, D., 1994, 72.

5. Mawson, D. J. W., 1980, 137-51.

6. Moore-Colyer, R., 1988, 54.

7. Miles, D., 1994, 67.

8. Miles, D., 1994, XXXVIII.

9. Blith, W., 1652.

10. Blith, W., 1652, 133.

11. Johnson, D.S., 2009b, 163-4, 166-8.

12. West Yorkshire Record Office, Wakefield, Hammond Papers, uncatalogued.

13. West Yorkshire Record Office, Wakefield, Middleton Papers, YAS/ MD59/12/20 and MD59/12/78, 30 October 1620.

14. Johnson, D.S., 2010a.

15. West Yorkshire Record Office, Wakefield, Middleton Papers, YAS/ MD59/14/103, 25 March 1678.

16. Worlidge, J., 1675, 24.

17. Worlidge, J., 1675, 61.

18. Society of Gentlemen, 1736, 355.

19. Hale, T., 1756, 81-3.

20. Hale, T., 1756, 86.

21. Maxwell, R., 1757, 191-5.

22. Skinner, B. C., 1969, 11.

23. Kames, Lord, 1815, 387.

24. Kames, Lord, 1815, 280-1.

25. Johnson, D. S., 2009b, passim.
26. Marshall, W., 1808, 477.
27. Marshall, W., 1808, 453.
28. Marshall, W., 1808, 384.
29. Brown, R., 1799, 77.
30. Brown, R., 1799, 135.
31. Marshall, W., 1808, 338.
32. An example of agricultural land improvement and the landowner's profit motive in action, as well as the impact of the Napoleonic wars, is provided in Mawson, D. J. W., 1980, 137-51.
33. Wilson, J. M., 1849, 177.
34. NYCRO. ZXF 4/1, Pennigent: Estate of Robert Preston 1801-46, 13 April 1811; ZXC 5/1, Preston family papers.
35. Quoted in Harris, A., 1977, 149-55.
36. Gash, N., 1979, 30.
37. Davy, Sir Humphry, 1814.
38. Rees, W. J., 1930, 172-3.
39. Davy (1814, 320) erroneously believed that mixing lime with animal dung would reduce the efficiency of the dung as a fertiliser.
40. Chippindall, W. H., 1931.
41. Austwick Court Baron Book, 29 November 1780.
42. Hutton, J., 1781, 49.
43. Brayshaw, T. and Robinson, R. M., 1932, 212.
44. Skipton Library, Raistrick Papers 1029, 1823.
45. Skipton Library, Raistrick Papers 557, 15 July 1806.
46. Minnitt, D., 1998, 143-8.
47. NYCRO. Z2, Covenant for building a lime kiln in Green Bank Pasture, Burtersett, 3 December 1857.
48. Moorhouse, S., 1941, 142-3.

CHAPTER 2

1. Stowell, F. P., 1963, 29.
2. Searle, A. B., 1935, 211-12, 531-2.
3. *Stone Trades Journal*, 1920 (38), 280.
4. Aspdin actually produced his new material, which he called Portland, thirteen years later. His cement was a concoction created by firing a mixture of clay and lime at very high temperatures. Sadly, he made little headway in Britain and ended up manufacturing cement near Berlin. Large-scale production of Portland cement began at Swanscombe in Kent in around 1850.
5. Devonshire Collection, Chatsworth, Bolton Abbey, Clifford Household Accounts, Book 2, 1515-16, Items within a list of expenses of building 'my lord's new chapel'.

6. NYCRO. ZRL 1/20, Contract for building Catterick church, 18 April 1412.

7. NYCRO. ZRL 1/23, building Catterick Bridge, 1421.

8. NYCRO. ZNK 1.1/849, Zetland (Dundas) Richmond deeds, a note of the charges for mending the Grene Myllnes, 23 August 1613.

9. Neve, R., 1726, 102-3.

10. NYCRO. ZAZ 79, Letters and papers of John Hutton of Marske 1657-1731, Mr Yeoman's the Bricklayers Bill for 96.

11. WYAS (L). JA31/2187(K/11), Newby Hall papers, Account book 1694-1759.

12. NYCRO. ZXF 4/5/4, 18 March 1870.

13. Stainforth History Group, 2001, 74.

14. NYCRO. ZS*, Masham manor court verdicts.

15. Quoted in Davies-Shiel, M., 1972, 85-111.

16. Marshall, W., 1788, 147-8, 154-5.

17. John McIlwaine, personal communication, August 2001.

18. I am grateful to Jean Scott-Smith for this information.

19. Brown, R., 1799, Appendix II, 52-3.

20. Sydney Johnson, personal communication, August 2001.

21. WYAS Bradford, DB9/4, Thomas Brown's account book, 1775-1807.

22. Johnson, D. S., 2009b, 311-16.

23. NYCRO. ZTO 5/1, Preston of Flasby: miscellaneous estate papers, list of land in Flasby, 1763.

24. CRO (K). WD/Hoth/Box 26, uncatalogued, miscellaneous Westmorland leases.

25. Jennings, B., 1992, 332.

26. Young, A., 1770, 484.

27. Young, A., 1770, 482.

28. Marshall, W., 1788, 3.

29. Marshall, W., 1788, 333.

30. Marshall, W., 1808, 384.

31. Brown, R., 1799, 154-161, 176-7.

32. Brown, R., 1799, Appendix I.

33. Clarke, A. J., 1987, 5-22.

34. Hutton, J., 1781, 12.

35. Black Burton is Burton in Lonsdale – a quiet village now, but once a hive of industrial activity based on coal pits and potteries.

36. Riley, F., 1923, 24.

37. Searle, A. B., 1935, 215.

38. Wilson, J. M., 1849, 181. J. Billingsley, the Board of Agriculture's surveyor for Somerset, was of the firm opinion that manure could not work on the soil without being mixed with lime. (See Daniel, P., 2001, 8-15.)

39. Morton, J. C., 1855, 534-9.

40. NYCRO. ZBL IV2/1/5, Kiplin Hall archive, leases with conditions, George Crowe of Kiplin to John Eden of Layland, 22 January 1778.

41. Corrie, F. E., 1926.
42. Kames, Lord, 1815, 505, 535.
43. Brown, R., 1799, 177.
44. Robertson, A., 1999, 14.
45. Searle, A. B., 1935, 535, 553; Gardner, H. W. and Garner H. V., 1953, 64.
46. More, E. J., 1933, 224-5.
47. Marshall, W., 1788, 349.
48. Hale, T., 1756, 81-2.
49. Maxwell, R., 1757, 191-5.
50. Brown, R., 1799, 154-61.
51. Kames, Lord, 1815, 276-9. First published in Scotland in 1776.
52. Wilson, J. M., 1849, 188-190.
53. I have in my collection a rather poor photograph of burnt lime being spread on a pasture just after the Second World War. Small heaps were laid out, following the contours, some 2-4 metres apart.
54. Wilson's first aid advice, should lime get onto the skin, was to wash the affected area with either vinegar or very sour milk.
55. *Settle Chronicle* no. 23, 1 December 1855.
56. *Settle Chronicle* no. 3, 1 April 1854.
57. Johnston, J. F. W., 1849, 55.

CHAPTER 3

1. Bessey, G., 1975, 11.
2. Wingate, M., 1985, 43.
3. Both Hale (1756, 81), quoted here, and Mortimer (1712, 68) stressed the qualities of bracken as kiln fuel.
4. Stuart Menteath, C. G., 1831, 127-31.
5. Skinner, B. C., 1969, 22.
6. Davey, N., 1961, 101.
7. NYCRO. ZS*, Swinton Park archive, uncatalogued.
8. See various correspondence items in *Industrial Archaeology News*: Starmer, G., 1995, no. 92; Leach, J., 1999, no. 110; Sowan, P. W., 1999, no. 111; Trueman, M., 2000, no. 112; and Leach, J., 2000, no. 113.
9. Wilson, J. M., 1849, 187; Walton, J., 1941, 205-6. In 1922 a Yorkshire farmer modified a disused field kiln to make a clamp kiln of considerable size, which took a week to fill and ten days to burn through (Ruston, A. G., 1924, 738-43). Clamp kilns were still in regular use on the west coast of Ireland into the 1940s and at South Elmsall in the West Riding.
10. Skinner, B. C., 1969, 12; Neve, R., 1726, 192-3.
11. Mortimer, J., 1712, 68; Jobey, G., 1966, 37-8; Skinner, B.C., 1969, 12.
12. Ward, A. H., 1983, 177-84.
13. Johnson, D. S., 2008.

14. Information supplied by Network Archaeology Ltd.
15. NYCRO. ZQH 4/8, Coverdale Estate papers 1681-1827. Chaytors of Spennithorne rental book, 8 October 1782.
16. Garth day books, Barker MSS, private collection.
17. Skinner, B. C., 1969, 12; Green, H. E., 1977, 45-46; Leach, J. T., 1995, 145-58.
18. Raistrick, A., 1972.
19. Johnson, D. S., 2010a.
20. Pyne, W. H., Hill, J. and Gray, C., 1808.
21. The vast majority of sites were surveyed by this writer. Other recorders were Brenda Capstick, Janet and Robert Harker, David McMahon, Mark Simpson, Jack Webster, D. L. Woolley, and members of the Sedbergh & District Historical Society.
22. Maxwell, R., 1757, 196-200.
23. Marshall, W., 1788, 338ff.
24. Cossons, N., 1972, 210.
25. Stuart Menteath, C. G., 1831, 127-31.
26. Wilson, J. M., 1849, 11-12.
27. Tomlinson, C., 1854, 294.
28. Hunt, R. and Rudler, F. W., 1878, 116.
29. Cossons, N., 1972, 213.
30. Johnson, D. S., 2010b.
31. Brock, J., 1987, 6-21.
32. Hale, T., 1756, 83.
33. Johnson, D. S., 2010b.
34. Mortimer, J., 1712, 68; Marshall, W., 1788, 338ff; Evans, D., 1987, 34.
35. See, for example, Hale, T., 1756, 83-4; Maxwell, R., 1757, 191-5; Marshall, W., 1788, 338-52; Wilson, J. M., 1849, 12; Cossons, N., 1972, 211.
36. Cumbria Record Office, Carlisle, D/Hud/3/66/2, 1845.
37. *Cement, Lime and Gravel,* 1943, 17, 214.
38. Related in *Quarry Manager's Journal* 1935, 18, 190.
39. Quoted in Skinner, B. C., 1975, 225-30.
40. Bray, W., 1783, 310.
41. Hale, T., 1756, 84.
42. NYCRO. ZS*, Swinton archive, Box 88, uncatalogued, counterpart of lease, Abstrupus Danby to Robert Rucroft and James Rucroft, May 1733.
43. Garth day books , Barker MSS, private collection.
44. NYCRO. ZPL 10, Morley family of Marrick Park, Marrick and Hurst papers, nineteenth century, 7 July 1870.
45. I have a photograph in my collection taken in the 1920s of similar sacks being used in South Wales.
46. Robertson, A., 1999, 16.
47. Fletcher, H., 1964; Unwin, G., 1968, 215; Hadfield, C., 1972, 198; Hadfield, C,. 1973, 309, 348, 361-2.

48. YAS, MS 1186, Plan of a proposed canal from Parkfoot Bridge to Settle, 1780.

49. LRO. DDPa/Box 1, Parkinson of Hornby, uncatalogued, Thoughts on the design of making a navigable canal from the vicinity of Kendal, to join some of the canals in the southern parts of Lancashire, by way of Lancaster, 1791.

50. Johnson, D. S., 2009b, 293.

CHAPTER 4

1. Wood, A., 1982, 178-9.

2. Brayshaw, T., 1911, 13.

3. Brown, G. H., 1896, 23.

4. *Bulmer's History, Topography and Directory of North Yorkshire*, 1890, 599.

5. Lambert, B., 1910, 6 and 19.

6. In the Museumspark in Rüdersdorf, east of Berlin, there is an extensive industrial archaeological site with kilns of various designs and dates.

7. Patent no. 4876 of 1883.

8. Patent nos 141 of 1881, 7308 of 1892 and 10,416 of 1894.

9. Kelly's Directories for the West Riding 1867, 1877, 1881, 1889 and 1897, and Slater's for 1887 and 1891, list the firm of John Winskill & Sons in various combinations of stone masons, builders, contractors and farmers.

10. The 1871 census lists John Winskill, aged forty-four, living at 31 Victoria Street as a builder and farmer. The 1881 census has him living at 49 Victoria Street as a stone mason and builder. In 1881 his son, also John, aged nineteen, is listed as a stone mason. John Sr died in Settle in 1890. He was credited with having built many of Settle's late Victorian houses and public buildings.

11. Patent no. 2495 of 1872.

12. Patent no. 4286 of 1889.

13. West Yorkshire Record Office, Wakefield, 899/92 and 911/43-44.

14. Barry Nuttall, personal communication, July 2001; WYAS, Sheepscar, DW 715B, Dawson of Langcliffe, Notice, 1 November 1878.

15. YAS, DD214, Box 1, No. 76, November 1875.

16. Patent no. 2048 of 1863.

17. Dulken, S. van, British Library Patents Information, personal communication, February 1997.

18. Patent no. 1456 of 1869.

19. Patent no. 3244 of 1869.

20. *Craven Weekly Pioneer*, 20 September 1862.

21. *Craven Weekly Pioneer*, 14 August 1869.

22. *Lancaster Guardian*, 23 October 1869.

23. *Craven Weekly Pioneer*, 21 August 1869.
24. *Lancaster Guardian*, 18 March 1893.
25. *Craven Herald*, 23 July, 30 July and 12 November 1881.
26. *Craven Herald*, 3 February 1883.
27. WYRD, vol. 7, no. 50, 14 February 1899.
28. WYRD, vol. 10, no. 315, 17 March 1910.
29. *Craven Pioneer*, 27 February 1875.
30. National Railway Museum, Charles Roberts & Co. Horbury, Order Book, No. 3 April 1897-March 1898, No. 8 July 1902-April 1903, No. 10 February 1904-November 1904.
31. Cale, K. J., 1999.
32. *Wildman's Household Almanac*, 1876, Settle.
33. NYCRO, PC/SNF-1, Rate Book, Township of Stainforth.
34. *Kelly's Directory of the West Riding of Yorkshire*, 1881.
35. National Railway Museum, Charles Roberts & Co. Horbury, Order Book, No. 11 November 1904-September 1905.
36. *Lists of quarries (under the Quarries Act)*, 1895-1922. London: HMSO.
37. *Stone Trades Journal*, 1905, May, vol. 23.
38. *Quarry Manager's Journal*, 1937, 19, 44.
39. Raleigh Hargreaves, personal communication, July 2001.
40. Bolton Abbey Estate Office, personal communication, December 2001.

CHAPTER 5

1. Hambler, D. J., 1995, 51-64.
2. YAS, DD214, Box 1, No. 28, February 1852. Plan of lime kilns and quarry in Hawbank Pasture.
3. YAS, DD214, No. 2, 1757. Plan of the manor and lordship of Skipton in Craven.
4. Firth, G., 1983, 50-62.
5. Hadfield, C. and Biddle, G., 1970, 80.
6. Firth, G., 1982, 129-34.
7. Killick, H. F., 1897, 65. In 1774 eighteen boats were already employed transporting lime out from Skipton with coal on the return journey.
8. WYAS Bradford, DB2. C1 and C2, Bradford Lime Kiln Co.
9. WYAS Bradford, BCC, Bradford Canal Co., Records, 1661-1923.
10. *Craven Herald*, 17 April 1970.
11. Hustler, J., 1770, 10; Hustler, J., 1788, 9-10. Hustler was a Bradford wool stapler who was treasurer for the canal company until his death in 1790. In his first pamphlet he compared the current cost of carting lime by road (1s per ton mile) with the 1d per ton mile on the proposed canal.
12. Binns, D., 2004, 12.

13. Local industries no. 5, Stone getting at Skipton Rock. *Craven Pioneer*, 27 February 1875.

14. YAS, DD214, Box 2, No. 13, December 1852. Plan of Hawbank Rock, the property of Sir Richard Tufton, Bart.

15. YAS, DD214, Box 1, No. 14, March 1853. Plan of land enclosed at the Haw Bank Rock, for the use of the canal company.

16. *Craven Pioneer*, 27 February 1875.

17. Smith, F. W. and Binns, D., 1986, 62.

18. Craven Museum, Leeds and Liverpool Canal Co., ledger 26, Skipton Rock pay sheets.

19. Craven Museum, Leeds and Liverpool Canal Co., ledger 26, Skipton Rock pay sheets.

20. Craven Museum, Ledger 71, Daily account of work at Skipton Rock May 1909 to February 1915'.

21. YAS, DD214, Box 1, November 1915. Leeds and Liverpool Canal: Skipton Rock.

22. West Yorkshire Record Office, Wakefield, RC2/14, 1920, Skipton Rock Co.

23. See, for example, Craven Museum, Skipton, ledger 29, Royalty Book 1912-1923, and ledger 31, Customers 1896-1897.

24. *The Quarry*, 1914, 19 (228), 326-7.

25. YAS, DD214, Box 2, no. 109, 11 November 1930, Plan.

26. *Quarry Manager's Journal*, 1954, 38 (1), 12.

27. Lang, W. R., 1964, 257-60.

28. *Craven Herald*, 11 April 1968.

29. *Craven Herald*, 23 January 1931.

30. Houston, J. W., 1964, 289-92.

31. Raleigh Hargreaves, personal communication, July 2001.

32. Minute Book of Halton East Quarries Ltd, 1 January 1934 to 15 April 1976; meeting of directors, 29 November 1955.

33. *Quarry Manager's Journal*, 1951, 35 (2), 84; *Craven Herald*, 11 May 1951.

34. Articles and correspondence in the *Craven Herald*, 23 July 1954 to 11 March 1955.

35. *Craven Herald*, 15 April 1955.

36. Minute Book of Halton East Quarries Ltd, meeting of directors, 29 November 1955.

37. Minute Book of Halton East Quarries Ltd, board meeting of 12 August 1965; *Craven Herald*, 13 May 1966.

38. *Craven Herald*, 13 May 1966.

39. Raleigh Hargreaves, personal communication, July 2001; *Craven Herald*, 23 March 1979.

CHAPTER 6

1. Mitchell, W. R., 1999, 133-5.
2. WYRD, vol. QY, no. 321, 8 February 1851, 290.
3. Mitchell, W. R., 1999, 133-5.
4. WYRD, from vol. 736, nos 114-115 of 28 April 1875 to vol. 846, no. 619 of 30 August 1880.
5. WYRD, vol. 902, no., 2 May 1884. Probate of John Clark's will.
6. *Craven Weekly Pioneer*, 18 January 1873; *Lancaster Guardian*, 1 February 1873.
7. *Settle Chronicle*, no. 30, 1 July 1856.
8. *Settle Chronicle*, no. 47, 1 December 1857.
9. *Settle Chronicle*, no. 53, 1 June 1858.
10. NYCRO. ZTW III/12/6, Ingleborough Estate.
11. Invoice from Joseph Bentham to the Greenwood Trustees for eleven loads of lime at 6d each, 12 November 1864; statement from R. Brown & Co. to Mr G. Denny for 196 loads of lime delivered from February to March at 8½d per load, May 1864. Both are in the author's collection.
12. Hewitson, A., 1893, 26.
13. *Craven Weekly Pioneer*, 13 June 1868.
14. D. S. Johnson Collection. Hoffmann's Patent Kiln. License (*sic*) to use inventions within a district around Ingleton and Settle, Yorkshire, 29 April 1868.
15. *Craven Weekly Pioneer*, 7 August 1869; *Lancaster Guardian*, 2 and 9 October 1869.
16. Recounted in *Quarry Manager's Journal*, 1940, 23 (2), 27.
17. *Lancaster Guardian*, 13 August 1870.
18. *Lancaster Guardian*, 13 August 1870.
19. *Craven Pioneer*, 5 October 1876.
20. *Craven Herald*, 21 February 1880.
21. *Craven Herald*, 9 April 1881.
22. *Craven Herald*, 5 August 1882; NYCRO. MIC 1726, ZTW III/1/47, entry in the Farrer accounts, Meal Bank sold to Craven Lime Co. for £2,750. This was formalised in a conveyance of all 'kilns, buildings, tramways and other erections' in Meal Bank Quarry, WYRD, vol. 889, no. 341, 8 March 1883. A bond of indemnity, 19 January 1873, gave a figure of £2,000 for the original purchase cost of the lease.
23. NYCRO. ZTW III/12/6, Ingleborough Estate.
24. *Craven Herald*, 9 February 1889.
25. *Craven Herald*, 9 March 1889.
26. *Craven Herald*, 18 November 1892.
27. Balderston, R. R. and Balderston, M., 1888, 5; *Craven Herald*, 8 and 30 January 1891, which latter reported plans to increase the size of the kiln.
28. Hewitson, A., 1896, 7.

29. *Craven Herald*, 23 December 1904.
30. *Craven Herald*, 4 January 1907 and 3 January 1908.
31. *Craven Herald*, 15 January 1909.
32. *Craven Herald*, 7 January 1910.
33. *Lancaster Guardian*, 15 October 1921.

CHAPTER 7

1. Brown, G. H., 1896, 120.
2. D. S. Johnson Collection, Memorandum and Articles of Association of the Craven Lime Co. Ltd, 9 April 1872.
3. D. S. Johnson Collection, Craven Lime Co., shareholders with account paid, 2 May 1872.
4. *Craven Pioneer*, 1 March 1873.
5. PRO, J.13, 4504.
6. D. S. Johnson Collection, draft agreement for the sale of limestone works at and near Settle Yorkshire, 1872.
7. PRO, BT31/14435/6175, Craven Lime Co. Ltd.
8. D. S. Johnson Collection, Craven Lime Co., shareholders with account paid, 2 May 1872.
9. D. S. Johnson Collection, draft agreement for the sale of limestone works at and near Settle Yorkshire, 1872.
10. WYRD, vol. 65, no. 132, 17 September 1919.
11. WYRD, vol. 76, nos 237-41, 23 October 1919.
12. PRO, RAIL 491/314, Settle to Carlisle Railway Construction Committee No. 1, 2 December 1873.
13. *Wildman's Household Almanac*, 1873, Settle.
14. *Wildman's Household Almanac*, 1876, Settle.
15. Midland Railway Estate Map, 1912; Ordnance Survey 25-inch map, sheet no. 132.2, 1894.
16. D. S. Johnson Collection, The Liverpool and London and Globe Insurance Co., policy no. 1913246, 20 November 1873.
17. Ordnance Survey 25-inch map, sheet no. 132.2, 1907; Midland Railway Estate Map. 1912.
18. NYCRO, MIC 2700/NGV/0985. Duties on land values, 1910.
19. I must acknowledge the willingness of Mr Ernest 'Bunny' Marklew and Mr Edward 'Ted' Ramsbottom, both of Settle, to rack their brains and reminisce about their working life at Craven eighty or more years ago. Both men proved invaluable in filling in niggling gaps.
20. Trueman, M., Isaac, S. and Quartermaine, J., 1989; Trueman, M., 1997; Trueman, M. R. G., 1992, 126-43.
21. The deepened quarry to the north was probably Slippet, and the south-eastern quarry Meal or Mealy Bank, but my informants could not be certain.

The name Meal(y) Bank has proved to be a real teaser. Ingleton and Craven both had a Meal Bank, a small limestone quarry above Upper Settle was also called Meal Bank, and there is another Meal Bank limestone quarry just north of Kendal. What 'Meal' signifies remains uncertain.

22. Edward Ramsbottom, personal communication, November 2000.

23. Derbyshire Record Office, D2667.1249/2. Settle Limes Ltd. private ledger no. 2, 1938-51.

24. Derek Soames, personal communication, October 2000.

25. PRO, J.13/4504. List of debts and liabilities as at 4 August 1907.

26. WYRD, vol. 675, no. 646, 22 August 1872, refers to the purchase of the first six cottages.

27. The whole saga was reported in the *Craven Herald* in great detail, in issues between 5 September 1902 and 8 May 1903.

28. *Craven Herald*, 13 February 1903; *The Quarry*, 1903, 8 (4), 250.

29. Brayshaw Collection, Giggleswick School. Balance sheets of the Union, 7 February and 9 May 1903.

30. *The Quarry*, 1903, 8 (3), 184.

31. PRO, J.13/14743. Order no. 00335 of 1935, The Craven Lime Co. Ltd.

32. PRO, J.13/14743. Order no. 00335 of 1935, The Craven Lime Co. Ltd.

33. *Quarry Manager's Journal*, 1936, 19, 313.

34. WYRD, vol. 140, no .204, 27 October 1939.

35. Flintshire Record Office, D/BC (Additional) MISC/4/12.

36. *Cement, Lime and Gravel*, 1961, 36 (2), 32.

37. WYRD, vol. 69, no. 512, 20 March 1967.

CHAPTER 8

1. Patent no. 2918 of 1859. Specification of Alfred Vincent Newton 22 December 1859.

2. Ziegel- und Kalk Museum, Flintsbach, 1998, 14.

3. Johnson, D. S., 2002, 2003.

4. Johnson, D. S., 2002, 2003.

5. Reuleaux, C., 1873.

6. Reuleaux, C., 1873, 44; Hielscher, R., 1914, 237-40.

7. Johnson, D. S., 2003.

8. For detailed archaeological drawings and measurements see Trueman, M., Isaac, S. and Quartermaine, J., 1989; Trueman, M. R. G. and Quartermaine, J., 1993; and Trueman, M. R. G., 1997.

9. Edward Ramsbottom, personal communication, November 2000.

10. Patent no. 238 of 1891. Improvements in brick burning kilns 31 October 1891; patent no. 2797 of 1894. Improvements in kilns for burning bricks, tiles and other articles 8 December 1894.

11. Edward Ramsbottom, personal communication, November 2000.

12. *Lancaster Guardian*, 4 January 1873; Edward Ramsbottom, personal communication, November 2000.

13. Edward Ramsbottom, personal communication, November 2000.

14. This account has been pieced together from the recollections of former operatives at Langcliffe. Accounts from the late nineteenth century have added extra detail, for example, Reuleaux, C, 1873, and the writings of Hoffmann and Licht themselves. Also, *Lancaster Guardian*, 23 January 1869 and 4 January 1873. For a full bibliography, see Johnson, D. S., 2002, 2003. Visits by the author to working Hoffmann kilns in Britain and Germany have enabled awkward pieces to be slotted into the jigsaw.

15. Edward Ramsbottom, personal communication, January 2001.

16. Edward Ramsbottom, personal communication, November 2000.

17. *Lancaster Guardian*, 4 January 1873.

18. One of the planks used for this still lies on the ground at the north end of the western rail dock, adjacent to the pillar on which it would have rested.

19. *Craven Herald*, 14 May 1926.

20. *Cement, Lime and Gravel*, 1938, 12, 40.

21. *Cement, Lime and Gravel*, 1938, 12, 40.

22. *Quarry Manager's Journal*, 1951, 34 (8), 450.

CHAPTER 9

1. Hall, P., 1975, 203-6. Patricia Hall was Carrie Delaney's adopted daughter. See also Mitchell, W. R., 1975, 206-7.

2. *Wildman's Household Almanac*, 1876, Settle.

3. Leeds University, MS, Deposit 1979/1, Carlton Hill Archives of the Society of Friends. Minutes of Brighouse Monthly Meeting, 12 April and 12 May 1876.

4. Leeds University, MS, 1979/1, Carlton Hill Archives of the Society of Friends. Minutes of Brighouse Monthly Meeting, 13 February and 13 March 1889.

5. Leeds University, MS, 1979/1, Carlton Hill Archives of the Society of Friends. Minutes of Brighouse Monthly Meetings, 9 July 1913.

6. *Lambert's Settle Almanac*, 1890, Settle.

7. Brown, G. H., 1896, 80.

8. WYRD, vol. 34, nos 709 and 710, 22 December 1887.

9. WYRD, vol. 10, no. 300, 11 March 1986; vol. 22, no. 317, 9 June 1896; vol. 44, no. 408, 2 November 1897; vol. 24, no. 54, 8 June 1899.

10. WYRD, vol. 2, no. 392, 12 January 1899.

11. *Craven Herald*, obituary, 30 December 1921.

12. Cumbria Record Office, WDB/33. Northern Quarries Ltd No. 5.

13. *West Yorkshire Pioneer*, 10 February 1922.

14. *Craven Herald*, 15 November 1901.

15. *Stone Trades Journal*, 1911, 29 (7), 606.

16. WYRD, vol. 64, no. 218, 13 September 1919.

17. Parker, R., 1914, 310-14.

18. *The Quarry*, 1916, 21 (245), 117.

19. D. S. Johnson Collection, Conveyance, 6 August 1925.

20. *Stone Trades Journal*, 1925, 44, 137; WYRD, vol. 105, no. 64, 13 October 1925.

21. *Quarry Manager's Journal*, 1931, 14 (6), 225-6.

22. *Quarry Manager's Journal*, 1938, 21 (8), 172.

23. *Quarry Manager's Journal*, 1935, 18, 180.

24. *Craven Herald*, 28 June 1935.

25. *Cement, Lime and Gravel*, 1935, 10 (2), 70.

26. *Craven Herald*, 25 March 1949. The accounts of Settle Limes Ltd include purchase of the new kiln in July at a cost of £4,174.14.11.

27. *Cement, Lime and Gravel*, 1961, 36 (2), 31-8; Mr B. J. Gee, personal communication, June 1998. He was the last joint managing director for Settle Limes when ICI Mond took it over.

28. *Lancaster Guardian*, 20 June 1980.

29. D. S. Johnson Collection, lease of a plot of land as a quarry situated in Garrow Copy and river pasture portions of Small House and Copy House Farms in the township of Broughton, 2 February 1899; agreement for lease or leases of cottages and premises in and near Broughton.

30. D. S. Johnson Collection, lease of a plot of land as a quarry situated in High Copy, 1 December 1903.

31. *The Quarry*, 1914, 19 (226), 268.

32. D. S. Johnson Collection, lease of a plot of land and quarry called Broughton Quarry; lease of a plot of land and quarry called Small House Quarry, 28 February 1922.

33. *Craven Herald*, 28 March 1902.

34. *Railway Magazine*, 1902, 11, 204-10.

35. *The Quarry*, 1914, 19 (225), 242.

36. Robert Chaney, personal communication, February 2000.

37. Leslie Dean, personal communication, February 2000.

38. *Cement, Lime and Gravel*, 1935, 10 (2), 70.

39. *Edgar Allen News*, 1934, 13 (148), 501-3. This hydrating plant was replaced in 1951.

40. Johnson, D. and Martlew, R., 2009, 7.

41. WYRD, vol. 30, no. 253, 31 December 1965.

42. *Craven Herald*, 13 May 1966.

43. Raleigh Hargreaves, personal communication, July 2001.

44. *Craven Herald*, 23 March 1979.

CHAPTER 10

1. Johnson, D. S., 2010a.
2. *Craven Herald*, 28 January 1938.
3. Wilson, K., 1972, 28.
4. Wilson, K., 1972, 58.
5. Butterfield, A., 1972, 64.
6. PRO, BT31/31260/35063. The Buxton Lime Firms Co. Ltd, agreement 31 August 1907.
7. *Stone Trades Journal*, 1923, 42, 179; WYRD, vol. 3, no. 438, 9 January 1924.
8. *Craven Herald*, 23 December 1949.
9. *Quarry Manager's Journal*, 1951, 35 (2), 62.
10. Derbyshire Record Office, 1244/2 and 1256/1, 1910. Spencer *v.* the Buxton Lime Firms Co. Ltd.
11. Knibbs, N. V. S., 1924, 148.
12. *Cement, Lime and Gravel*, 1961, 36 (2), 40-5. Referring to a set of Spencer kilns at Fulwell, a commentator noted that 'this battery of six kilns is certainly one of the most economical lime-burning plants in the world' in *The British Limemaster*, 1927, 1 (11), 254.
13. Patent no. 767 of 1870.
14. Patent no. 16,043 of 1894.
15. Patent no. 3094 of 1900.
16. *The Quarry*, 1905, 10 (10), 443-6.
17. Knibbs, N. V. S., 1924, 140.
18. I am grateful to Mr Norman Whitaker and Mr Victor Busfield for sharing their memories of Swinden.
19. *Craven Herald*, 28 November and 5 December, 1980 and 3 January 1981.
20. *The Quarry*, 1914, 19 (226), 267-8; *West Yorkshire Pioneer*, 16 January 1914.
21. *Craven Herald*, 19 July 1901.
22. WYRD, vol. 12, no. 99, 1 February 1902 and vol. 3, no. 438, 9 January 1924.
23. *Craven Herald*, 5 September 1902.
24. *Quarry Manager's Journal*, 1968, 52, 359-66.
25. *Quarry Manager's Journal*, 1973, 57, 409-18; *Cement, Lime and Gravel*, 1974, 49, 49-54.
26. The use of rotary kilns came late to Britain, which is puzzling, as the technology was first perfected, for cement, in the USA in 1873, and was brought to this country fifteen years later. The first application of rotaries for lime burning in England was in 1894, but it took many years to gain a real foothold. Construction of the first British commercially operated rotary lime kiln was claimed by Edgar Allen & Co. of Sheffield, who made it for export to India. *Quarry Manager's Journal*, 1926, 8, 300.

27. *Craven Herald*, 28 November 1980.
28. WYRD, vol. 3, no. 438, 9 January 1924, which assigned the business assets of the Spencers to the new P. W. Spencer Ltd.
29. WYRD, vol. 145, no. 98, 22 December 1920.
30. Anon, 1928, 347-57.
31. West Yorkshire Record Office, Wakefield, RC/2/14. Minutes of the West Riding Highways Committee 1919-22.
32. *Craven Herald*, 28 January 1921.
33. Anon, 1928, 347-57.
34. I am grateful to Mr Ernest (Bunny) Marklew who worked at Giggleswick from 1936-47, and to Mr William Lawson who worked there from 1945-62, for their memories.
35. *Craven Herald*, 4 September 1925.
36. NYCRO. Settle Rural District Council Register of Plans Approved, No. 31, p. 97.
37. *Craven Herald*, 16 April 1971.
38. WYRD, vol. 161, no. 152, 23 October 1936.
39. WYRD, vol. 185, no. 114, 17 July 1964.
40. *Craven Herald*, 26 September 1969.
41. *Craven Herald*, 15 February 1974.
42. David Parry, personal communication, August 2000.

CHAPTER 11

1. PRO, BT31/30976/16762. Ribblesdale Lime Co. 1882-1939.
2. WYRD, vol. 129, no. 211, 9 August 1954.
3. *Craven Herald*, 2 January 1959.
4. *Craven Herald*, 4 January and 6 September 1963; Hillhead Hughes Ltd. Minute Book, 10 May 1961-15 June 1966.
5. Derbyshire Record Office, D2667. 1249/2. Settle Limes Ltd, Private ledger No. 2, 1938-51. The company paid £883 for a Ruston and Hornsby 20D.L diesel loco on 31 July 1950.
6. Johnson, D. S., 2006a.
7. Houston, W. J., 1964, 235-40.
8. *Cement, Lime and Gravel*, 1949, 23 (10), 395, and 23 (12), 434: *Quarry Manager's Journal*, 1949, 32 (12), 25.
9. I am grateful to Mr Keith Mallinson, former manager at Cool Scar Quarry, for this information.
10. *Craven Herald*, 19 August 1983.
11. Johnson, D. S., 2006b.
12. Greenhow Local History Club, 2005, pp. 128-9.
13. *The Quarry and Road Making*, 1932, 37, 126.
14. *Quarry Manager's Journal*, 1951, 35 (1), 21.

15. *Quarry Management*, 1986, 13, 11-17.
16. I am indebted to the Rt. Hon. Lord Bolton for granting permission to consult the Bolton Estate mining archives, and to Mr Peter G. Morgan of Wardell Armstrong Consulting Group in Newcastle upon Tyne for making them available to me.
17. White, W., 1840; *Slater's Directory of Yorkshire*, 1849.
18. *Bulmer's History, Topography, and Directory of North Yorkshire*, 1890, 599.
19. I am grateful for information on Leyburn Quarry to Mr Barry Richardson. I also acknowledge the willing help on northern quarries of Mr Dick Horner and Mr David Walker, both former quarrymen, and to Mrs E .Bradley.
20. *Quarry Manager's Journal*, 1938, 21 (6), 172.
21. *Quarry Manager's Journal*, 1962, 46 (10), 397-404.
22. *The Quarry and Road Making*, 1930, 35, 120.
23. I am grateful to Ms Victoria Cooper, manager at Wensley Quarry, for information on this quarry.
24. *The Quarry and Road Making*, 1932, 37, 370.
25. *The Quarry*, 1915, 20, 42.
26. NYCRO, MIC 3781/DC/SET IV. Settle Rural District Council, list of roads repairable by the above council in the rural district, 2 April 1896.
27. *Craven Herald*, 22 July 1904.
28. *Craven Herald*, 18 January 1907.
29. West Yorkshire Record Office, Wakefield, RC/2/14, 1921.
30. *Craven Herald*, 13 July and 14 September 1928.

CHAPTER 12

1. There are no entries for quarrymen or limeburners in, for example, *Baines Yorkshire, vol. 1, West Riding*, 1822 or White's *Directory and Topography of Leeds, Bradford etc*, 1847.
2. *Craven Herald*, 9 January 1925.
3. *Quarry Manager's Journal*, 1948, 31 (12), 626.
4. *Craven Herald*, 4 March 1955.
5. *Craven Herald*, 10 September 1920.
6. *Mines and Quarries. General Report and Statistics*, 1898, HMSO.
7. *The Quarry*, 1911, 16, 71-2.
8. *The Quarry*, 1914, 19, 326-7.
9. *Stone Trades Journal*, 1947, 70 (4), 40; *Quarry Manager's Journal*, 1947, 30, 525.
10. *Quarry Manager's Journal*, 1948, 32 (2), 84-5.
11. *Cement, Lime and Gravel*, 1948, 23 (2), 48.
12. Hale, T., 1756, 84.
13. Hyelman, A. C., 1984, 54-5.

14. Craven Museum, Skipton, Leeds and Liverpool Canal Co., ledger no. 62, daily account of work at Skipton Rock February 1898-October 1903.
15. *Craven Pioneer*, 27 February 1875.
16. Craven Museum, Skipton, Leeds and Liverpool Canal Co., ledger no. 26, Skipton Rock pay sheets for weeks ending 15 August 1895-1 October 1896.
17. *Craven Herald*, 4 December 1931.
18. *Lancaster Guardian*, 30 March 1872.
19. *Craven Herald*, 5 June and 17 July 1875.
20. Lambert, J. E., 1928, 75-8.
21. Maurice Lambert, personal communication, August 2001. His experience dates to the 1940s. Also William Lawson, personal communication, February 2001, talking of the 1960s. Black powder was an amalgam of sodium or potassium nitrate, charcoal and sulphur.
22. *Craven Herald*, 3 April and 10 April 1936; *Quarry Manager's Journal*, 1936, 19 (2), 56.
23. *Craven Herald*, 27 August 1937; *Quarry Manager's Journal*, 1937, 20 (8), 244. The blast took place at 6 p.m. on 27 August.
24. Here, the tunnel was sealed in the following way: the charges in the cross arms were covered in hay and straw bales to protect them, and the tunnel was stemmed with stone for two thirds of its length, the outermost third being left open. This was all necessary to prevent gas escaping, and to send the force of the blast through the rock face, not straight out of the tunnel.
25. *Craven Herald*, 7 January 1938.
26. *Quarry Manager's Journal*, 1941, 23 (12), 289; BBC programme script 'In Britain Now. The Big Blast,' narrated by Norman Thornber. I am grateful to Mr Richard Warham for bringing this to my attention.
27. *Craven Herald*, 26 June 1953.
28. Raleigh Hargreaves, personal communication, July 2001.
29. Stowell, F. P., 1963, 8.
30. *Craven Herald*, 24 July and 7 August 1953.
31. William Lawson, personal communication, February 2001.
32. Norman Whitaker, personal communication, February 2000.
33. Leslie Dean, personal communication, February 2000.
34. Robert Chaney, personal communication, February 2000.
35. Arthur Berry, personal communication, February 2000.
36. Johnson, D. S., 2009b, passim.
37. Corrie, F. E., 1926, 75.
38. Gardner, H. W. and Garner H. V., 1953, 8-9; Ruston, A. G., 1924, 738-43.
39. MAFF, 1981, 6; *Cement, Lime and Gravel*, 1958, 32 (9), 238.
40. Corrie, F. E., 1926, ii.
41. Lancaster Smith, A., 1929, 123.
42. In 1932 P. W. Spencer Ltd put out a series of advertisements in the local press extolling the benefits of lime, and encouraging farmers to try it, with

a loaded cartoon of a desperate farmer and a skinny cow, captioned, 'On Craven Moor bah't LIME!!!'

43. *Craven Herald*, 4 March 1938.
44. *Craven Herald*, 12 November 1937.
45. MAFF, 1981, 6.
46. *Craven Herald*, 2 January 1953.
47. *Craven Herald*, 1 January 1954.
48. *Craven Herald*, 22 November 1963.
49. Sludge from paper mills was spread in considerable quantities on at least two farms near Slaidburn in the Forest of Bowland in May 2010.
50. Ogg, W. G., 1942, 355-66, wrote that during the war years ground limestone was actually the more expensive of the two.

EPILOGUE

1. Fish, B. G., 1973, 275-80.
2. Shoard, M., 1989, 193.
3. Craven Museum, Raistrick Collection, 2000, 1202, Box 13, RS1040.3, hard rock resources of the Craven District of Yorkshire. Mineral strategy.
4. West Riding County Council, Planning Department, 1973, *Hard rock resources in the Craven District of Yorkshire*, Wakefield.
5. *http://www.yorkshiredales.org.uk/minerals_and_waste_local_plan_1998_saved_policies_october_8230*. Accessed 5 July 2010.
6. *The Times*, 22 March 2000.
7. *www.aggbusiness.com/article.asp?id=1878*. Accessed 20 June 2010.
8. Cowell, R., 2000, 134-44.
9. Material on current and future operations has been provided by management at the various quarries, for which I express my gratitude.
10. I am grateful to managers, Mr Bob Orange and Mrs Shirley Everett, of Hanson Aggregates at Coldstones Quarry, for their assistance.
11. I am grateful to Mr Scott Train, manager at Leyburn Quarry, for his assistance.
12. *Quarry Management*, August 2001, 10-22.
13. Johnson, D. S., 2010b.
14. See, for example, Manning, A., 2000, 49-63; Williams, A., 2000-2001, 14-15; The Archaeological Practice, 2000.
15. Craven District Council, Recreation and Amenities Committee, 1982, *Visit to Hoffman kiln, Craven Quarry, Langcliffe, Saturday 1 May 1982*. Unpublished report.
16. *Daily Telegraph*, 7 October 1986; Wakeford, J. and Whitelegg, J., 1986.
17. White, R., 1995, 87-95.
18. Trueman, M., Isaac, S. and Quartermaine, J., 1989; Trueman, M. R. G., 1992.
19. Owen, M. J., 1995.

Glossary

armour stone: large, irregular blocks of stone used, for example, in sea defences

basic slag: a mixture of slaked lime and slag from blast furnaces used as a cheap soil additive

BHP: 'best hand picked', i.e. burnt lime that has been hand-sorted

brander: a cast iron grate at the bottom of a kiln

calcination: the process whereby carbon dioxide is driven out of the limestone at temperatures above 900°C in a kiln

cement: the product that results from burning chalk or limestone with clay

clinker: burnt stone that has not fully calcined to its core because the temperature was not high enough; pieces of stone fuse together (also known as bullheads)

cob lime: an alternative term for lump lime

dead burnt lime: see **clinker**

dry hydrated lime: quicklime with a small amount of water added to it, then dried

flux: limestone reacts chemically at high temperatures with impurities in metals, forming slag – the flux acts as an agent to dissolve oxides in metals

ground burnt limestone: quicklime ground down to powder form

horse: wedge-shaped stone at the bottom of a kiln to direct burnt lime to the draw hole

hydrated lime: lime in powdered form that has been carefully slaked and then dried

hydraulic lime: lime that will readily set under water

kibbled lime: agricultural burnt lime that has been carefully crushed and screened

kiln dust: coal ash mixed with lime ashes and overburnt quicklime that was once laid as a cheap floor covering

lime ashes: the residue of small particles of burnt lime mixed with coal residue

lime hydrate: slaked lime

lime mortar: a mixture of lime, sand and water used for binding courses together when building

lime plaster: a mixture of lime putty, sand and (traditionally) horse hair

lime putty: hydrated lime with more water added than to dry hydrated lime

lime sludge: waste lime that has already been used in paper making or sugar beet processing

limestone dust: low grade waste from the crushing plant (also known as duff)

limewash: a milky mixture of slaked lime and water used as an internal wall coating

lump lime: quicklime with a mean size of 65-300 mm

marl: soft, calcareous clays or mudstone

milk of lime: hydrated lime with a water content greater than lime putty

Portland cement: cement made from a mixture of clay and calcium carbonate, said to resemble natural Portland stone

quarter: a measure of capacity equal to 8 bushels or 6 cwt (36 litres today)

quicklime: lime that results from the calcination or burning process; equivalent to burnt lime, i.e. calcium oxide

render: an external wall covering of plaster, not containing hair

scaffolding: an undesirable situation in a kiln when pieces of stone fuse together in large clumps

sintering: the process whereby high temperatures in the kiln fuse together particles within the bowl lining to form a hard, impermeable surface – similar to **vitrification**

slaked lime: quicklime with water added either by hand or from rain that changes the lime from calcium oxide to calcium hydroxide

small lime: the poor-quality and smaller pieces of quicklime

stucco: a fine, decorative plaster, often containing gypsum

thermal decomposition: the process by which one compound is broken down into two or more by the action of heat

temming: ramming the charges so that they are tightly packed at the end of a bore hole

tines: fork-like prongs pulled by a tractor or horse in farming

vitrification: conversion of the surface layer of the bowl lining into a glass-like solid by high temperatures

whitewash: a liquid solution of lime and water

Further Reading

Useful sources of material on the quarrying and lime burning industries are the following trade journals:

Stone Trades Journal 1882-53 (published as *The Stonemason* until 1900)
The Quarry (and Roadmaking) 1896-1938
Cement, Lime and Gravel 1926-74 (published as *British Limemaster* until 1928)
Quarry Management and Products 1974-83
Quarry Management 1984-present

Local newspapers covering the Dales provide contemporary references, particularly the *Craven Herald* and the *Craven Pioneer*, for many years combined as one paper, but in early years published separately, and the *Lancaster Guardian*.

Documents, patents, records and historic publications have been consulted in the following record offices and archives:

British Library at Colindale, Boston Spa and St Pancras
Cumbria Record Office, Carlisle (CRO.C)
Cumbria Record Office, Kendal (CRO.K)
Craven Museum, Skipton
Flintshire Record Office, Hawarden
Cumbria Record Office, Kendal
Keyworth (British Geological Survey)
Leeds University (Brotherton Collection)
Derbyshire Record Office, Matlock
North Yorkshire County Record Office, Northallerton (NYCRO)
Patents information services at St Pancras and Leeds
Lancashire Record Office, Preston
National Archives, Kew (NA)

Denbighshire Record Office, Ruthin
West Yorkshire Registry of Deeds, Wakefield (WYRD)
West Yorkshire Record Office, Wakefield
West Yorkshire Archive Service, Sheepscar, Leeds (WYAS.L)
West Yorkshire Archive Service, Bradford (WYAS.B)
Yorkshire Archaeological Society (YAS)

BOOKS AND ARTICLES

Anon, 1902, 'The Yorkshire Dales Railway', *Railway Magazine* 11, 204-10

Anon, 1928, 'Solving the conveying problem at Giggleswick Lime Works, in Settle', *British Limemaster and Limestone Quarry Owners' Journal*, 2 (12), 347-357

Archaeological Practice, 2000, 'Marsden Limekilns, Whitburn, South Shield: Archaeological survey and assessment', unpublished report prepared by the University of Newcastle upon Tyne for Tilcon (North) Ltd

Ayers, B. S., 1990, 'Building a fine city: the provision of flint, mortar and freestone in medieval Norwich', in Parsons, D., *Stone Quarrying and Building in England AD 4-1525*, Chichester: Phillimore

Balderston, R. R. and Balderston, M., 1888, *Ingleton; Bygone and Present*, London: Simpkin Marshall

Becker, B. and H., 2003, *Typologien Industrielles Bauten*, Munich: Schirmer/Mosel

Bessey, G. E., 1975, 'Production and use of lime in the developing countries', *Overseas Building Notes* no. 161, Garston: Overseas Division Building Research Station

Bick, D., 1984, 'Lime-kilns on the Gloucestershire-Herefordshire border', *Industrial Archaeology Review* VII (1), 85-93

Binns, D., 1990, *The Yorkshire Dales Railway: The Grassington Branch*, Skipton: Northern Heritage

Binns, D., 2004, *The Haw Bank Tramway*, Skipton: Trackside Publications

Blith, W., 1652, *The English Improver Improved, or the Survey of Husbandry Surveyed*, London: John Wright

Boynton, R. S., 1980, *Chemistry and Technology of Lime and Limestone*, New York: John Wiley

Bray, W., 1783, *Sketch of a Tour into Derbyshire and Yorkshire*, London: B.White

Brayshaw, T., 1911, *The 'Borough' Guide to Settle and Giggleswick*, Cheltenham: Burrow

Brayshaw, T. and Robinson, R. M., 1932, *Ancient Parish of Giggleswick*, London: Halton

Brock, J., 1987, 'Lime kilns around Richmond', *The Richmond Review*, 6-21

Brown, G. H., 1896, *On Foot around Settle*, Settle: J. Lambert

Brown, G. H., 1896, *On Foot around Settle: Extra Illustrated Edition, Vol. 4*, private publication

Brown, R., 1799, *General View of the Agriculture of the West Riding of Yorkshire*, Edinburgh: James Watson

Butterfield, A., 1972, 'The Raygill lime kiln and barytes mine' in Wilson, K., *History of Lothersdale*, Lothersdale Parish Council, 64-8

Cale, K. J., 1999, *Toft Gate Limekiln,* archaeological survey and report for the Moorhouse Residents Group, Bewerley, North Yorkshire

Chippindall, W. H. (ed.), 1931, *The Parish Register of Thornton-in-Lonsdale 1576-1812*, Yorkshire Parish Register Society

Clarke, R.J., 1987, 'The Closeburn Limeworks Scheme: A Dumfriesshire waterpower complex', *Industrial Archaeology Review* X (1), 5-22

Cleasby, I., 1995, 'Limekilns in Sedbergh, Garsdale and Dent', *Current Archaeology* 145, 16-20.

Corrie, F. E., 1926, *Lime in Agriculture*, London: Chapman and Hall

Cossons, N, 1975, *The BP Book of Industrial Archaeology*, Newton Abbot: David and Charles

Cowell, R., 2000, 'Localities and the international trade in aggregates', *Geography* 85 (2), 134-144.

Cowper, A. D., 1927, *Lime and Lime Mortars*, London: HMSO

Dancaster, E. A., 1916, *Limes and Cements*, London: Crosby Lockwood

Daniel, P., 2001, 'Limeburning in Priddy', *Somerset Industrial Archaeological Society* 86, 8-15

Davey, N., 1961, *A History of Building Materials*, London: Phoenix House

Davies, P. B. S., 1997, *Pembrokeshire Limekilns*, St David's: Merrivale

Davies-Shiel, M., 1972, 'A little known late medieval industry – Part 1, the making of potash for soap in Lakeland', *Transactions of the Cumberland and Westmorland Antiquarian and Archaeological Society* 72, 85-111

Davy, Sir Humphry, 1814, *Elements of Agricultural Chemistry*, London: Longman, Edinburgh: Constable

Dix, B., 1979, 'Roman lime-burning', *Britannia* 10, 261-262

Evans, D., 1987, 'The technique of lime burning', *Devon and Cornwall Notes and Queries*, 36 (1), 34-5

Faull, M. L. and Moorhouse, S. A. (eds.), *West Yorkshire: An Archaeological Survey*, Wakefield: West Yorkshire Metropolitan County Council

Firth, G., 1982, 'The Bradford Lime Kiln Co. 1774-1800', *Bradford Antiquary*, October, 129-34

Firth, G., 1983, 'Bradford coal, Craven limestone and the origins of the Leeds and Liverpool canal 1765-1775', *Journal of Transport History* 17, 50-62

Fish, B. G., 1973, 'Towards a strategy for quarrying', *Quarry Manager's Journal* 57, 275-80

Fletcher, H., 1964, *Samuel Oldknow and the Marple Lime Kilns*, pamphlet in Manchester Central Library

Gardner, H. W. and Garner, H. V., 1953, *The Use of Lime in British Agriculture*, London: Farmer and Stockbreeder

Gash, N., 1979, *Aristocracy and People*, London: Arnold

Gourdin, W. H. and Kingery, W. D., 1975, 'The beginnings of pyrotechnology: Neolithic and Egyptian lime plaster', *Journal of Field Archaeology* 2, 133-50

Green, H.E., 1977, *The Limestone Mines of Walsall*, Black Country Society

Greenhow Local History Club, 2005, *Life on the Hill: Greenhow*, Cleckheaton: Amadeus Press

Hadfield, C. and Biddle, G., 1970, *The Canals of North West England Vol. 1*, Newton Abbot: David and Charles

Hadfield, C., 1972, *The Canals of Yorkshire and North East England Vol. 1*, Newton Abbot: David and Charles

Hadfield, C., 1973, *The Canals of Yorkshire and North East England Vol. 2*, Newton Abbot: David and Charles

Hale, T., 1756, *A Compleat Body of Husbandry*, London: T. Osborne and J. Shipton

Hall, P., 1975, 'The life and times of John Delaney', *Dalesman*, 203-6

Hambler, D. J., 1995, '"The Haw", an eighteenth century greenfield site near Skipton', *The Naturalist* 120, 51-64

Harris, A., 1977, 'A traffic in lime', *Transactions of the Cumberland and Westmorland Antiquarian and Archaeological Society* 77, 149-55

Hewitson, A., 1893, *The Story of My Village: Ingleton 1840-50*, Ingleton: John Bentley

Heywood, A., 1903, *A Guide to Ingleton and Its Vicinity*, Manchester: Abel Heywood

Hielscher, R., 1914, 'Dem Gedenken Friedrich Hoffmanns und seiner Erfindung', *Tonindustrie-Zeitung* 17, 237-40

Houston, J. W., 1964, 'Recent developments at a Yorkshire limestone quarry', *Quarry Manager's Journal* 48, 289-92

Hunt, R. and Rudler, F. W., 1878, *Ure's Dictionary of Arts, Manufactures and Mines Vol .3*, London: Longmans Green

Hustler, J., 1770, *A Summary View of the Proposed Canal from Leeds to Liverpool, and of Its Importance to the Public*, Leeds: Griffin Wright (in Craven Museum, Skipton)

Hustler, J., 1788, *An Explanation of the Plan of the Canal from Leeds to Liverpool*, Bradford: George Nicholson (in Craven Museum, Skipton)

Hutton, J., 1781, *A Tour to the Caves in the Environs of Ingleborough and Settle*, London: Richardson and Urquhart

Hyelman, A. C., 1984, *The Development of Quarrying in Rural Areas of Lonsdale and South Westmorland*, unpublished MSc thesis, Lancaster University

Isham, K., 2000, *Lime Kilns and Limeburners in Cornwall*, St Austell: Cornish Hillside Publications

Jennings, B. (ed.), 1992, *A History of Nidderdale*, Pateley Bridge: Nidderdale History Group

Jobey, G., 1966, 'A note on "sow" kilns', *Journal of Newcastle upon Tyne Agricultural Society* 20, 37-8

Johnson, D. S., 2002, 'Friedrich Edouard Hoffmann and the invention of continuous kiln technology: the archaeology of the Hoffmann kiln and 19th-

century industrial development' Part 1, *Industrial Archaeology Review* XXIV (2), pp. 119-32

Johnson, D. S., 2003, 'Friedrich Edouard Hoffmann and the invention of continuous kiln technology: the archaeology of the Hoffmann lime kiln and 19th-century industrial development' Part 2, *Industrial Archaeology Review* XXV (1), pp. 15-29

Johnson, D. S., 2006a, 'Foredale Quarry, Helwith Bridge, a historical and archaeological survey', *British Mining* 80, pp. 111-34

Johnson, D. S., 2006b, 'An introductory history of Ribblehead Quarry, Ingleton', *Industrial Heritage* 32 (1), pp. 18-24

Johnson, D. S., 2008, 'The archaeology and technology of early-modern lime burning in the Yorkshire Dales: developing a clamp kiln model', *Industrial Archaeology Review* XXX (2), 127-43

Johnson, D. S., 2009a, 'How Hill, Halsteads, Dalehead, Slaidburn: Excavation of a clamp lime kiln, data structure report', unpublished report

Johnson, D. S., 2009b, *Lime Burning in the Central Pennines: The Use of Lime in the Improvement of Agricultural Land from the Late Thirteenth Century to c. 1900*, unpublished PhD thesis, Lancaster University

Johnson. D. S., 2010a, 'Hushes, delfs and river stonary: Alternative methods of obtaining lime in the gritstone Pennines in the early modern period', *Landscape History* 31 (1), 37-52

Johnson, D. S. 2010b, 'Lime kilns in the Central Pennines: Results of a field survey in the Yorkshire Dales and contiguous areas of North and West Yorkshire', *Yorkshire Archaeological Journal* 82, 231-62.

Johnson, D. and Martlew R. (eds.), 2009, *Threshfield Quarry. Industrial heritage in the Yorkshire Dales*, Kettlewell: Yorkshire Dales Landscape Research Trust

Johnston, J. F. W., 1849, *On the Use of Lime in Agriculture*, Edinburgh: William Blackwood

Kames, Lord, 1815, *The Gentleman Farmer*, Edinburgh: Bell and Bradfute, London: Longman

Killick, H. F., 1897, *Notes on the Early History of the Leeds and Liverpool Canal*, Bradford: H. Gaskerton

Knibbs, N. V. S., 1924, *Lime and Magnesia*, London: Ernest Benn

Lambert, B., 1910, 'Limestone and lime', *Settle Pamphlets* No. 4

Lambert, J. E., 1928, 'Blasting in quarries' *Quarry Managers' Journal* 11 (3), 75-8

Lancaster Smith, A., 1929, 'Liming: the foundation of soil fertility', *Cement, Lime and Gravel* 3, 123

Lang, W. R., 1964, 'Plant modernisation at a limestone quarry', *Cement, Lime and Gravel* 39(8), 257-60

Leach, J. T., 1995, 'Burning lime in Derbyshire pye kilns', *Industrial Archaeology Review* XVII, 145-58

Manning, A., 2000, 'The excavation of three 'flare' lime kilns at Garn-ffrwd Farm, Llanddarog, south-east Carmarthenshire', *Tarmac Papers* 4, 49-63

MAP Archaeological Consultancy, 1998, 'West Street, Gargrave, North Yorkshire: Assessment report', unpublished report for North Yorkshire County Council environmental services

Marshall, G., Palmer, M. and Neaverson, P., 1992, 'The history and archaeology of the Calke Abbey lime-yards', *Industrial Archaeology Review* XIV (2), 145-76

Marshall, W., 1788, *The Rural Economy of Yorkshire*, London: T. Cadell

Marshall, W., 1808, *The Review and Abstract of the County Reports to the Board of Agriculture: Vol. 1, Northern Department*, York: Thomas Wilson

Mawson, D. J. W., 1980, 'Agricultural lime burning – the Netherby example', *Transactions of the Cumberland and Westmorland Antiquarian and Archaeological Society* 80, 137-51

Maxwell, R., 1757, *The Practical Husbandman*, Edinburgh: C. Wright

Miles, D. (ed.), 1994, *The Description of Pembrokeshire*, facsimile edition, first published 1603 by George Owen of Henllys, Llandysul: Gomer Press

Ministry of Agriculture, Fisheries and Food, 1981, *Lime and Liming*, reference book 35, London: HMSO

Minnitt, D. 1998, 'Notebooks of James Willis of Yorescott', *Yorkshire History Quarterly* 3 (4), 143-8

Mitchell, W. R., 1975, 'Some stories about a Dales tycoon', *Dalesman*, 206-207

Mitchell, W. R., 1999, 'Michael Wilson: A forgotten quarryman', *Yorkshire History Quarterly* 4 (4), 133-5

Moore-Colyer., R., 1988, 'Of lime and men: aspects of the coastal trade in lime in south-west Wales in the 18th and 19th centuries', *Welsh History Review* 14, 54-77

Moorhouse, S., 1941, 'The limestone workers of north Lancashire', *Cement, Lime and Gravel* 15, 142-3

More, E. J., 1943, 'Lime and its application in agriculture', *Cement, Lime and Gravel* 8, 224-5

Mortimer, J., 1712, *The Whole Art of Husbandry or the Way of Managing and Improving of Land*, London: Mortlock and Robinson

Morton, J. C., 1855, *A Cyclopedia of Agriculture, Practical and Scientific*, Glasgow: Blackie.

Neve, R., 1726, *The City and Country Purchaser, and Builder's Dictionary*, London.

Oates, J. A. H., 1998, *Lime and Limestone*, Weinheim: Wiley-VCH

Ogg, W. G., 1942, 'The revival of liming', *Scottish Journal of Agriculture* 23 (4), 355-66

Owen, M. J., 1995, 'Hoffman Kiln and Langcliffe Quarry: Ecological survey, summer 1995', unpublished report for the Yorkshire Dales National Park

Parker, R., 1914, 'Equipment of a Yorkshire quarry', *The Quarry* 19 (228), 310-14

Parsons, D. (ed.), 1990, *Stone Quarrying and Building in England AD 43-1525*, Chichester: Phillimore

Pyne, W. H., Hill, J. and Gray, C., 1808, *Picturesque Groups for the Embellishment of Landscape*, London: William Miller

Raistrick, A., 1960, 'Story of the limekiln', *Dalesman* 122, 545-54

Raistrick, A., 1972, *Industrial Archaeology: An Historical Survey*, London: Eyre Methuen

Rees, W. J., 1930, 'The manufacture of lime', *Cement, Lime and Gravel* 5, 172-73

Reuleaux, C., 1873, *Der Hoffmann'sche Ringofen*, Berlin Polytechnische Buchhandlung

Riley, F., 1923, *The Settle District and North-West Yorkshire Highlands*, Settle: F. Riley

Robertson, A., 1999, *Limekilns of the North Pennines*, Nenthead: North Pennines Heritage Trust.

Ruston, A. G., 1924, 'Lime burning on a Yorkshire farm', *Journal of the Ministry of Agriculture* 31 (8), 738-43

Searle, A. B., 1935, *Limestone and Its Products*, London: Ernest Benn

Shoard, M., 1999, *A Right to Roam*, Oxford: University Press

Skinner, B. C., 1969, *The Lime Industry in the Lothians*, Edinburgh: University Press

Skinner, B. C., 1975, 'The archaeology of the lime industry in Scotland', *Post-Medieval Archaeology* 9, 225-30

Smith, F. W. and Binns, D., 1986, *Railways in the Northern Dales 1: The Skipton and Ilkley Line*, Skipton: Wyvern Publications

Society of Gentlemen, 1736, *The Complete Family-Piece and Country Gentlemen and Farmer's Best Guide*, London: J. Roberts

Spackman, C., 1979, *Some Writers on Lime and Cement from Cato to the Present Time*, Cambridge: W. Heffer

Stainforth History Group, 2001, *Stainforth: Stepping Stones through History*, Stainforth

Steane, J. M., 1984, *The Archaeology of Medieval England and Wales*, London: Croom Helm

Stowell, F. P., 1963, *Limestone as a Raw Material in Industry*, London: Oxford University Press

Stuart Menteath, C. G., 1831, 'On the construction of lime-kilns', *Transactions of the Highland Society of Scotland* 8, 127-31

Taylor, T., 2002, *The Buried Soil*, London: Fourth Estate

Toft, L. A., 1988, 'Lime burning on the Gower Peninsula's limestone belt', *Industrial Archaeology Review* XI (1), 75-85

Tomlinson, C. (ed.), 1854, *Cyclopaedia of Useful Arts Vol. 2*, London: James S. Virtue

Tomson, S. J. N. and McIlwaine, J. J., 1993, 'A Roman limekiln in Womersley, North Yorkshire', *Roman Antiquities Section Bulletin*, Yorkshire Archaeological Society

Trueman, M. R. G., 1992, 'The Langcliffe quarry and limeworks', *Industrial Archaeology Review* XIV (2), 126-43

Trueman, M. R. G., 1997, 'Langcliffe quarry near Settle, North Yorkshire, archaeological survey', unpublished report by Lancaster University Archaeological Unit for the Yorkshire Dales National Park

Trueman, M. R. G., Isaac, S. and Quartermaine, J., 1989, 'The Langcliffe quarry limeworks, Settle: An archaeological survey of the site and Hoffman limekiln', unpublished report by the Lancaster University Archaeological Unit for the Ribblesdale Trust

Trueman, M. R. G. and Quartermaine, J., 1993, 'Meal Bank quarry and Hoffman kiln, Ingleton, North Yorkshire', unpublished report by Lancaster University Archaeological Unit for the Yorkshire Dales National Park

Unwin, G., 1968, *Samuel Oldknow and the Arkwrights: The Industrial Revolution in Marple and Stockport*, Manchester: Manchester University Press

Wakeford, J. and Whitelegg, J., 1986, *The Ribblesdale Project Feasibility Study*, Lancaster University

Walton, J., 1941, 'Early Yorkshire lime burning', *Cement, Lime and Gravel* 15, 205-6

Ward, A. H., 1983, 'A sod lime kiln on Cefn Bryn, Gower, West Glamorgan', *Post-Medieval Archaeology* 17, 177-84

White, R., 1995, 'Langcliffe quarry: a balancing act', in Berry, A. Q. and Brown, I. W. (eds.), *Managing Ancient Monuments: An Integrated Approach*, Mold: Clwyd County Council

White, W., 1840, *History, Gazetteer and Directory of the East and North Ridings of Yorkshire*

Williams, A., 2001, 'A North Pennine landscape', *Archaeology in Northumberland 2000-2001*, 14-15.

Wilson, J. M., 1849, *The Rural Cyclopedia or a General Dictionary of Agriculture Vol. 3*, Edinburgh: A. Fullarton

Wilson, K., 1972, *The History of Lothersdale*, Lothersdale Parish Council

Wilson, R. E., 1980, 'Lime burning in East Devon', *The Devon Historian* 21, 12-16

Wingate, M., 1985, *Small-Scale Lime-Burning*, London: Intermediate Technology Publications

Wood, A., 1982, *Nineteenth Century Britain 1815-1914*, Harlow: Longman

Worlidge, J., 1675, *Systema Agriculturae: The Mystery of Husbandry Discovered*, London: Thomas Dring

Wright, G. N., 1967, 'Lime-kilns of the Pennine Dales', *The Yorkshire Ridings* 4 (4), 33-5

Young, A., 1770, *A Six Months Tour through the North of England, Vol. 4*, London: W. Strahan.

Ziegel und Kalk Museum, 1988, *Ein Führer Durch das Museum*, Winzer

Index